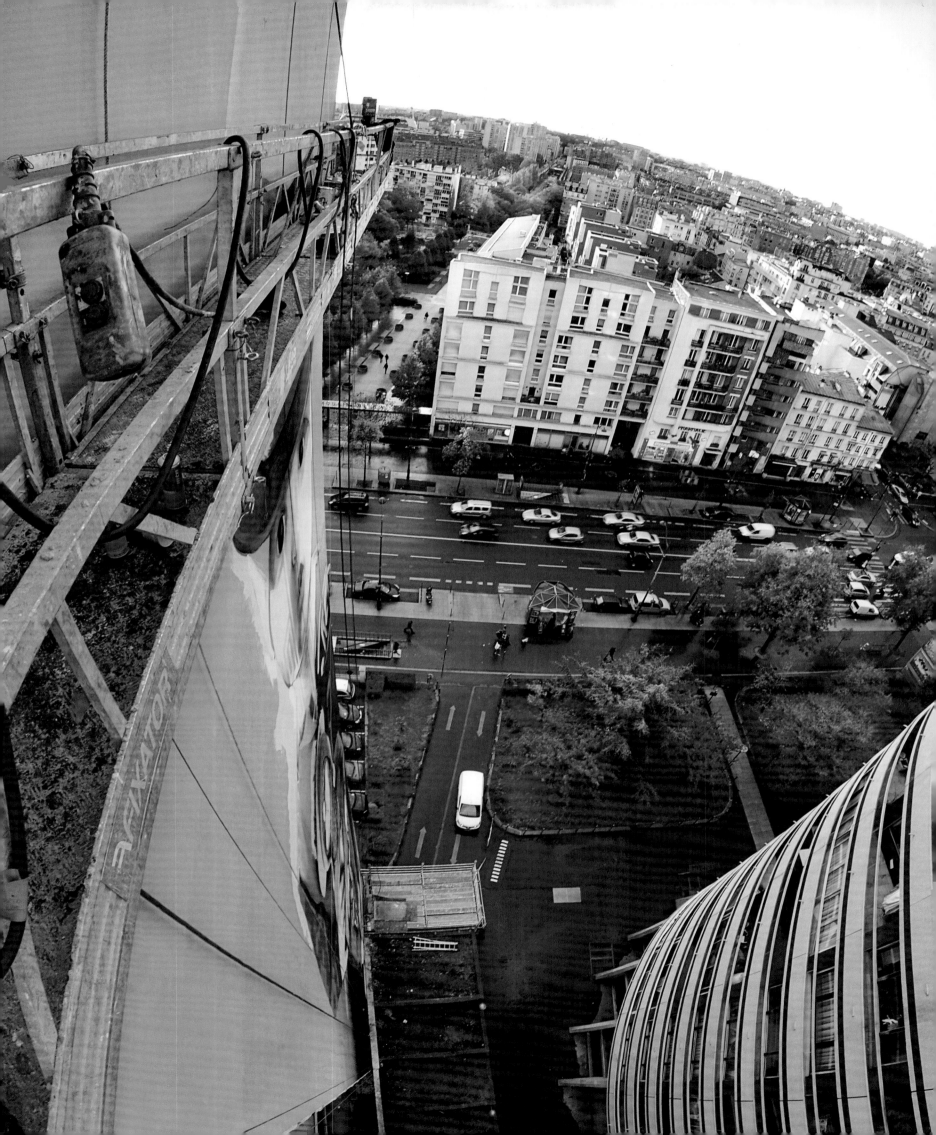

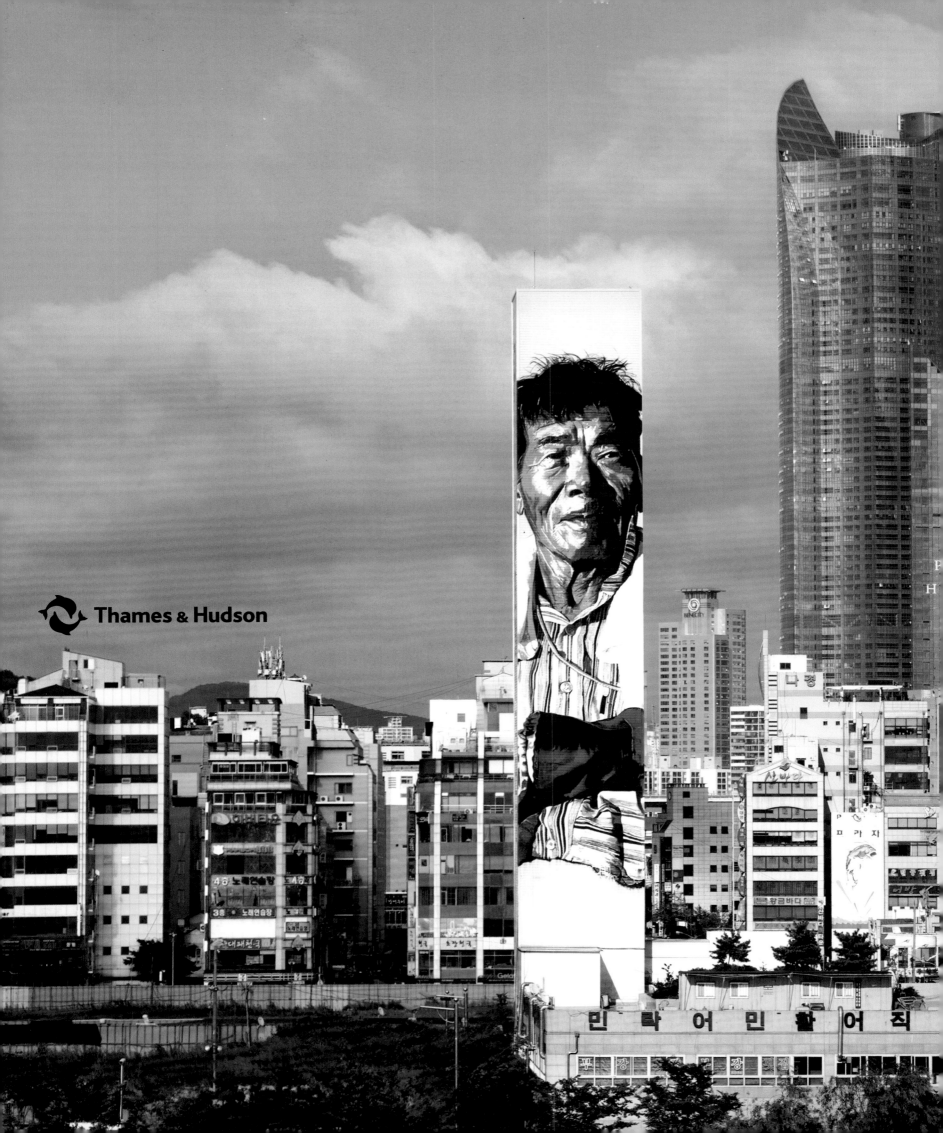

Claudia
Walde

Mural
XXL

First published in the United Kingdom in 2015 by
Thames & Hudson Ltd, 181A High Holborn,
London WC1V 7QX

Mural XXL © 2015 Claudia Walde

Designed by Sam Clark
www.bytheskydesign.com

British Library Cataloguing-in-Publication Data
A catalogue record for this book is available
from the British Library

ISBN 978-0-500-23930-8

Printed and bound in China
by C&C Offset Printing Co. Ltd

To find out about all our publications, please visit
www.thamesandhudson.com. There you can
subscribe to our e-newsletter, browse or download
our current catalogue, and buy any titles that
are in print.

CONTENTS

Introduction

Although the urban outdoor mural has been around for hundreds – even thousands – of years, graffiti and street artists have only recently begun working on such a large scale. Before this, most street art was put up illegally, so pieces had to be finished within hours or even minutes, which limited their size. Only in the few spots where public art was permitted without restrictions could works be larger and more detailed. At graffiti jams, for instance, writers often teamed up to create large collaborative walls with their various pieces. But since the colour, concept and proportion of the work as a whole were rarely considered beforehand, many of these walls weren't as visually appealing as they might have been. Street artists, meanwhile, worked more closely with the individual location and context of their work, often with a specific audience and artistic concept in mind.

Over time, a few graffiti and street artists created larger works, some commissioned, others just for fun. One of the largest graffiti pieces to date was created by Saber along the bank of the Los Angeles River (overleaf) in the 1990s; it required working throughout the night over a period of more than a month. This mural was especially impressive as it was painted in full colour by a single person. Some time later, the MTA crew painted an even bigger piece alongside the same river, but this one was only in two colours. (Both pieces were buffed by the city authorities and are unfortunately not visible any more.) These new, large walls were better proportioned and conceptually well thought out, fitting the shape and context of the wall itself.

As the works became larger, the two separate genres – street art and graffiti writing – grew closer, and the sheer scale of some works caught the attention of both fellow artists and the public.

There are many factors that make the XXL street mural movement a phenomenon of its own. Since the works are usually done with permission, they last much longer than illegal graffiti walls. They are very visible in terms of size and location, so can't be easily ignored by passers-by. For artists, working in such a large-scale format presents many technical challenges, and allows much less spontaneity than is possible when making smaller pieces. A plan based on a grid, or at least a detailed sketch of the final work, is necessary to

PRECEDING PAGES: INTI, *Our Utopia Is Their Future*, Paris, 2013 (frontispiece); ecb, Busan, South Korea, 2012 (title spread); Dabs and Myla painting *Christmas Mural 2011*, Culver City, CA, USA, 2011 (contents pages).

OPPOSITE: D*Face x Candy at work on *Don't Look Back*, Shibuya, Tokyo, 2013.

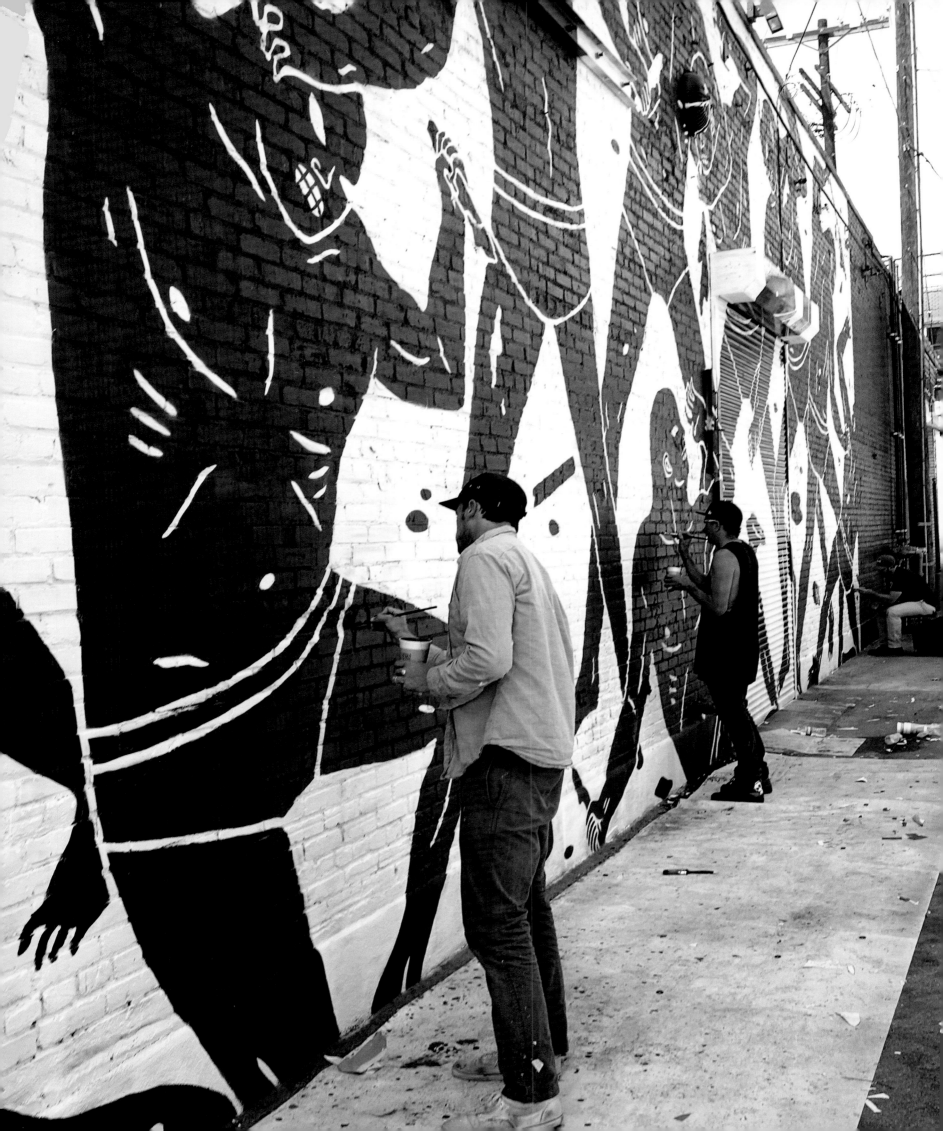

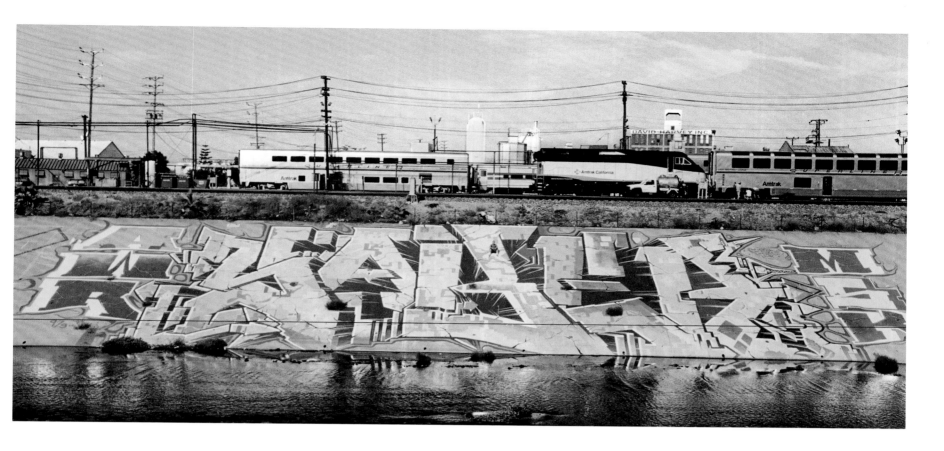

ABOVE: Saber, Los Angeles River, 1997. OPPOSITE: Cleon Peterson, Los Angeles, 2013.

create a mural, which requires a lot of careful planning before the actual painting process begins. Once it has, the artist usually can't get enough distance from the wall to judge the appearance of the work while it is in progress, and the scaffolding and lifts obscure the view from below. Painting an XXL mural is a physically demanding task that takes days rather than minutes or hours, and a mechanical cherry picker, a scissor lift or pre-installed scaffolding is usually necessary to reach the higher parts of the 'canvas'. Spray cans, traditionally the preferred tools of graffiti and street artists, are generally not efficient enough when filling very large spaces, so in many cases ordinary wall paint and rollers need to be used instead. Wall paint also needs more time to dry than spray paint, which can be a problem if rain is on the way. The weather also poses other obstacles: heat reflecting off the wall on a hot, sunny day can be intense; and cherry pickers or scissor lifts can only be used if the wind speed is low. The machines themselves can create their own problems: if the diesel fuel in your cherry picker runs out, you can find yourself stuck uncomfortably high in the air until you reach someone by phone or passers-by help you out; and it can be very time-consuming to adjust the position of the machine repeatedly in order to reach every part of the wall. In less developed countries, you may not even have a mechanical lift at all, and can instead find yourself on scaffolding so unstable you fear for your life.

Another challenge for the XXL mural artist is in planning the proportions of the work and judging the amount of detail necessary at different levels of the painting. Since anything more than a few metres above the ground doesn't show all its detail, artists sometimes spend hours working on something that no one can see from below. To avoid this, the artist needs to develop a different

sense of proportion and composition, taking each of the various possible viewpoints into account.

Despite all these technical challenges, large murals also have significant advantages over smaller works. For one thing, they last longer: they won't be painted over within a couple of weeks – or even days – by the owner of the wall, and vandals or rival artists are unlikely to damage the murals since they can't reach them easily. Exterior paint also resists weathering better than most spray paint brands, so the works will look fresh and bright for much longer. And, of course, since every piece looks that much more impressive when executed at a large scale, passers-by will respect the hard work and technical challenges that have gone into the mural.

Building owners, development companies, architects and city planners have long understood the power of large murals to transform forgotten industrial areas into outdoor galleries, or to change the public's perception of notorious urban crime hotspots. Street art walks are initiated, and mural festivals take place alongside (and sometimes even instead of) graffiti festivals. Yet most mural artists work without payment, receiving only expenses for travel, materials and equipment. Their sole reward for all their hard work and planning is the opportunity to create a lasting piece of artwork in a very public location. The exposure afforded by large outdoor pieces, however, can sometimes open important doors for an artist in the indoor world of gallery exhibitions.

Since new murals appear every day in cities around the world, and artists who create small-scale pieces constantly experiment with upsizing their work, this book can never hope to provide a complete record or exhaustive compendium of the graffiti and street art mural movement. Instead, it focuses on the work of a small selection of artists who made their names working at a very large scale and who paved the way for many of their followers today, or whose work is otherwise outstanding in terms of technique, style, concept or scale. The book explores their methods of working, preferred technique, biggest challenges and largest works to date. For anyone who wants to see some of the works in person, a map at the end shows where a selection of the best XXL murals can be found worldwide.

THIS PAGE: SatOne, *Lungful*, Warsaw, 2011.
OPPOSITE: HENSE, Madison Theater Building, Detroit, MI, USA, 2014.

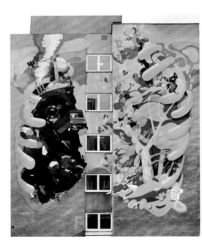

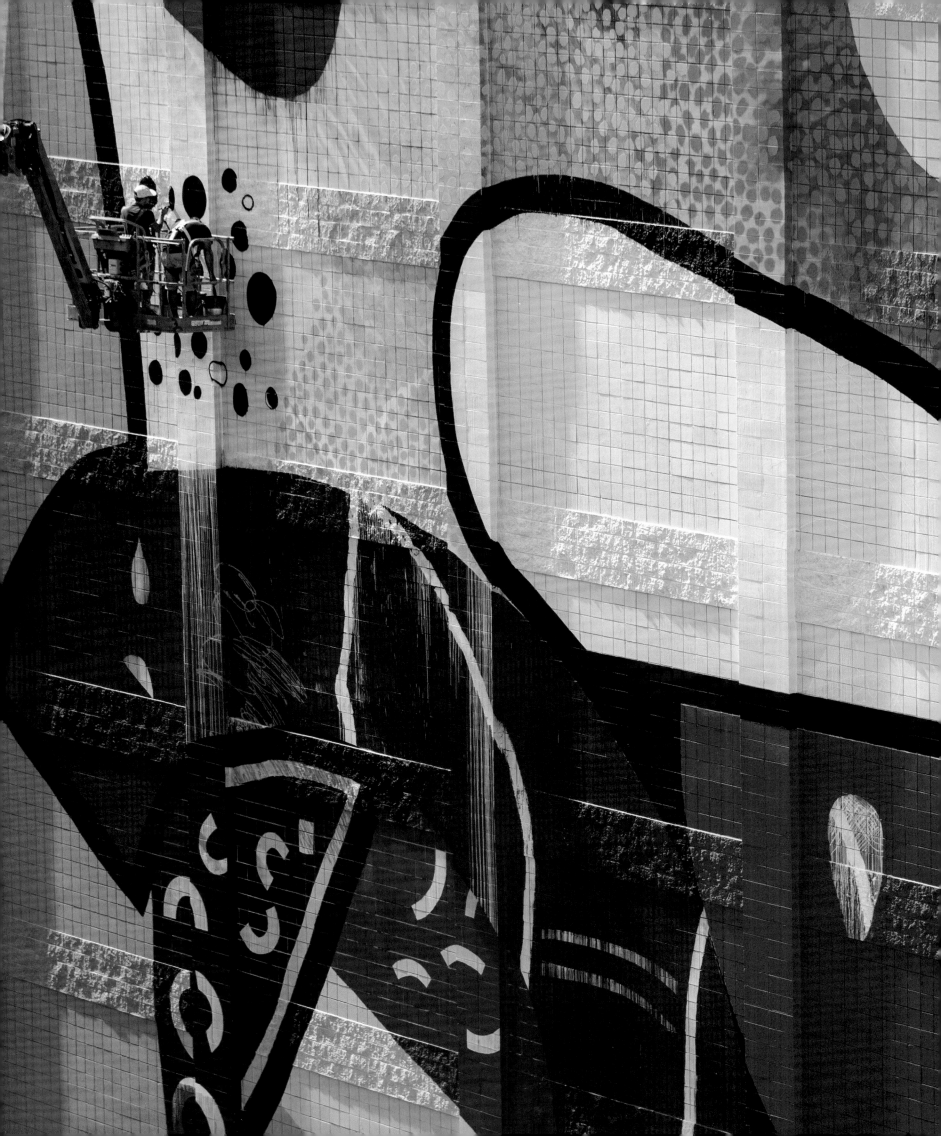

Aryz

Aryz is a young mural artist from Barcelona. He grew up in a small village outside the city, but also spent parts of his childhood in the USA. His earliest pieces were classic graffiti and spray-can work, but it is his large pieces that have brought him widespread recognition and invitations to paint buildings around the world.

Aryz began painting surfaces in derelict factories in Spain in 2007 because he was fascinated by their large size and textures. To reach as high as possible he had to be inventive with his tools, using 6-metre (20-foot) extendable poles, paint rollers and ladders. His signature colour palette of dirty, faded-looking colours also developed during this period because he had to use old, expired household paint, intended to be thrown away, to cover the large walls. Later, when he was invited to paint large walls at festivals, he experimented with flashy colours, but found that subdued tones were better suited to urban surroundings because they were less aggressive.

Although viewers often try to find messages, symbolism or underlying themes in his detailed and varied work, Aryz says he simply paints for the sake of fun, and for the pleasure he takes in working out a composition to fit a particular wall. His pieces feature funny creatures, people, skeletons, animals or natural elements such as leaves and flowers.

Aryz never completely fills up a wall with paint, but always makes use of its underlying texture. All his pieces are site-specific and are designed for the wall's particular shape and location. He still uses spray cans for his smaller works, but in his larger pieces he relies mainly on brushes, rollers and emulsion, even for fine details.

Often organizers of mural festivals underestimate the logistics of painting a large-scale piece. Aryz has had to contend with obstacles ranging from paint supplies that run out or arrive late to old cherry pickers that get stuck or don't reach high enough. This means that he always has to be ready to improvise under time pressure, knowing that people will see only what he has painted instead of the process it took to achieve the result: 'People don't know about the problems and they expect the best from you.'

ABOVE: Łódz, Poland, 2012. OPPOSITE: Cologne, Germany, 2013. OVERLEAF: Rennes, France, 2013. SECOND OVERLEAF: Oslo, 2013 (left); San Francisco, 2013 (right).

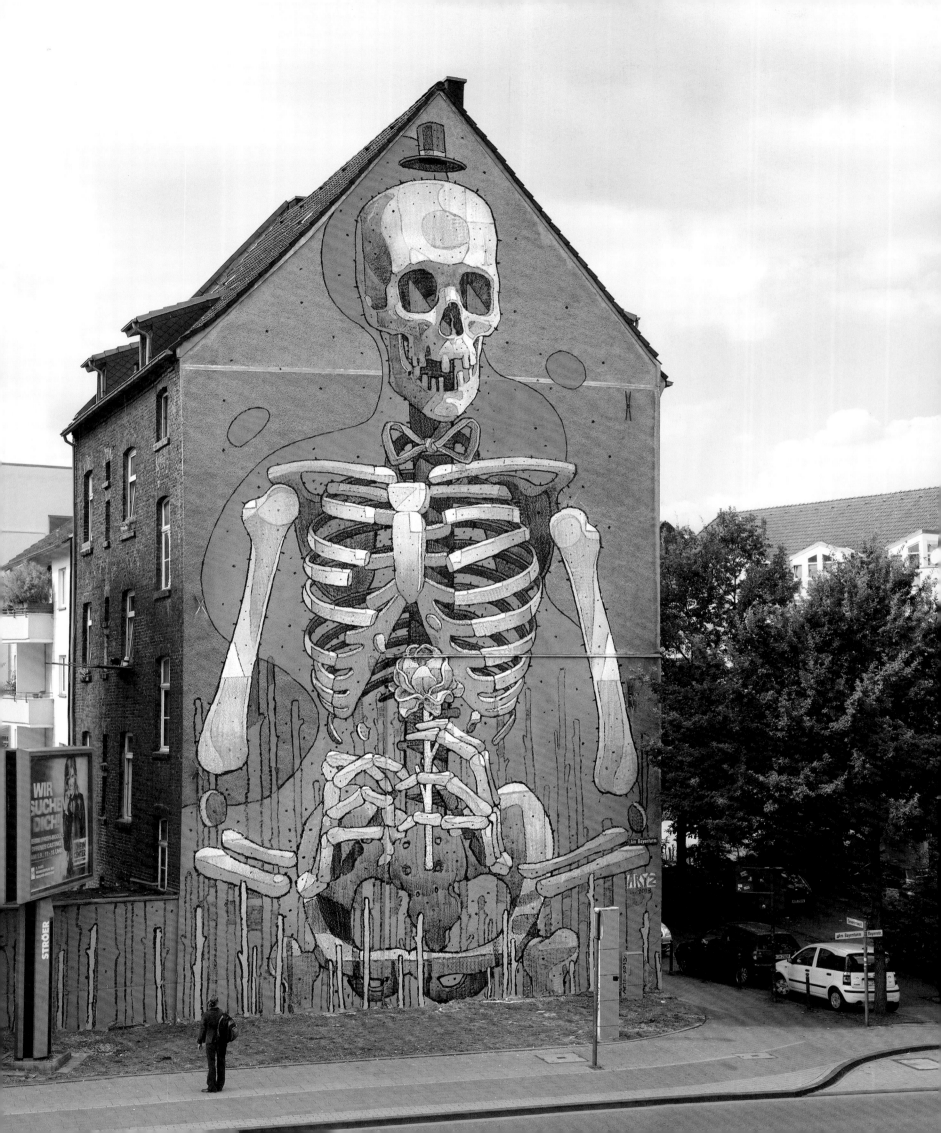

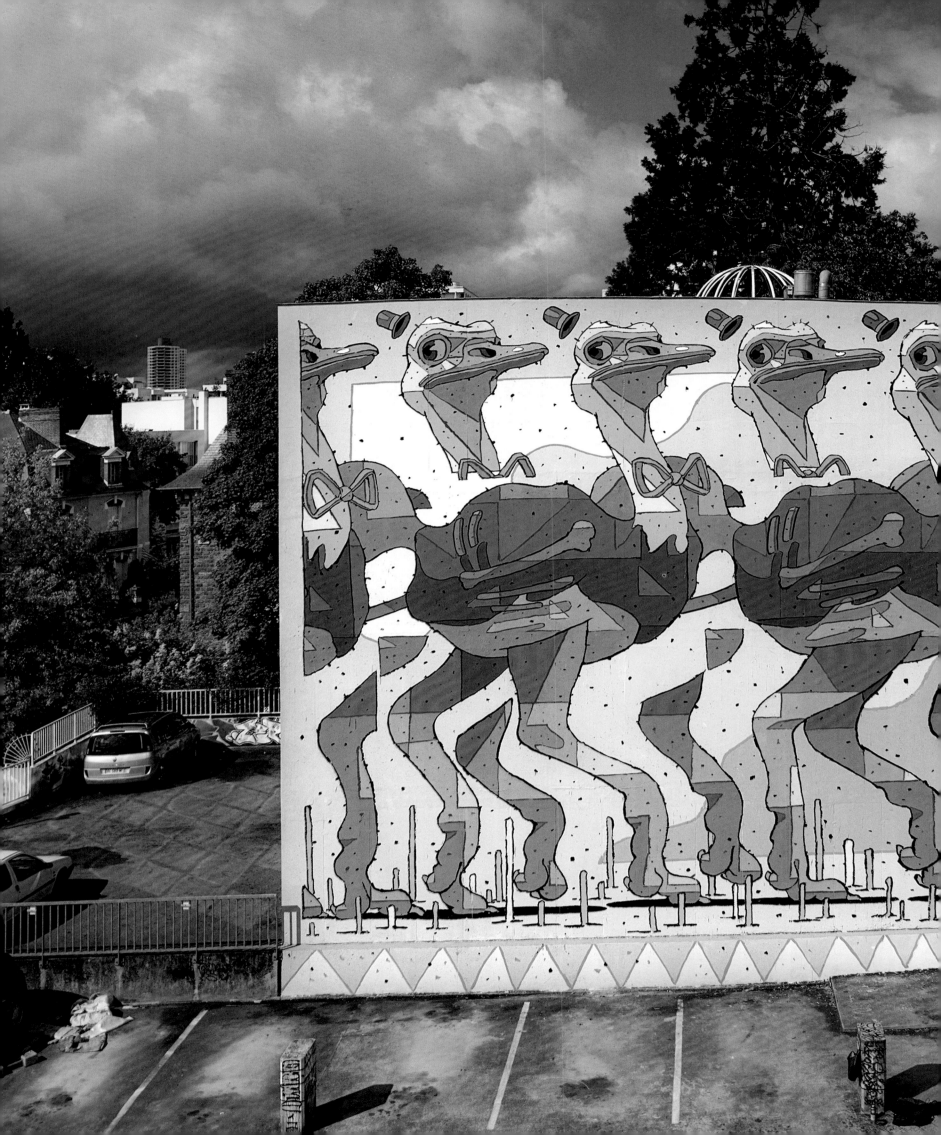

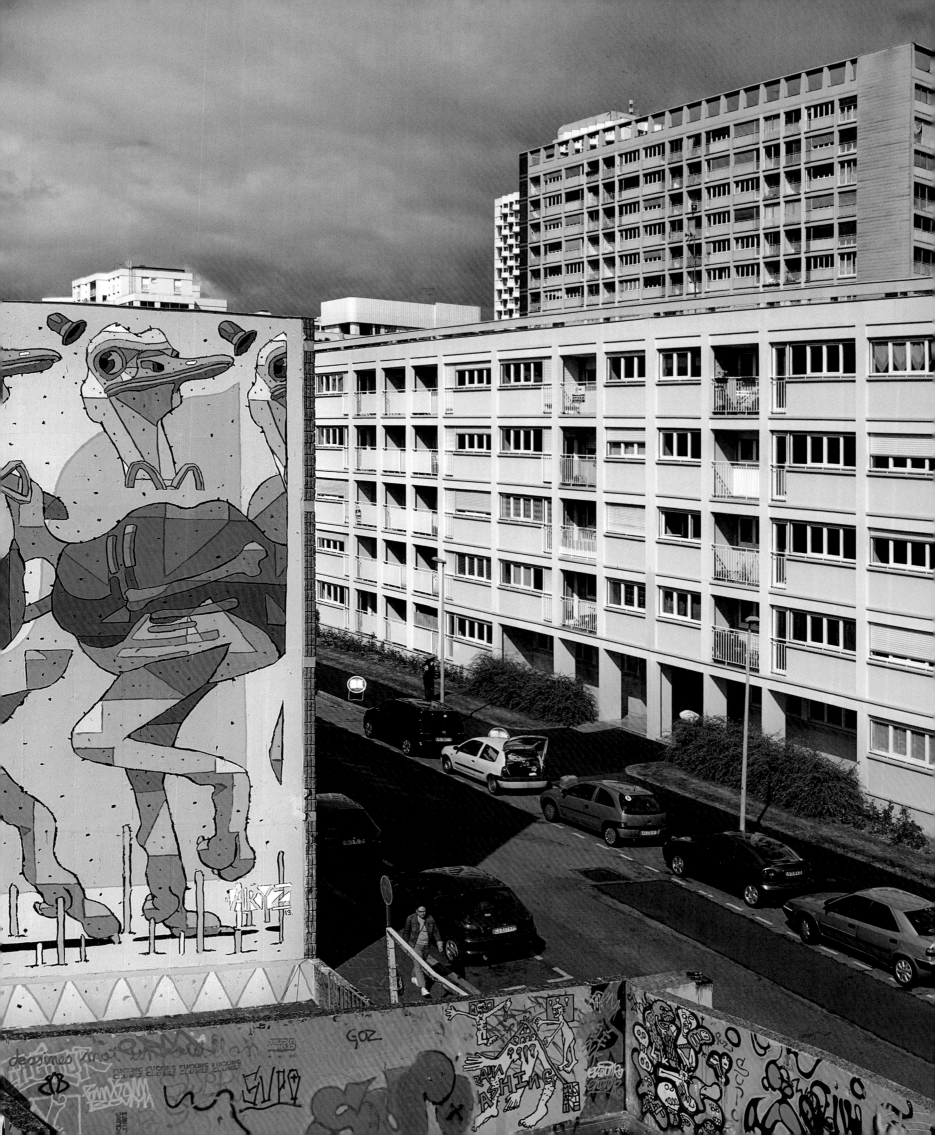

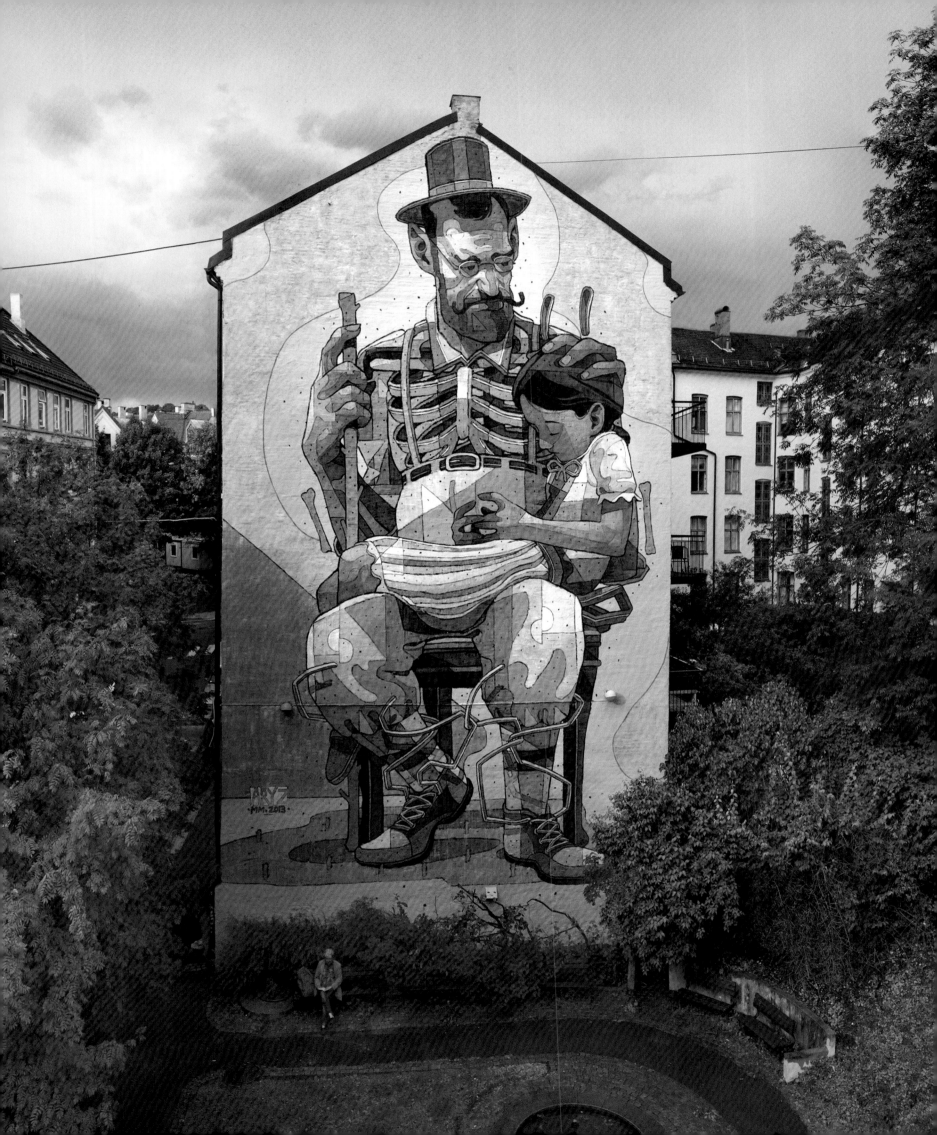

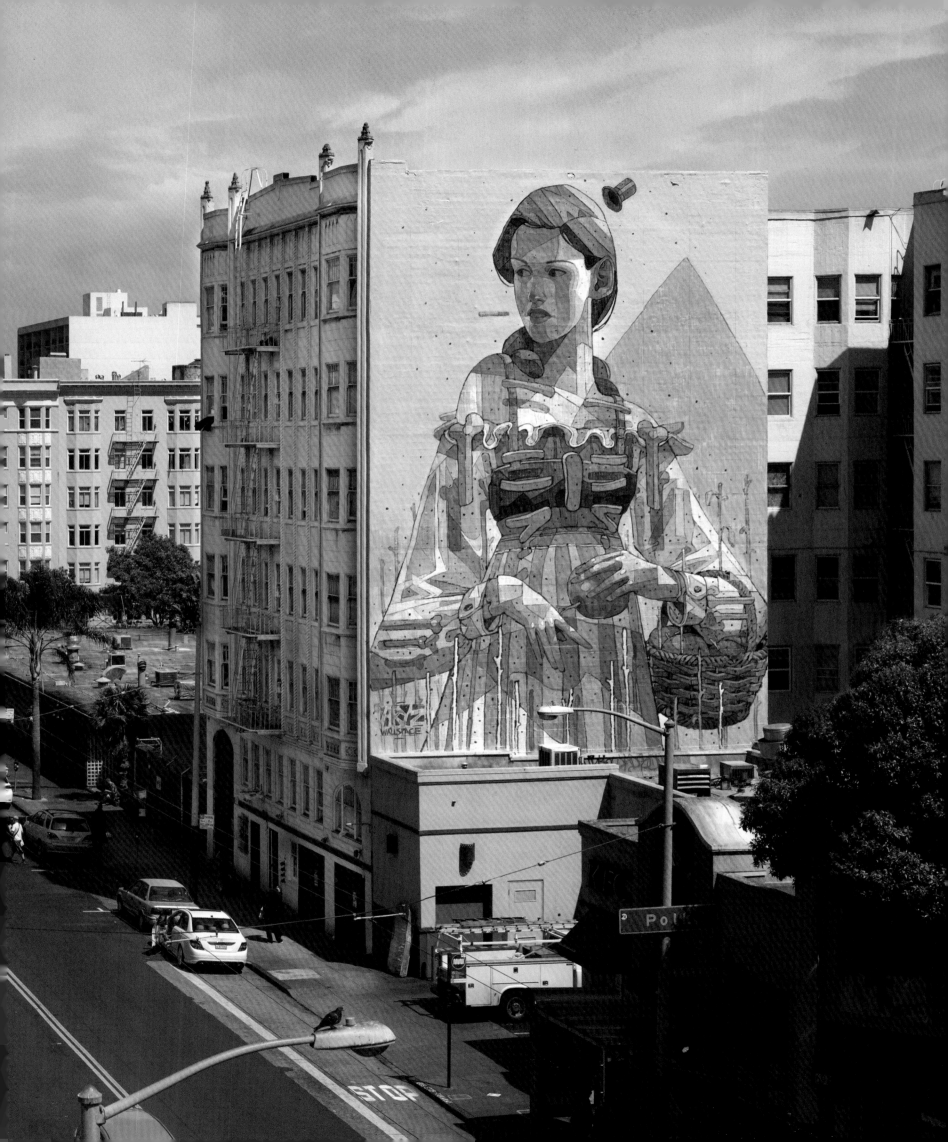

C215 painted the first of his large murals at the Moscow International Biennale for Young Art in 2010. His largest wall to date is in Paris. It depicts a 25-metre (82-foot) cat on a blue background, and was finished within only two days in the spring of 2013.

C215's work most prominently features portraits of his daughter, as well as of homeless people, the elderly and his friends. His recent work also incorporates animals. Extensive use of colour, uncommon for a stencil artist, is part of his characteristic style, in combination with energetic freestyle backgrounds made up of lines and shapes.

When C215 goes big, however, he abandons his stencils, instead selecting one of his designs and working his way along the wall freehand with the help of a grid: 'In large murals I like the challenge of doing something I am not controlling that much compared to stencils.' If the wall isn't too big, he occasionally uses a projector. For very large works, he combines rollers and emulsion with spray paint. For him the hardest part in this process is keeping his style recognizable despite the difference in painting technique. He sees his main motivation for painting on a large scale as 'experiencing new things that I am not mastering. What's important in the end is to push your own limits.'

ABOVE AND OPPOSITE: Ivry-sur-Seine, France, 2013. **OVERLEAF:** Paris, 2013 (left); Tudela, Spain, 2011 (above centre); Bristol, UK, 2013 (above right); Vitry-sur-Seine, France, 2012 (below right).

Parisian street artist Christian Guémy, better known as C215, is widely recognized for his complex, multi-coloured stencil work. He first went out tagging at the age of fifteen, but stopped only four years later. More than a decade passed before his return to the streets. In 2005, as a gift for his newborn daughter Nina, the new father published a book of poetry illustrated by his urban artist friends, who signed their pages with their street names. Inspired by the work in the book, he returned to the streets under the new moniker C215 and in 2006 his first stencils appeared in and around Paris.

C215

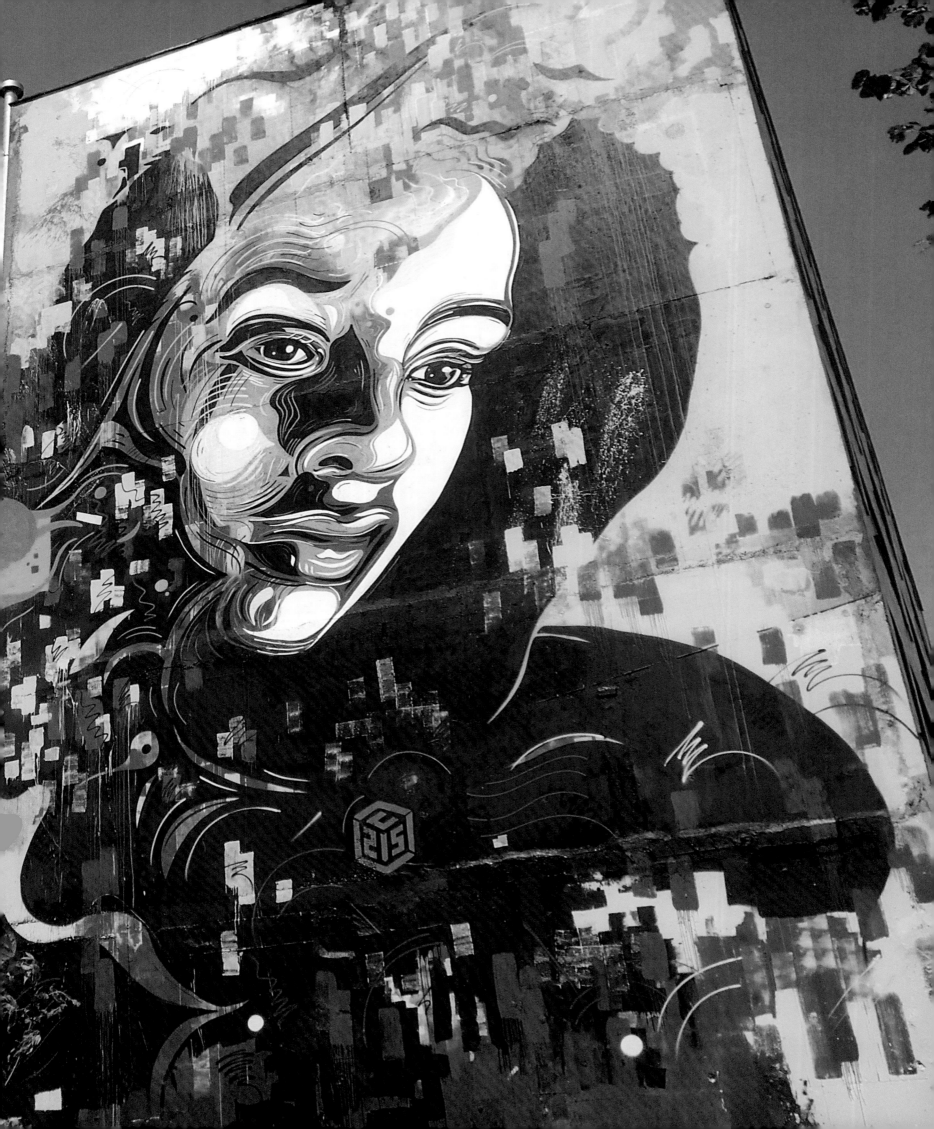

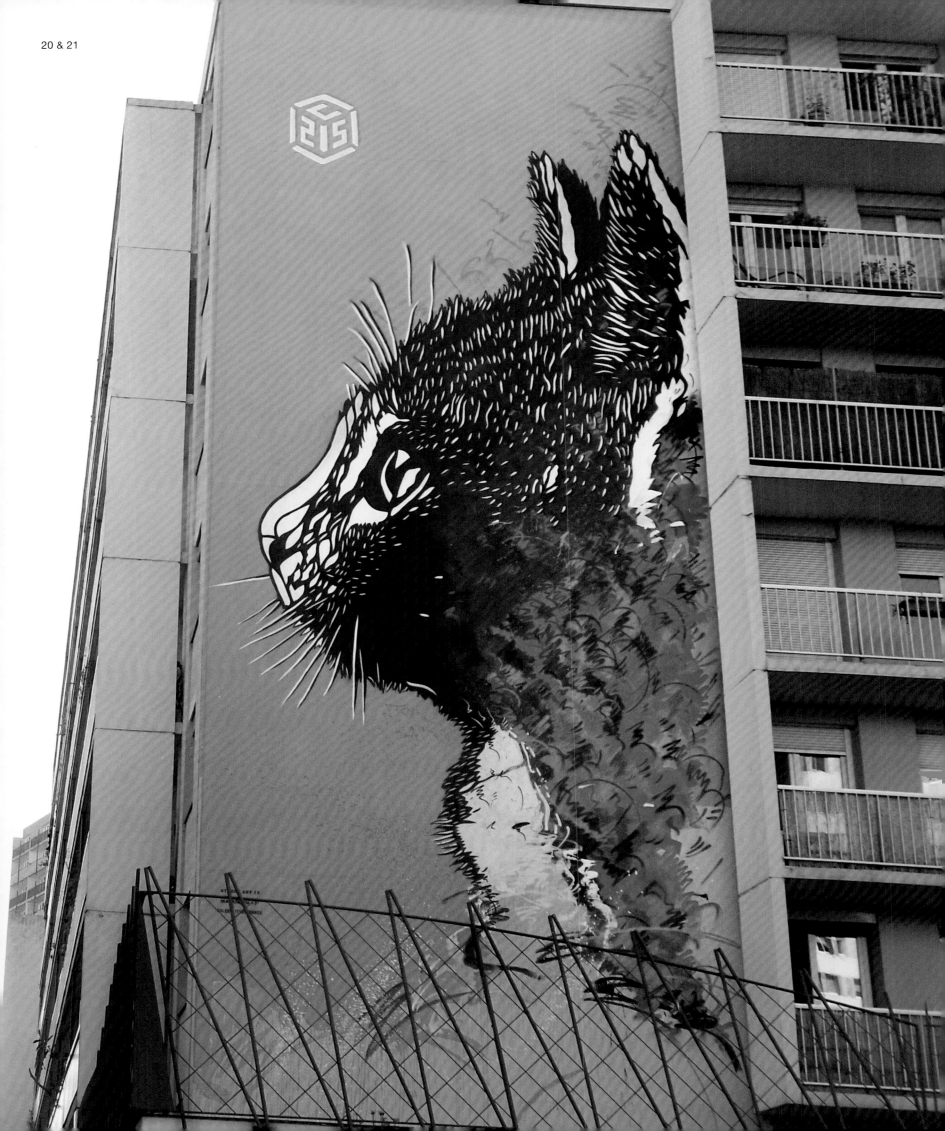

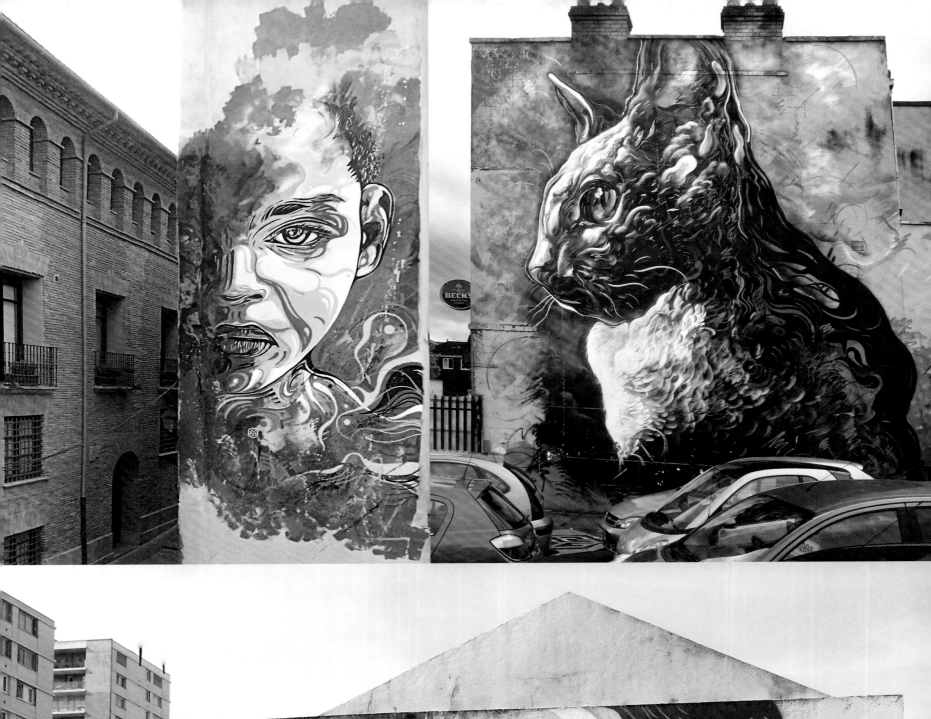
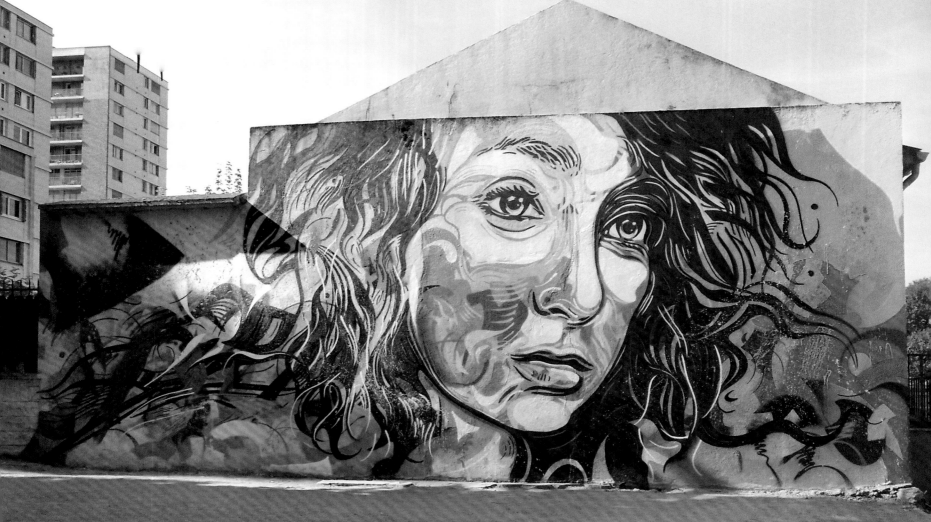

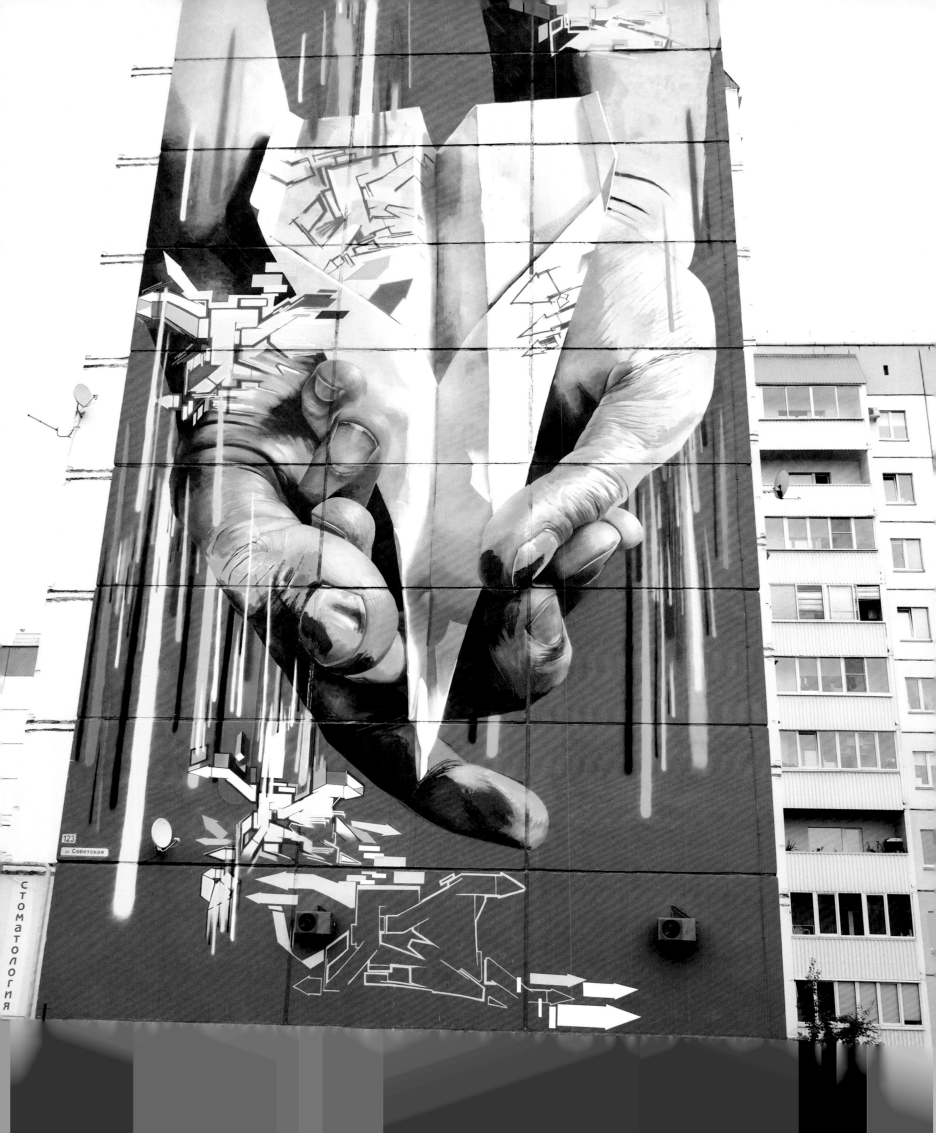

Andreas von Chrzanowski, better known as Case, lives and works in Frankfurt, Germany. He was born and raised in a small town in East Germany, where he spray-painted his first wall in 1995. In 2000, Case and his fellow artists Tasso, Akut and Rusk founded the MA'CLAIM Crew, which became known for its photorealistic works done solely with spray paint, starting a new movement towards photorealistic graffiti both in Germany and internationally. Case soon made a name for himself with his detailed, precisely executed photorealistic portraits and images of parts of the human body. In particular, his murals of overlapping, gesturing hands in radiant colours have brought him international recognition in the mural art world and beyond. He painted his biggest piece yet with German graffiti artist WOW123 in Magnitogorsk,

Russia, in 2013. The ten-story building took them six days to finish, involving the help of the local fire department and their fire engine's extendable ladder.

Colour is central to Case's artistic approach. 'Since I can remember I have been interested in colours and how they mix. To mix two totally different colours to create a certain new shade is fascinating to me time and again. It is like cooking by following a certain recipe.'

Case feels that the greatest challenge in painting a large mural is in transferring the small photo or sketch to the large surface. He doesn't use a projector or a grid for this, but instead looks for the imperfections in the wall and uses them as his guides. If there are no imperfections to be found, he deliberately adds his own marks to the wall. He then superimposes his initial design over a photograph of the wall, prints out the

Case

composite image with the marks visible, and goes straight to work. 'I carry my computer and printer with me at all times. Guidance with the help of certain spots in a wall is the easiest way to work because every wall is different, like a fingerprint.'

Case is excited by the powerful effect that large walls have on people: 'Mankind is awestruck by everything that is massively big. It always reminds us how small we actually are.'

ABOVE AND OPPOSITE: Magnitogorsk, Russia, 2013. OVERLEAF: Rochester, NY, USA (above left); Cairo, Egypt, 2012 (below left and above right); Erfurt, Germany, 2013 (below centre); New York City, 2013 (below right). SECOND OVERLEAF: PowWow Festival, Honolulu, HI, 2015 (left); in memory of Tugçe Albayrak, Miami, 2014 (above right); The Trait of Life, Portsmouth, NH, USA, 2011 (below right).

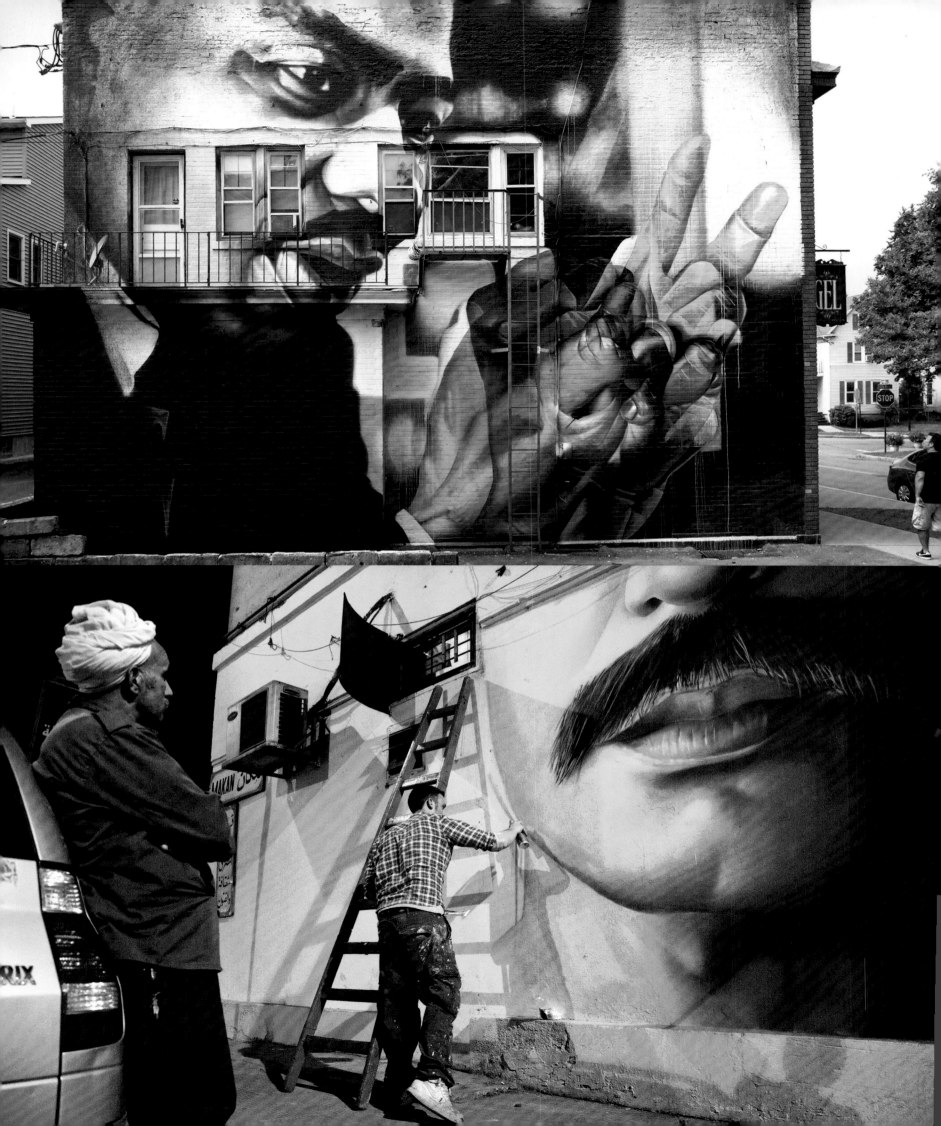

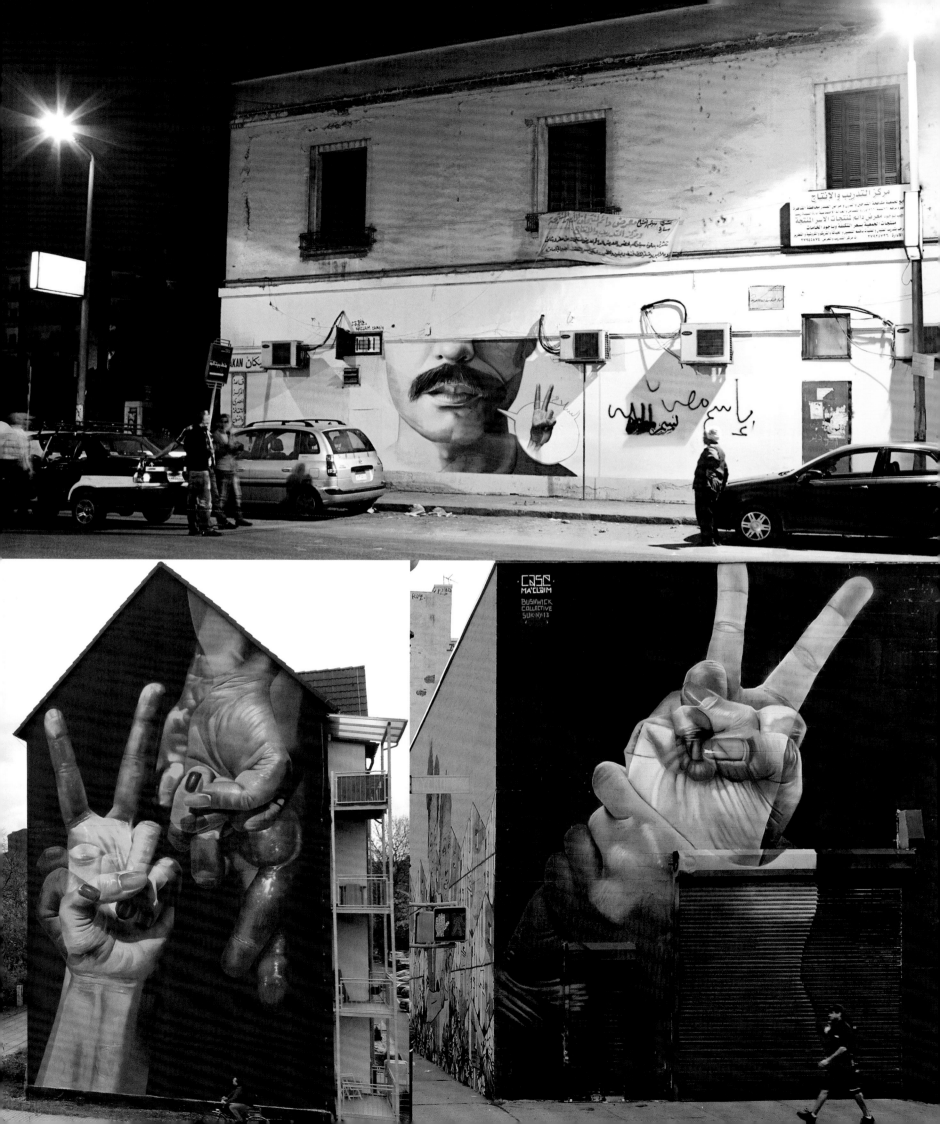

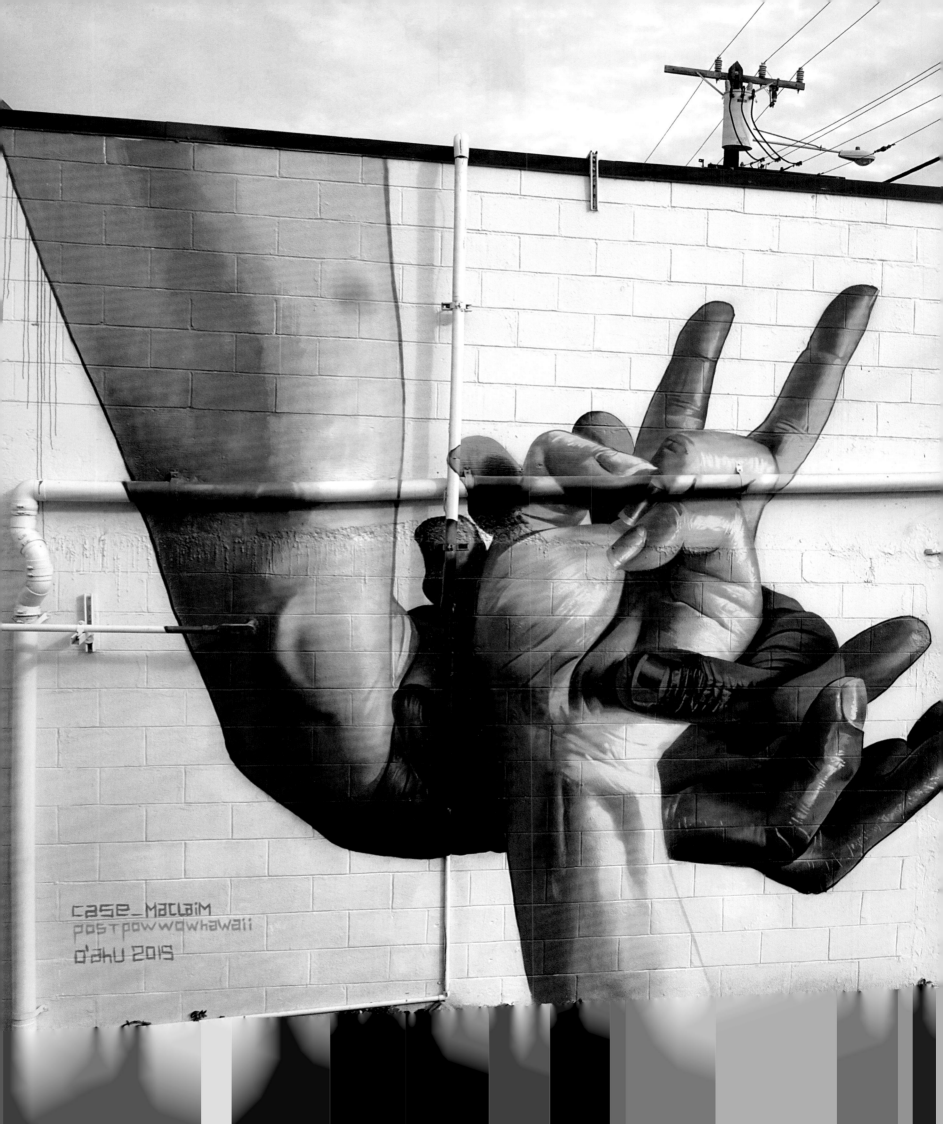

case_maclaiM
postpowwowhawaii
o'ahu 2015

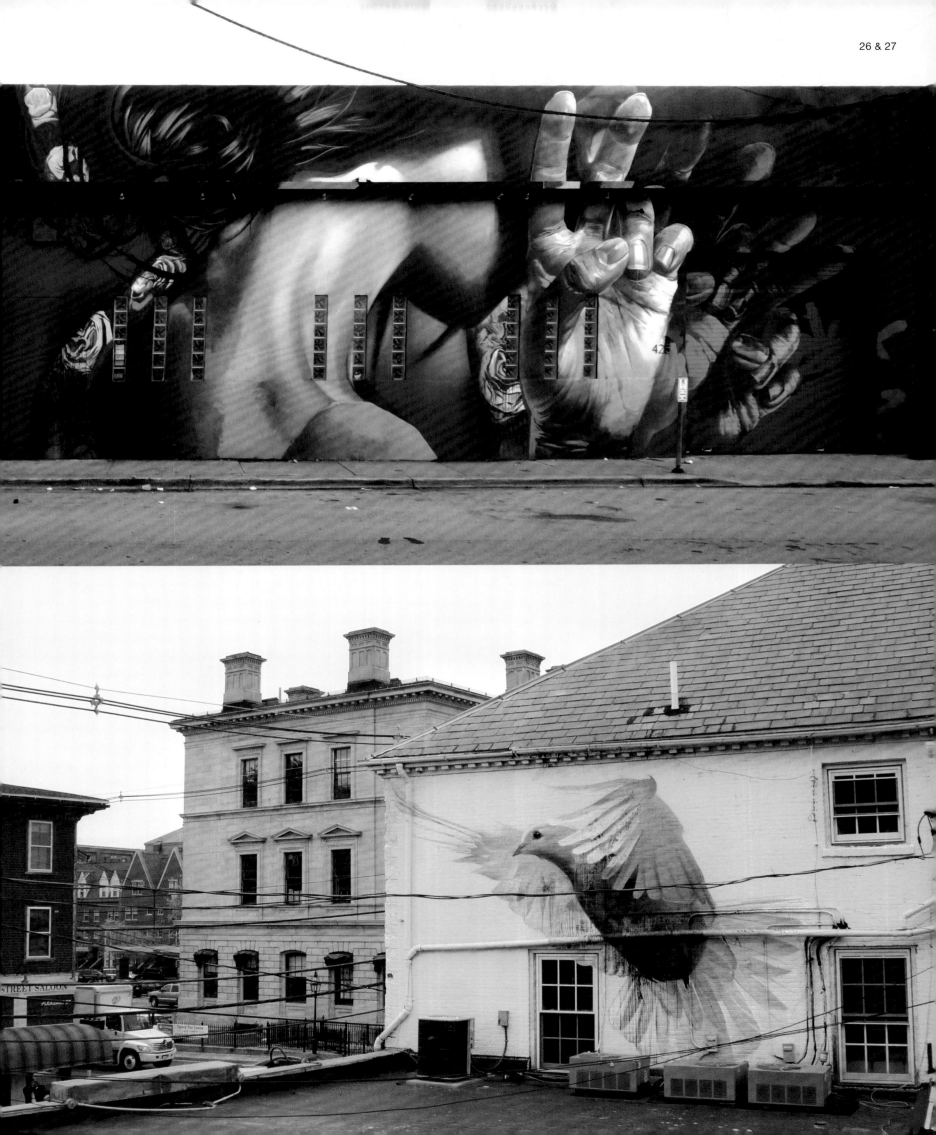

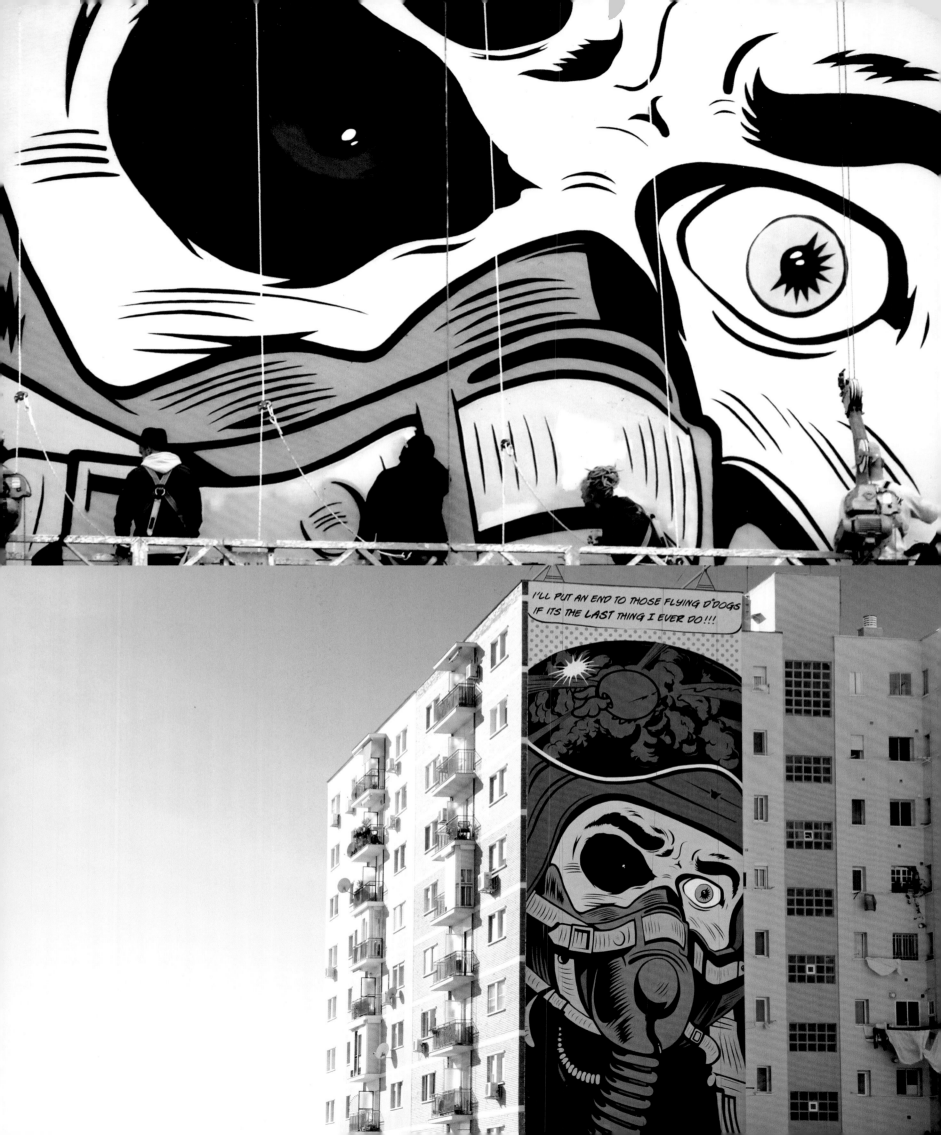

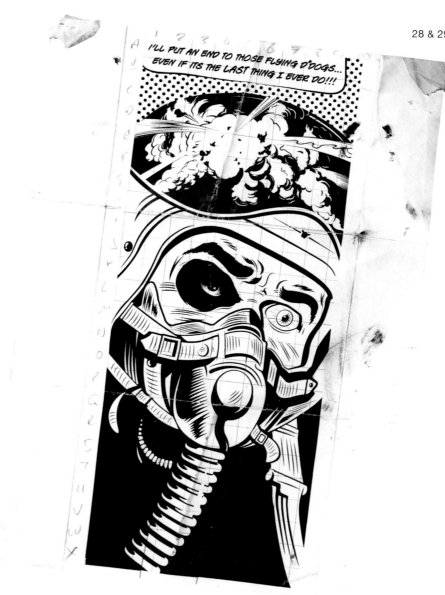

OPPOSITE AND ABOVE:
Malaga, Spain, 2013.
OVERLEAF: Brooklyn,
NY, 2012. **SECOND**
OVERLEAF: Los Angeles,
2011 (above left);
London, 2013 (below
left); San Juan, Puerto
Rico, 2013 (right).

D*Face

British artist Dean Stockton, aka D*Face, has been active on the streets for more than fifteen years. As a child he drew cartoons, later moving on to graffiti and painting band logos on jackets. From the very beginning he was fascinated with American pop culture and the idea of the American Dream, but when he grew older and finally had a chance to travel to the States, he saw their flaws and failings, and started to address this duality in his artistic work. 'I'm inspired by popular culture, centring around the ideals of the American Dream and the notion of "good" triumphing over "evil". What is good; what is evil? The perception of both and our increasingly bizarre fascination with celebrity, fame and consumerism are central topics in my work. As such I draw inspiration from what surrounds us and the refuse of our consumption, from advertising, comics, cartoons, motifs and cultural icons. All these are reworked and recrafted,' says D*Face. One element that appears in a lot of his work are the little wings he often attaches to his characters. He first introduced them in stickers of his signature balloon dogs.

D*Face's largest mural to date was painted with two assistants in Malaga, Spain in 2013, and is 37 metres (120 feet) high. For his large pieces, he works with both rollers and spray paint, and likes to combine a matt fill colour with a gloss black outline in 'enamel lead-based paint. The glossiness of the black is second to none.' Even though he paints very large, he isn't too fond of cherry pickers and prefers to work from a swing stage instead. 'I'm not a fan of the "sea legs" you get on a cherry picker, and whilst my head tells me they're safe, I have an underlying feeling that somehow the geometry and science is wrong.'

Before he begins to paint one of his large, cartoon-like murals, D*Face first takes a look at the wall and chooses a piece from his smaller drawings that fits its shape and immediate context. 'It's important to have a dialogue with the surroundings: buildings, location and the public. Whether it's obvious at first glance or not, there's always an underlying message,' he says. 'You know how people say that concrete or brick has no soul: when you've spent seven days face-to-face with a wall, you realize each wall has its own personality and nuances.'

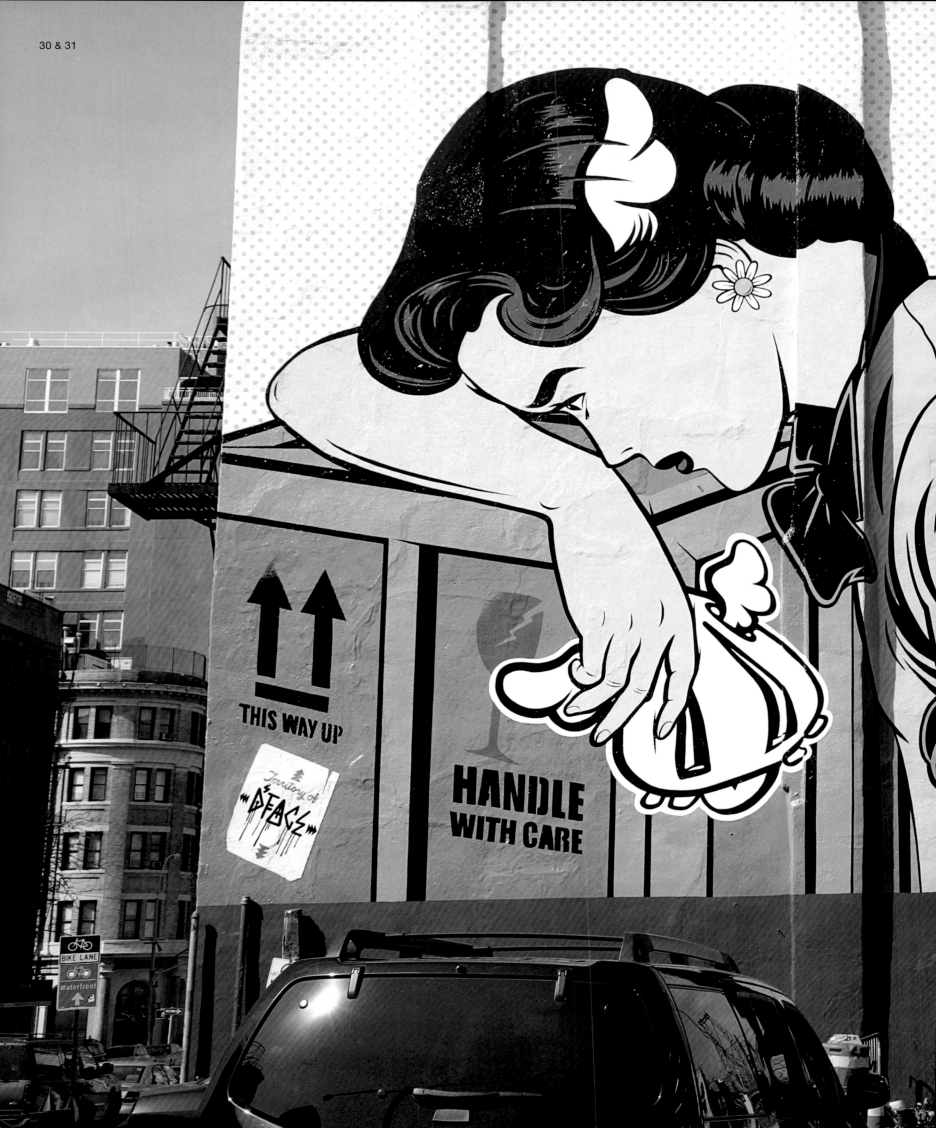

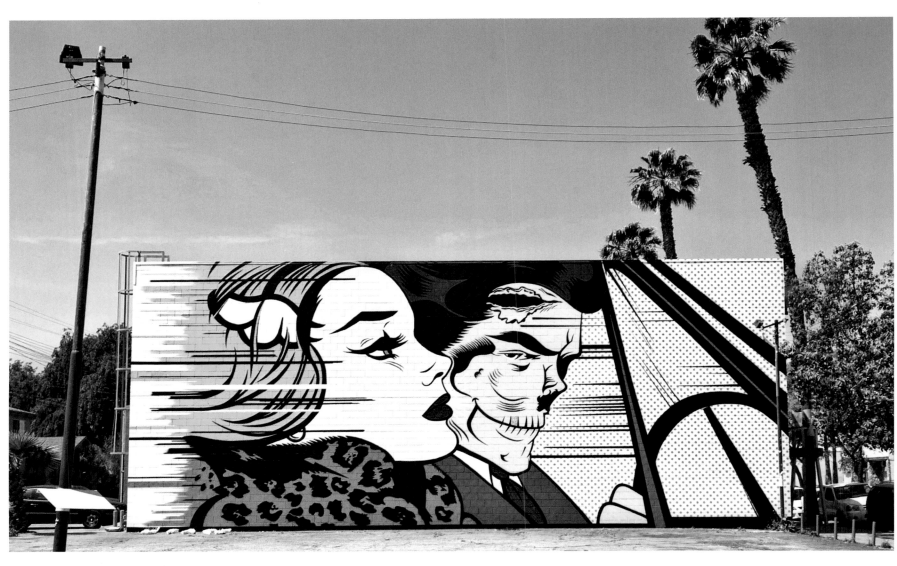

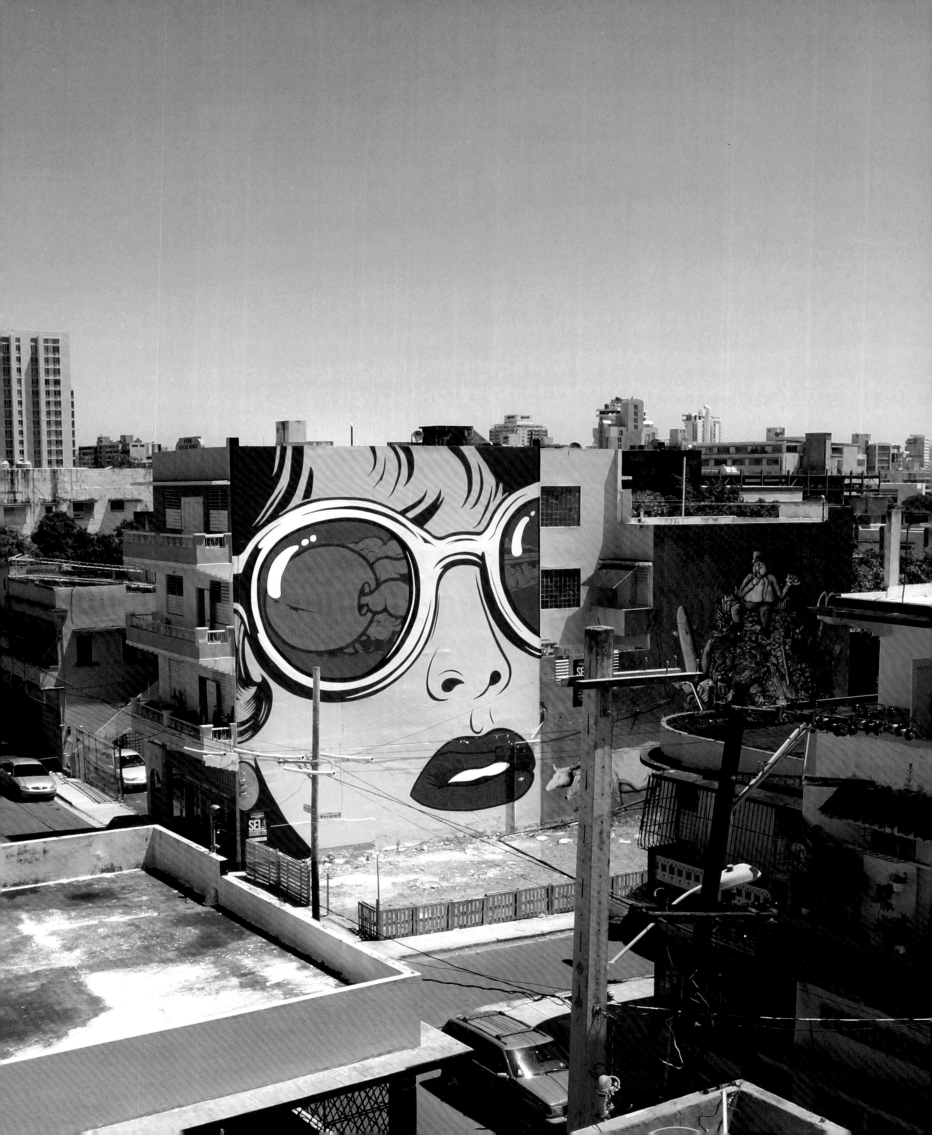

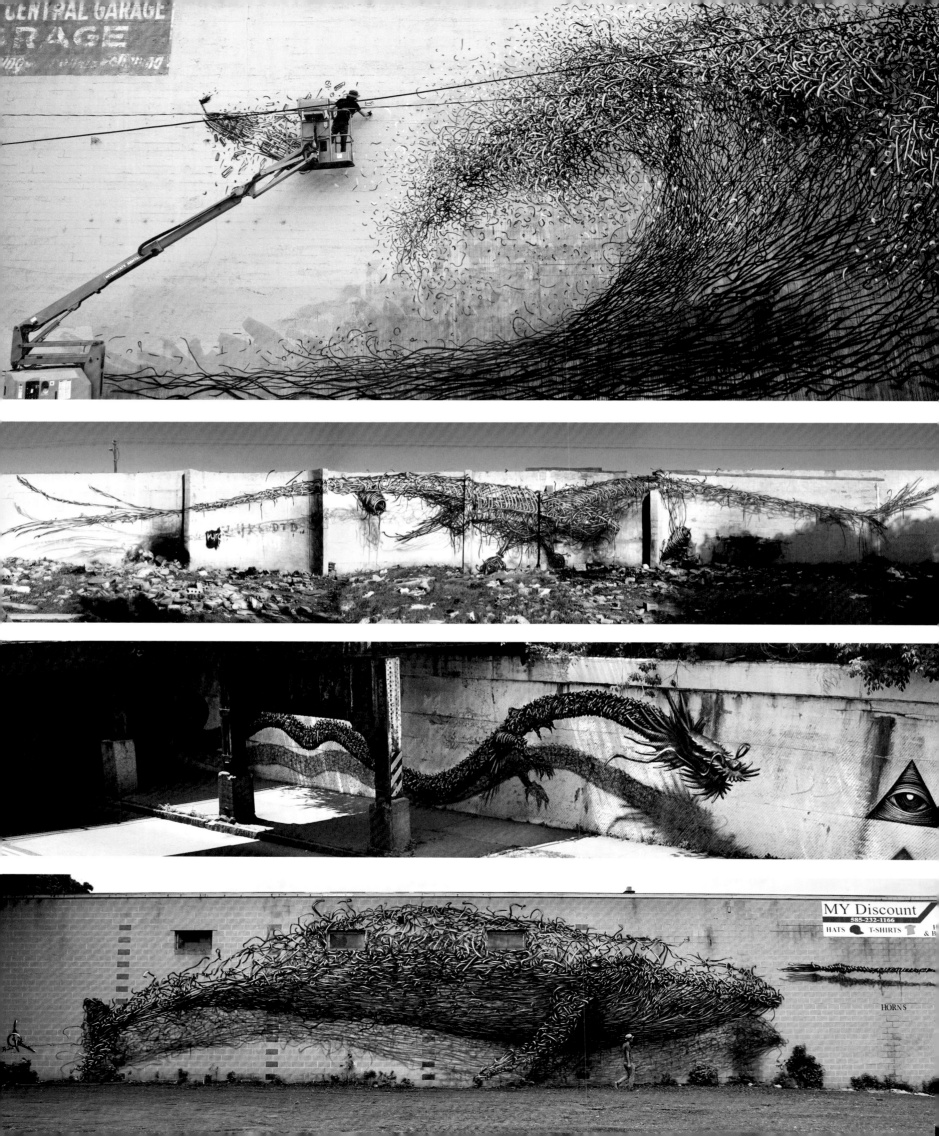

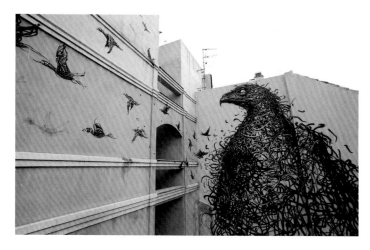

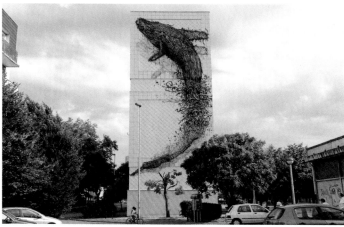

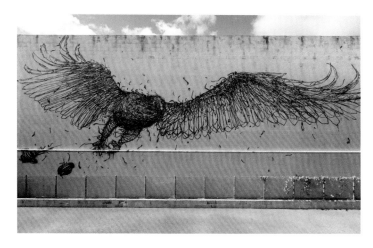

DALeast

DALeast is from China, and prefers to remain a mystery while painting his murals around the globe.

ABOVE, FROM TOP: *Abiding in the Broken Heart*, Malaga, Spain, 2013; *C*, Melun, France, 2012; *Abcission*, Honolulu, HI, USA, 2013.
OPPOSITE, FROM TOP: *Persistent Parabola*, Portland, OR, USA, 2014; *Milestone*, Cape Town, 2012; *Imperial Blind*, Rochester, NY, USA, 2011; *Discount Evolution*, Rochester, NY, USA, 2012.

OVERLEAF: *Defoliation*, Dunedin, New Zealand, 2014.
SECOND OVERLEAF: *Gaia-D*, Łódz, Poland, 2014 (above and below left); *DKR*, New York City, 2014 (right).

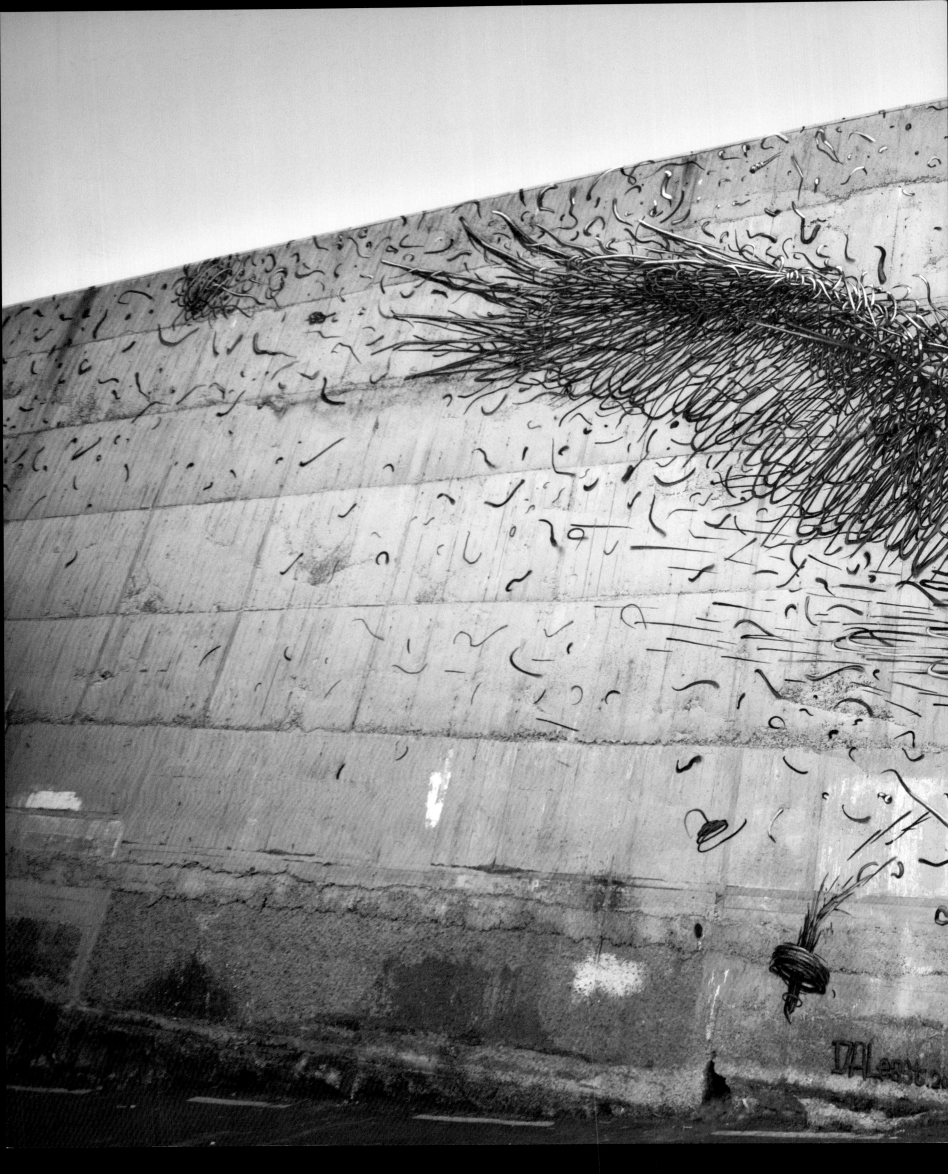

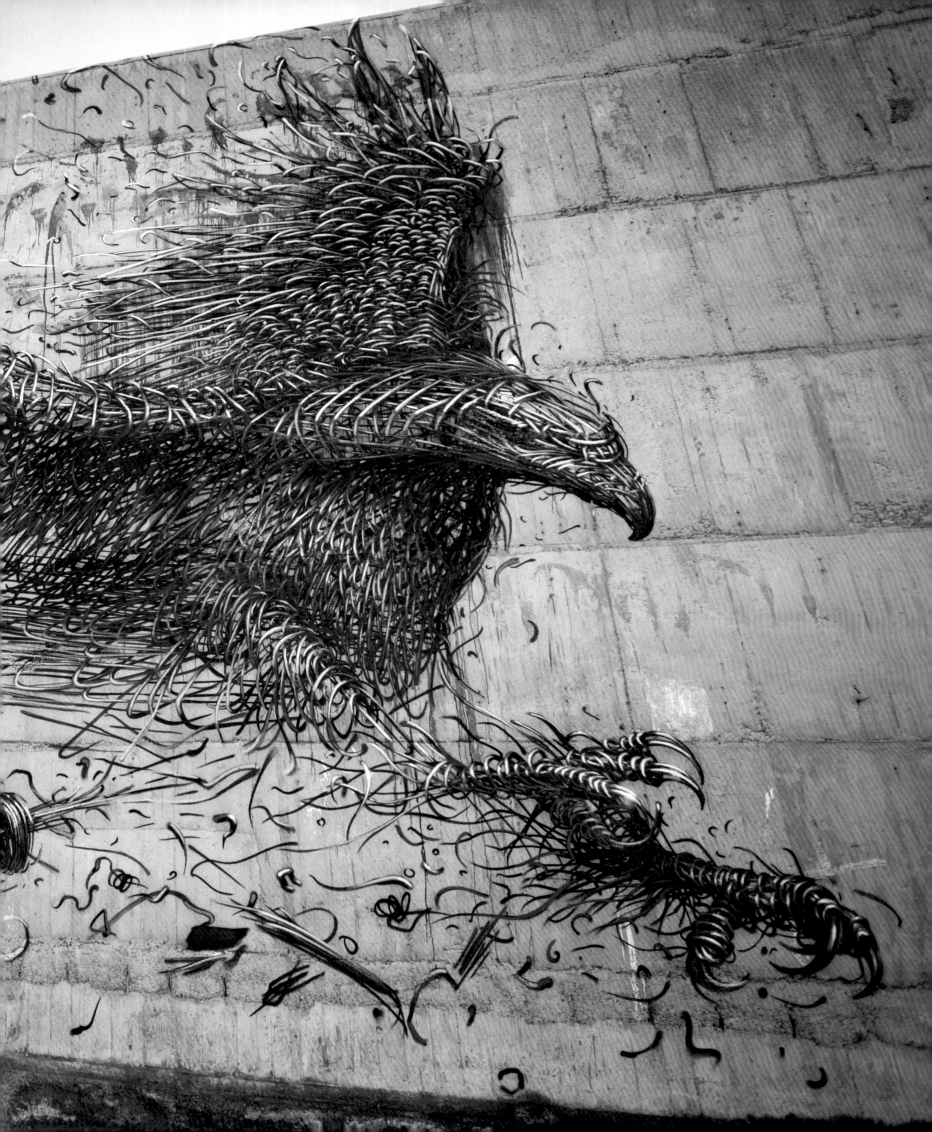

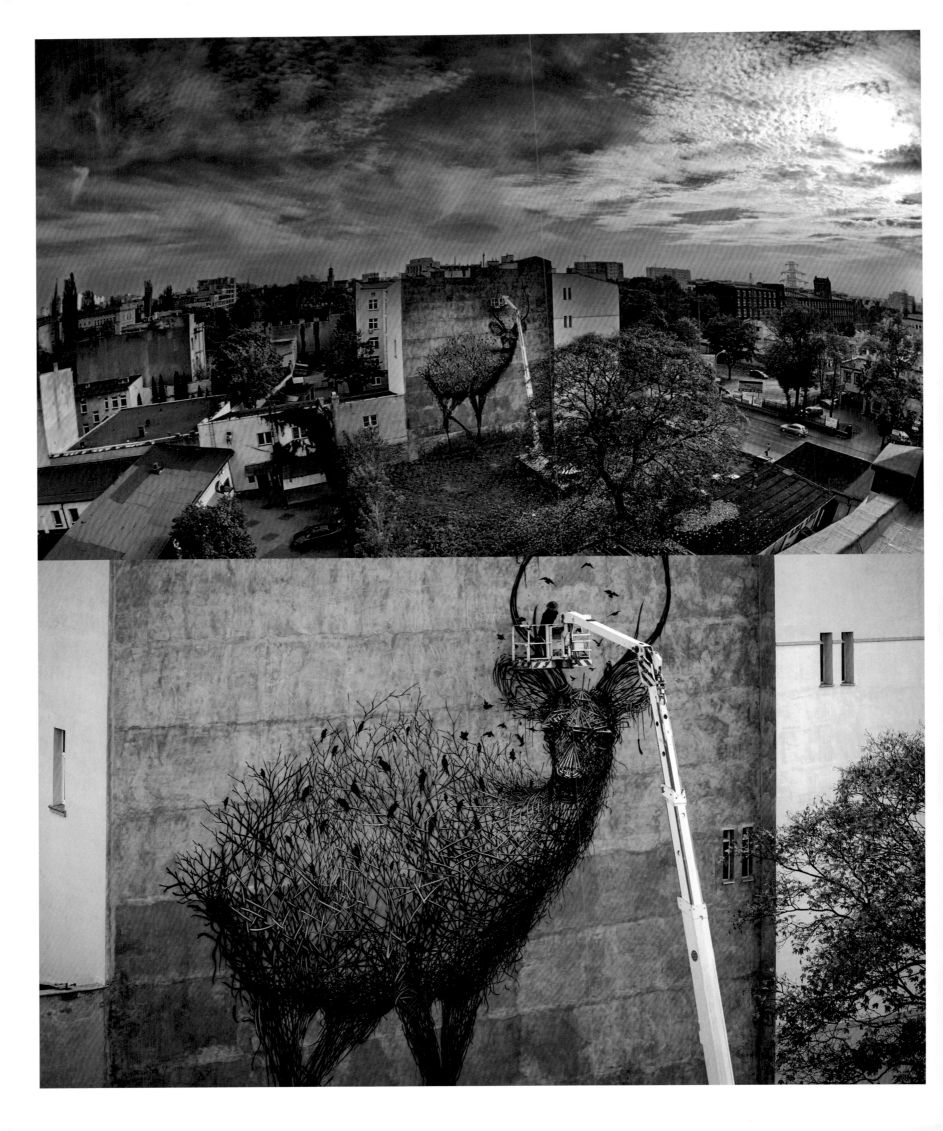

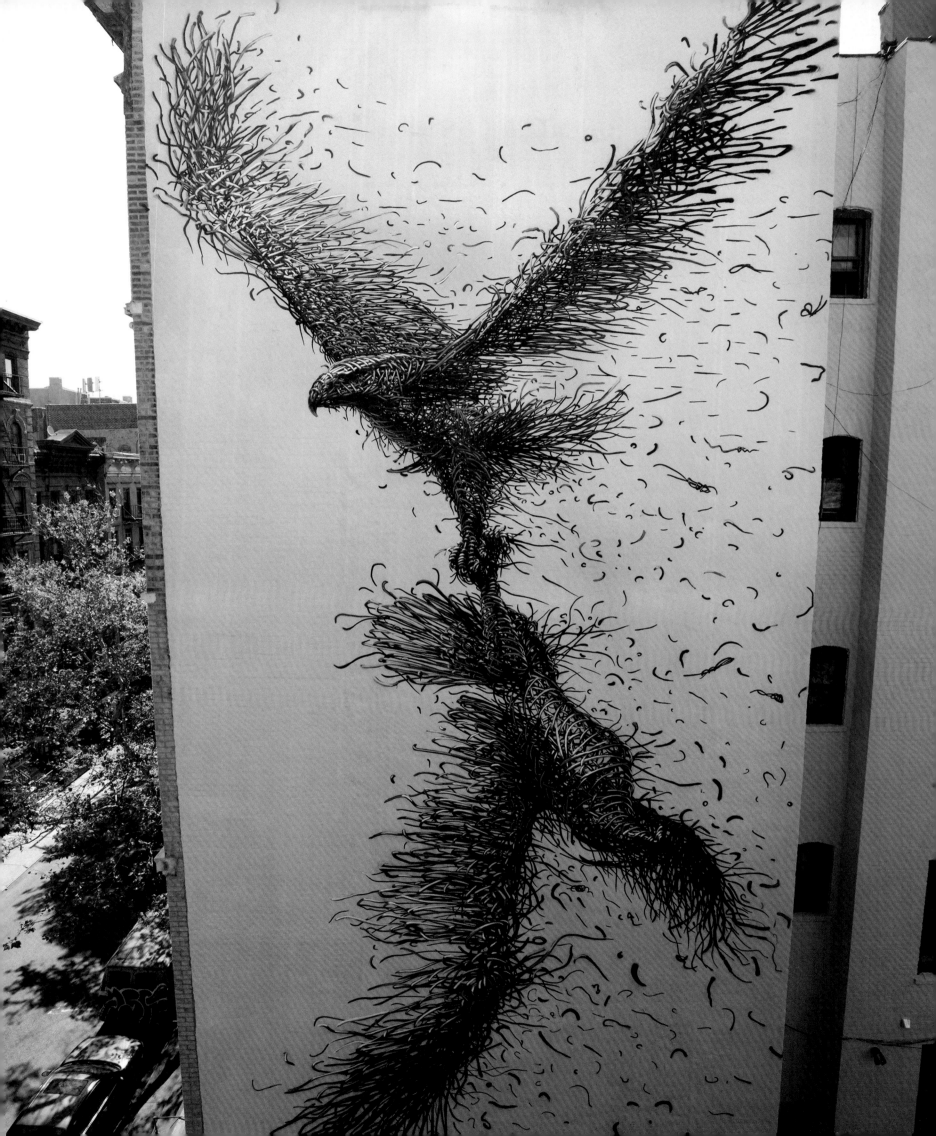

ecb

BELOW: New Delhi, 2014. **OPPOSITE:** *Starting Dreams*, New York City, 2013. **OVERLEAF:** portrait of a Swedish sailor, Borås, Sweden, 2014 (left); Heerlen, the Netherlands, 2014 (right). **SECOND OVERLEAF:** Baltimore, MD, USA, 2014 (above left); Ferropolis, Germany, 2014 (below left); portrait of a Siberian man for an exhibition on the commonalities between Russian and American peoples, Halle, Germany, 2013 (right).

German artist Hendrik Beikirch is known on the streets as ecb, a tag made up of letters from his name without any particular meaning. He started out writing classic graffiti letters back in 1989, but is now famous for his massive black-and-white portraits, mostly of elderly men. He painted his first large piece in 1996 and currently creates around twenty XXL walls every year. His distinctive visual language has developed over time, drawing on both his art school education and his intensive study of the faces of ordinary people. Alongside the highly polished and artificially youthful faces on advertising posters and in the media, ecb's faces stand out, radiating melancholy and conveying the depths of the subject's soul.

The large size and carefully thought-out placement of ecb's murals also capture the pedestrian's attention. His tallest mural, 72 metres (236 feet) high, is a portrait of a fisherman painted in 2012 on the side of the local fishermen's market in Suyeong-gu, Busan, South Korea (pp. 2–3). In another massive project, he painted a series of portraits of miners in Ferropolis, a former open-cast mine in Germany (second overleaf, below left) in 2014. The portraits, which are arranged over multiple sides of the buildings, bring a new dimension to ecb's work in showing a group of people rather than just a single face. In Baltimore, MD, USA, a giant portrait of the father of a local businessman (second overleaf, above left), one of the founding residents of Baltimore's Korean neighbourhood, serves as a spotlight to draw attention to this little-known community.

ecb holds many records when it comes to large-scale murals. He painted the tallest mural in India, a portrait of Gandhi that was unveiled in New Delhi on the anniversary of his death (below), and, in Heerlen, the Netherlands, the tallest mural in Benelux, a portrait of a deckhand that pays homage to the city's hardworking blue-collar workers (overleaf, right). The size of his pieces has an artistic importance that goes beyond mere record-setting, however. 'I think one should use open spaces to their limits. For me this is manifested in the size and height of a piece. All my images are therefore full frame, no matter how high the wall may be.' The limited colour scheme helps him to cover such large surfaces in a reasonable amount of time. He usually sketches freehand with a spray can, standing on a mechanical lift, and hardly ever uses a grid. He works his way along the wall with rollers, emulsion and spray paint, starting with the darkest shades and going lighter step by step. At the very end he often adds a short text in his signature typography.

In planning his work, ecb always tries to pay attention to the tension between his pieces and their surroundings, such as architecture or advertising hoardings. He doesn't just want to paint random faces in random places.

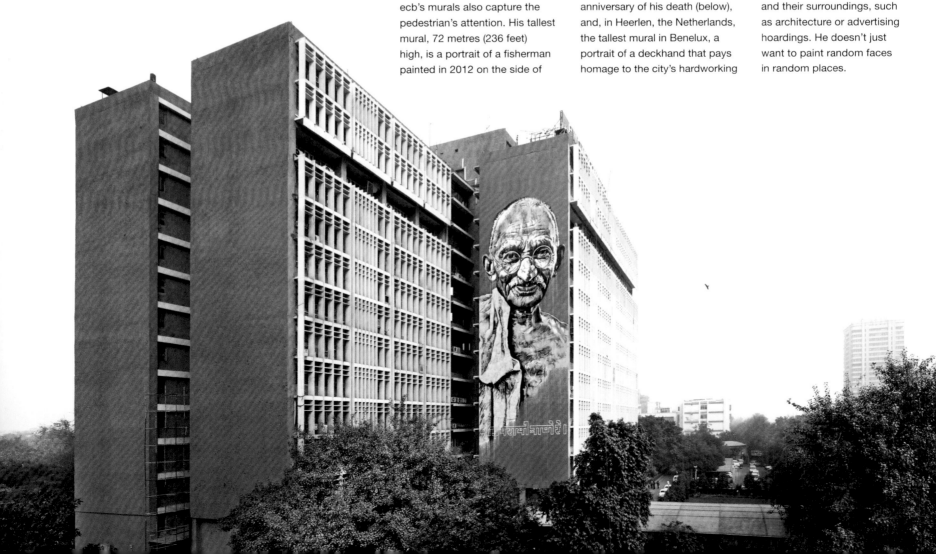

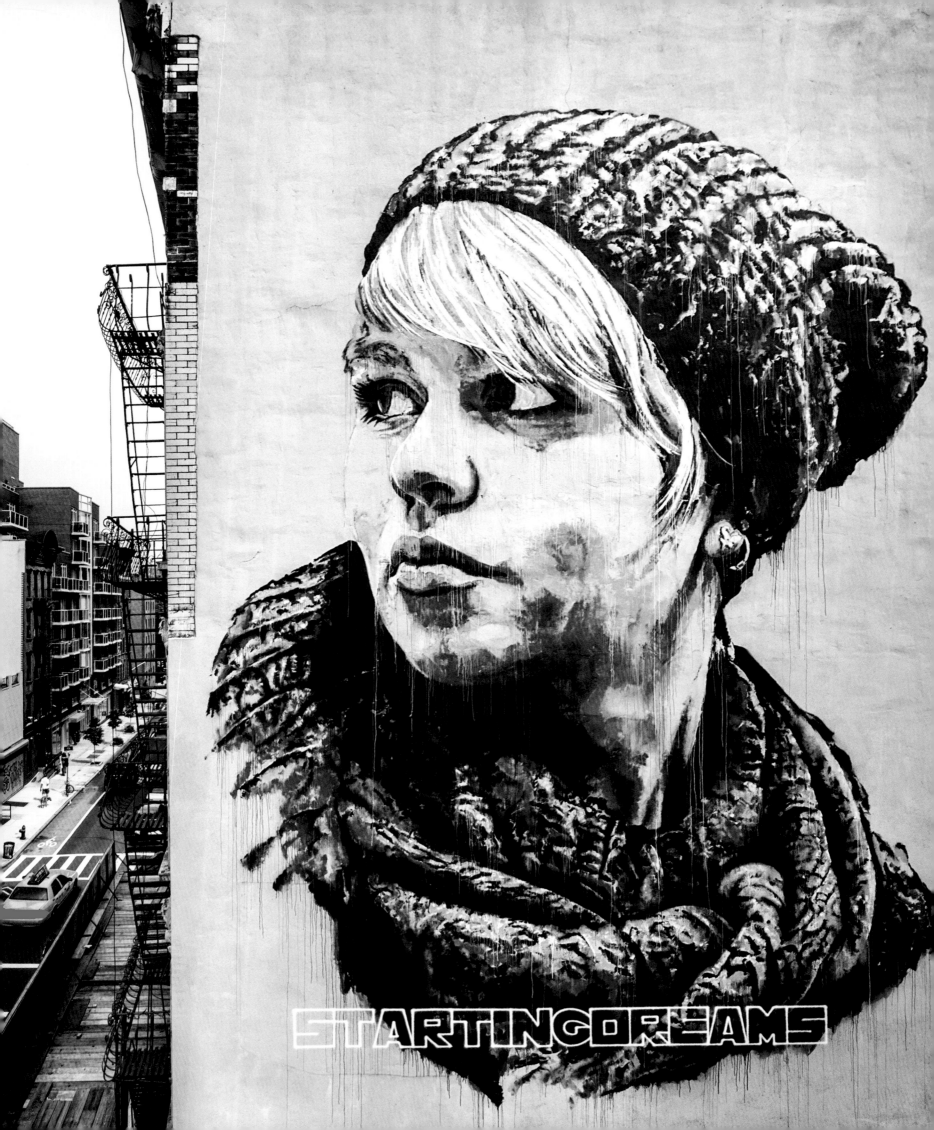

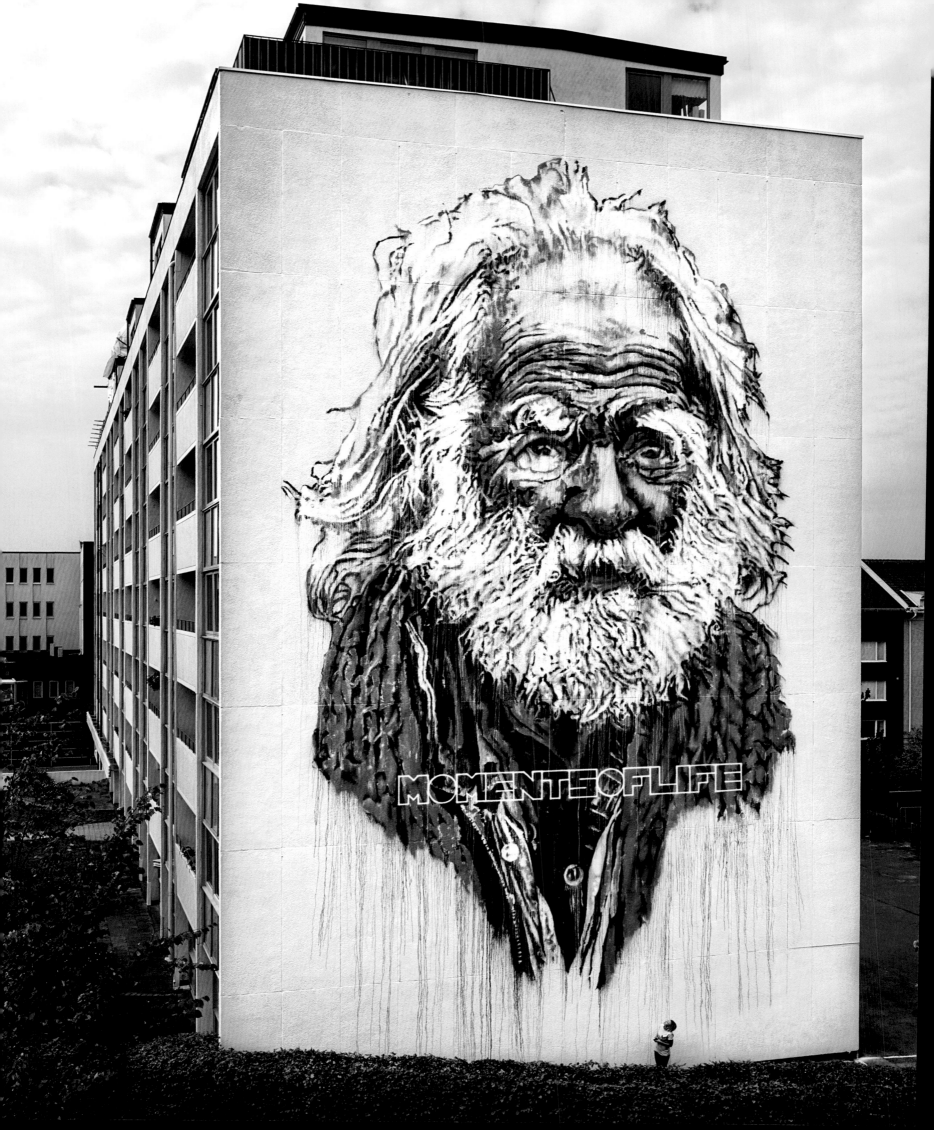

MOMENTEOFLIFE

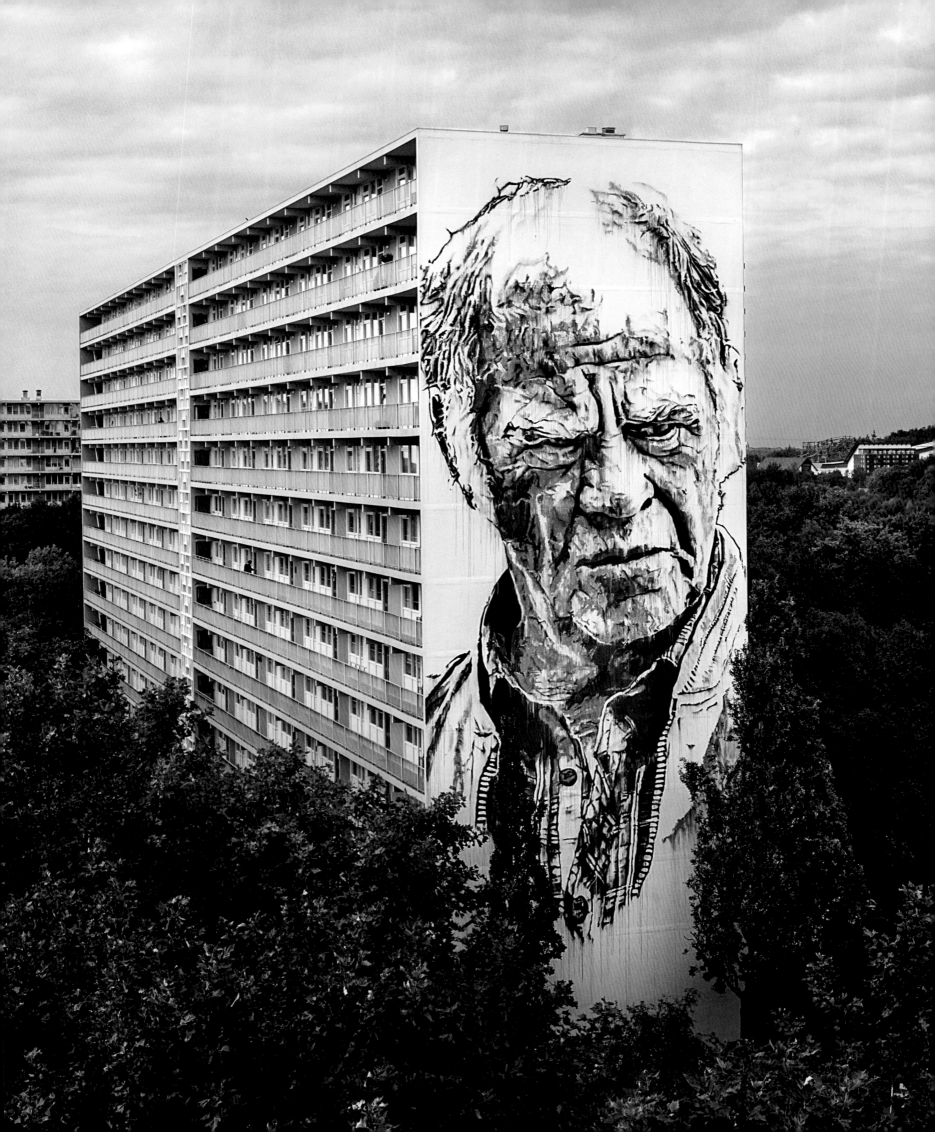

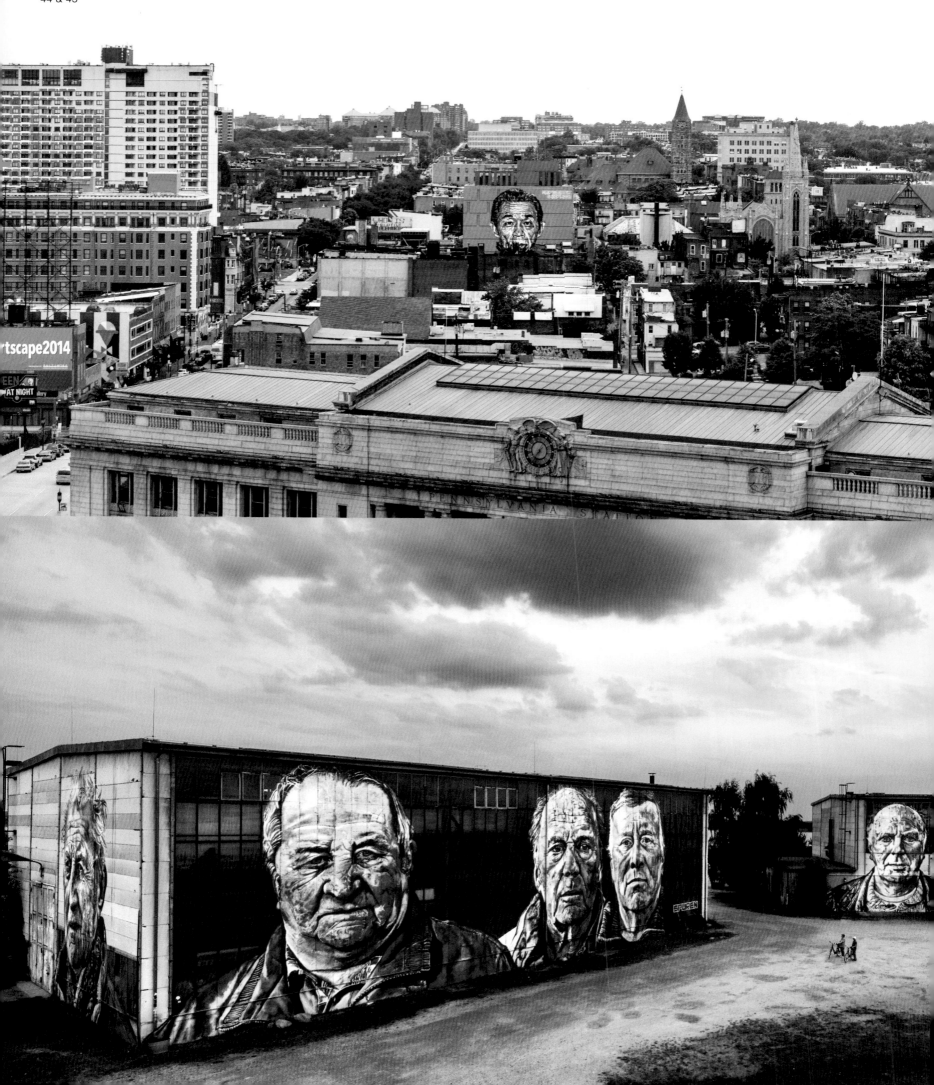

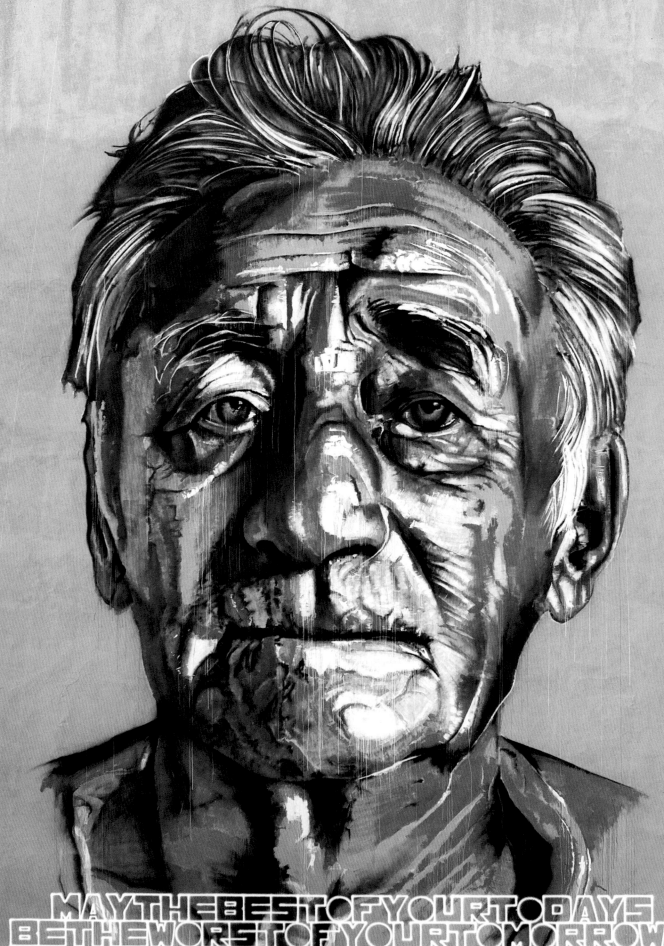

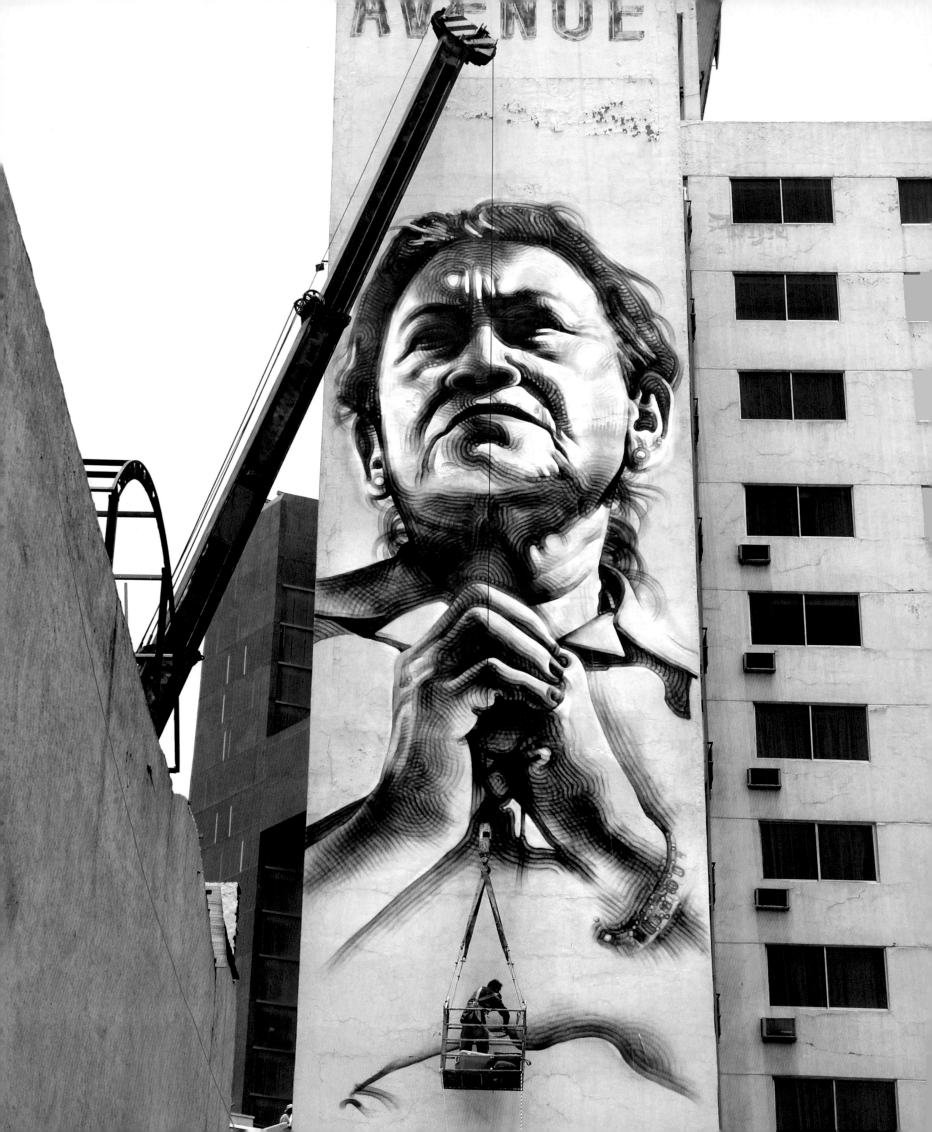

El Mac grew up in Phoenix, AZ, USA, and since the 1990s has lived and worked in Los Angeles, where he was born. He first became known in the city for his large murals, often accompanied by the abstract calligraphy of his artist friend Retna, with whom he began working in 2003. In the mid 1990s, El Mac learned about graffiti art through friends tagging the streets and through the book *Subway Art*. Although he has a creative background – his mother was an artist – he never went to art school and is completely self-taught. Rather than painting classic graffiti letters, El Mac became a photorealistic portrait painter, exploring the history and personalities of Chicano and Mexican culture.

El Mac's portraits are based on photos he takes of ordinary people. They are not usually intended as a homage to the person painted, but as a representation of many people. The portrayals are always beautiful; they radiate calmness and humility, giving the impression of something religious and holy. El Mac chose this way of painting to show people something positive, something that elevates their spirits and inspires them through beauty.

It is not just the way he presents the people in his murals, but his unique style of painting that ensured El Mac his place in the ever-growing mural art movement. Rather than fading different shades of colours together to create depth, El Mac builds up layers of parallel lines that give the impression of a ripple effect or of something vibrating. Adopting this technique was not a conscious decision, but something that developed on its own from painting at night with a Fat Cap. Over the years, he perfected this technique, using only New York Fat Caps, which make a perfect, empty circle when held still, or two widely spaced parallel lines when moved quickly across the surface. To give himself even better control over this effect, El Mac always carries his paint in a cooler filled with ice. The cold lowers the pressure inside the spray cans and reduces the amount of paint emitted.

When asked what scale El Mac prefers for his artwork, he says, 'I prefer to paint big, as big as possible.'

ABOVE, LEFT TO RIGHT:
Barcelona, 2011; *Dio de Muertos en Pomuch***, Campeche, Mexico, 2010;** *Régulo de León Santos***, Monterrey, Mexico, 2010. OPPOSITE:** *Maria de la Reforma***, Mexico City, 2012. OVERLEAF:** *Mother and Child***, Bristol, UK, 2011 (left);** *Manuel Lee Chang – El Coreano***, Campeche, Mexico, 2010 (right). SECOND OVERLEAF:** *Purity of Heart***, Aalborg, Denmark, 2013 (two views of three-sided work).**

El Mac

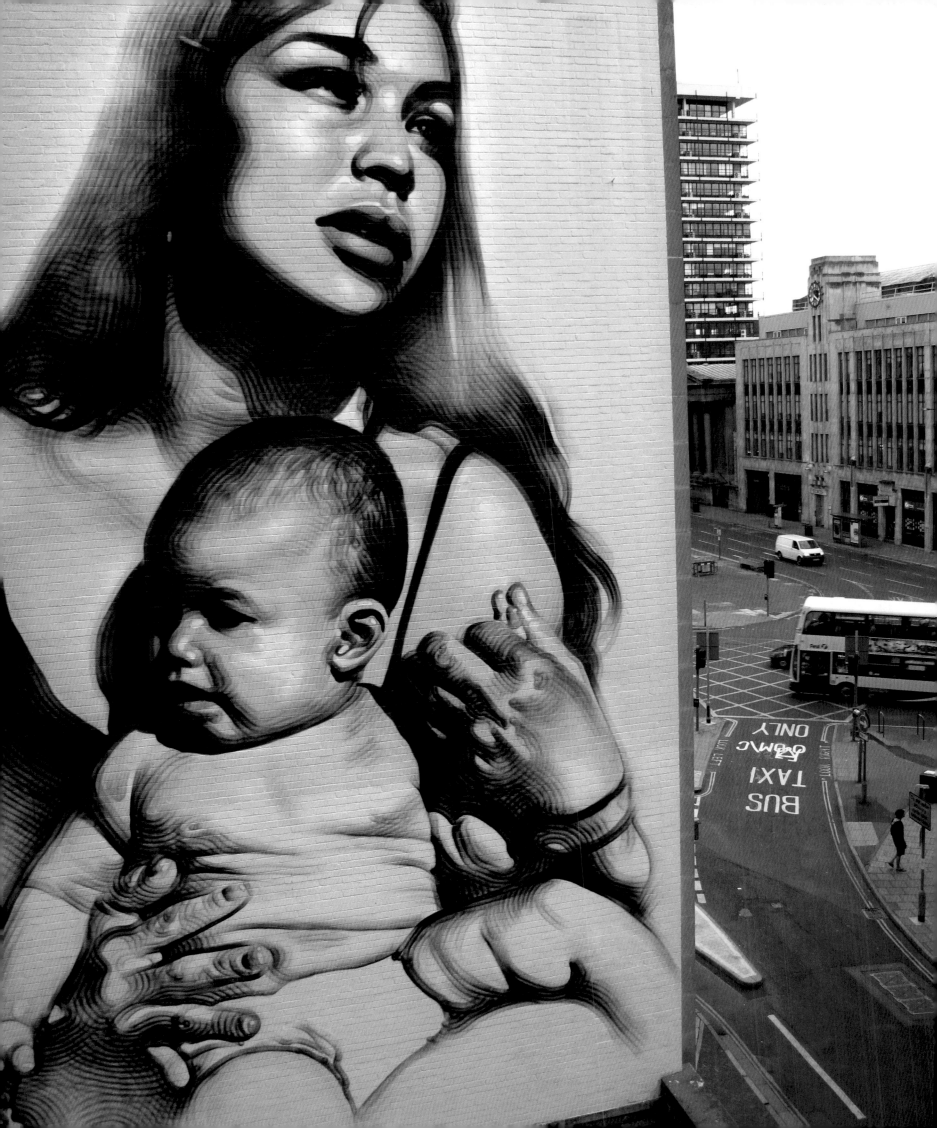

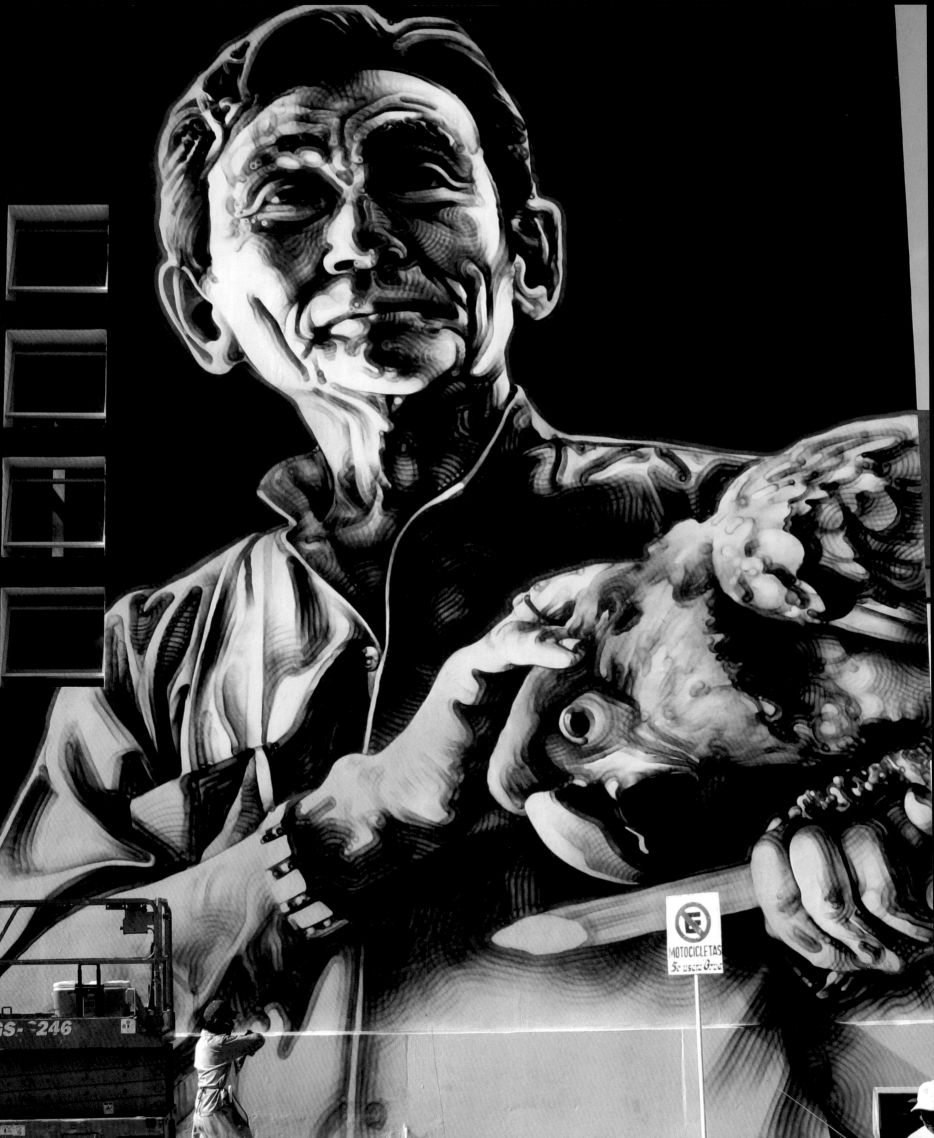

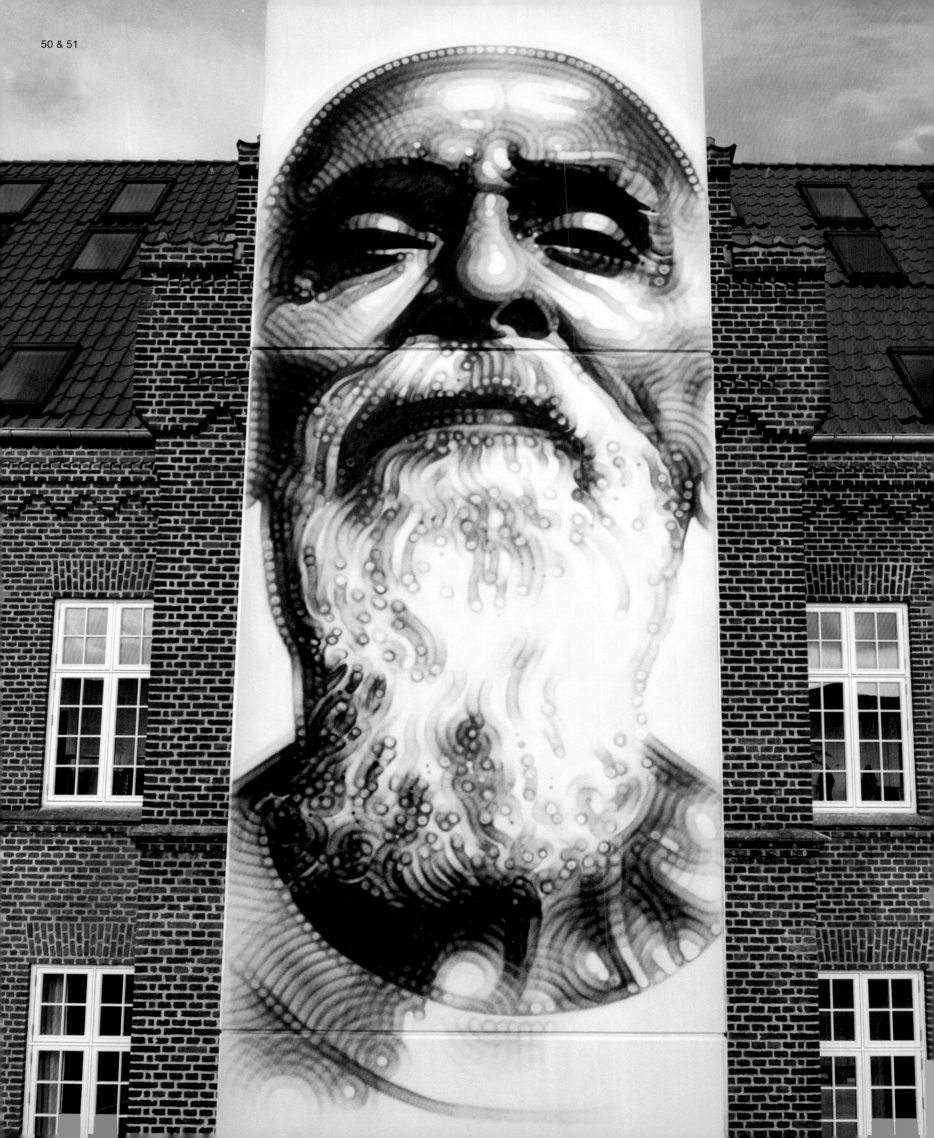

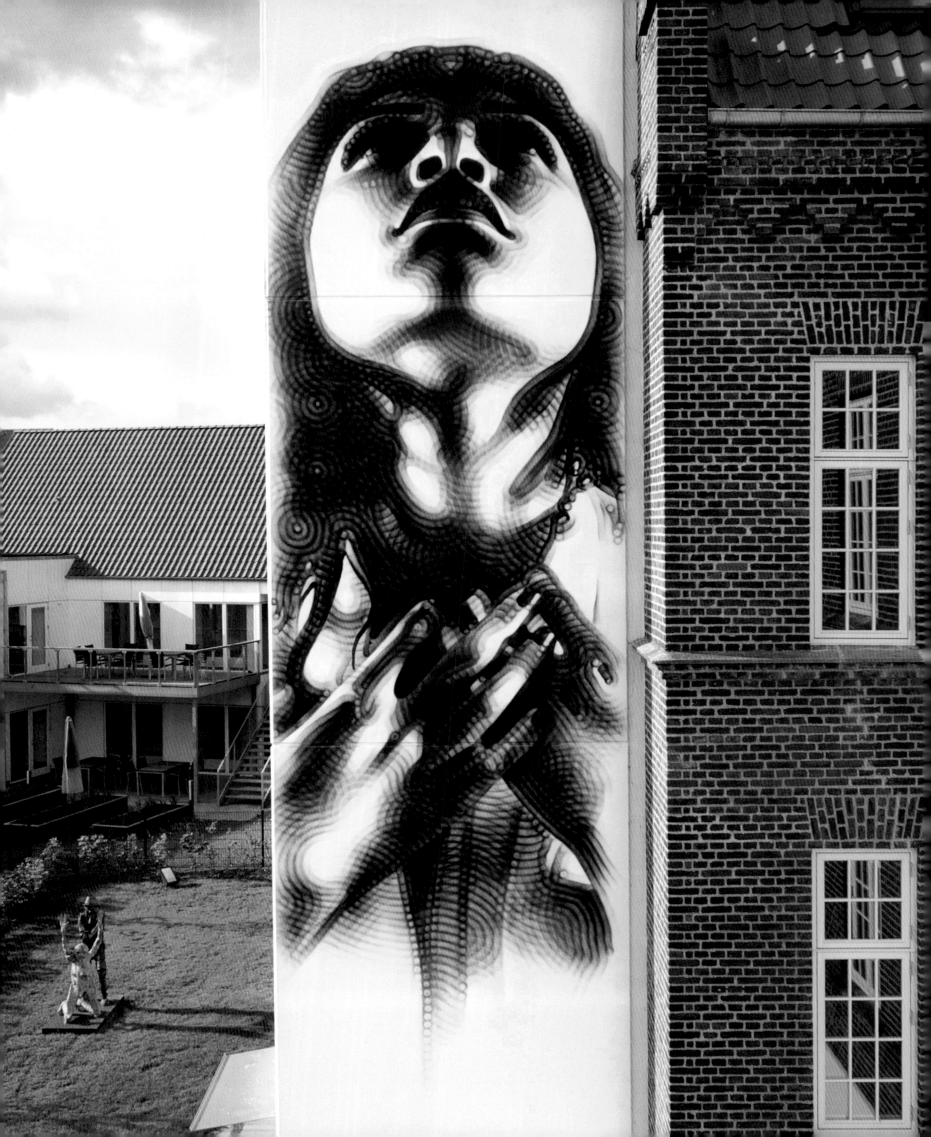

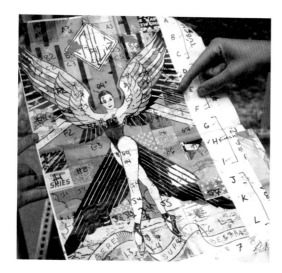
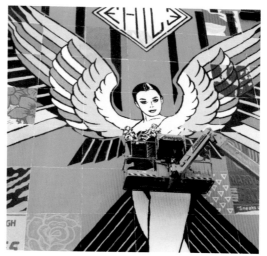
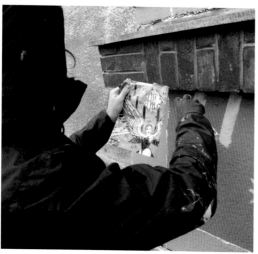
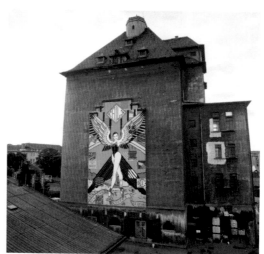

FAILE

ABOVE: Vienna, 2013. OPPOSITE: Tate Modern, London, 2008. OVERLEAF: New York City, 2013. SECOND OVERLEAF: Dallas, TX, USA, 2013.

FAILE is an artistic collaboration between Patrick McNeil and Patrick Miller. The name is an anagram of their first project, *A Life*. The Brooklyn-based duo, who started out using stencils and wheat-pastings in the late 1990s, have adapted their signature mass-culture-driven iconography to a vast variety of materials and techniques. In addition to murals, FAILE also produce collaged work that is applied to wooden boxes, window pallets, canvases, prints, sculptures, stencils, installations, prayer wheels, custom-designed pinball machines and video games. One theme that can be found in many of their works is the crash of the Challenger space shuttle, which exploded shortly after its launch in 1986. Either the shuttle or the date of the crash appears in many of the team's pieces, including their murals.

FAILE weren't known for large works initially. 'We've been doing stencils and small works in the street since the 1990s. Our first large outdoor mural was in Austin, Texas in 2004.' In 2005 FAILE moved into a permanent studio and began exhibiting in well-received group and solo gallery shows while continuing to experiment with murals, enjoying not only the fascination of seeing their work at a large scale, but also 'the ability to transform a run-down wall into something people will walk by every day and enjoy.'

Since then they have painted murals in cities around the globe, including New York, Los Angeles, Oslo, Berlin, London, Vienna and many more. Depending on the size and location of the wall, the duo variously work freehand or with grids, stencils or projection. When approaching a mural, they find their biggest challenge in translating smaller works onto a large scale. Whether they are painting from a cherry picker or scaffolding isn't important to their working method: 'Either is better than a rickety wooden ladder.'

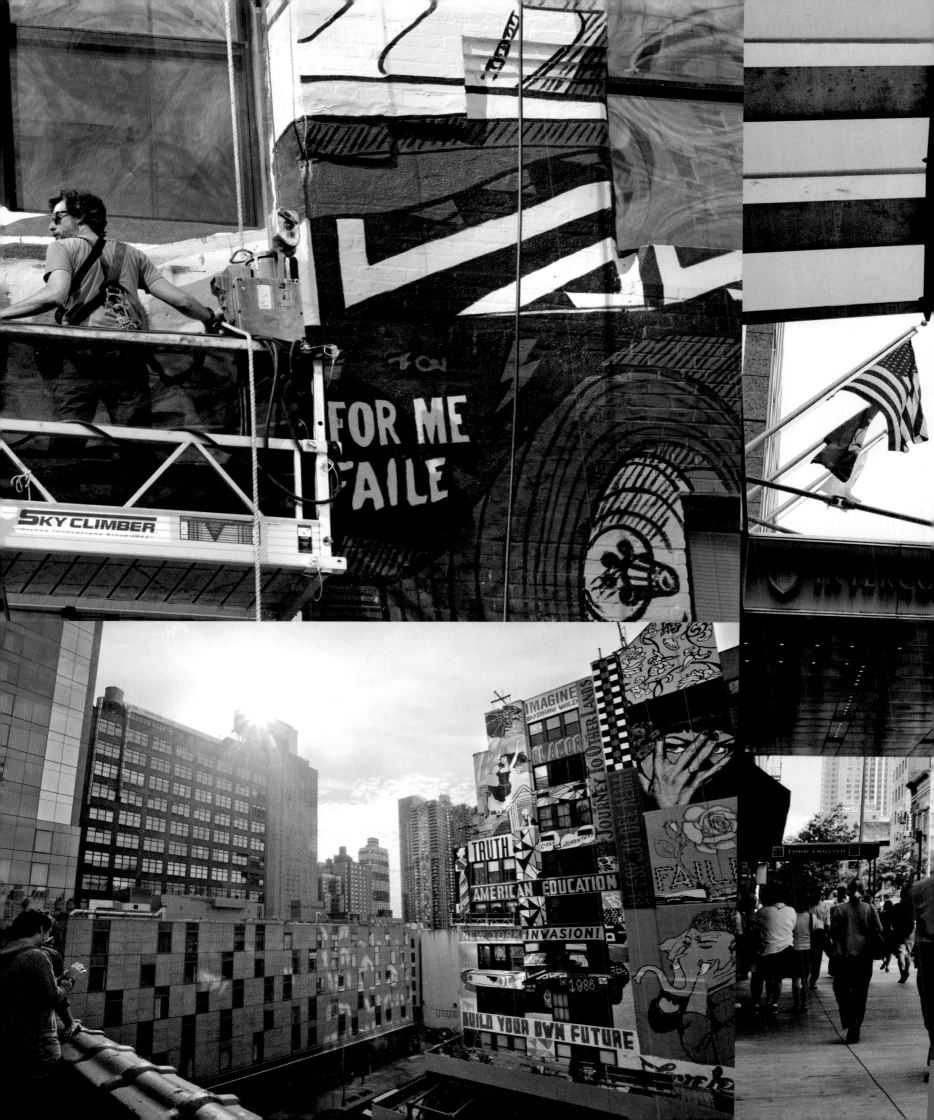

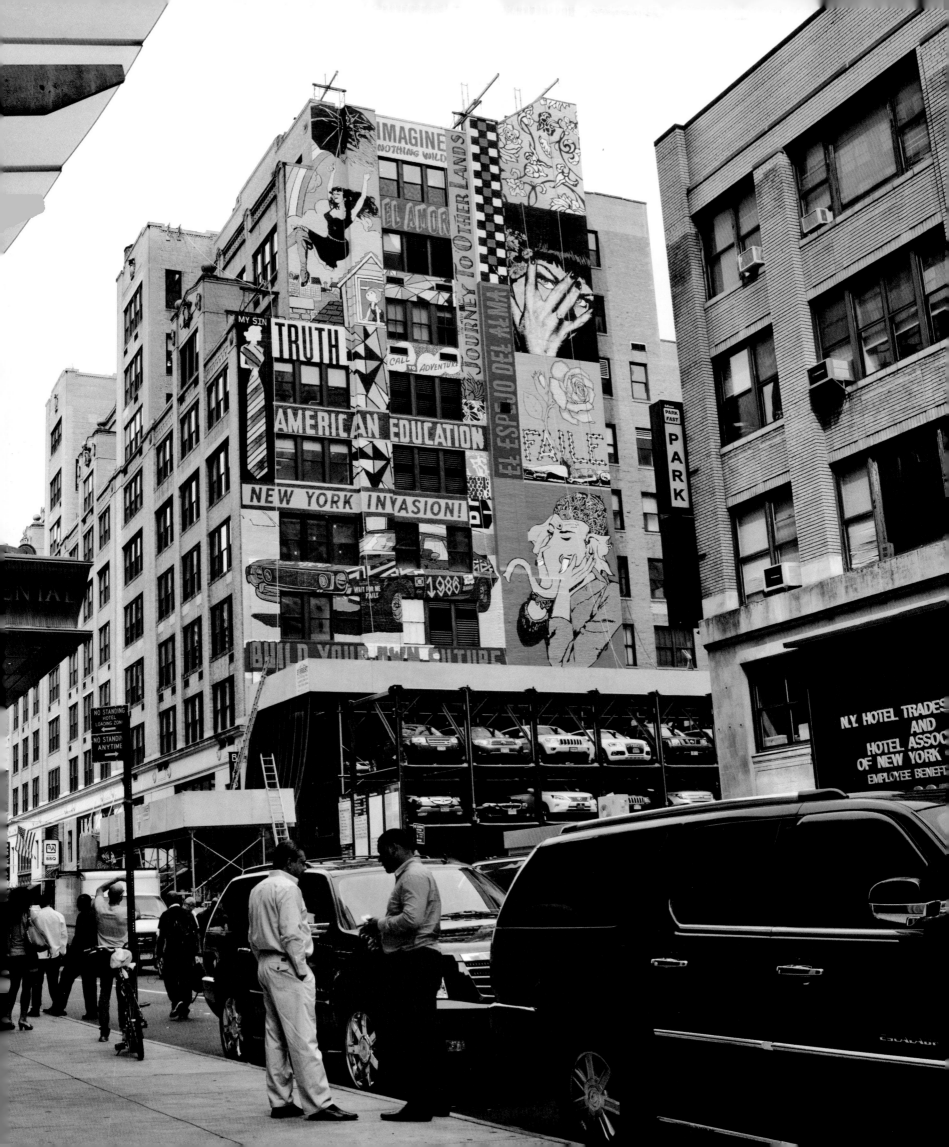

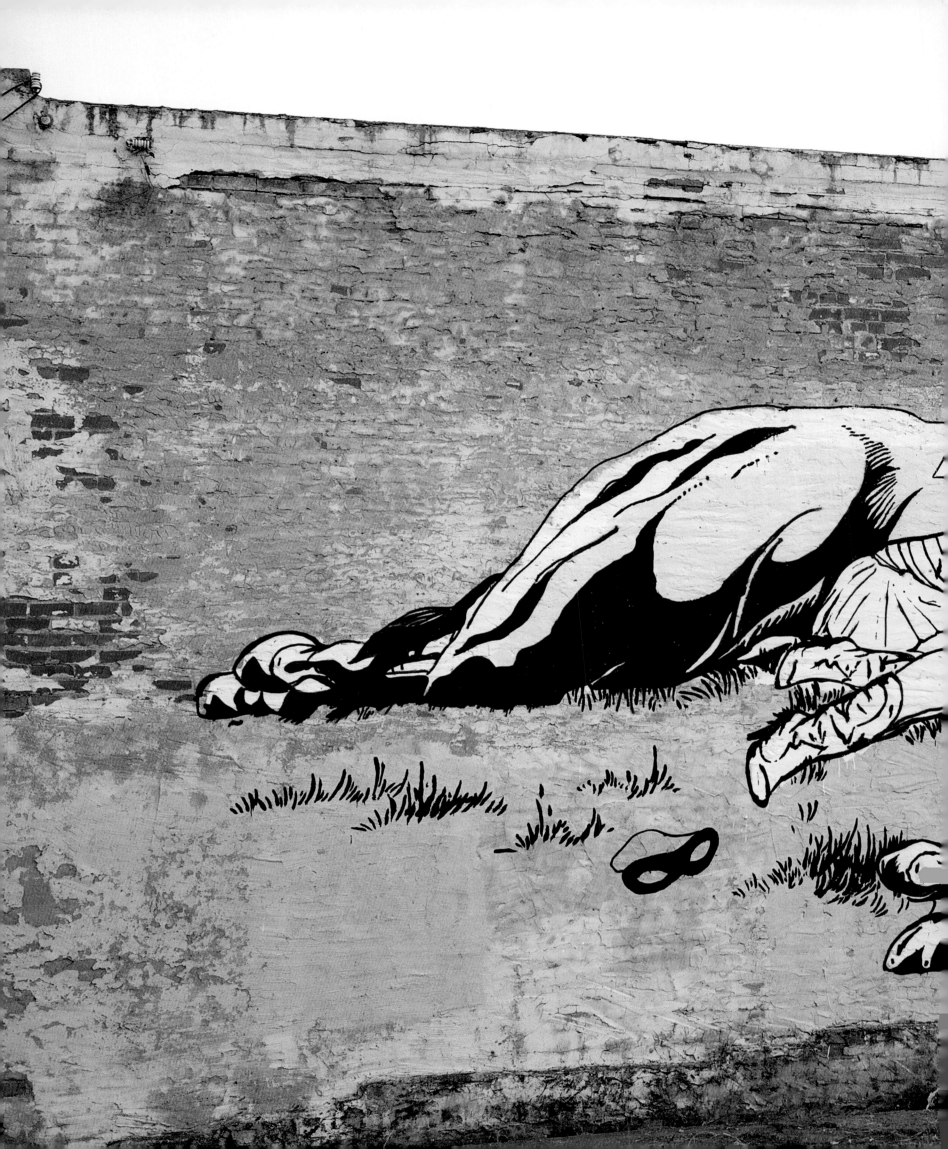

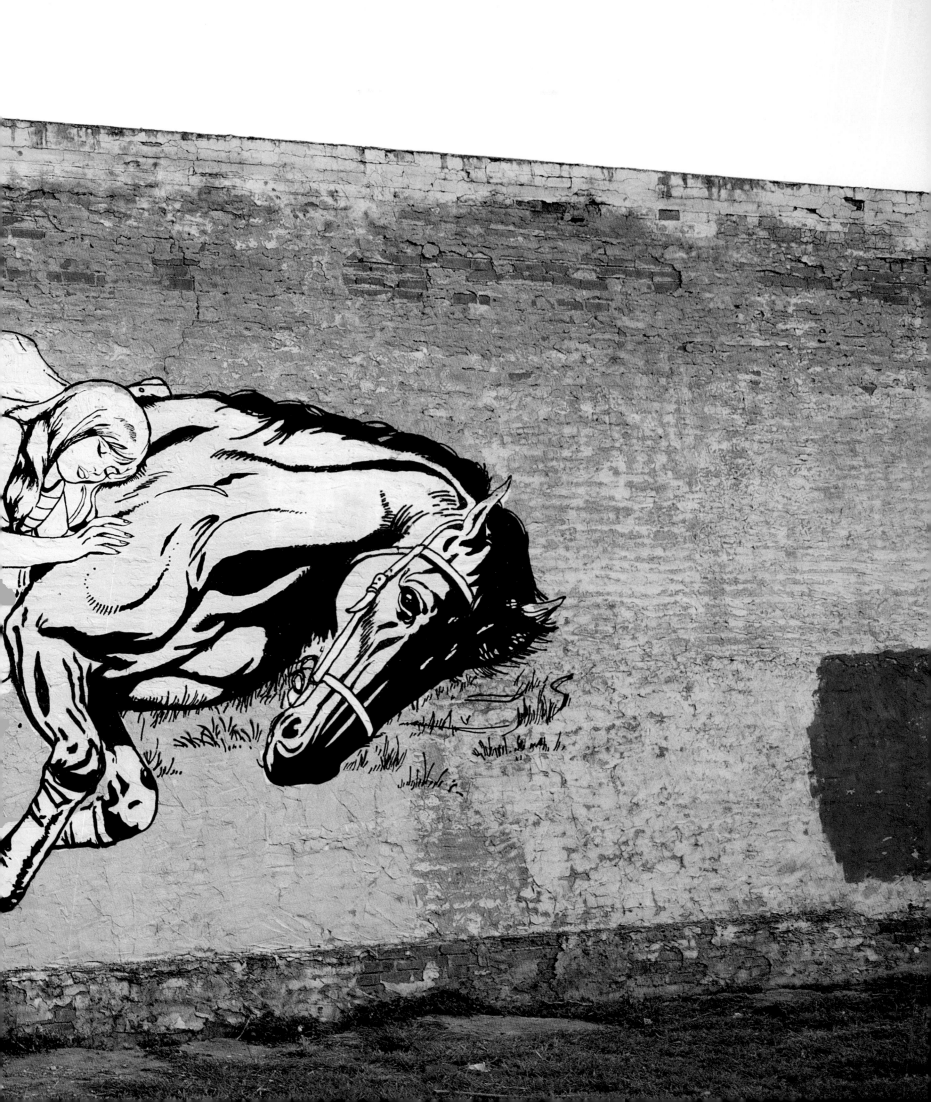

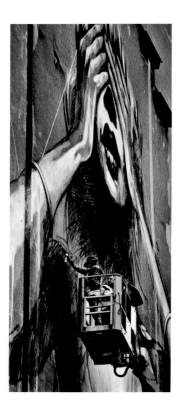
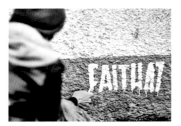

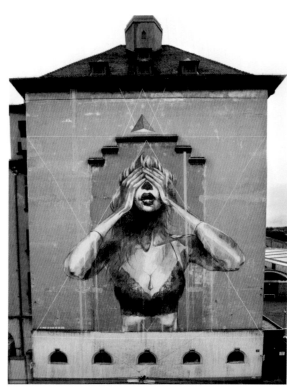

Faith47

Faith47 calls Cape Town, South Africa her base, but travels the world most of the year to paint her murals. In 1997 she started painting traditional graffiti with unique calligraphic letters, replacing them over time with her now well-known human and animal characters, which radiate emotion, sensitivity, symbolism and sacredness as well as a dark, mysterious quality.

Faith47 never covers up a wall with her pieces, but rather incorporates the surface texture: 'I prefer to work on raw, dilapidated surfaces and incorporate them into my image.

There is some soul in a building that one wants to preserve and relate to.' She makes use of many different materials and techniques in her painting: spray paint, ink, collage, oil paint and graphite drawings, to name a few. Like her smaller works on paper, wood and canvas, her murals often look like they were drawn with an oversized pencil. In her most recent work, she experiments further with new materials, particularly the use of metallic golds. In her piece *harvest* (opposite), painted in 2014 in Cape Town, LED lights were incorporated in the wall.

The largest wall she has painted on her own to date is *the immense gap between past and future* (above) in Vienna, completed over the course of three rainy days in 2013. This project 'was intimidating at first, but once you get going the fear dissipates and becomes inspiration.' She describes the many challenges that large-scale murals present – problems with wind and weather, lifts breaking down, difficulty accessing certain areas, getting the proportions right – but remains drawn to this work regardless: 'There is something ambitious about

large murals. At times, I see a large, beautiful, decayed, aching wall calling to me, resonating somewhere deeply within. That is the beginning of our entwinement. It's hard to explain. Of course there is also something very powerful about appropriating a public space that is so large. This is something to consider. I like and dislike this.'

ABOVE: *the immense gap between past and future*, Vienna, 2013.
OPPOSITE: *harvest*, Cape Town, 2014.
OVERLEAF: *infinitud del universo*, Malaga, Spain, 2013.

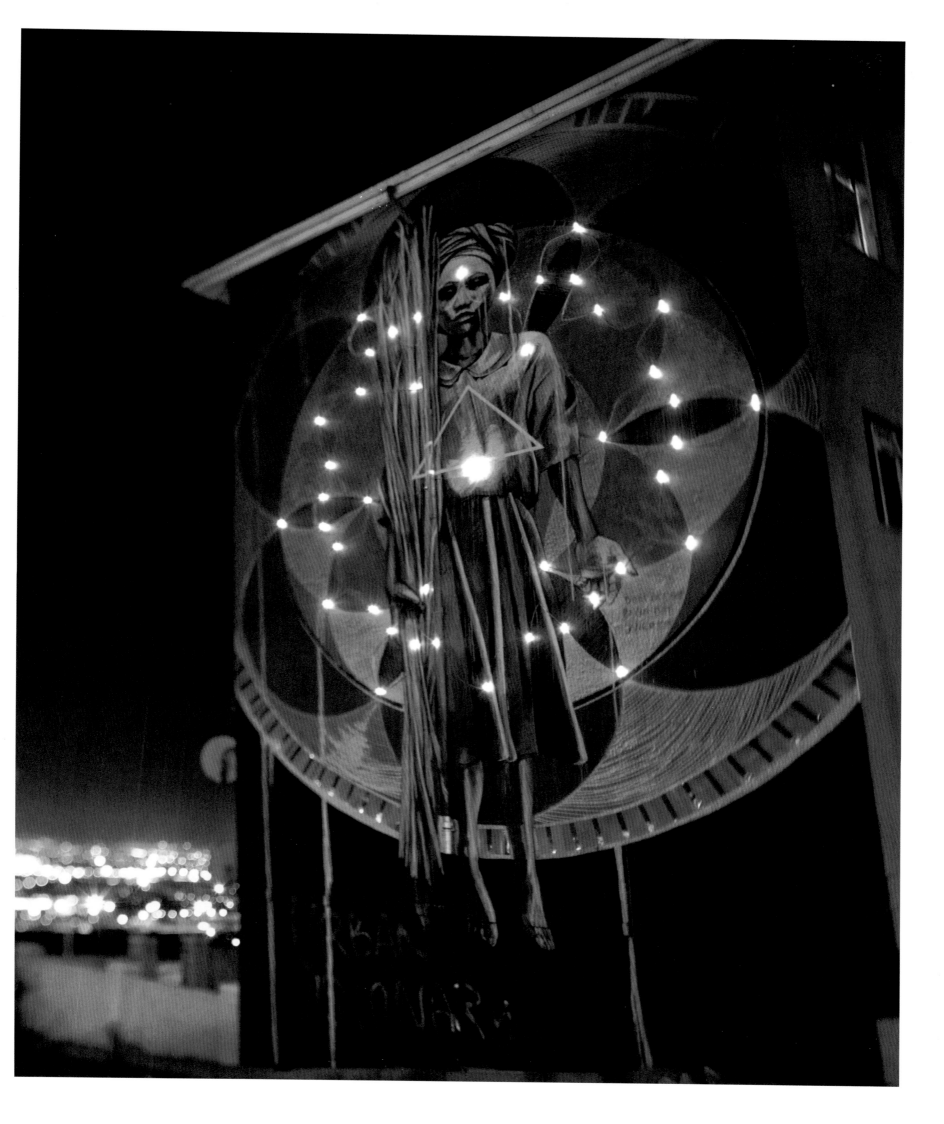

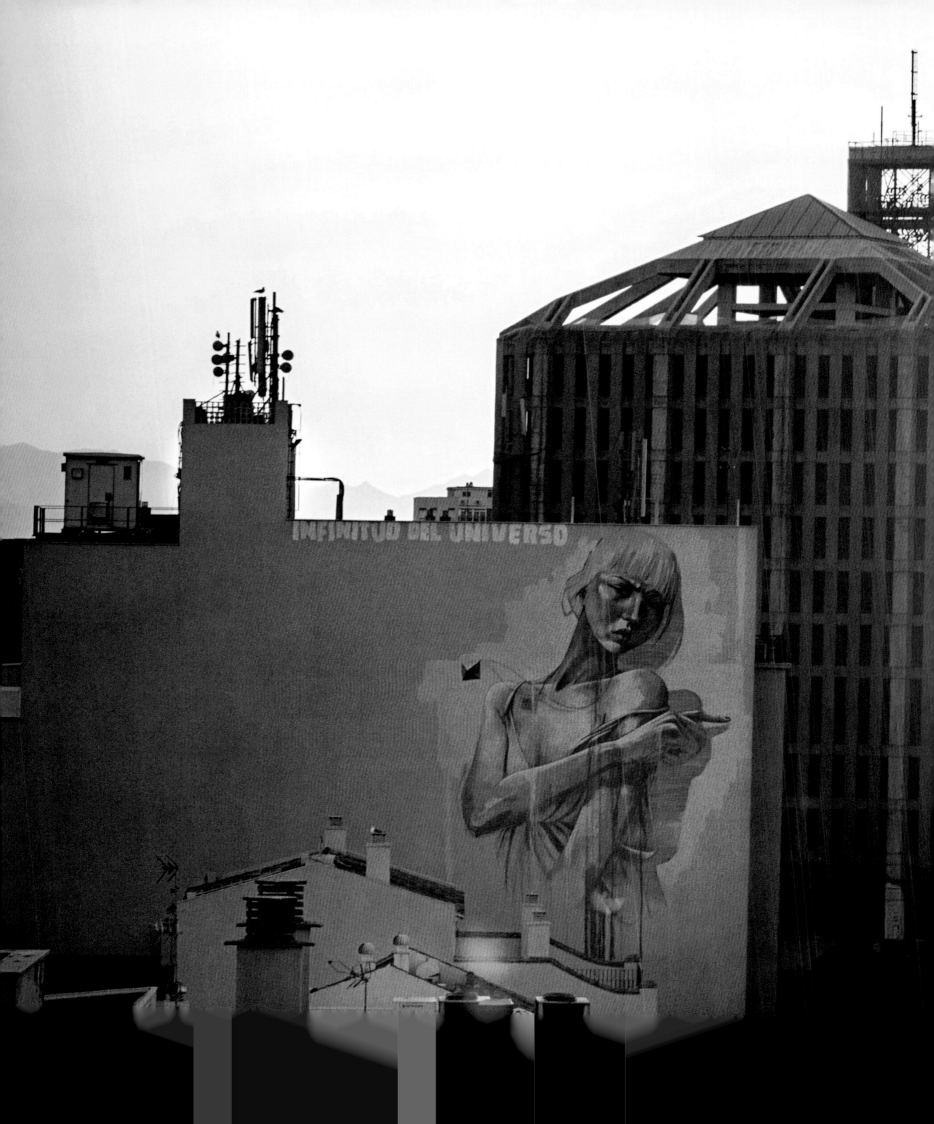

OPPOSITE: *Duel of Bristol*, **Bristol, UK, 2012. OVERLEAF:** *San Juan Fight Club II*, **San Juan, Puerto Rico, 2013. SECOND OVERLEAF:** Rochester, NY, USA, 2013 (above left and above right); Vardø, Norway, 2012 (below left and below right).

Conor Harrington was born in Ireland, but calls London his creative home. He is well known for his unconventional blending of historical imagery with abstract forms drawn from his past career as a graffiti writer. His murals typically portray male figures engaged in violent combat, invoking both the conflicts of modern society and the oppressive choreography of traditional male gender roles.

Harrington usually uses photographs of posed, costumed actors as an initial visual reference. He then adds freehand shapes before applying large amounts of cellulose thinner to dissolve everything into a dripping image. The results are powerful, often monochromatic paintings that have a very spontaneous feel even when executed at an extremely large scale.

His largest mural, in San Juan, Puerto Rico (overleaf), is about 18 metres (60 feet) high. His approach to working on large-format pieces depends on the size and setting of the wall. 'If the wall is very big and the space allows for it, I'll use a projector [to transfer the photograph], but a lot of the time I use a grid. I then start blocking it in, working from the ground up to make sure I don't end up painting over any of my drips.' He prefers to work from a cherry picker, as it allows him to zoom in and out to see what he's doing. Its movement when high up can be nerve-racking, and he recalls that during his first time on a cherry picker in 2008, 'I thought I was going to die.'

Like most of his fellow street mural artists, Harrington makes a living from his studio work and usually doesn't get paid for his murals. He prefers it this way, as it allows him to view murals as a joy and a challenge, rather than simply as a job. 'I've always seen wall painting as a David and Goliath thing, taking on something much bigger than yourself: sometimes you win and sometimes you don't.'

Conor Harrington

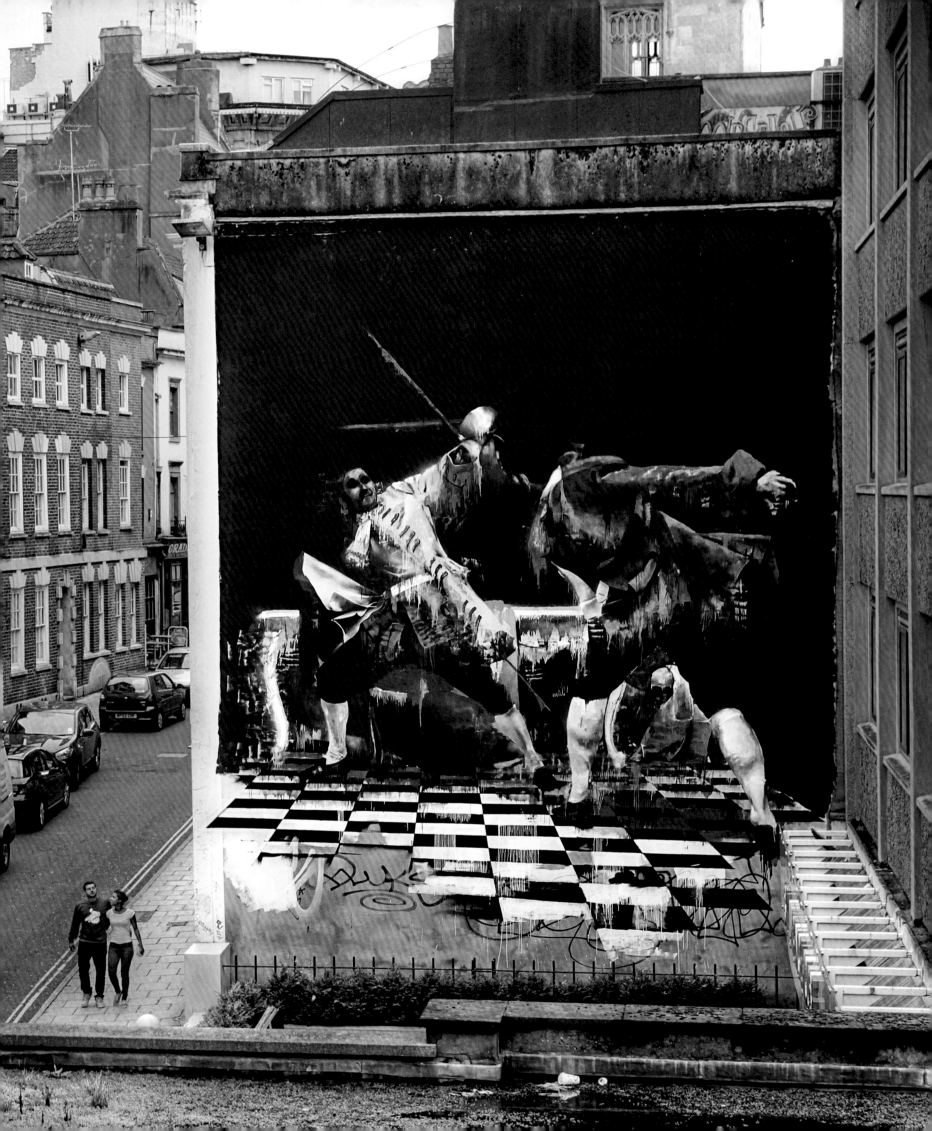

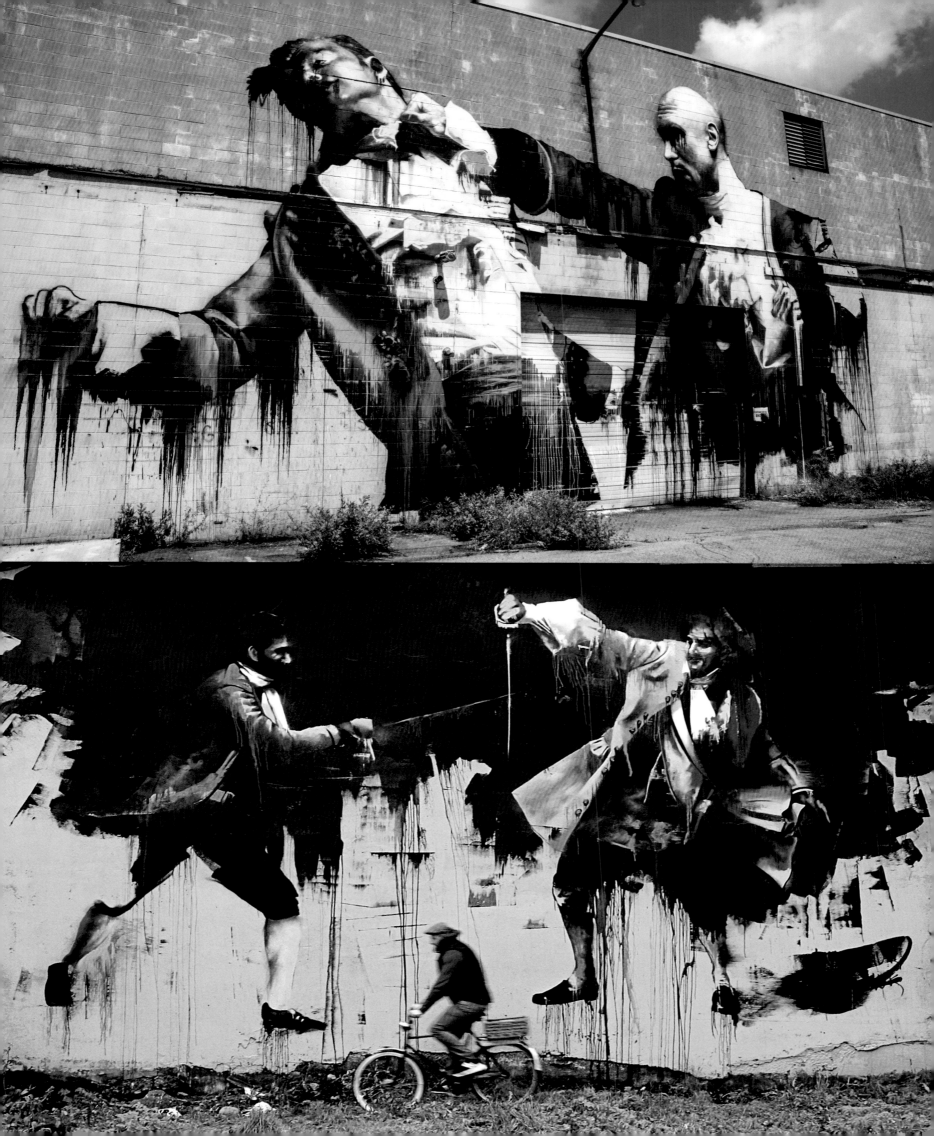

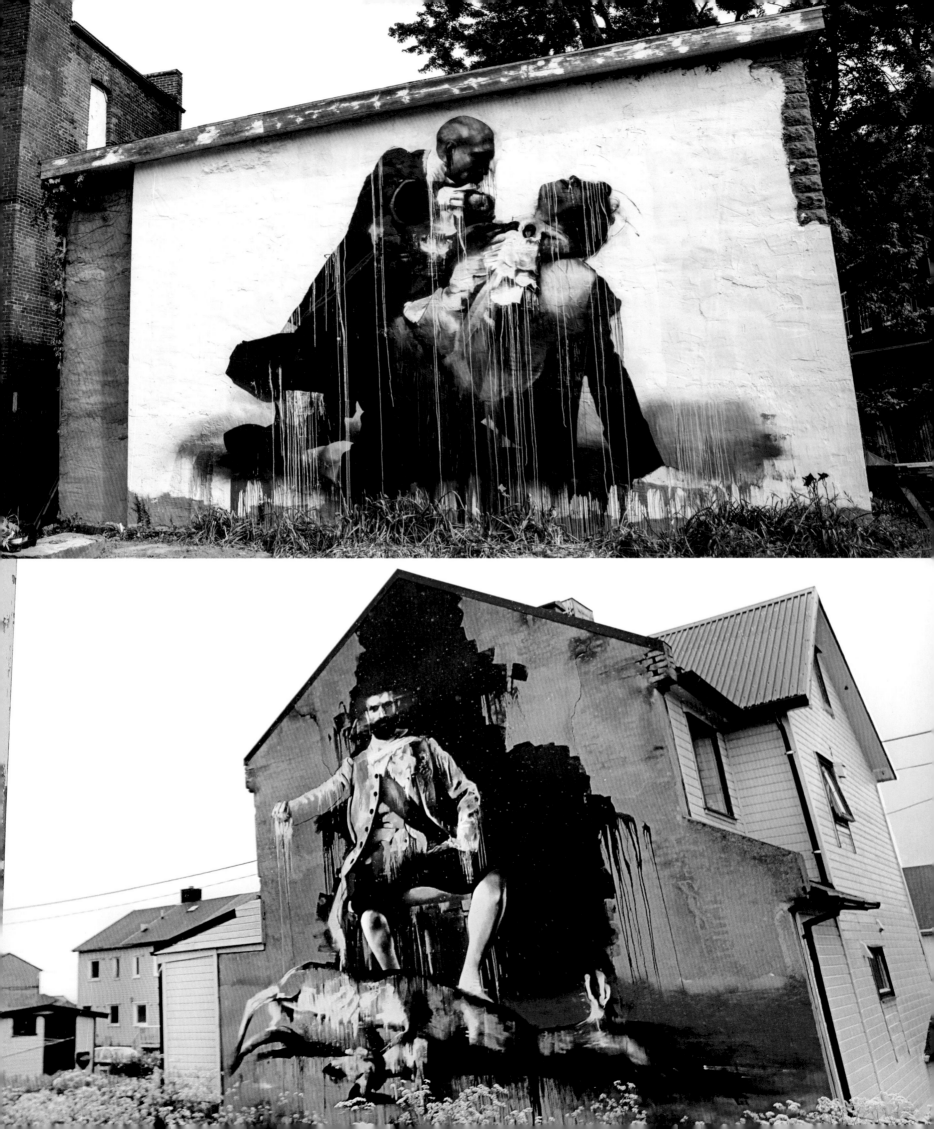

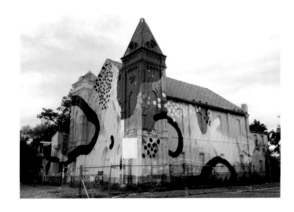 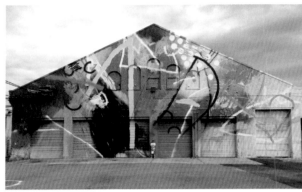

ABOVE: Church,
700 Delaware Ave,
Washington DC,
2012 (left and right);
Richmond, VA, USA,
2013 (centre). OPPOSITE:
Float, Atlanta, GA, USA,
2012 (above); Columbus,
GA, USA, 2014 (below).
OVERLEAF: ISIL Institute,
Lima, Peru, 2013. SECOND
OVERLEAF: Madison
Theater Building, Detroit,
MI, USA, 2014.

HENSE

When HENSE started painting the streets of his hometown of Atlanta, GA in the 1990s, he used the letter-based imagery typical of graffiti culture at the time. From the very beginning, however, he painted big, blockbuster pieces and quickly became used to covering large surfaces. Since then, his style has become completely abstract, allowing him to develop methods that are quite different from those of fellow graffiti artists working at a large scale. Whether painting large outdoor murals or smaller pieces on canvas, he always works spontaneously, without a preconceived concept or preliminary sketch. He builds up each work in layers, changing some things and covering up others until he feels the project is finished. It is important to him to keep the physical act of painting visible in his murals, as well as to use bold, bright colours.

HENSE often works with a crew of assistants to execute his large murals. His best-known and largest pieces are his Lima installation (overleaf), which is 40 metres high and 50 metres wide (130 × 164 feet) and a former church in Washington DC (above), whose entire exterior was painted in rainbow colours, requiring more than 300 gallons of paint and nearly a month to complete. For the Lima installation he had the help of ten local professional painters; together they spent a month on the piece. To reach all parts of the wall, he had to build his own tools, adding extensions to his brushes or using strings to create perfectly round circles. In addition to these homemade tools, he normally uses rollers of all sizes, brushes, spray paint, paint sprayers, mops, acrylics and whatever else seems useful in realizing his colourful, abstract creations.

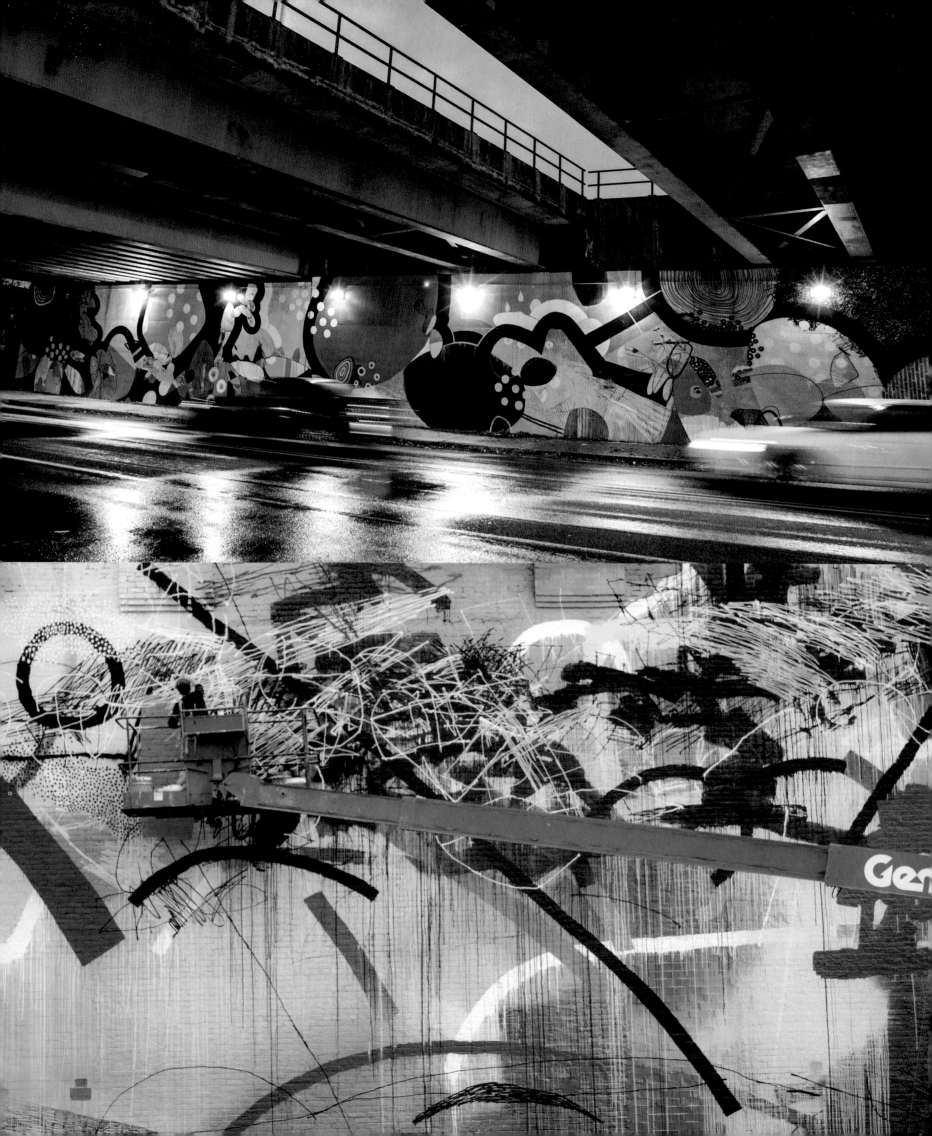

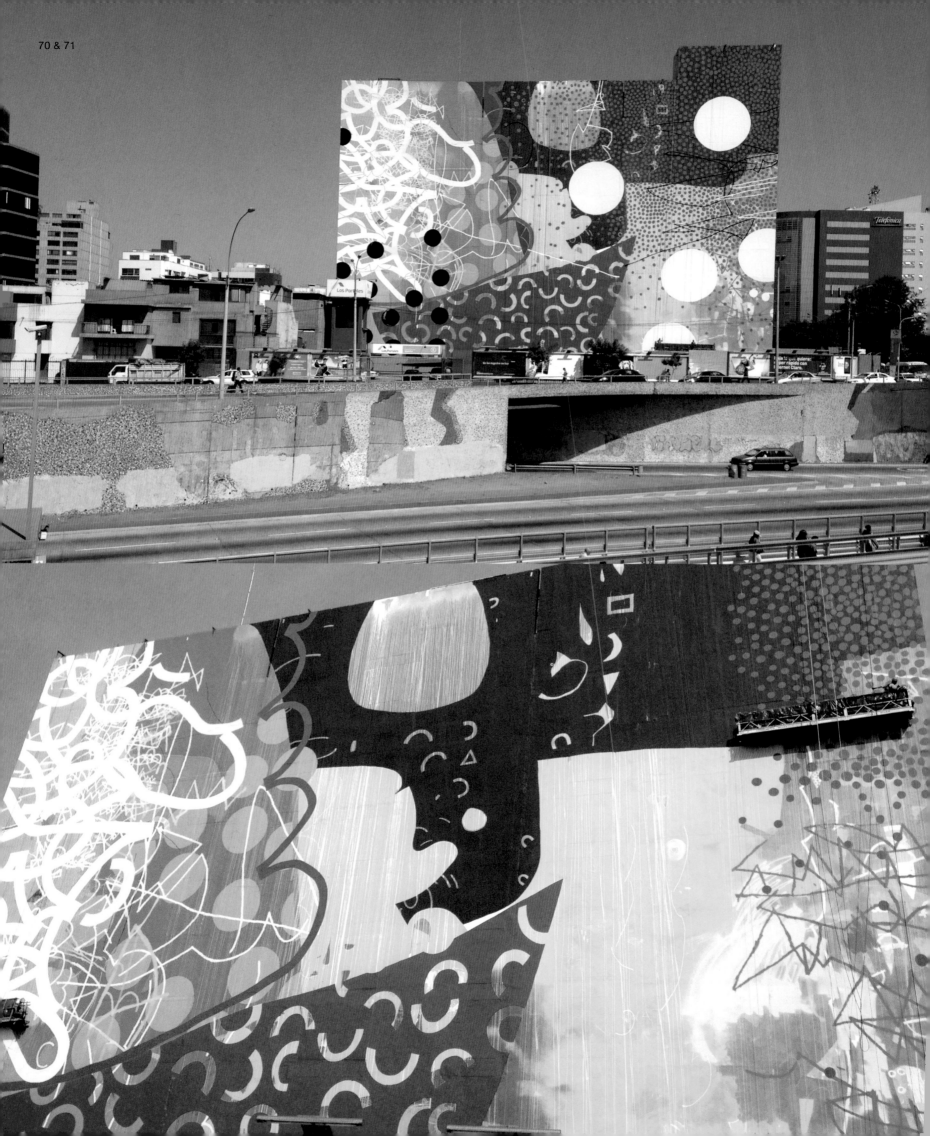

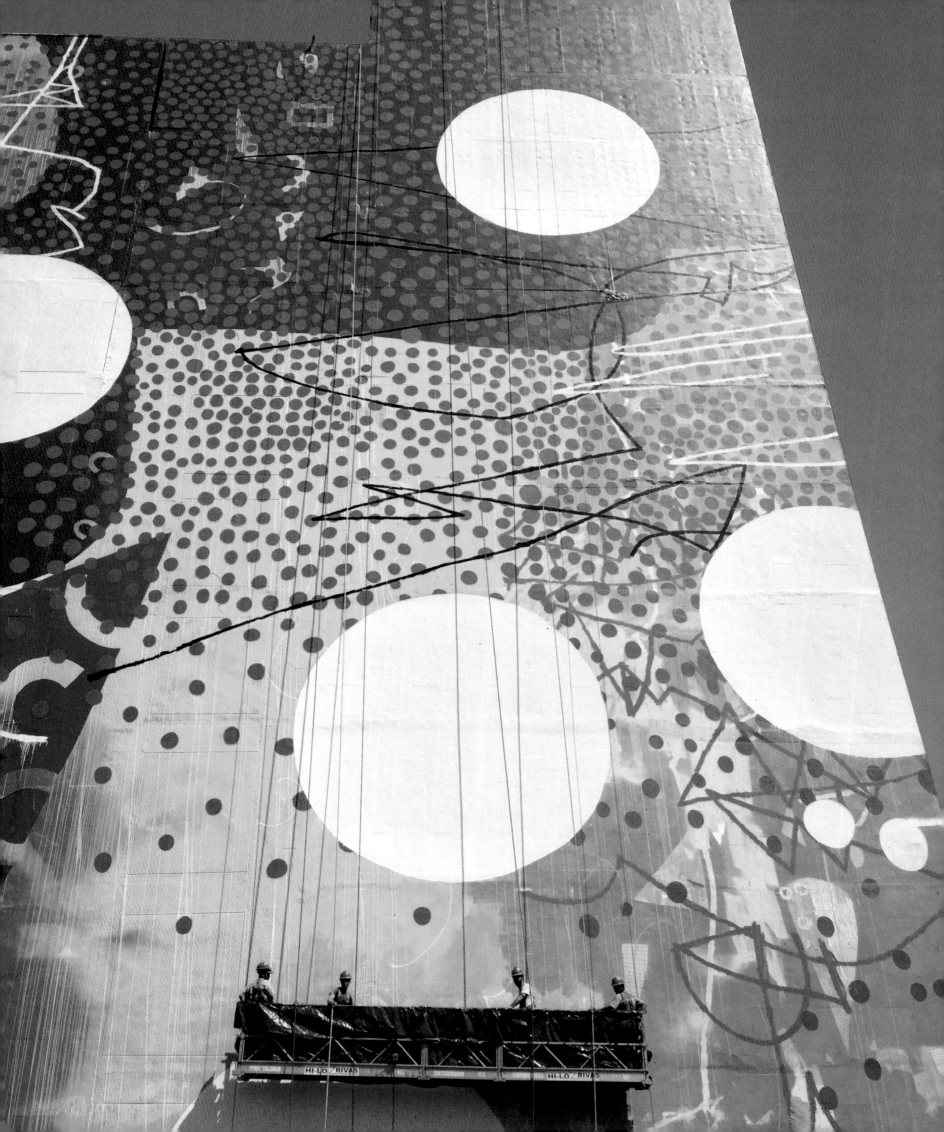

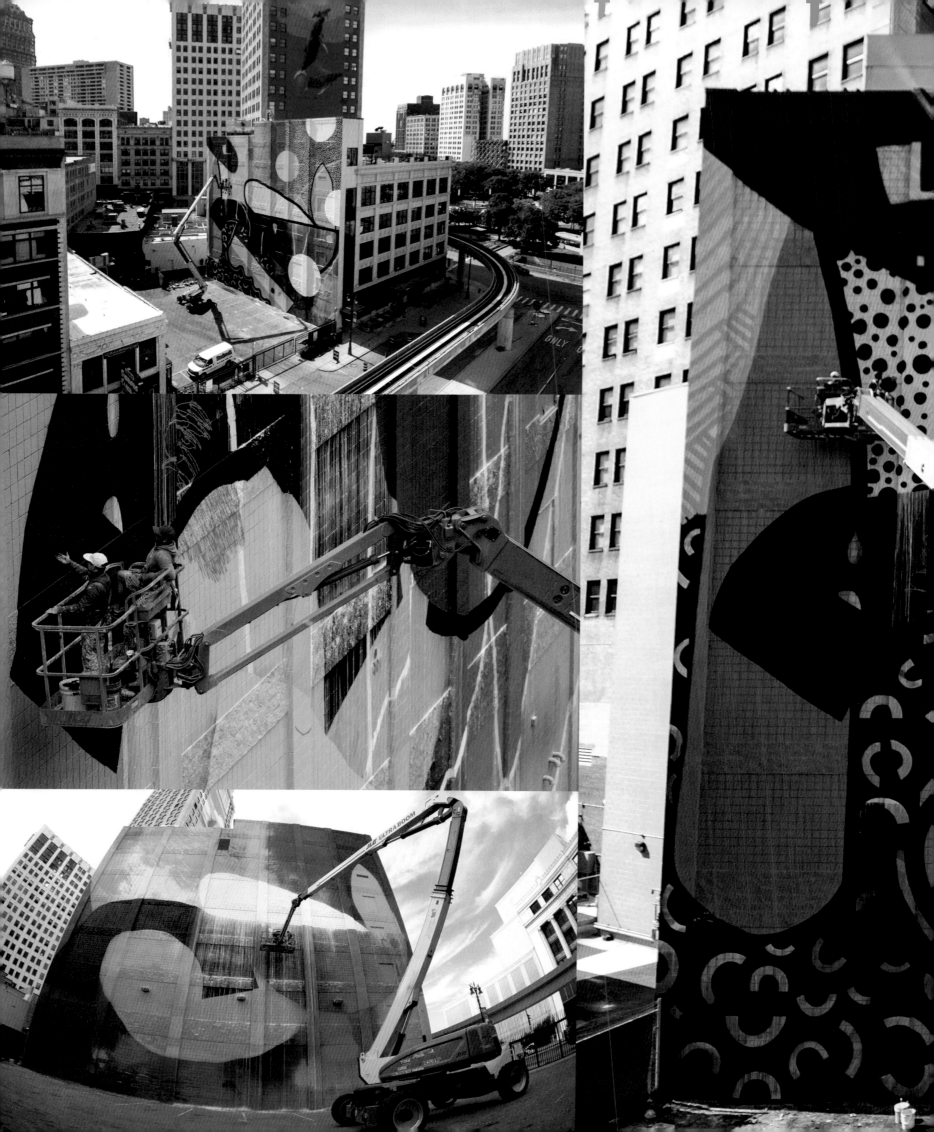

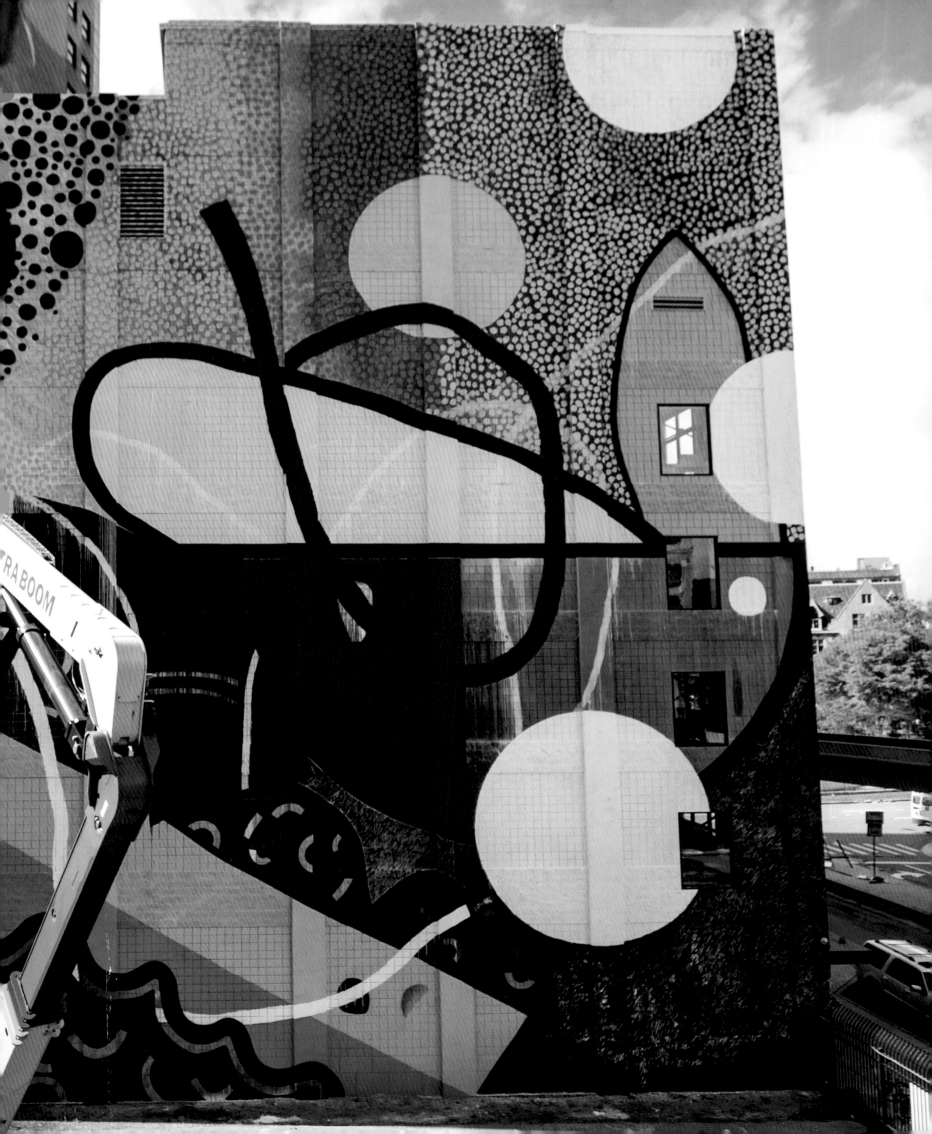

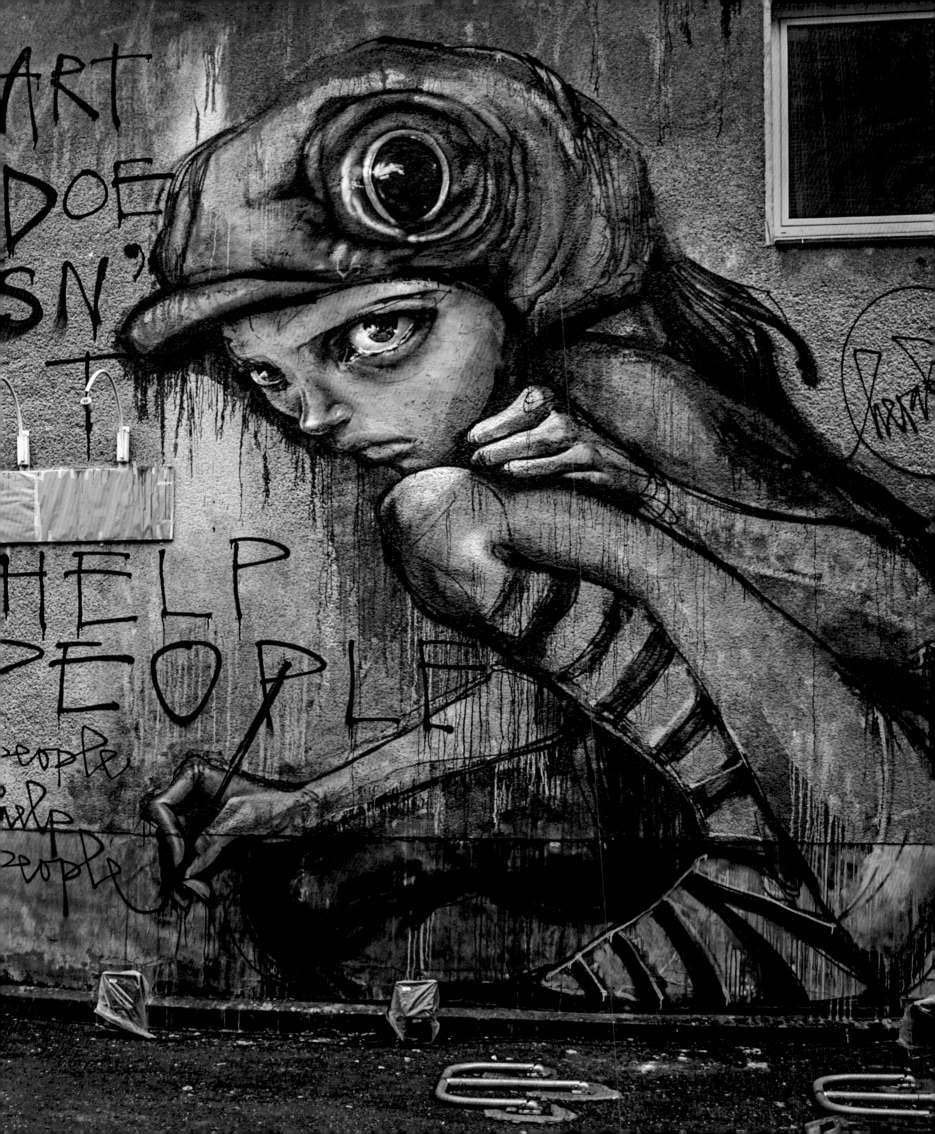

Herakut

Herakut are a German street mural duo known for their fantastic fairy-tale imagery and chimerical creatures. Graffiti artists Hera and Akut have worked together since 2004; their contrasting styles and techniques, which they developed while working independently in the early graffiti scene, mesh surprisingly well. Hera's approach is very rough, spontaneous and sketchy. She gives each piece its overall direction and incorporates text quotes. Akut then adds photorealistic elements: in some pieces just a single eye; in others the entire skin of the character. Their work often depicts creatures that are a mix of animal and human. The cultural significance of each animal, and its traditional associations with certain human characteristics, convey emotions and ideas that are often explicitly political, or at the very least critical of the social status quo.

In 2013 the team completed their biggest project to date, a *Giant Storybook* (above and overleaf) told through twenty different murals spread from San Francisco to Kathmandu to Hera's hometown of Frankfurt. The largest mural in this series is 20 metres high and 30 metres wide (65 × 100 feet). To create such large paintings, the team uses emulsion, brushes, rollers and, of course, spray paint. Akut is especially dependent on aerosols for his photorealistic illusions. Since the team works spontaneously, without a lot of pre-planning, they prefer to paint from a cherry picker rather than scaffolding, as a cherry picker makes it possible to see the overall work in progress.

Akut enjoys making murals because their large size allows him to use his favourite artistic tool – the spray can – to apply very fine details that are difficult to achieve even on a standard-sized art canvas. Hera loves to work large because it makes painting become a very physical act in which she sees her own bodily energy transformed into a piece of art.

ABOVE: *Giant Storybook*: Mannheim, Germany, 2011 (left); San Franciso, 2012 (centre); Rochester, NY, USA, 2012 (right). **OPPOSITE:** Lüneburg, Germany, 2011. **OVERLEAF:** *Giant Storybook*, Miami, 2012. **SECOND OVERLEAF:** Frankfurt, 2013 (above left); Los Angeles, 2011 (below left); Tel Aviv, 2011 (above right); *Giant Storybook*, Lexington, KY, USA, 2013 (below right).

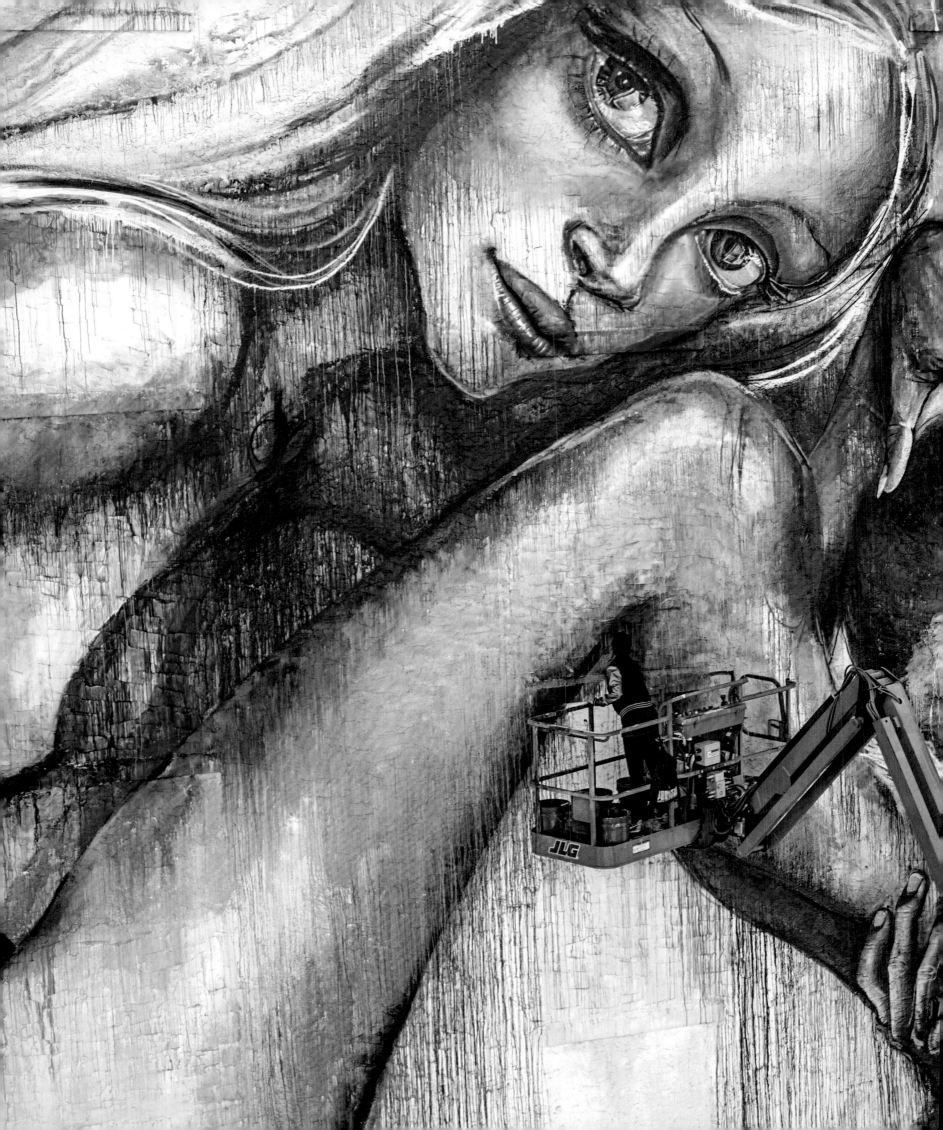

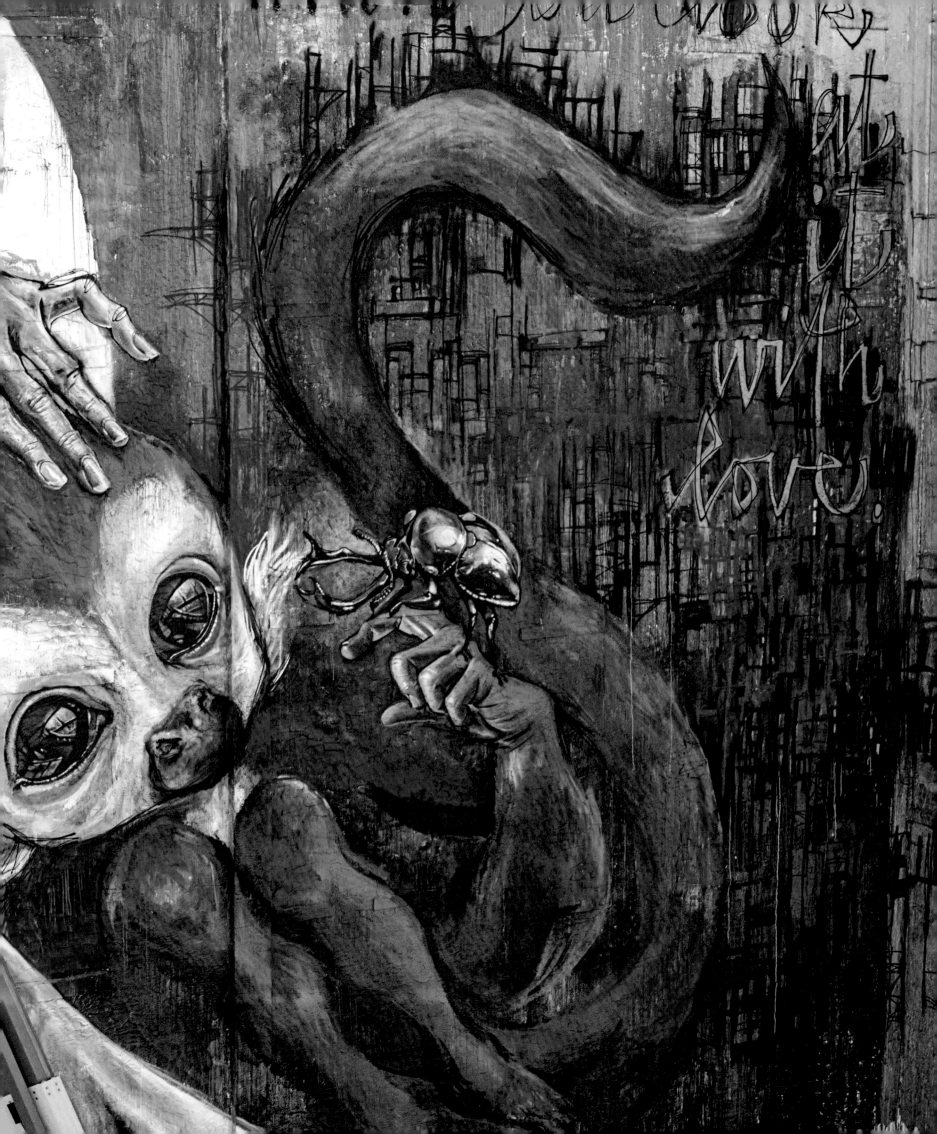

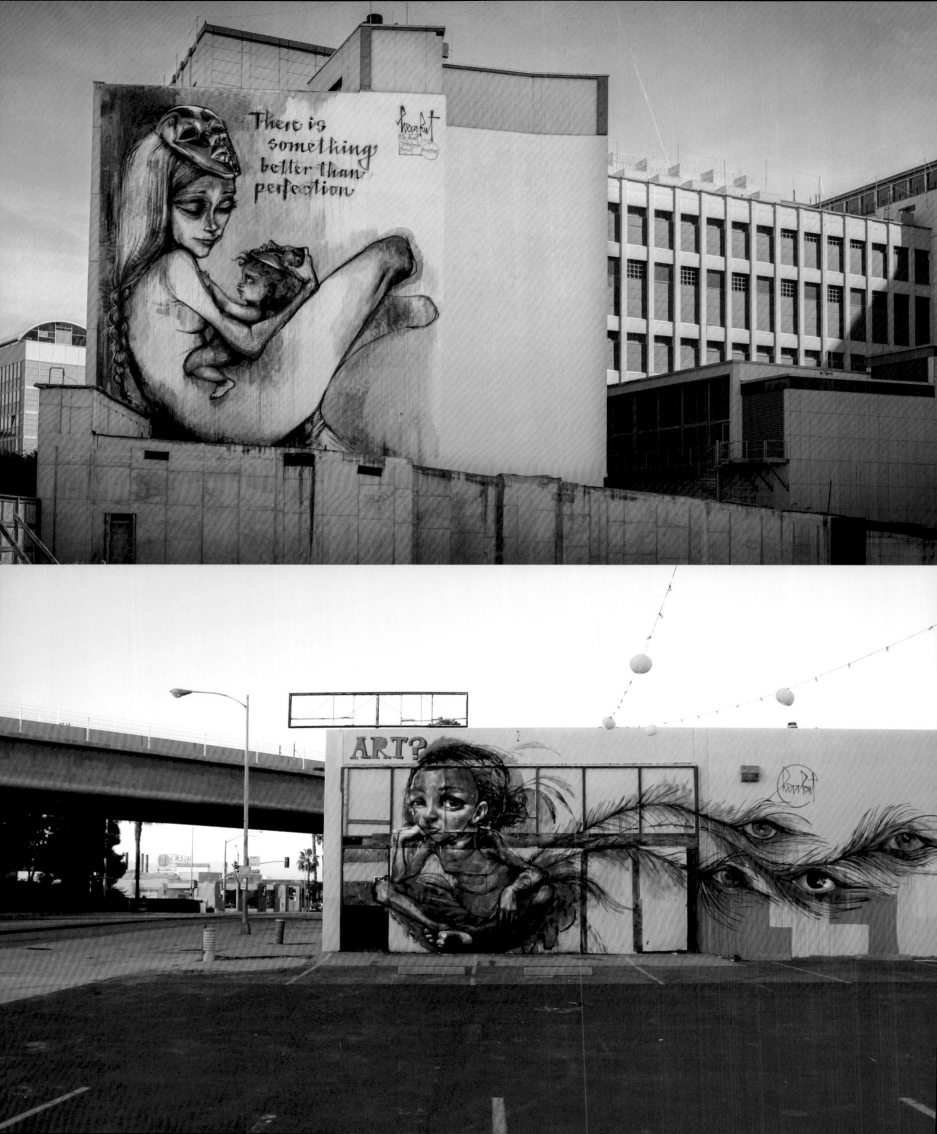

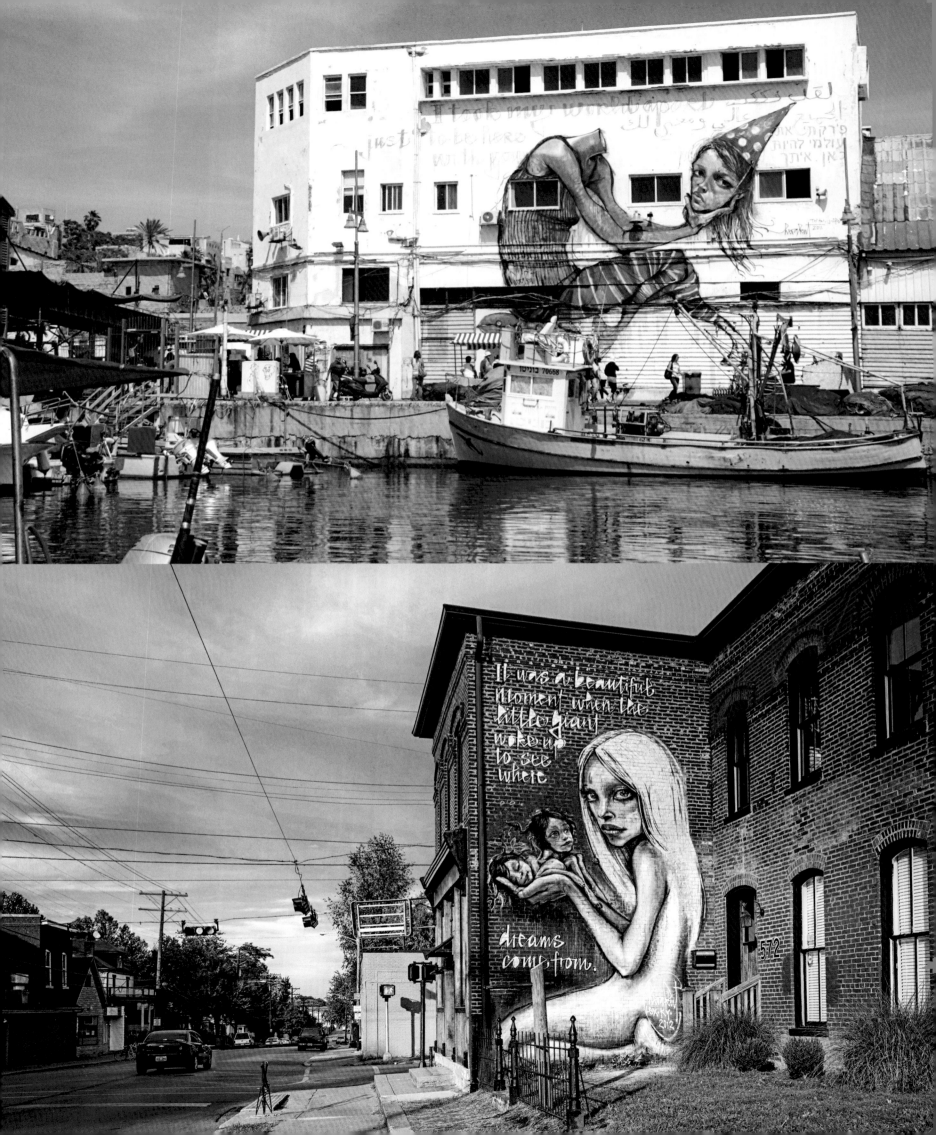

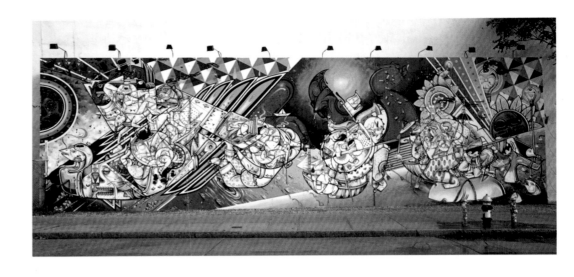

How and Nosm

How and Nosm are the identical twin brothers Raoul and Davide Perre. They were born in Spain, brought up in Germany and later moved to New York City, where they still live and work. In 1988 they started painting classic letter-based graffiti and gained recognition among their peers in Germany and Europe. Later, after moving to New York, they became members of the well-known Bronx-based TATS CRU. How and Nosm painted their first large mural in 1995, but the first large piece in their signature style wasn't painted until 2008.

How and Nosm's work is easy to recognize, with its reduced colour scheme of black, white and red, its multi-layered stories and characters, and its illustrative style of fine lines and geometric forms. The twins draw inspiration from their own past and that of society at large. Those experiences are mirrored in the many different messages and meanings of their complicated compositions. 'Our general source of inspiration is life and its many different aspects, as well as everyday experiences.'

The brothers' largest piece to date is *Heartship* (overleaf), 'about five stories high and 150 feet [45 metres] long', painted over five days in 2011 in the Arts District of Los Angeles. Their preferred tool is still the spray can, alongside paint rollers, extension sticks and brushes. They see the physical aspect of creating a large mural as their biggest challenge, especially when spending sixteen hours a day painting, but feel that painting large walls is very satisfying, both as a change from their studio work and because it gives them

the opportunity of 'knowing that every single line we just painted completely came out of our imagination.' Their way of approaching a mural project is very free and doesn't involve a lot of advance planning: 'We develop the concepts for our murals a few days before we start painting them, or right there on the spot. We improvise a lot and change the concept while we are painting the mural. Environment and surroundings as well the location of the mural play a big role in how it will turn out.'

ABOVE: *The Day After*, Houston/Bowery wall, New York City, 2012.
OPPOSITE: *Choose a Path*, Lisbon, 2013.
OVERLEAF: *Heartship*, Los Angeles, 2011 (above left); *Lost Conversation*, Bethlehem, Palestine, 2013 (above right); *Homing Pigeons*, Miami, 2012 (below).

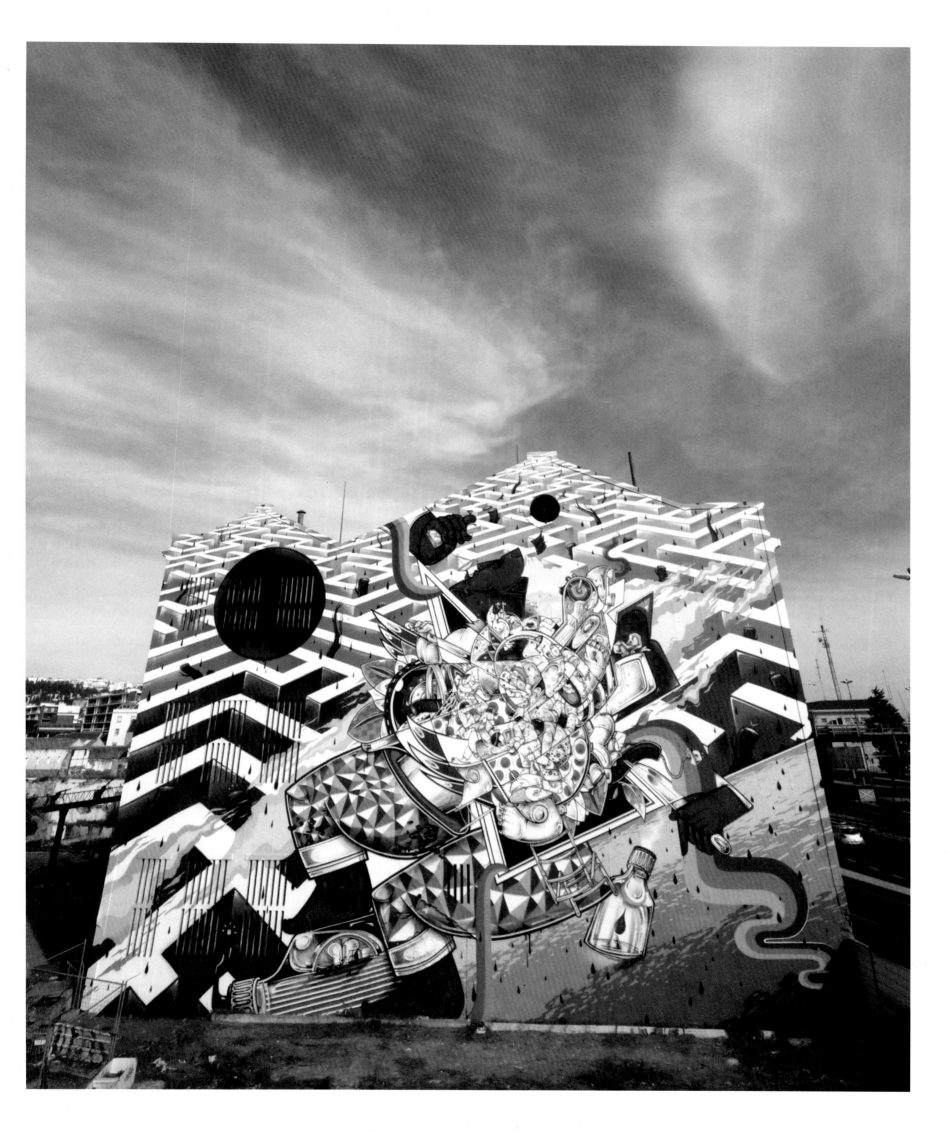

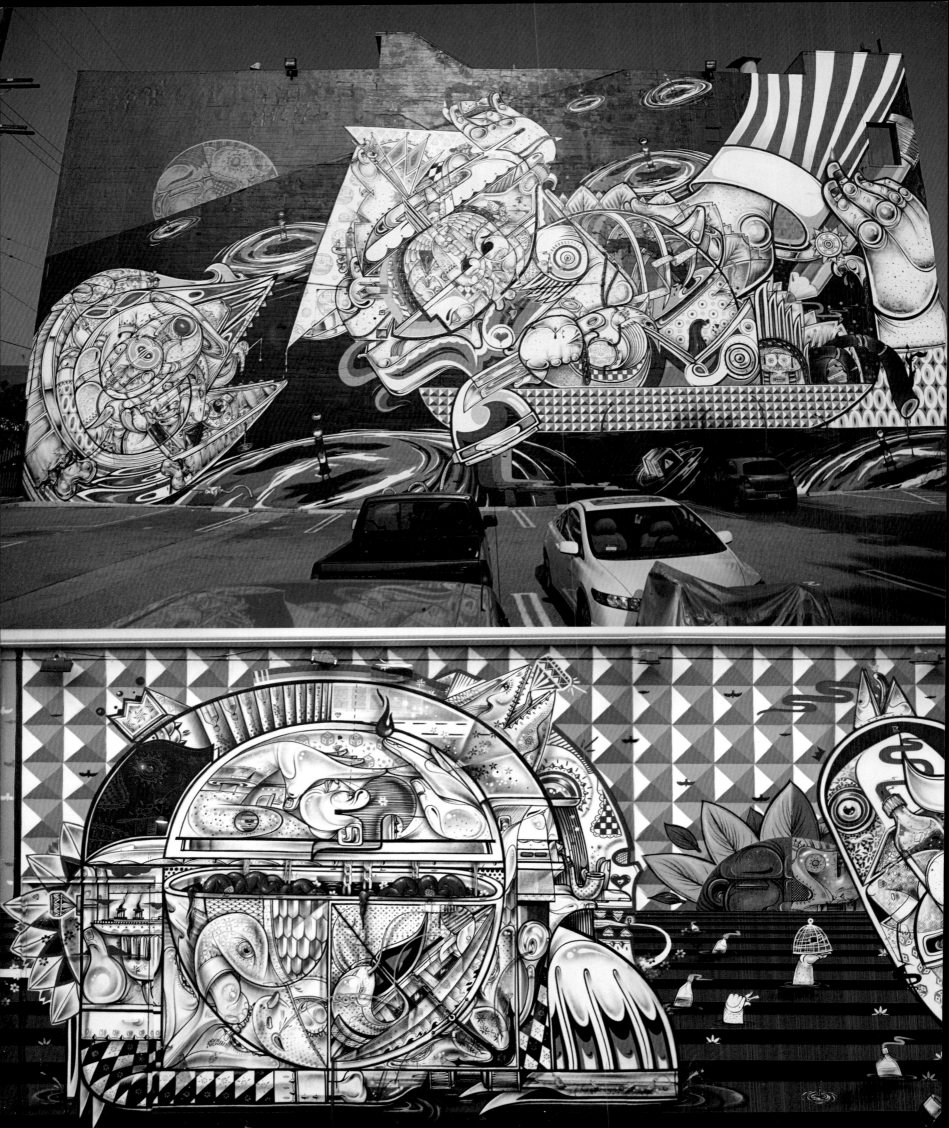

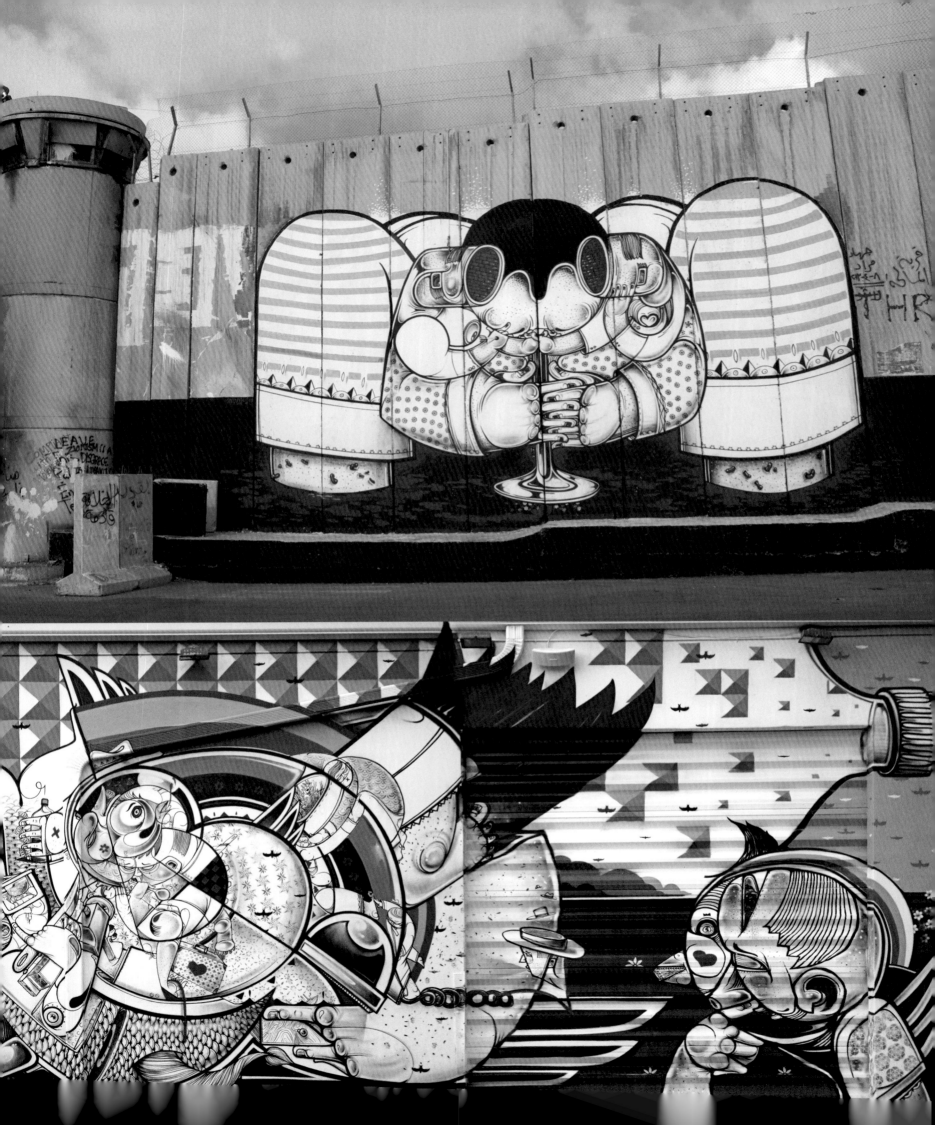

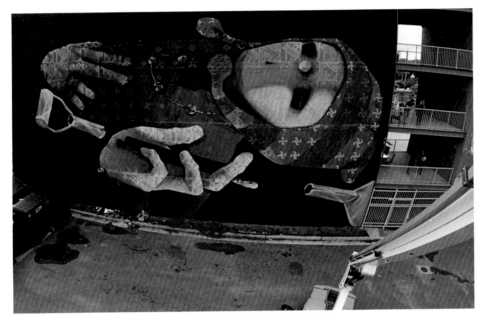

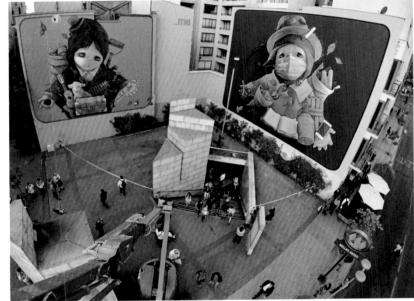

INTI

Chilean artist INTI started painting small-scale pieces in 1997 on the streets of his hometown, Valparaíso, and it was there that he created his first large mural in 2010. Since then, he has painted at least eight large-scale murals every year throughout the world. INTI's work is easily recognized by its warm, glowing colours, usually contrasting yellow and orange tones with purple, as well as by its distinctive puppet-like characters. He frequently takes inspiration from indigenous Latin American cultures in the dress of his figures and the graphic symbols and patterns that overlay them. His images typically have a religious, political or carnivalesque aspect, either in the pose of the central figure or in the surrounding elements. His largest piece to date, entitled *Our Utopia Is Their Future* (p. 1), was painted in November 2012 in Paris. It is 47 metres (155 feet) high and took ten days to finish.

To prepare his large pieces, INTI always starts with a sketch and a simple colour study to determine the type and quantities of materials. He then starts painting the wall from a mechanical lift, using only reference points rather than a complete grid to enlarge his sketch. He works layer by layer: first a light sketch, then darker lines for the final shapes; larger areas are filled with acrylic paint using rollers, then brushes are used to apply colour to smaller areas; finally, spray cans add depth, shadows and other finishing details. 'I work 80% with acrylic wall paint and 20% with spray paint,' he says. For spray-can work he uses only Astro Fat Caps; otherwise it would be impossible to fill the large spaces in such a short amount of time.

INTI usually works alone. Without someone on the ground to offer constant feedback, it can be difficult to keep the proportions and colours right when working in so large a format, but INTI loves the challenge each different wall poses: 'I love to go the difficult ways in life rather than the easy ones.'

ABOVE: Atlanta, GA, USA, 2013 (left); Santiago, Chile, 2013 (right). OPPOSITE: Istanbul, 2013. OVERLEAF: *Holy Warrior*, Łódz, Poland, 2012 (left); *La Virgen de la Discordia*, San Juan, Puerto Rico, 2013 (right).

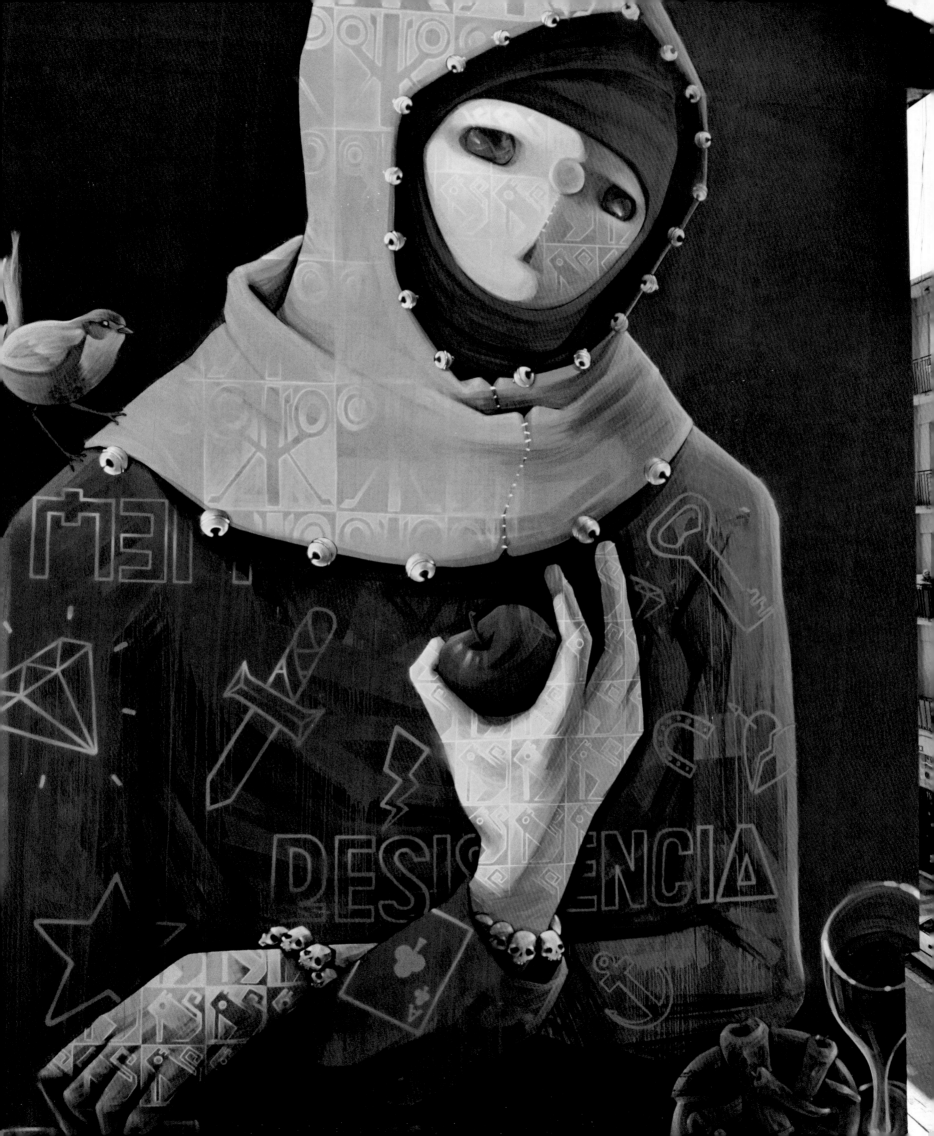

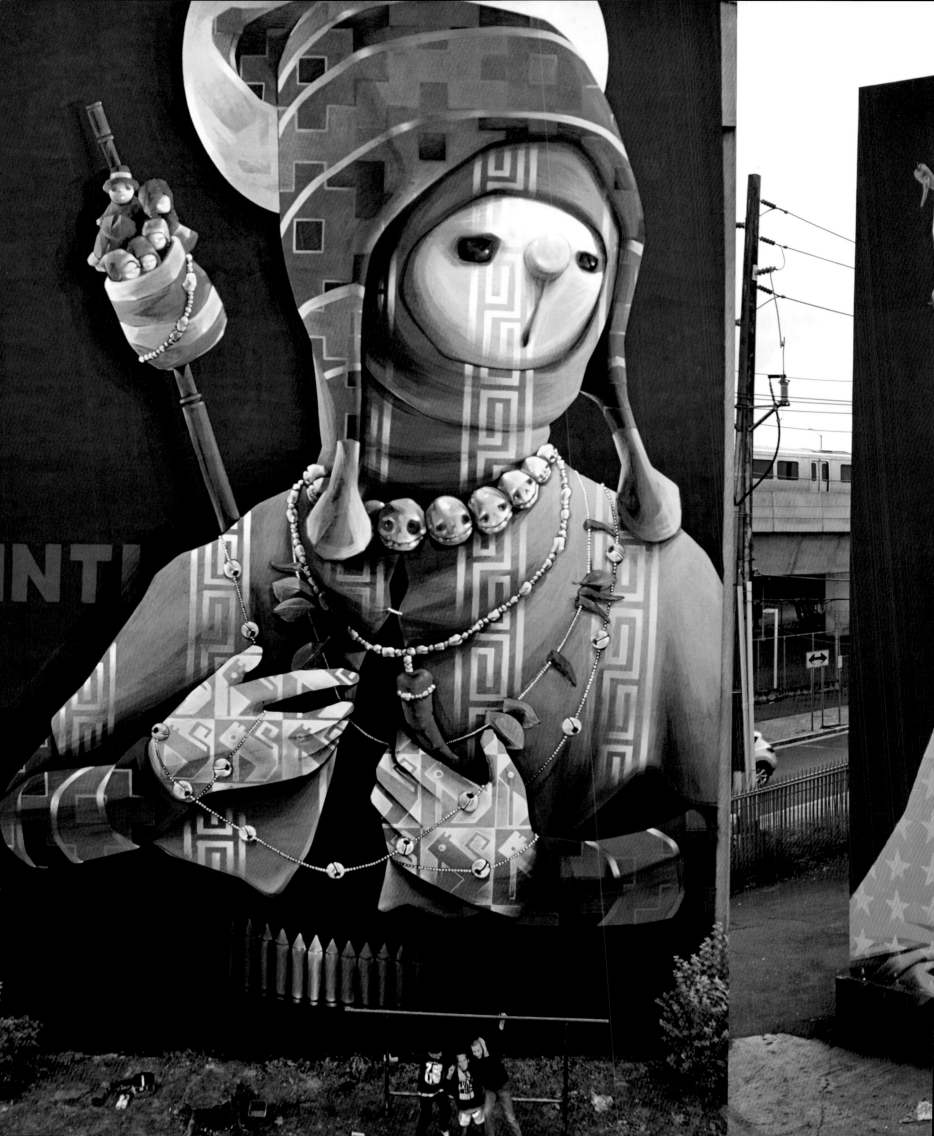

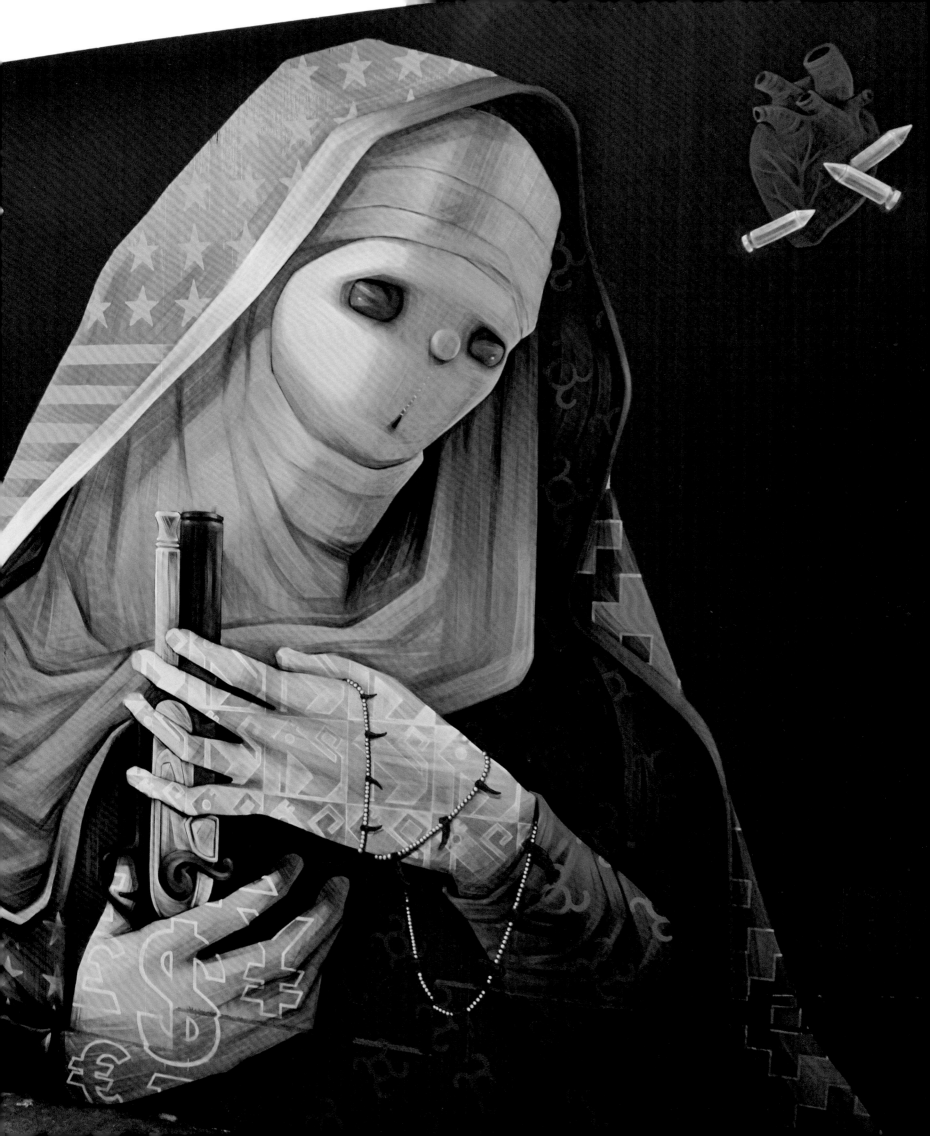

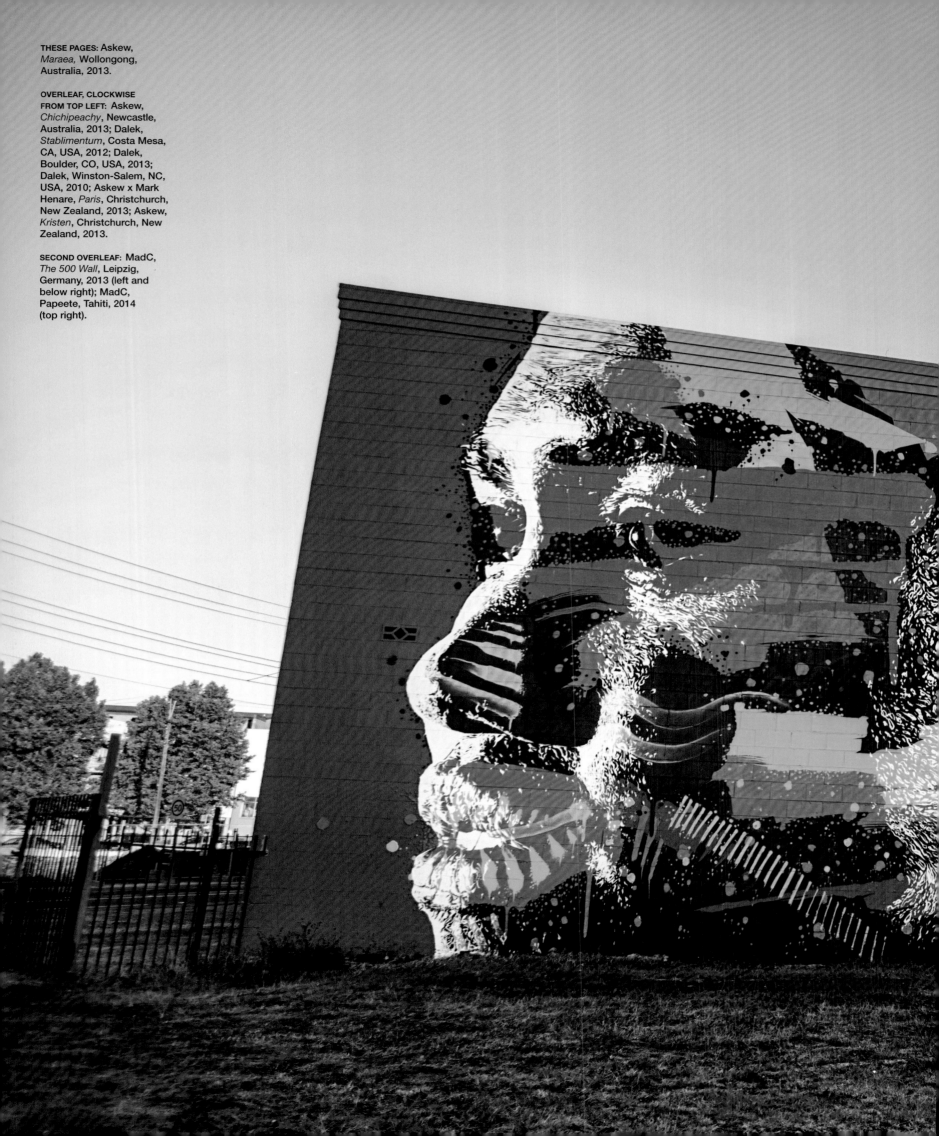

THESE PAGES: Askew,
Maraea, Wollongong,
Australia, 2013.

**OVERLEAF, CLOCKWISE
FROM TOP LEFT:** Askew,
Chichipeachy, Newcastle,
Australia, 2013; Dalek,
Stablimentum, Costa Mesa,
CA, USA, 2012; Dalek,
Boulder, CO, USA, 2013;
Dalek, Winston-Salem, NC,
USA, 2010; Askew x Mark
Henare, *Paris*, Christchurch,
New Zealand, 2013; Askew,
Kristen, Christchurch, New
Zealand, 2013.

SECOND OVERLEAF: MadC,
The 500 Wall, Leipzig,
Germany, 2013 (left and
below right); MadC,
Papeete, Tahiti, 2014
(top right).

Mixed

Since no single book can hope to cover the ever-growing movement of XXL mural art, these 'Mixed' pages are intended to showcase a wider range of artists and graphic styles.

Askew, from New Zealand, gained international fame as a graffiti writer many years ago. These days he honours his roots by painting massive murals of Polynesian people.

German artist MadC, who is the author of this book, also started out as a graffiti writer and has always painted large. For some years she has translated her works on canvas into large scale murals, painting her name in abstract, calligraphic shapes made up of transparent layers that look like watercolours.

Dabs and Myla are a married artist couple originally from Australia, but now living and working in Los Angeles. They have travelled extensively over the past few years and gained recognition for their comic illustrations and wall creations.

American artist James Marshall, also known as Dalek, originally became famous for his 'Space Monkey' character (which actually looked like a mouse). Over time, however, the graphic elements surrounding the character took centre stage,

as he began producing abstract works of radiating lines in vibrant shaded colours.

Tristan Eaton lives in Los Angeles. He started working as a street artist when he was a teenager but later made a name for himself as a toy designer. He studied at the School of Visual Arts in New York City and now dedicates his time to painting both murals and smaller works on canvas.

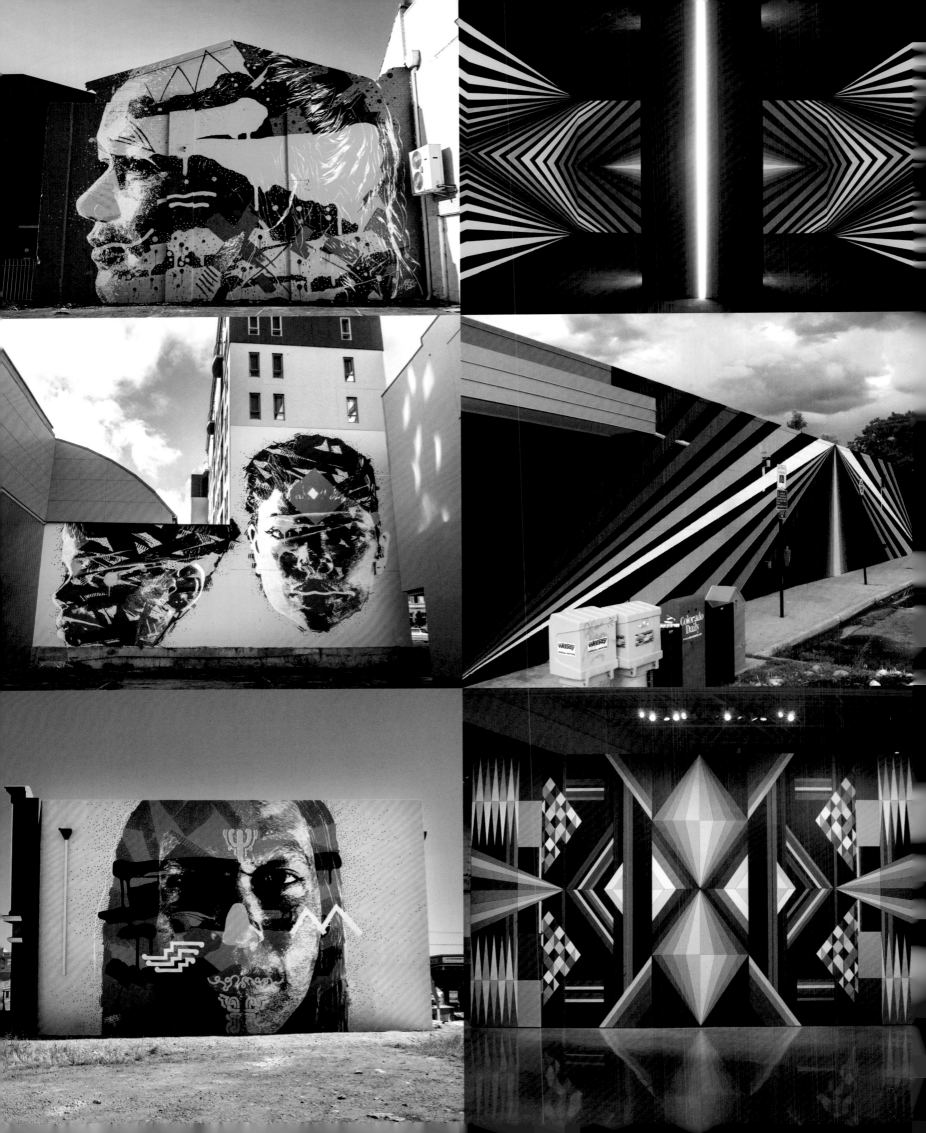

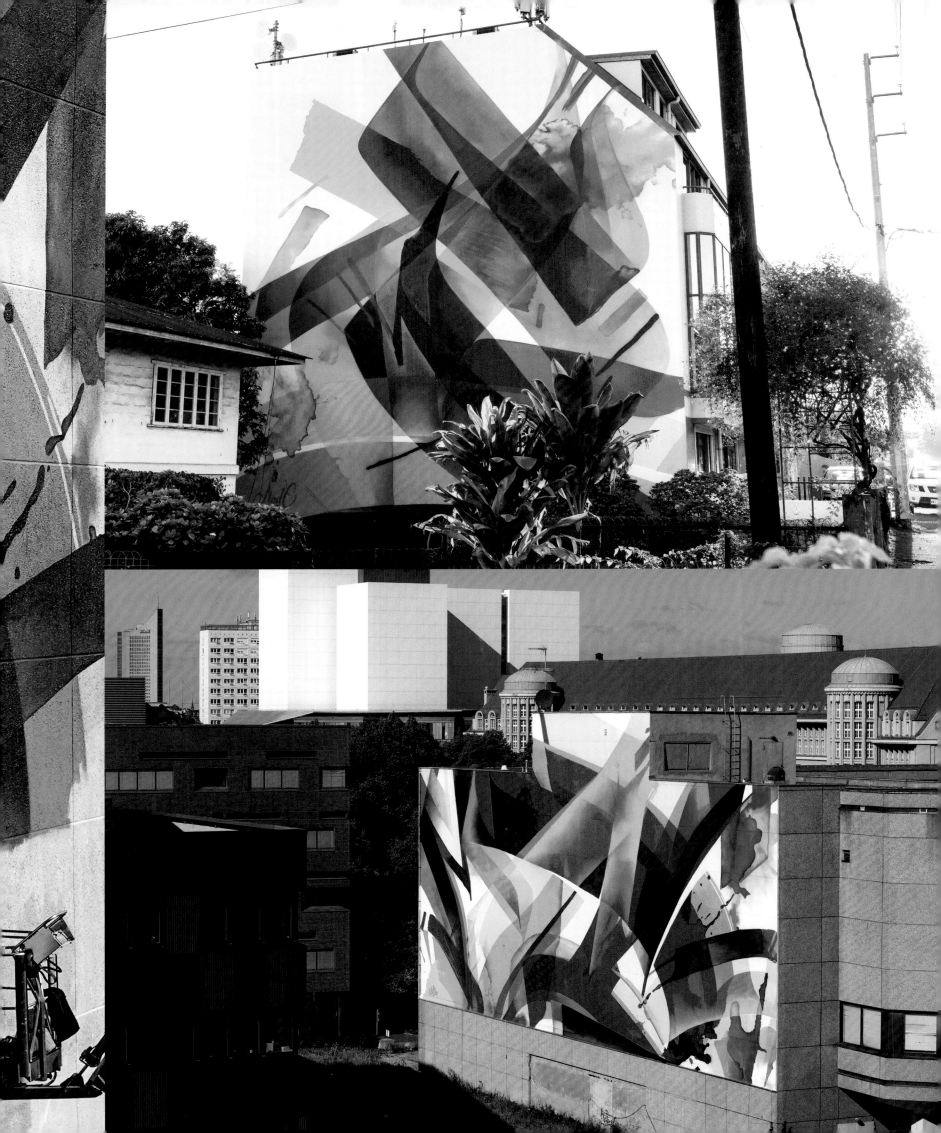

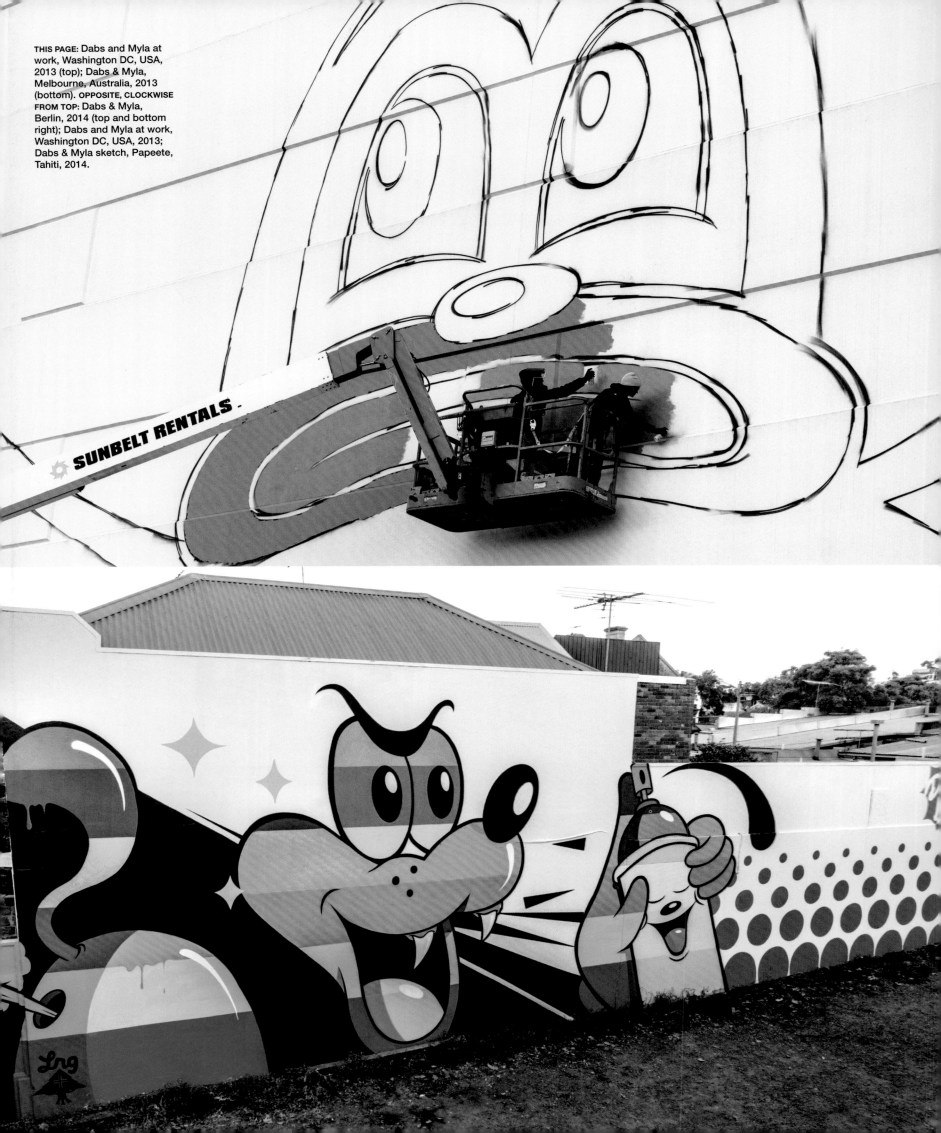

THIS PAGE: Dabs and Myla at work, Washington DC, USA, 2013 (top); Dabs & Myla, Melbourne, Australia, 2013 (bottom). OPPOSITE, CLOCKWISE FROM TOP: Dabs & Myla, Berlin, 2014 (top and bottom right); Dabs and Myla at work, Washington DC, USA, 2013; Dabs & Myla sketch, Papeete, Tahiti, 2014.

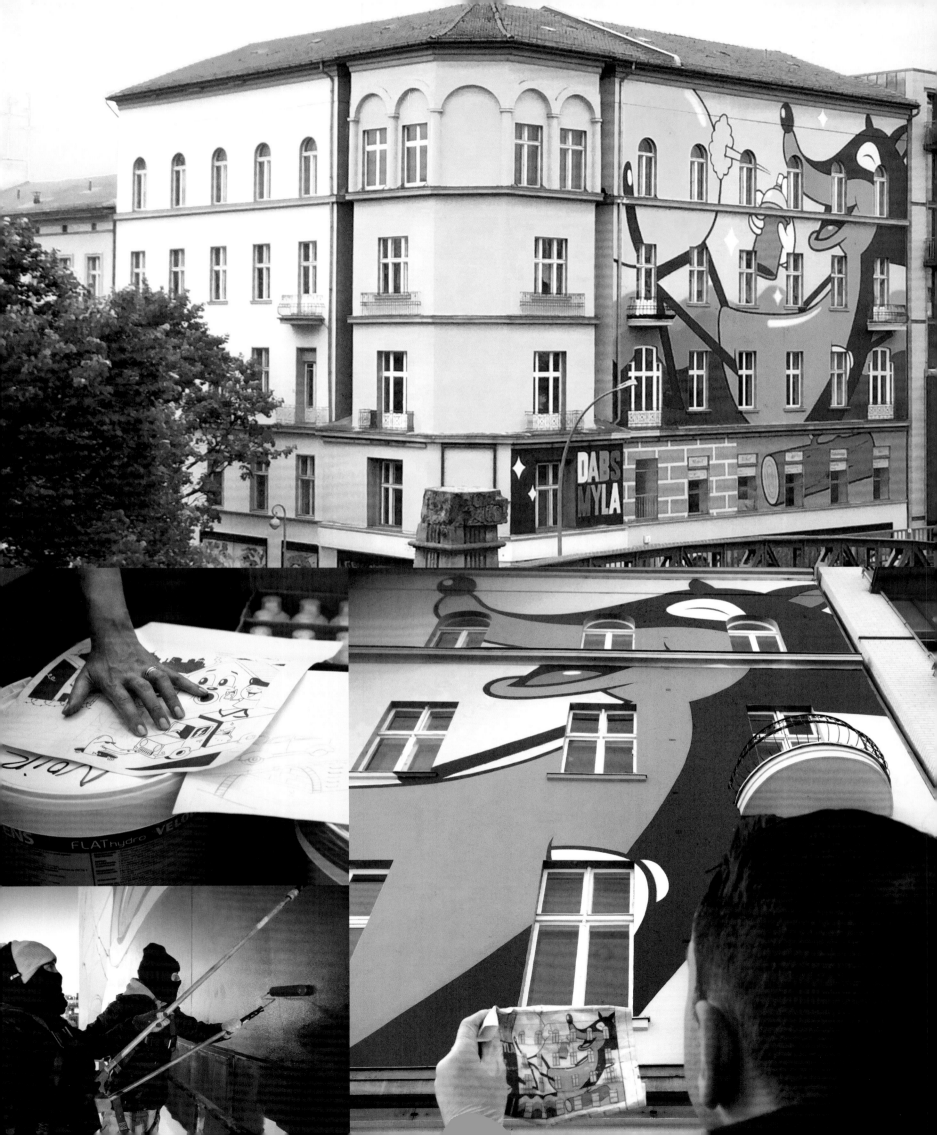

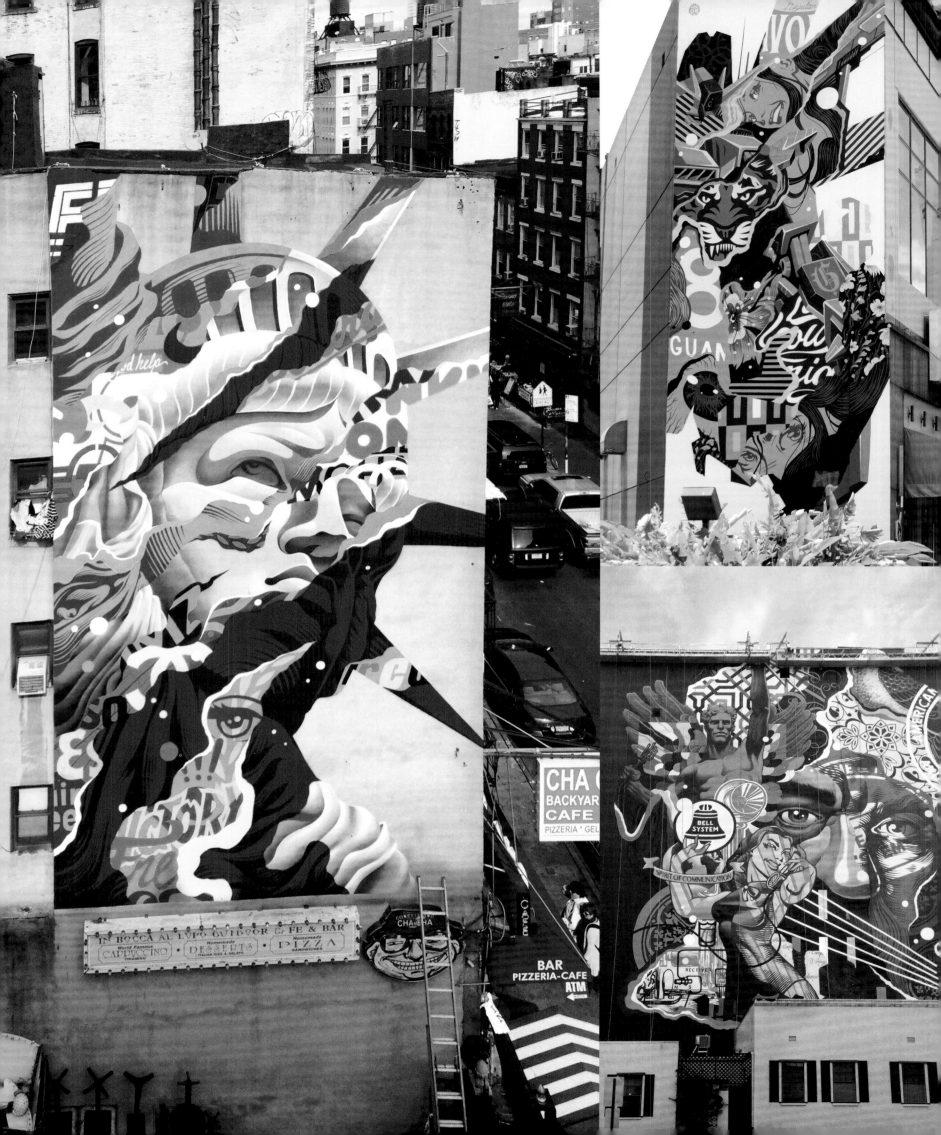

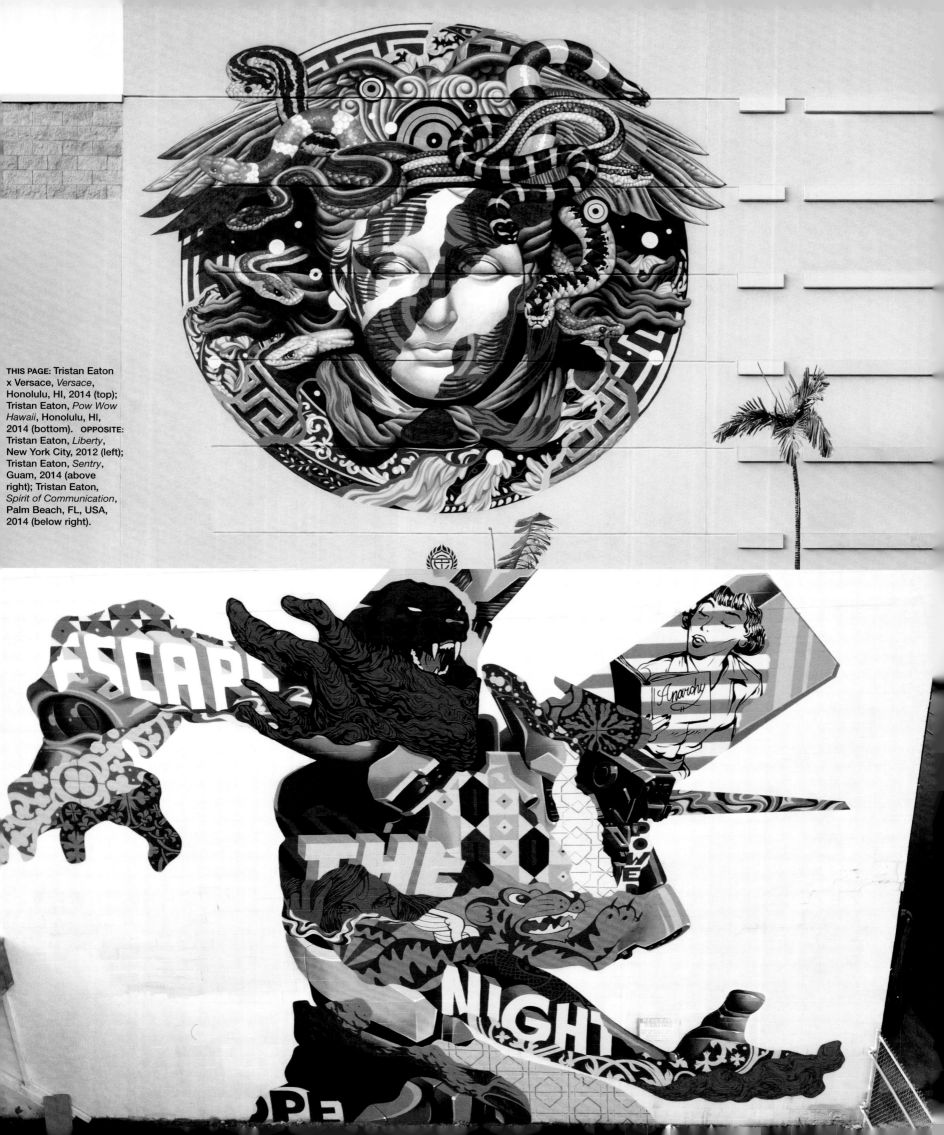

THIS PAGE: Tristan Eaton x Versace, *Versace*, Honolulu, HI, 2014 (top); Tristan Eaton, *Pow Wow Hawaii*, Honolulu, HI, 2014 (bottom). OPPOSITE: Tristan Eaton, *Liberty*, New York City, 2012 (left); Tristan Eaton, *Sentry*, Guam, 2014 (above right); Tristan Eaton, *Spirit of Communication*, Palm Beach, FL, USA, 2014 (below right).

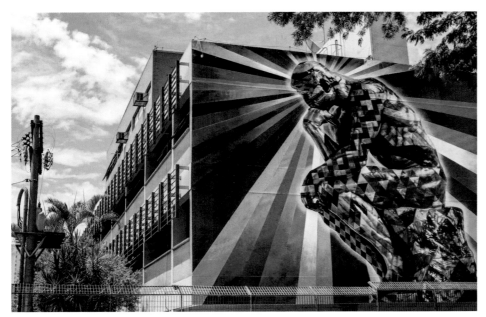
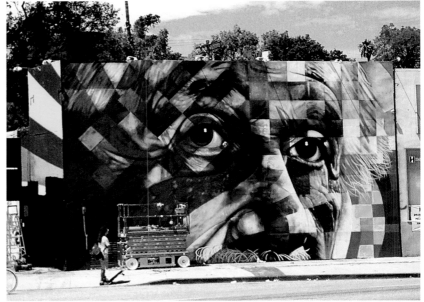

Eduardo Kobra

Brazilian artist Eduardo Kobra started painting pixação in the streets of São Paulo in 1987. Ten years later he turned to painting large-scale walls, gaining recognition for his massive compositions of geometric shapes in strong, contrasting colours, filled with large photorealistic faces and sceneries. He draws his inspiration mainly from historic images, vintage photographs and iconic historical figures. Wherever he paints a mural, its subject is related to the past of the city or the country in which it is situated. One well-known example of his work can be found in New York City, where he painted an interpretation of Alfred Eisenstaedt's famous photograph in *Life* magazine of a sailor spontaneously kissing a nurse in Times Square while celebrating Japan's surrender to the Allies at the end of the Second World War (second overleaf, below right). On a second wall, below the kissing couple, Kobra painted a scene showing Times Square in 1945, the year the picture was taken by Eisenstaedt.

Kobra's biggest and best-known mural (opposite) is in Brazil, on Avenida Paulista, one of São Paulo's busiest streets. The piece covers the entire side of a building and is 52 metres (170 feet) tall. Kobra dedicated the mural to the well-known Brazilian architect Oscar Niemeyer, who passed away shortly before the painting of the wall started in 2013. It took Kobra and his team 40 days to finish the mural. 'I worked with three more artists from my team, but it required other people involved in the whole-project logistics.' The self-taught artist makes use of many different painting techniques in order to adapt to different wall sizes and surfaces. His main tools are brushes, rollers, airbrushes and spray cans.

Kobra and his team paint an unusually large number of murals throughout the year. 'I have about 3,000 pictures of murals I have painted and we do between two and four murals every month.'

ABOVE: *The Thinker*, São Paulo, 2014 (left); *Einstein*, Los Angeles, 2013 (right). OPPOSITE: *Oscar Niemeyer*, São Paulo, 2013. OVERLEAF: *The Dancer*, Moscow, 2013. SECOND OVERLEAF: *Lincoln*, Lexington, KY, USA, 2013 (above left); *Salvador Dalí*, Miami, 2013 (below left); *Frida Kahlo*, Miami, 2013 (above right); New York City, 2012 (below right).

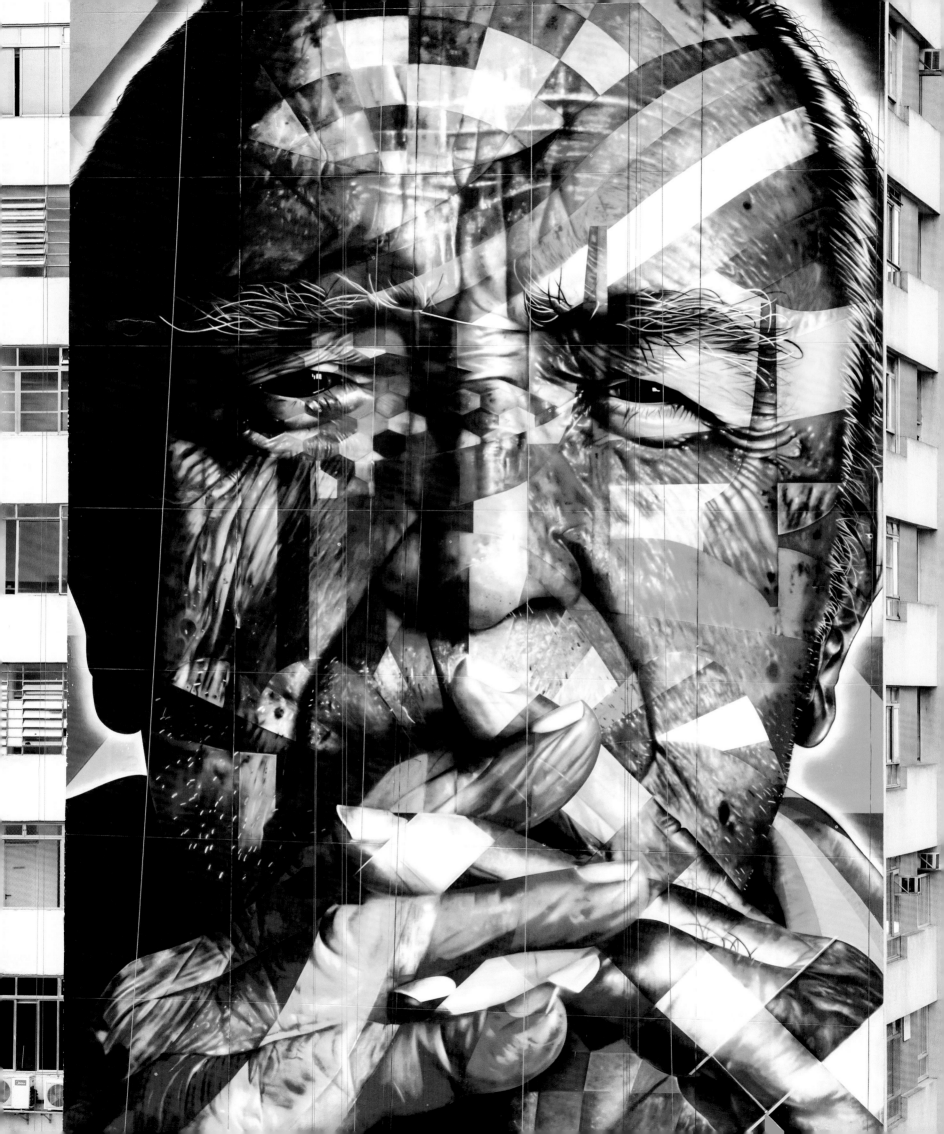

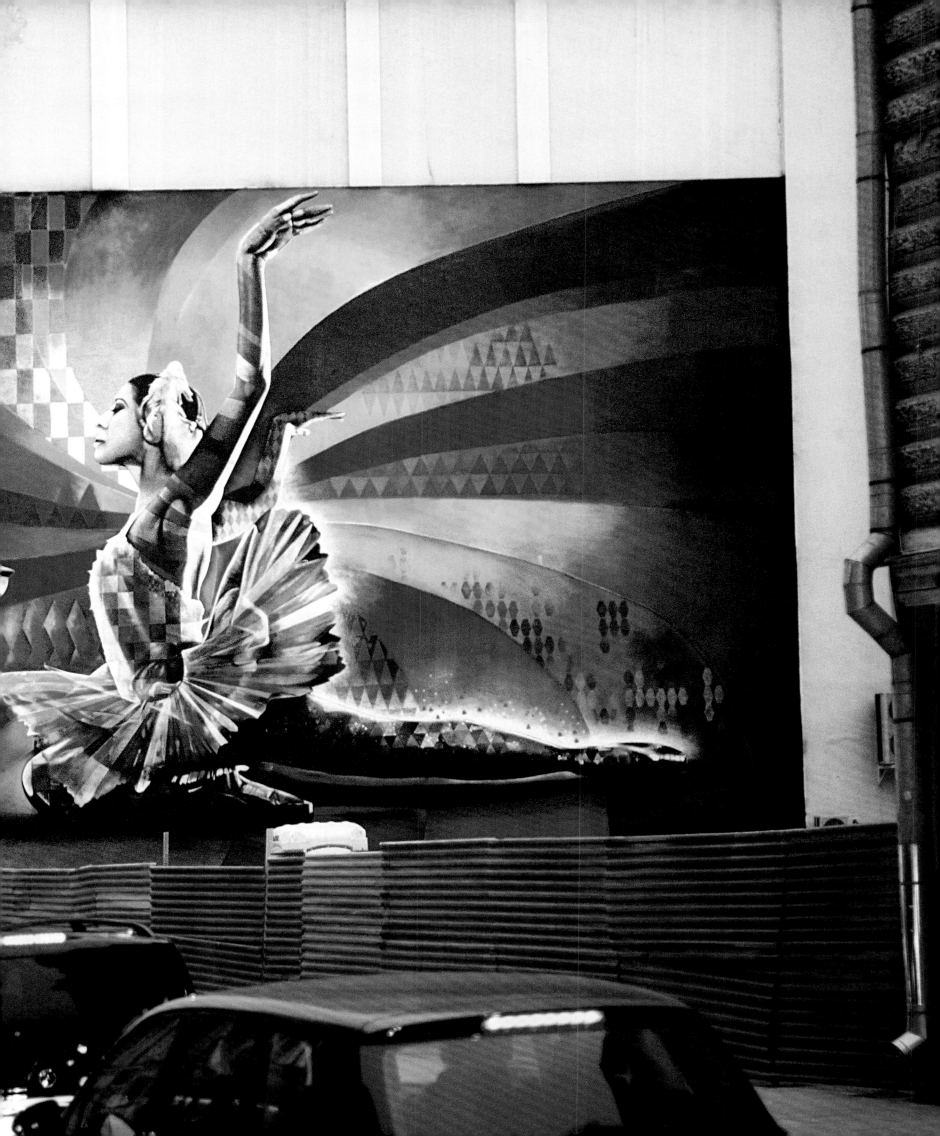

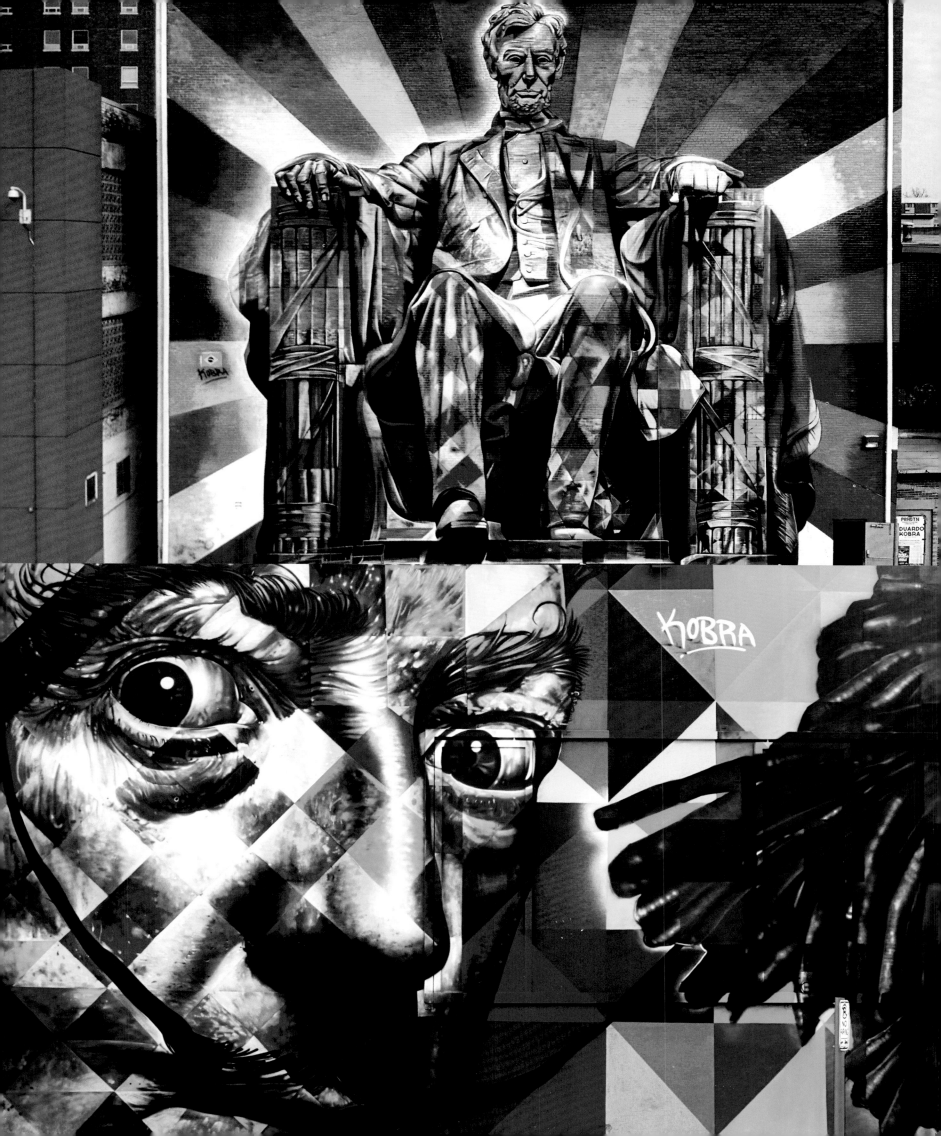

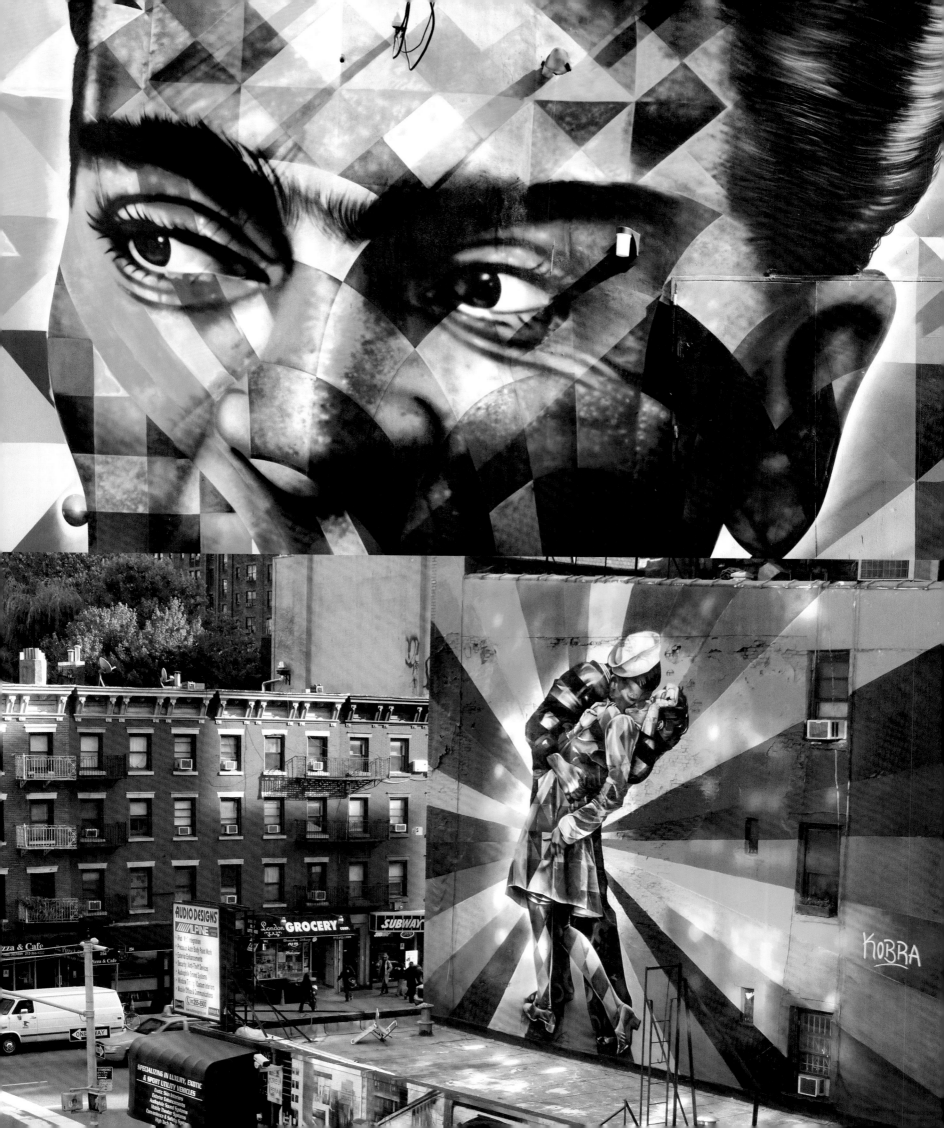

Kofie

Augustine Kofie was born and raised in Los Angeles, where he began earning his stripes in the graffiti movement under the name Kofie in 1993. After studying, stretching and reconstructing the letters in his wildstyle pieces, he developed his characteristic abstract approach, which is based on elementary structures of squares, triangles and circles. 'I admire non-representational works. I've always gravitated toward the abstract and percussionist movements. I also have a dedicated and driven personality. I very much enjoy control. Painting allows me to exploit these personalities as well as share my imagination and perspectives of shape, form and balance.' In combination with his earth-toned colour palette, his complex compositions of thin lines and dynamic mechanical shapes become abstract, futuristic pieces with a vintage touch, a style described variously as Vintage Futurism or Post-Graffiti. Kofie painted his first large mural in 2002. His largest piece to date, in the Colonia Roma district of Mexico City (this page and opposite), measures 610 square metres (2,000 square feet) and was finished by him and two assistants in December 2013.

Besides latex paint, spray paint and rollers in various sizes, Kofie also makes use of masking tape, straight edges and chalk lines. 'I superimpose a loose sketch over a photograph of the proposed wall. I try to take in windows, wall blemishes, brick or other architectural markers on the wall as points of reference for the mural. I'm not against the use of a projector, but since my designs are already in a grid-like pattern, it's unnecessary.'

Even though Kofie feels that the painting process is very physically and mentally demanding, he enjoys painting on such a large scale. 'The undertaking. The challenge. The reward. I sometimes take for granted my ability to understand scale. I appreciate this ability to transition from small scale to massive somewhat comfortably.'

THIS PAGE AND OPPOSITE:
Circulations Emerge in Roma Norte, **Mexico City, 2013. OVERLEAF:** *Futurino,* **Turin, Italy, 2012.**

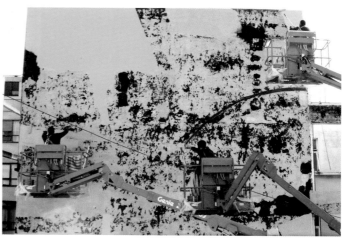

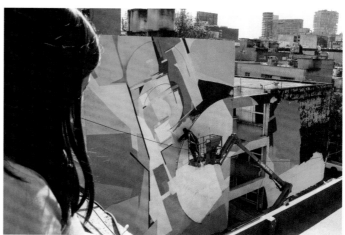
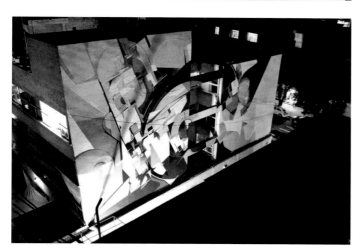

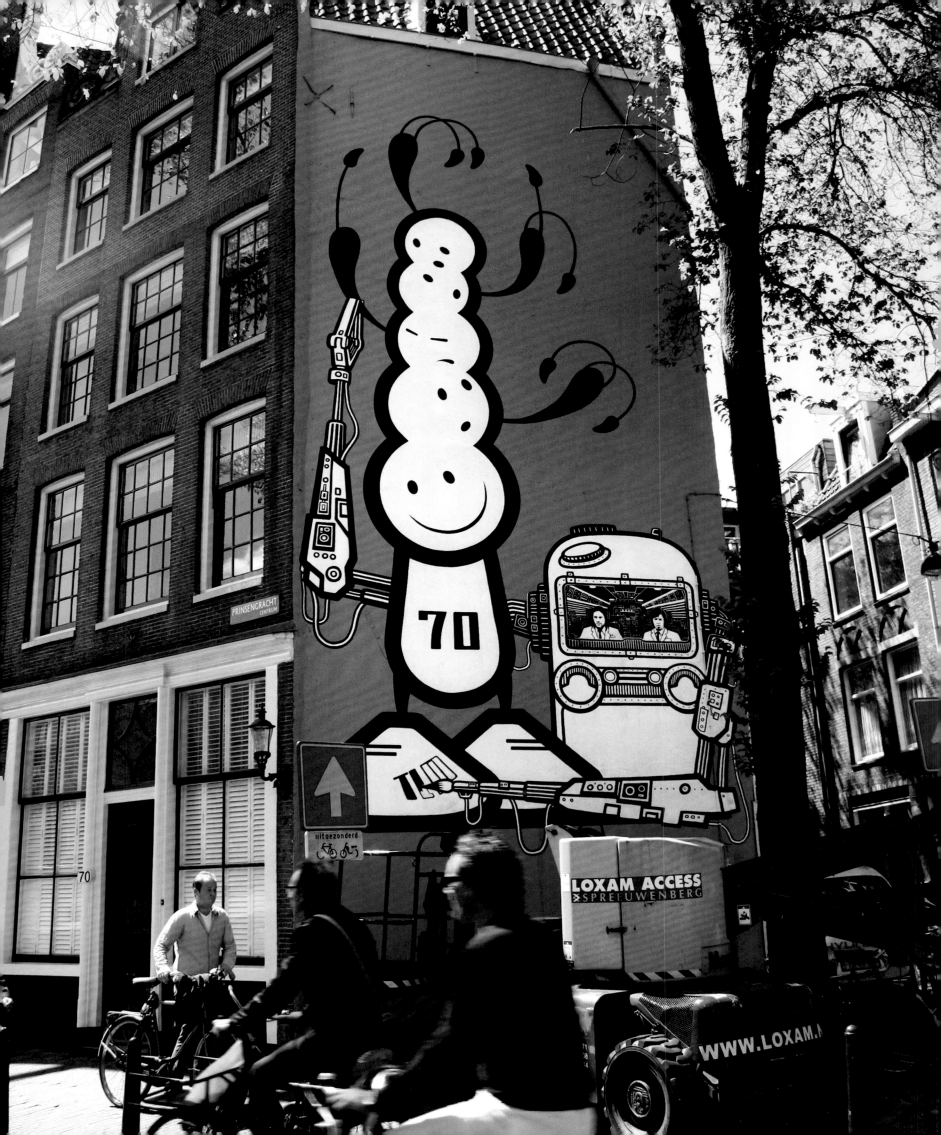

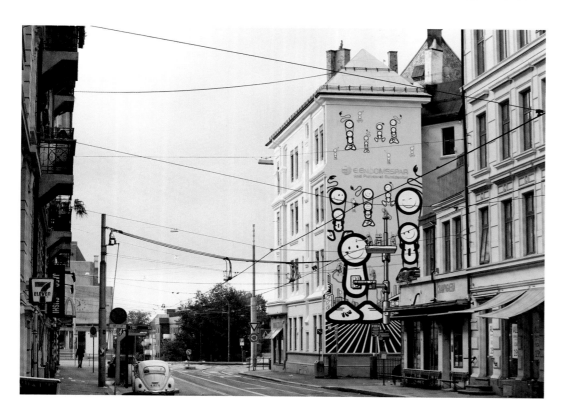

The London Police

The London Police is a collaboration between British artists Chaz Barrisson and Bob Gibson that started back in 1998. Their original idea was to take photographs and paste them up in the streets, but they never got around to it. After moving from London to Amsterdam that same year, the team became known for their iconic black-and-white figures, called 'LADs', which

had perfectly circular heads and smiling faces. These characters were mainly Chaz's creations. Bob left the team for a while, hoping to create something of his own; he attended art school and a few years later rejoined Chaz, adding architectural illustrations and robotic elements to Chaz's LADs that gave them a new world to play in. Despite Bob's innovations, the team stayed true

to their signature black-and-white colour scheme, graphic line work and friendly faced LADs.

In order to paint the LADs, Chaz has taught himself to paint a perfectly round circle freehand. To achieve a perfect result, he first draws a thin line to get the rough shape right and paints over it with a broad-tipped marker pen, using the left edge of the tip as a guide. Sometimes they also use circular stencils for the smaller round shapes in the murals. Even on large walls, Chaz and Bob use acrylic paint markers, emptying a huge number of them

in the process. They use the paint markers to sketch up the complete piece at the start, and later to add the many tiny details that finish the mural. They also use a large amount of masking tape, both as a painting guide and to help produce especially sharp line work. For larger areas they resort to wall paint, rollers of different sizes and brushes.

This method of working is very time-consuming, but it allows the London Police murals to keep their clean, graphic look when viewed up close as well as from a distance. Walls created by the team can be found in more than thirty-five countries ranging from Slovakia to Norway, and in the world's largest cities, including Berlin, Amsterdam, Singapore, Oslo and various locations in the USA.

ABOVE: Oslo, 2011. **OPPOSITE:** Amsterdam, 2009. **OVERLEAF:** The Ship Inn, Newcastle, UK, 2012 (above left); Miami, 2013 (below left); Miami, 2010 (above right); Hollywood, FL, USA, 2014, (below right).

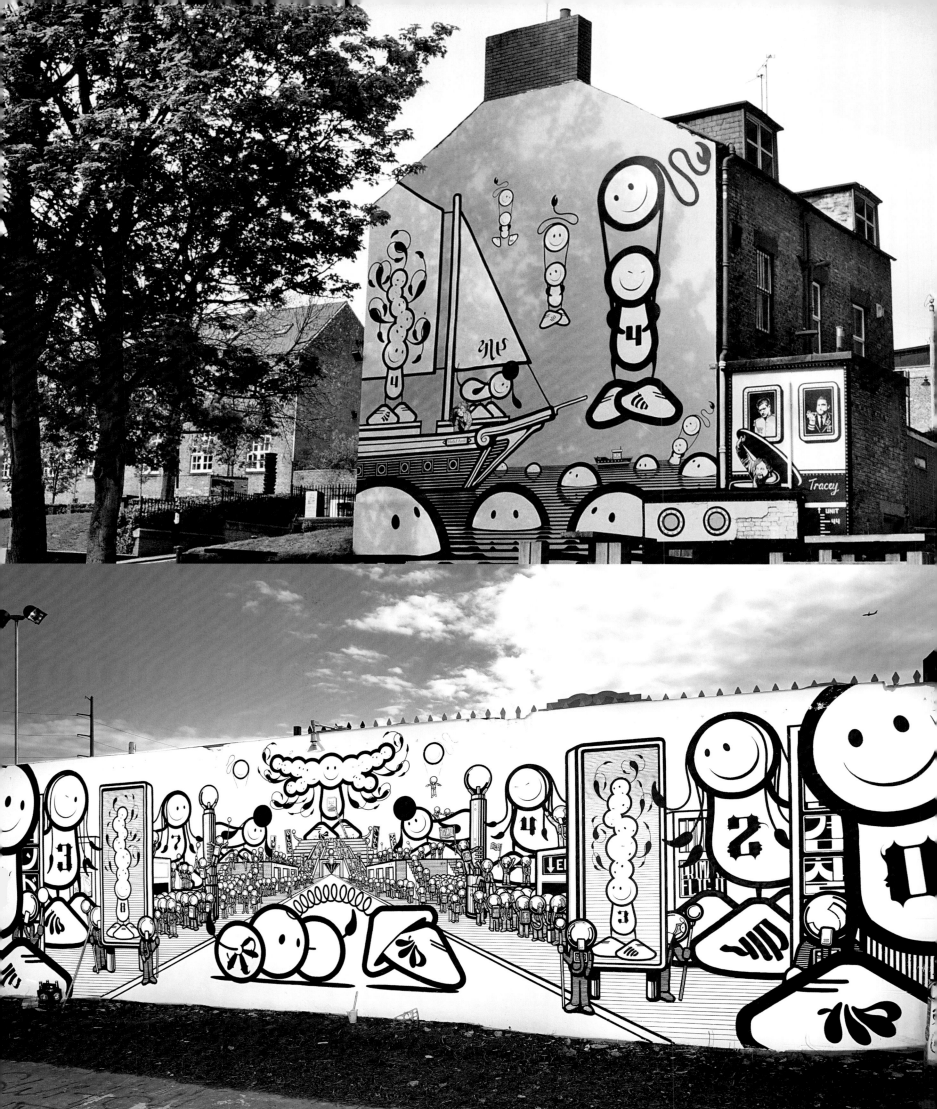

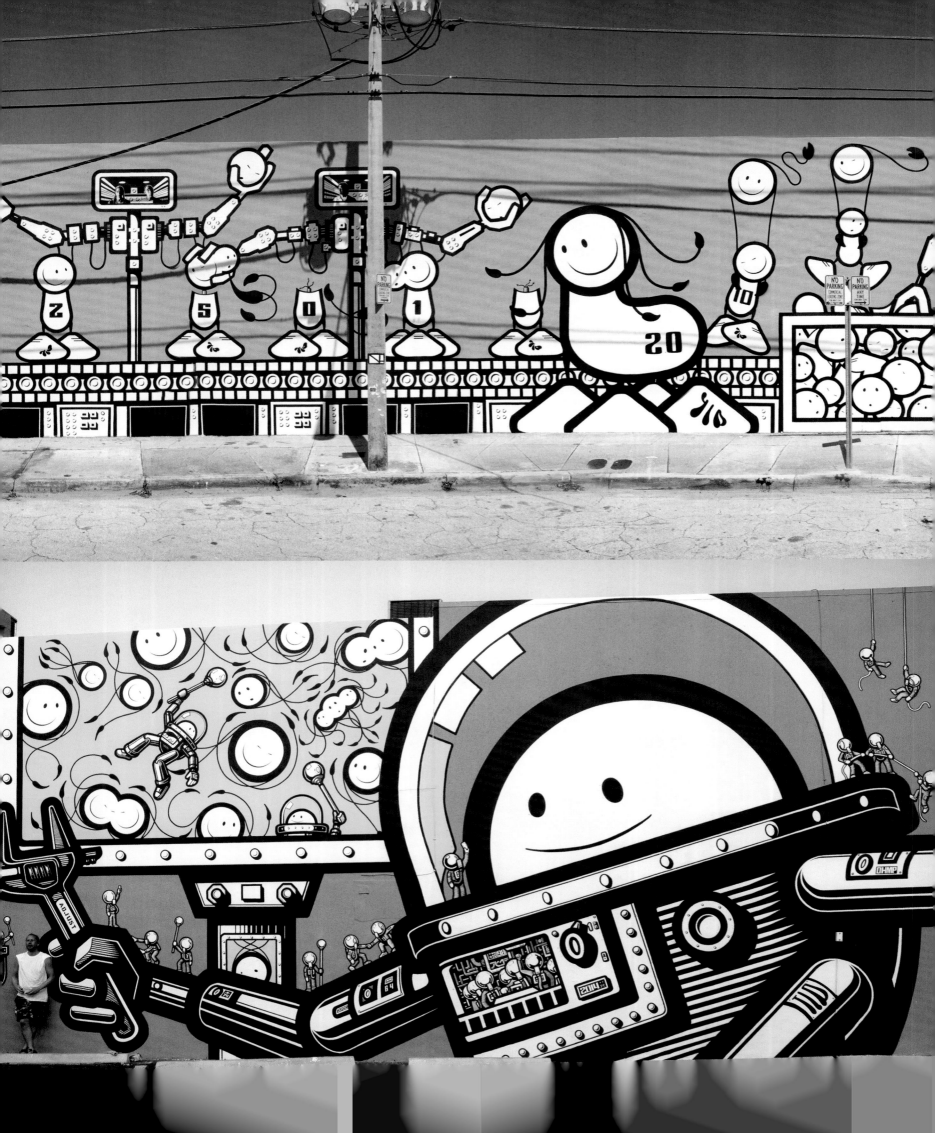

M-City

Polish artist Mariusz Waras started his M-City project in 2003. In addition to the massive murals that he paints worldwide, he also exhibits his work in galleries and lectures at the Academy of Fine Arts in Gdansk, Poland. M-City is known for his limited use of colour, and for his massive, monochromatic, single-layer stencilled illustrations. His pieces depict detailed industrial landscapes composed of machines, chimneys, cog wheels, cranes, skyscrapers and factories. 'My work is friendly from a distance, but when you look closer and closer it turns darker and darker. Then it becomes a dirty, dark and black world with smoking factories and abandoned houses. It's not easy to find green trees and people there. That is my world.'

M-City has painted many unusual site-specific pieces, such as at the control tower at Stavanger Airport in Norway or the former Soviet Palace of Trade Unions in Vilnius, Lithuania. 'It's very important to paint something specific for the place, so it is good to know everything about the surroundings beforehand.' Once he has come up with his idea and made a sketch for the mural, he projects it in his studio to create large stencils, which he cuts, rolls up and then brings to the wall to be assembled into the complete piece. He used this technique to paint his largest mural to date, in downtown Los Angeles in 2008. The piece is 6 metres high and 85 metres long (20 x 280 feet).

M-City prefers to spend as little time as possible in the actual painting of his murals. 'I don't like to paint for long. Usually it takes me between two to four days to finish any size of a wall.' The massive hand-cut stencils that help him work quickly outdoors, however, require a lot of preparation time in his studio. 'I prefer to work with stencils because I love the stencil style and they allow me to fill thousands of square metres in a short amount of time. Of course this means that I must spend a lot of time in my studio to prepare the stencils first. When I paint three days, I also cut three days.' At first he found the size of large walls intimidating, but after painting fifteen to twenty murals a year he gradually lost his fear. 'Today it is very easy to approach a large wall. But in the beginning everything was wrong: the wall was too high, too big and I was too scared.'

THIS PAGE AND OPPOSITE: *m-city 716*, Cologne, 2013. OVERLEAF: *m-city 659*, Bologna, 2012 (top left and top centre); *m-city 464*, Mexico City, 2011 (centre and centre left); *m-city 715*, Stavanger, Norway, 2013 (bottom left and bottom centre); *m-city 732*, New Delhi, 2014 (top right and bottom right). SECOND OVERLEAF: *m-city 236*, Gdańsk, Poland, 2008.

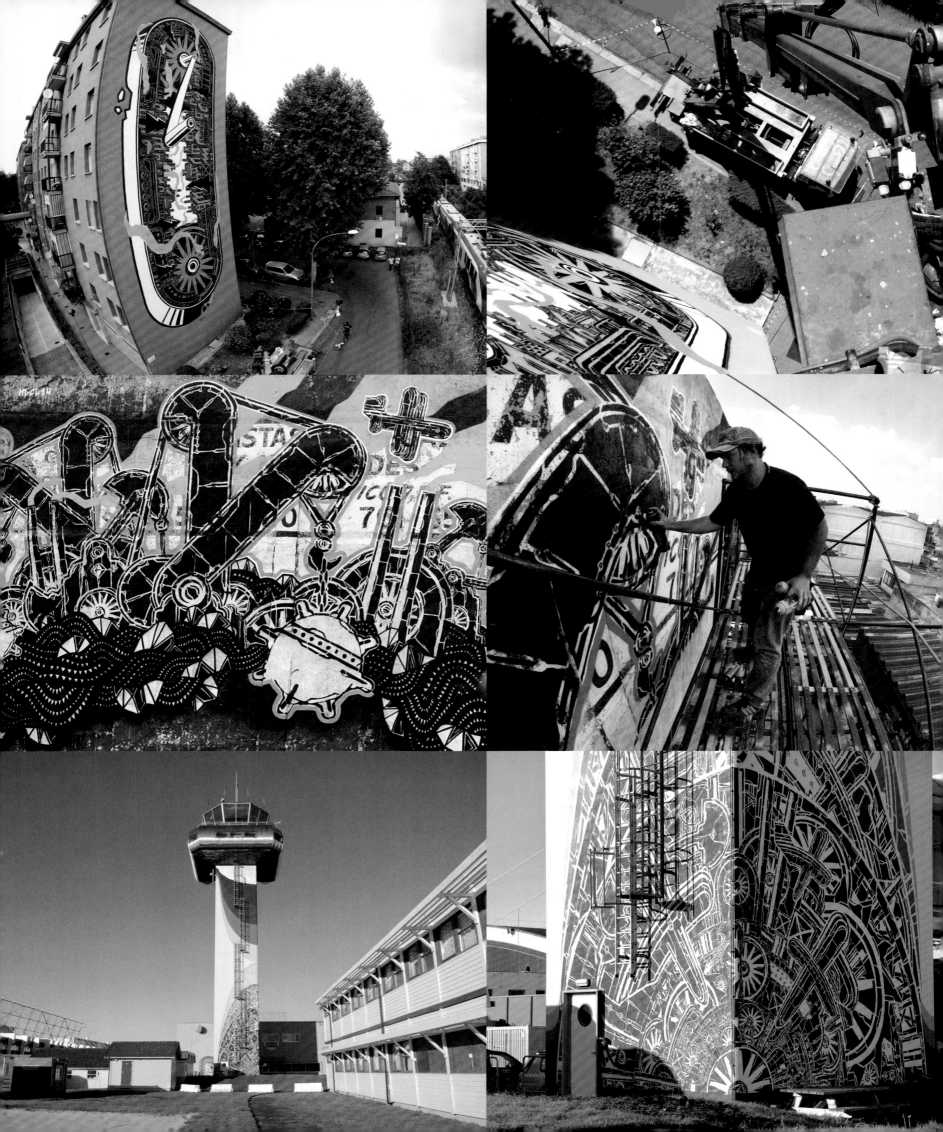

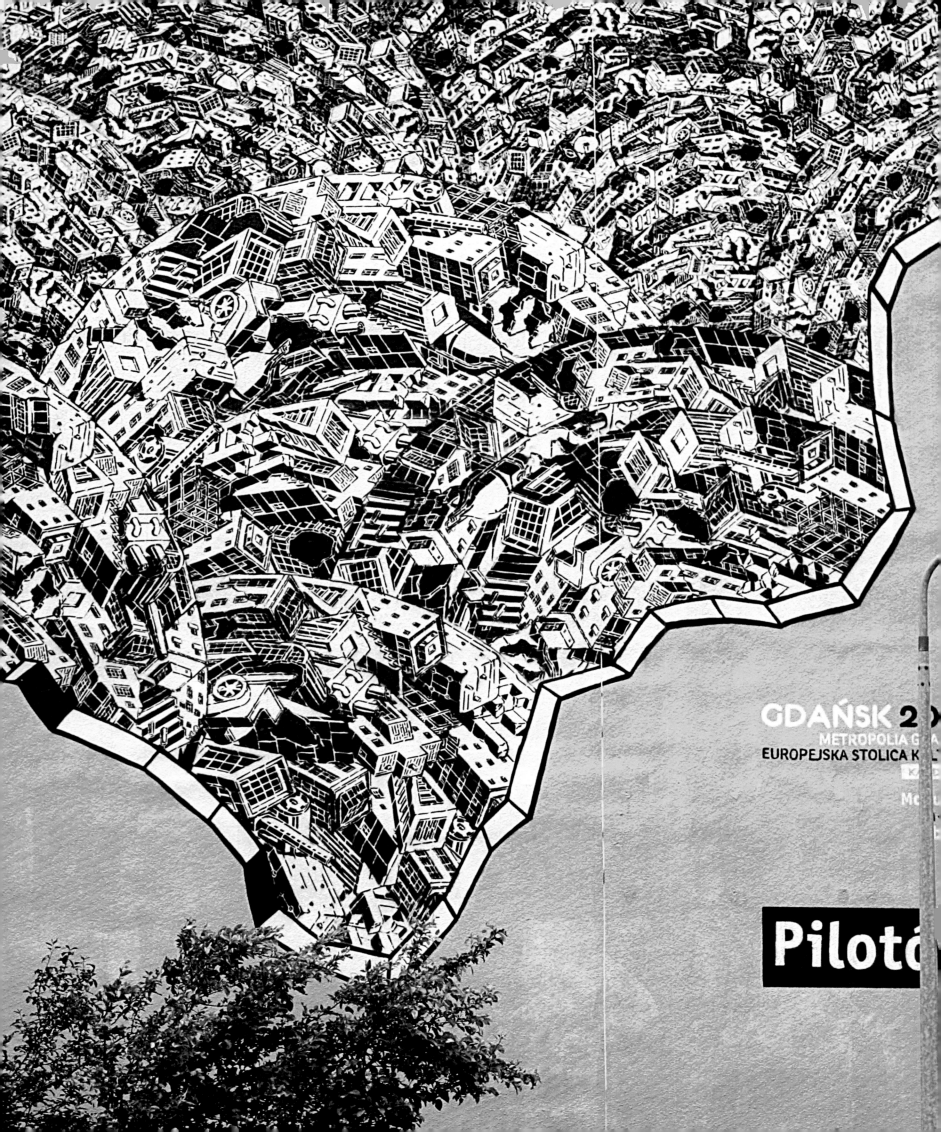

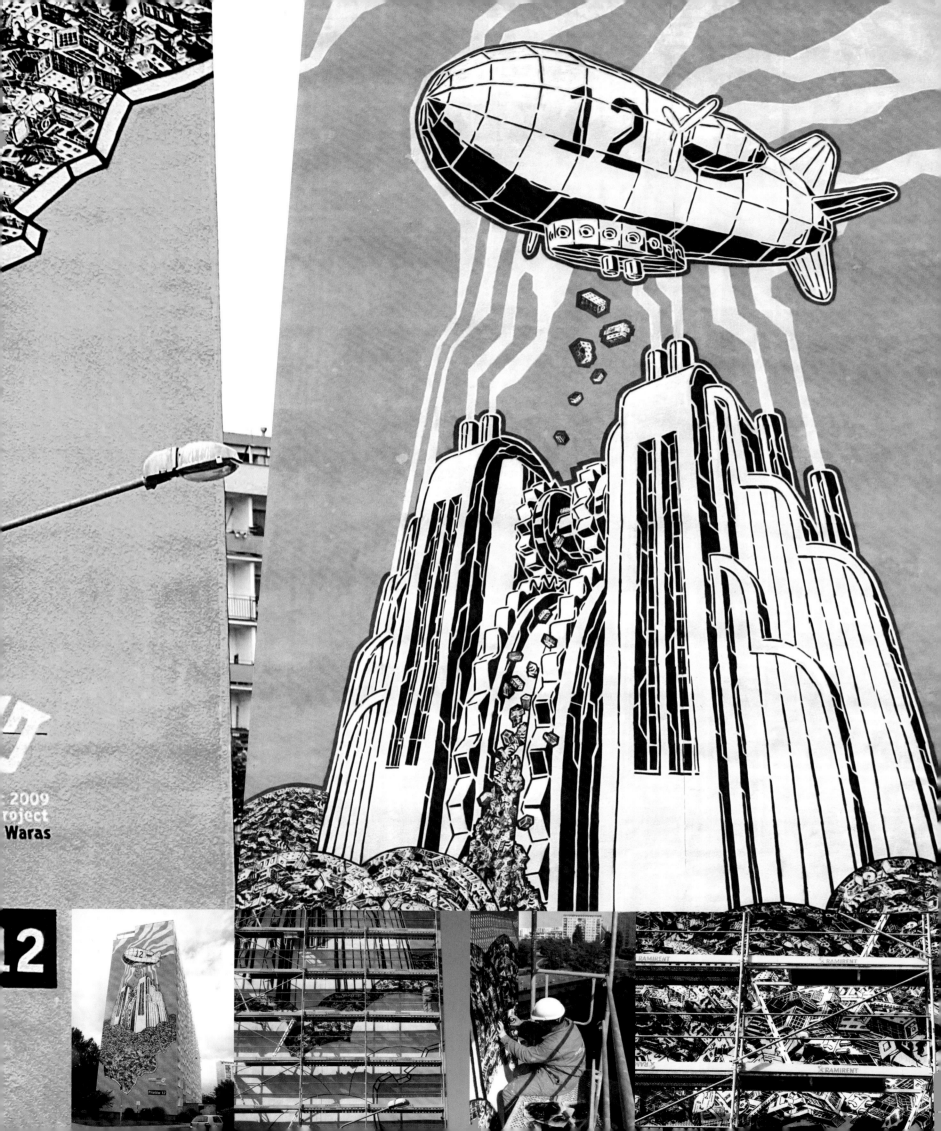

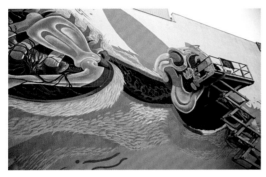
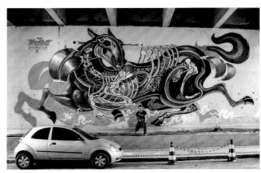

Nychos

Nychos grew up in a family of hunters in the south of Austria and first became familiar with animal anatomy by watching his father and grandfather skin and butcher their trophies. After developing an interest in cartoons and heavy metal, Nychos first picked up a spray can in 1999 and quickly became known for the black-and-white cartoon-style rabbits that he painted in only two minutes, like throw-ups. This concept became know as the Rabbit Eye Movement, which eventually evolved into a brand, with an art space and agency in the heart of Vienna. Nychos himself further developed his style throughout the years in his murals and illustrations, adding realistic internal anatomy revealed by dissection and x-ray in his comic cartoon animals, fantasy creatures and humans. With each piece, his dissections become more and more detailed, showing intestines, skeletons and other internal anatomy of cartoon characters.

Although he had always painted on walls, it took Nychos a few years to adapt his illustrations to much larger surfaces. In 2010 he painted his very first large-scale mural with Pixel Pancho in Turin, Italy; since then, he has tried to complete at least three large murals every year. His largest piece to date was painted in Oakland, California, in 2014. Entitled *Dissection of the Easter Rabbit* (above right and below left), it is about 18 metres high and 50 metres wide (60 x 165 feet) and was finished on Easter Sunday.

With the increase in work size, Nychos had to change the range of tools he was using, eventually swapping spray cans for rollers and emulsion. Today spray paint and Fat Caps make up only 20% of each mural, and are used mainly for the details and fine fading. To sketch up his large characters, he always uses a cherry picker, since his freestyle method of painting requires him to move along the wall easily and to get distance from it frequently to check perspective. With so many pauses to reposition the cherry picker, it sometimes takes him more than four hours just to do the rough sketching-up. When asked what worries him most about the process, he says: 'One of my main concerns when painting a large mural is the point of view of the passers-by. All the shadows and drop shadows have to work out correctly from their point of view.'

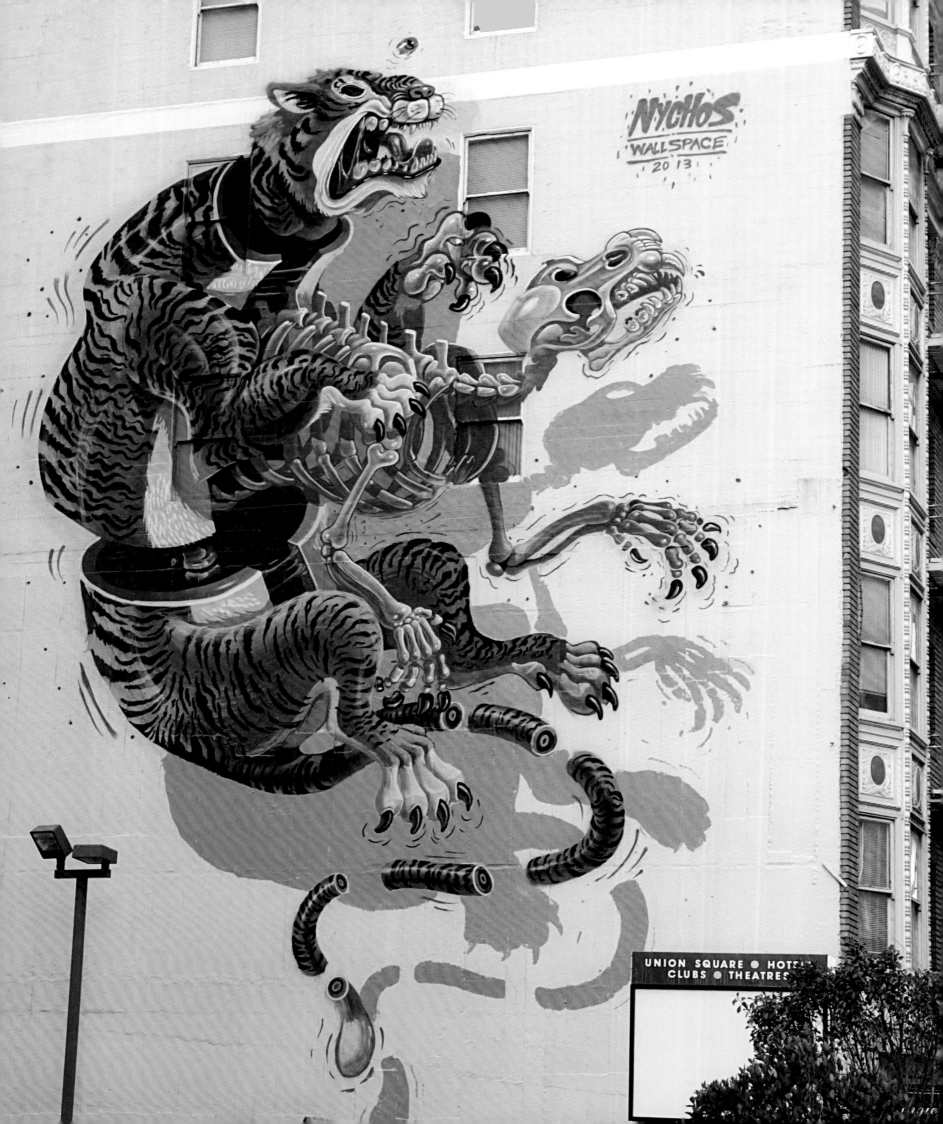

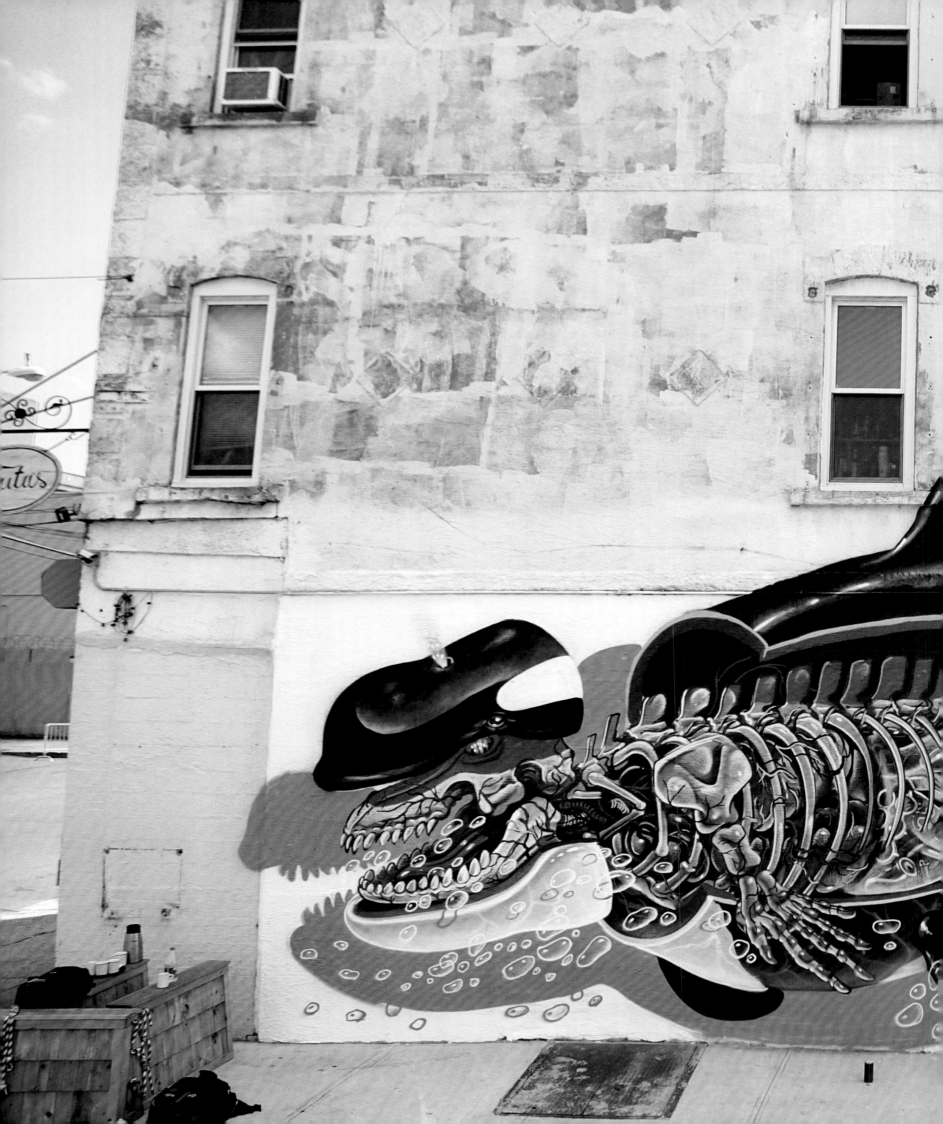

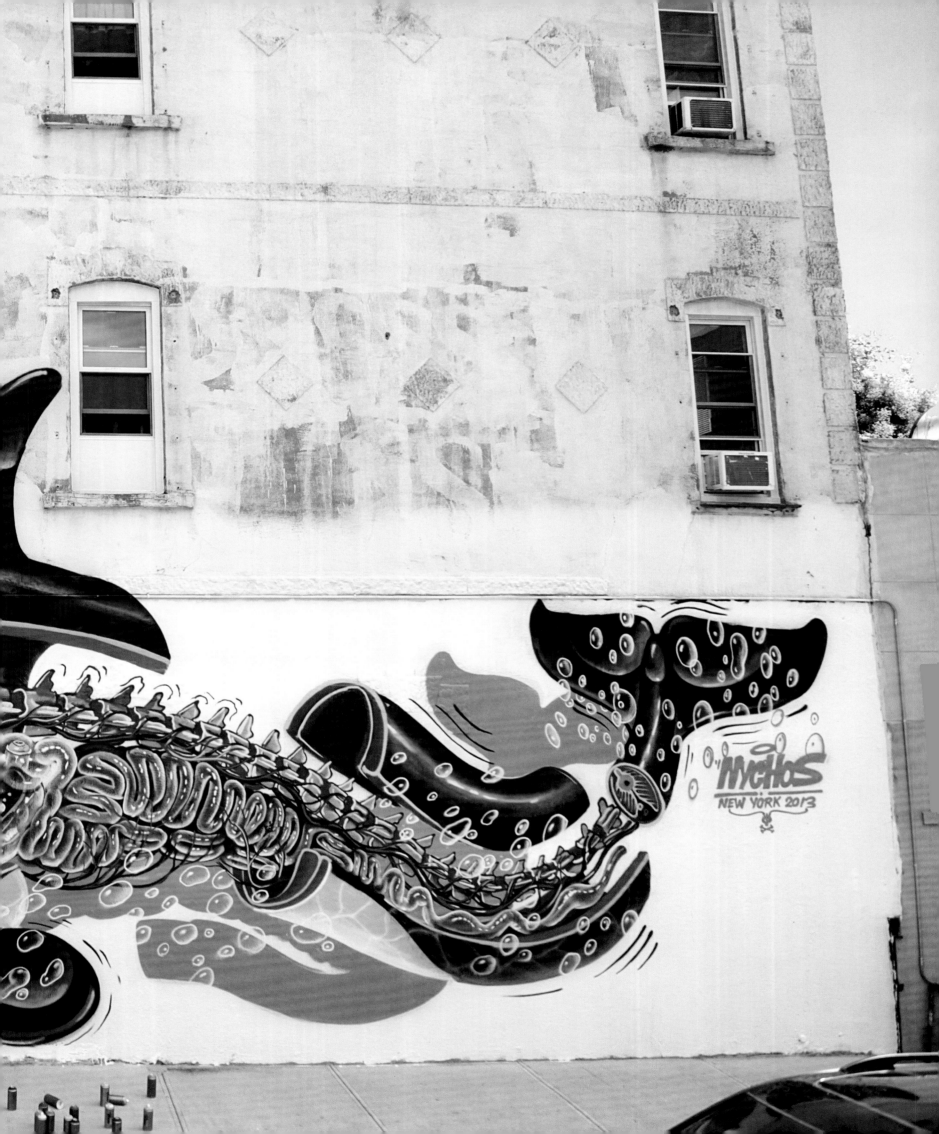

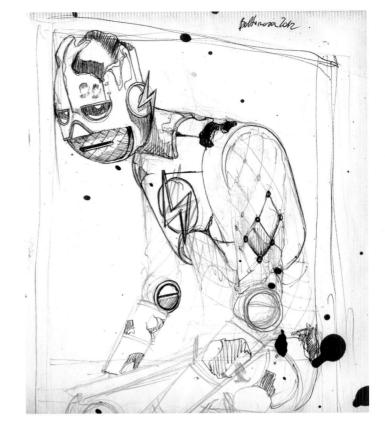

THIS PAGE: Sketch for Baltimore mural, 2012. **OPPOSITE:** Bassano del Grappa, Italy, 2012. **OVERLEAF:** Baltimore, MD, USA, 2012 (above left); Montreal, 2013 (below left); Jersey City, NJ, USA, 2013 (above right); Lisbon, 2013 (below right).

Pixel Pancho is an Italian street artist from Turin. He started his painting career in 1996 as a graffiti writer, but it wasn't until the year 2000 that he began the Pixel Pancho project. He painted his first walls under this name while attending the Albertina Academy of Fine Arts in his hometown, and continued to develop his street work during his further studies in Valencia, Spain, where he painted his first XXL mural in 2001.

Pixel Pancho's favourite themes are old, rusted robots and robotic environments, often in combination with animals or humans. His robots are not shiny or hi-tech, but part of an imaginary steampunk-inspired world compiled of old rusty metal plates, screws and cogwheels in earthy, subdued colours. The pieces tell a story of humanized robots and their history. 'I like to incorporate my characters into the environment of the mural, and that the people in the neighbourhood accept that a giant robot lives around the corner. I want to make people dream in this sad world where everyone just follows the money god.'

His biggest piece to date is in Kazan, Russia. The 33-metre (108-foot) high piece shows a robot and a boy in a field of flowers, using a visual language strongly reminiscent of the Communist era. With the aid of one assistant, the wall was completed in the course of three and a half days of hard labour,

Pixel Pancho

using rollers, extension poles and spray paint. He prefers to work from a cherry picker when painting his murals. This allows him to keep all his materials with him at all times, as well as giving him a good view of the entire wall while he is sketching up. 'Getting the proportions and the perspective right is the biggest challenge when painting so large. In my opinion, sketching up is the most important and most difficult step in creating a mural.'

The feeling of accomplishment that comes with finishing a large piece is Pixel Pancho's greatest motivation. 'It is always very satisfying to finish a big wall. It's like a drug: you can't stop and you always want more.'

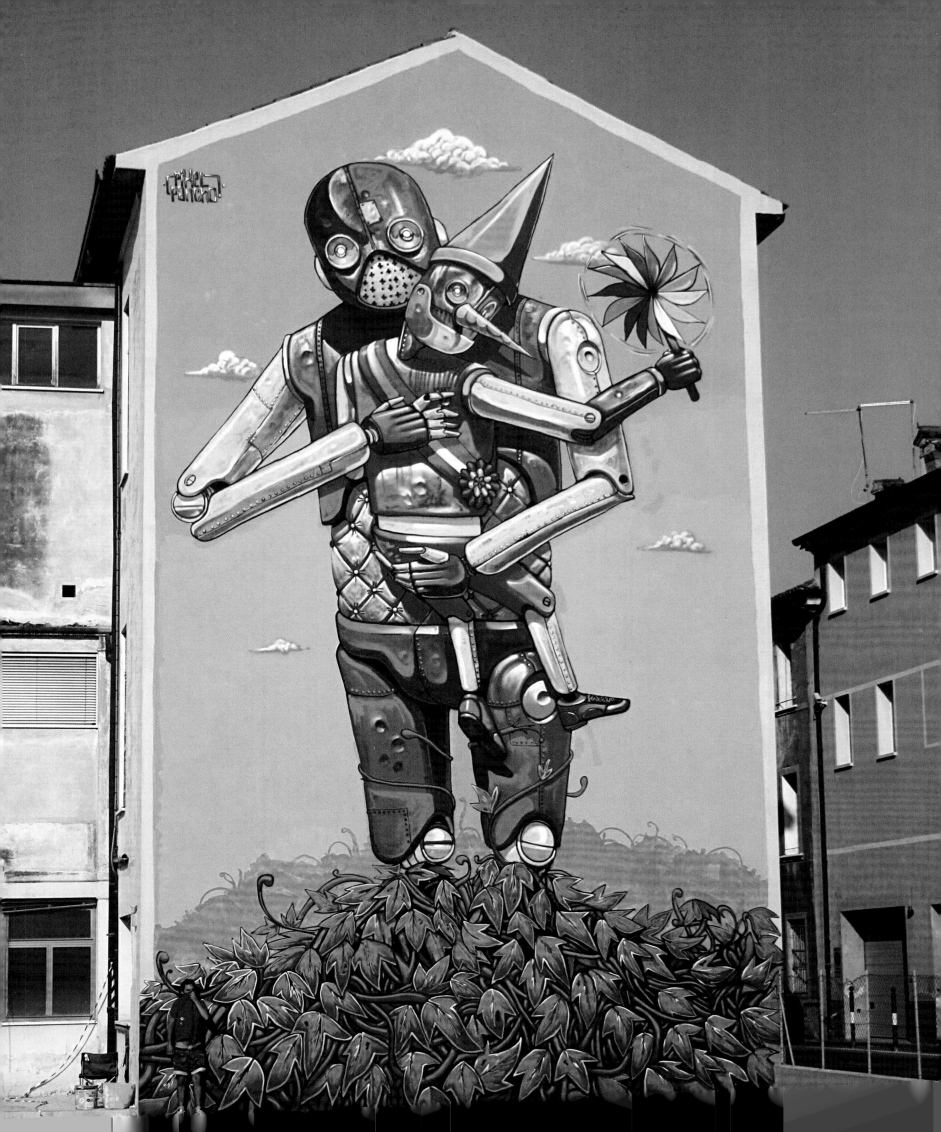

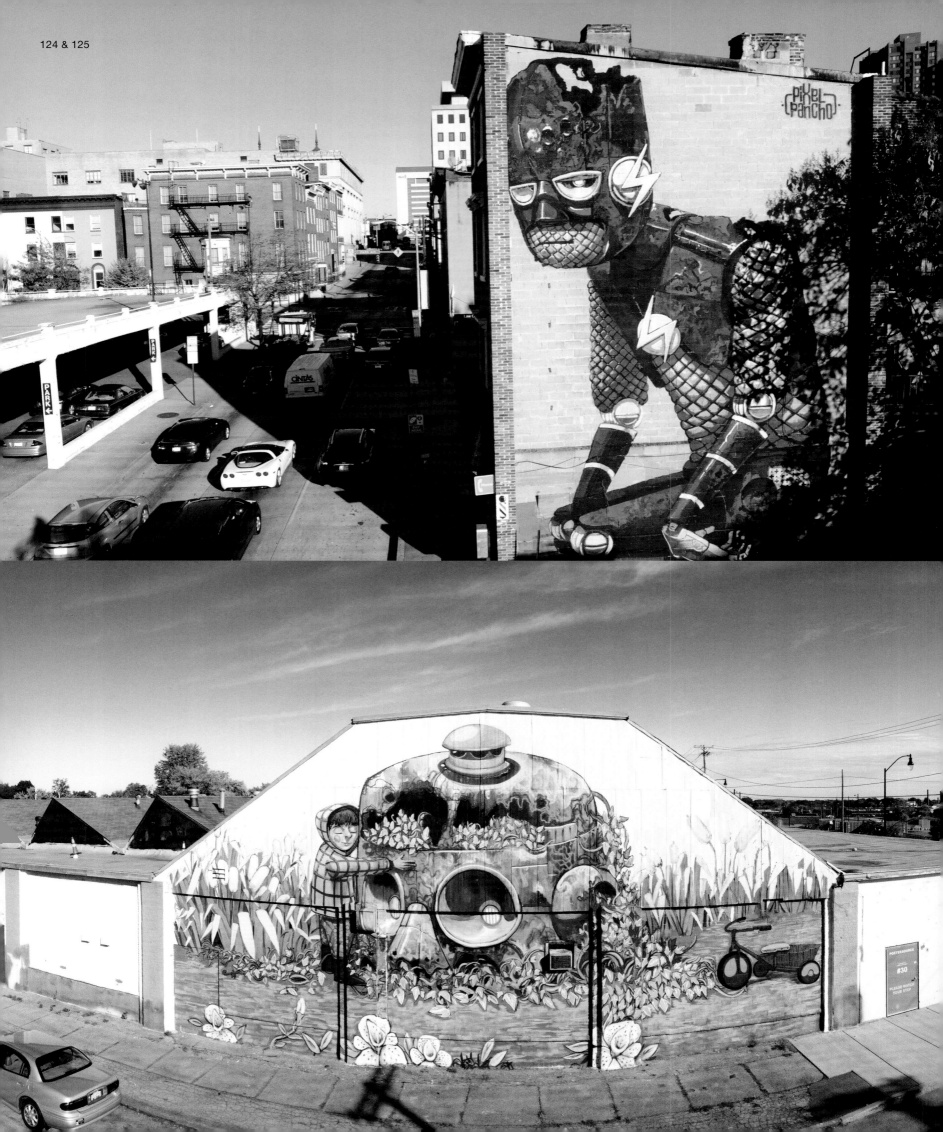

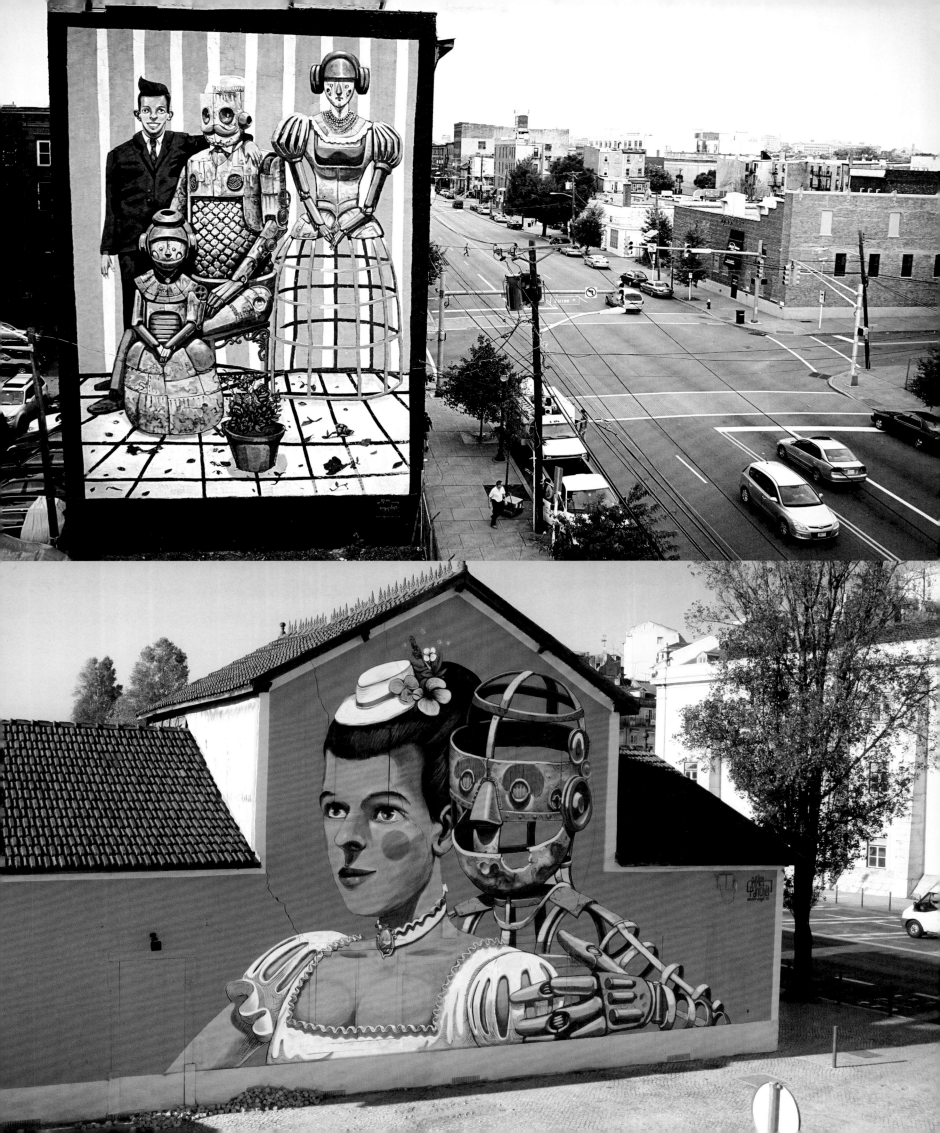

 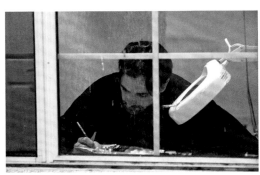

Cleon Peterson

THIS PAGE AND OPPOSITE: Chicago, 2014. **OVERLEAF:** Katowice, Poland, 2013. **SECOND OVERLEAF:** Los Angeles, 2013.

In the midst of a flood of beautiful, easy-to-digest street art pieces, Cleon Peterson's work stands out for its stylized depictions of the dark, brutal and violent side of humanity. Peterson's goal is not to make art that everyone likes, 'but making work that people can experience physically and emotionally.'

While growing up in Seattle, Peterson was ill and frequently hospitalized, and started making art simply as something to do while undergoing treatment. In his twenties, he moved to New York where he got into drugs and a lifestyle of desperation, cut off from the usual rules of society. Following numerous court orders, incarceration and, finally, a job offer from Shepard Fairey, Peterson moved to Los Angeles and began working on designs at Fairey's Studio Number One. He quickly made a name for himself with his clean, flat paintings in a very limited colour palette: black, white and fluorescent red or gold. His paintings feature graphic scenes of chaos, struggle, desperation and disorder. They can be understood not only as representing the horrific things going on in the world, but also as a mirror of the dark world inside all of us.

In 2013 Peterson painted his first large mural in downtown Los Angeles (second overleaf). He says that he enjoys 'painting large in an environment outside the gallery where people who may not go to art galleries will see the work.' His largest mural to date, painted in 2014 under a bridge in Katowice, Poland (overleaf), is 5 metres high and 45 metres long (17 x 150 feet) and was completed with the help of four or five assistants. Peterson has a very specific method for approaching his large murals. 'I do a painting at the same proportions but smaller. I scan that into the computer and print out large stencils at 100% to the wall. Then it's just about cutting the stencils out and spraying the wall.' He points out that getting the correct measurements of the walls presents the biggest challenge in this way of working.

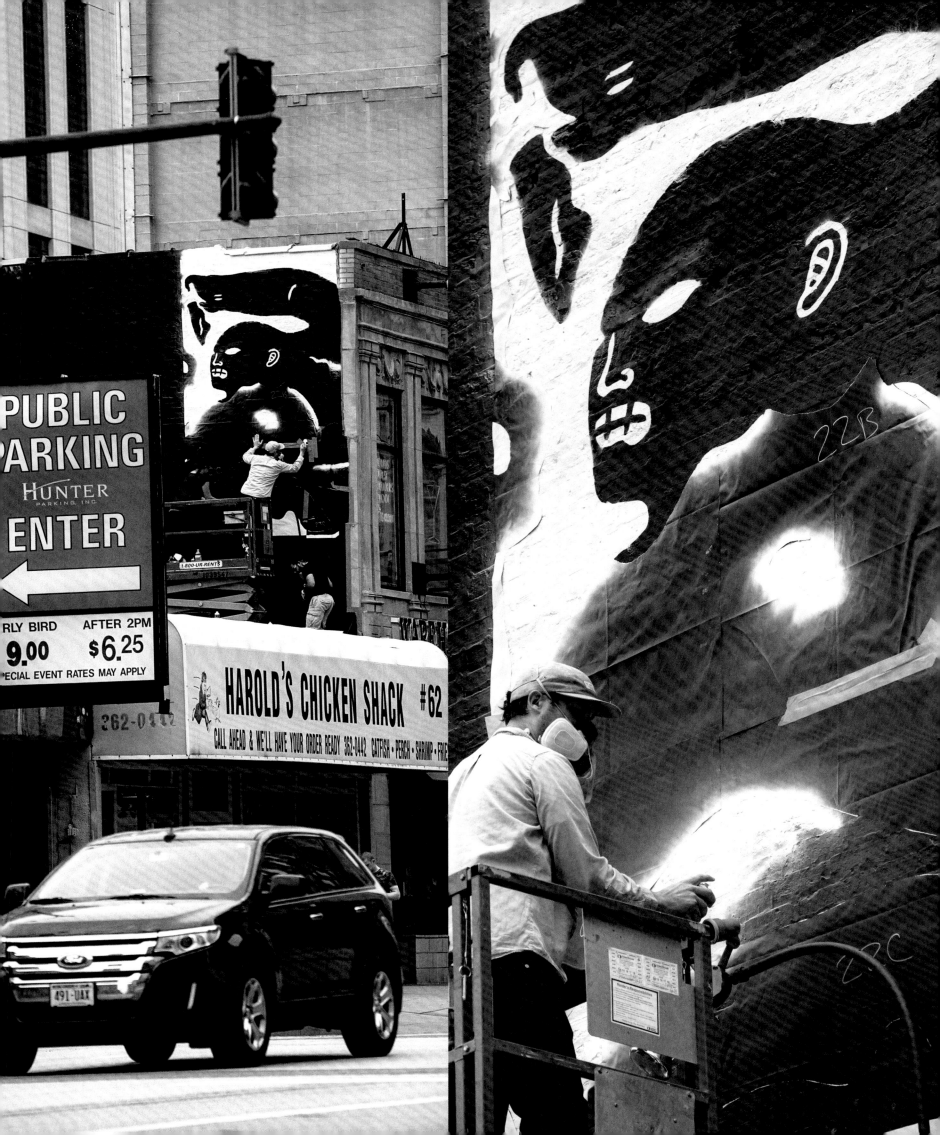

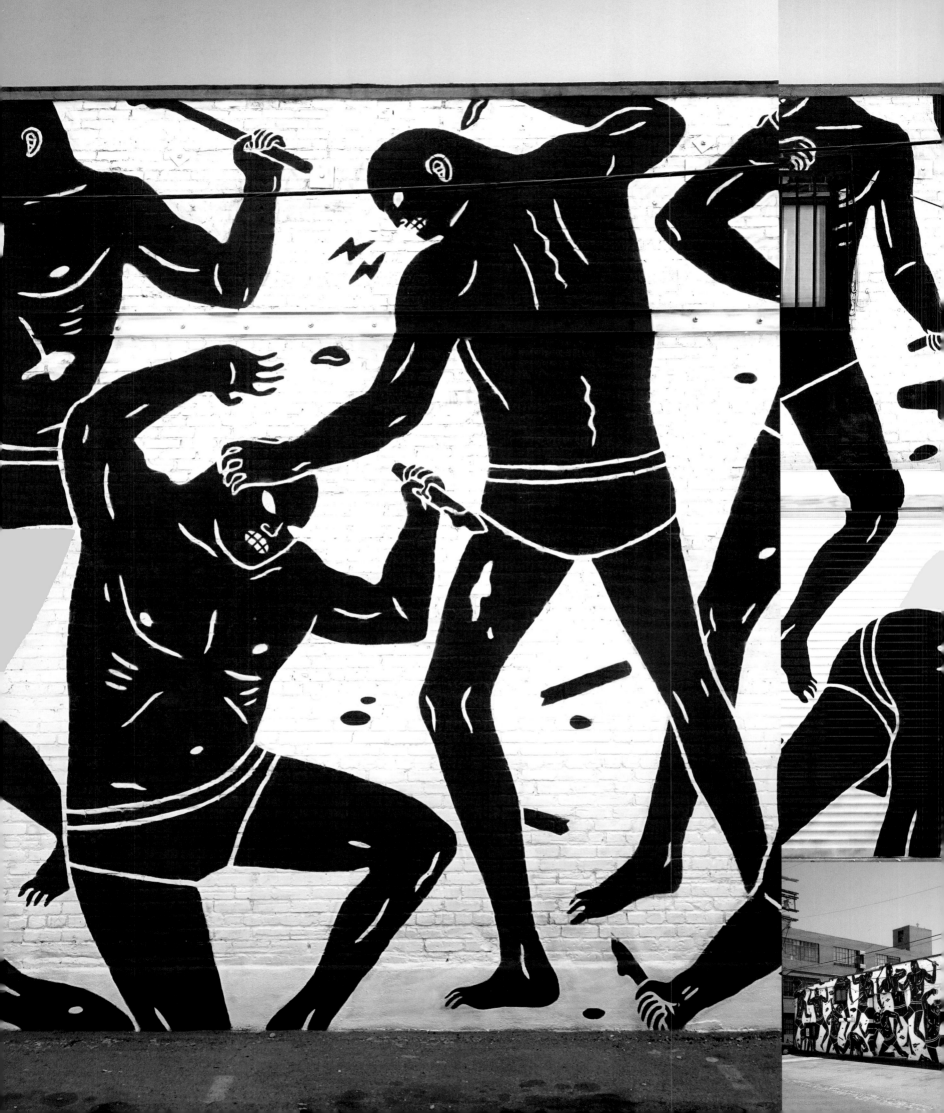

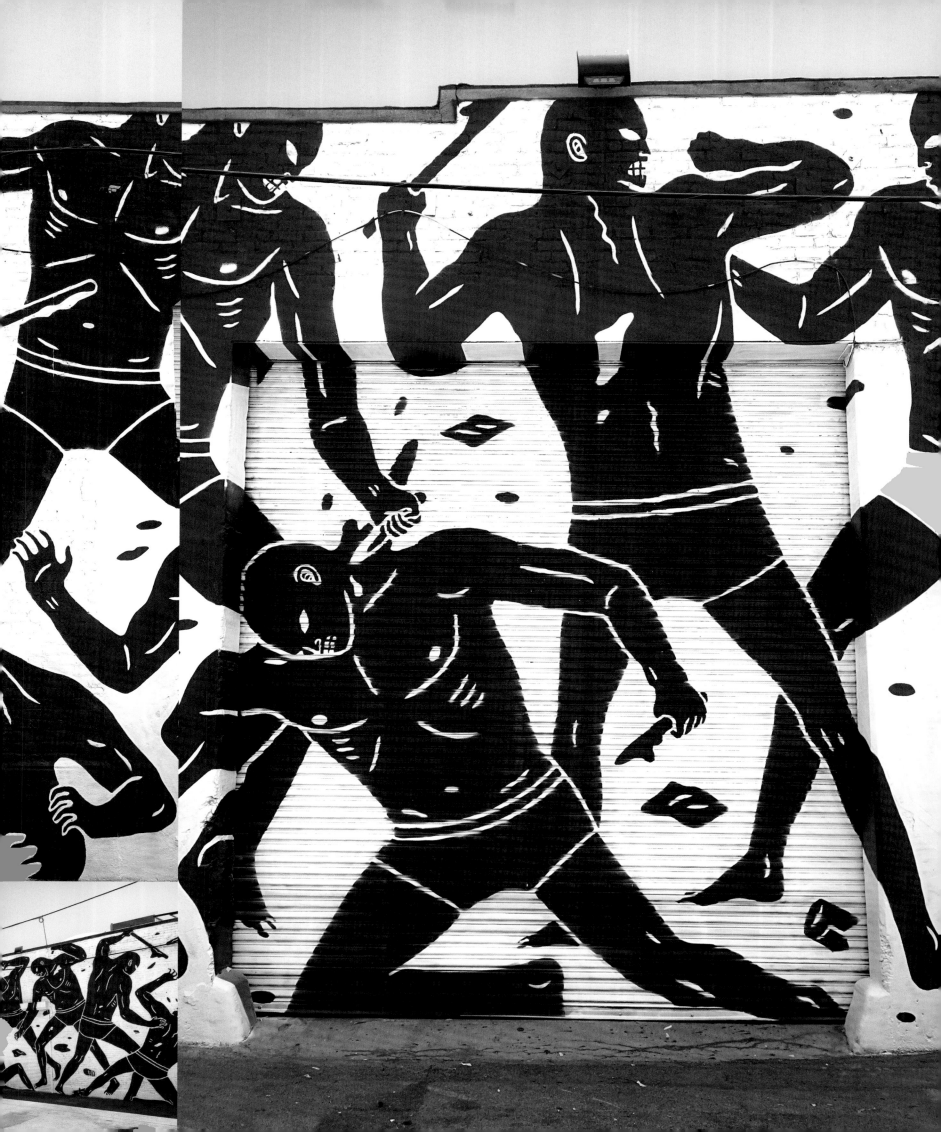

Ripo

New York native Max Rippon, better known as Ripo, has now called Barcelona his home for ten years, but his work has brought him to many far-flung places around the world, to paint murals and other custom-designed pieces or to do gallery shows.

Ripo's skilfully crafted letters, words and slogans are inspired by hand-painted signage, modern graffiti and graphic design as well as by handmade and digital typography. Ripo often slices up words, making use of the negative space and playing with his compositions so that the focus shifts away from the words' meaning and towards the abstract forms, symbolism, and aesthetics of the collaged piece itself. In 2006 he studied the negative space of fonts by painting on mirrors, leaving the forms of the letters as the raw mirrored surface, installing them on the street

and seeing how the reflections changed the paintings. In another series he explored the relationship between the aesthetics of words versus their meanings by painting ugly words such as 'Fuck' or 'Bitch' large in public. He was surprised at the positive reactions these works received.

Ripo painted his first large mural in Buenos Aires in 2007. In approaching a large surface, Ripo doesn't use a grid or projector, but sketches up the wall freely, with a design often based on one of his paintings. When asked to point out some of the challenges he faces when creating something so big, he says: 'Going in too loose or unprepared can make things go much slower and fuck things up in the end. Don't

worry too much about tiny details – no one will notice them on something that size. And just putting in the work needed to finish even if you get frustrated, impatient, or physically exhausted by it. Weather can really put a damper on things, too.'

Despite the difficulties of painting XXL murals, Ripo believes that the large scale changes how audiences perceive his work in important ways: 'Artwork on that scale affects the cityscape; it becomes a noticeable part of everyday life for people. Whatever work I do in a gallery or my studio will never reach the same size and scope of audience. It's this scale of influence and visibility my work takes on as well as the act of painting with material on that scale which is something special.'

THIS PAGE: *You Got My Back*, based on inset letter-sketches by children who attend the community centre on which it is painted, Cologne, 2011. **OPPOSITE:** *Timeless*, Buenos Aires, 2008 (above); *Menos o Mas*, Guatemala City, 2008 (below). **OVERLEAF:** *Just the Two of Us 2*, Paris, 2014 (above left); *All That Is Solid Melts into Air*, Rochester, NY, USA, 2014 (below left); *Domestic Violence*, Cologne, 2014 (right).

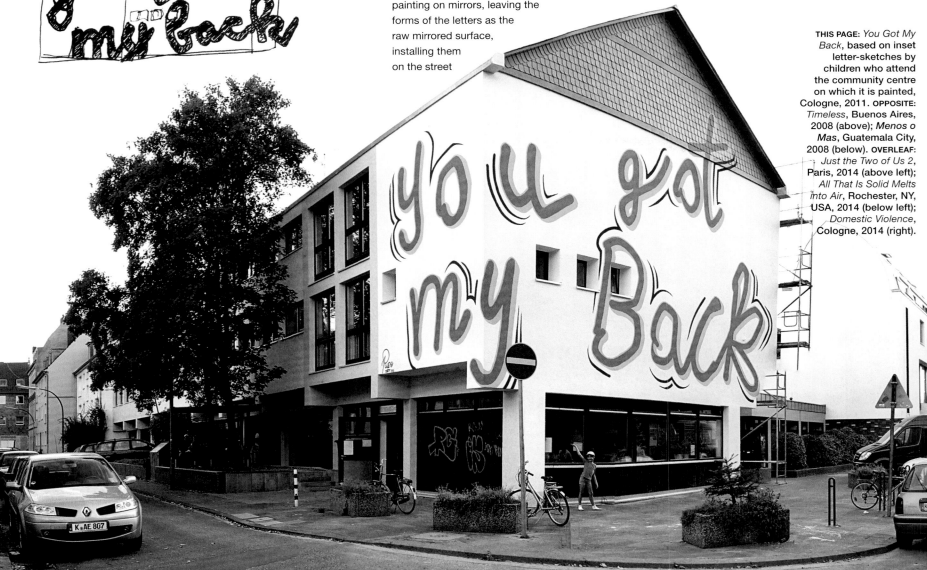

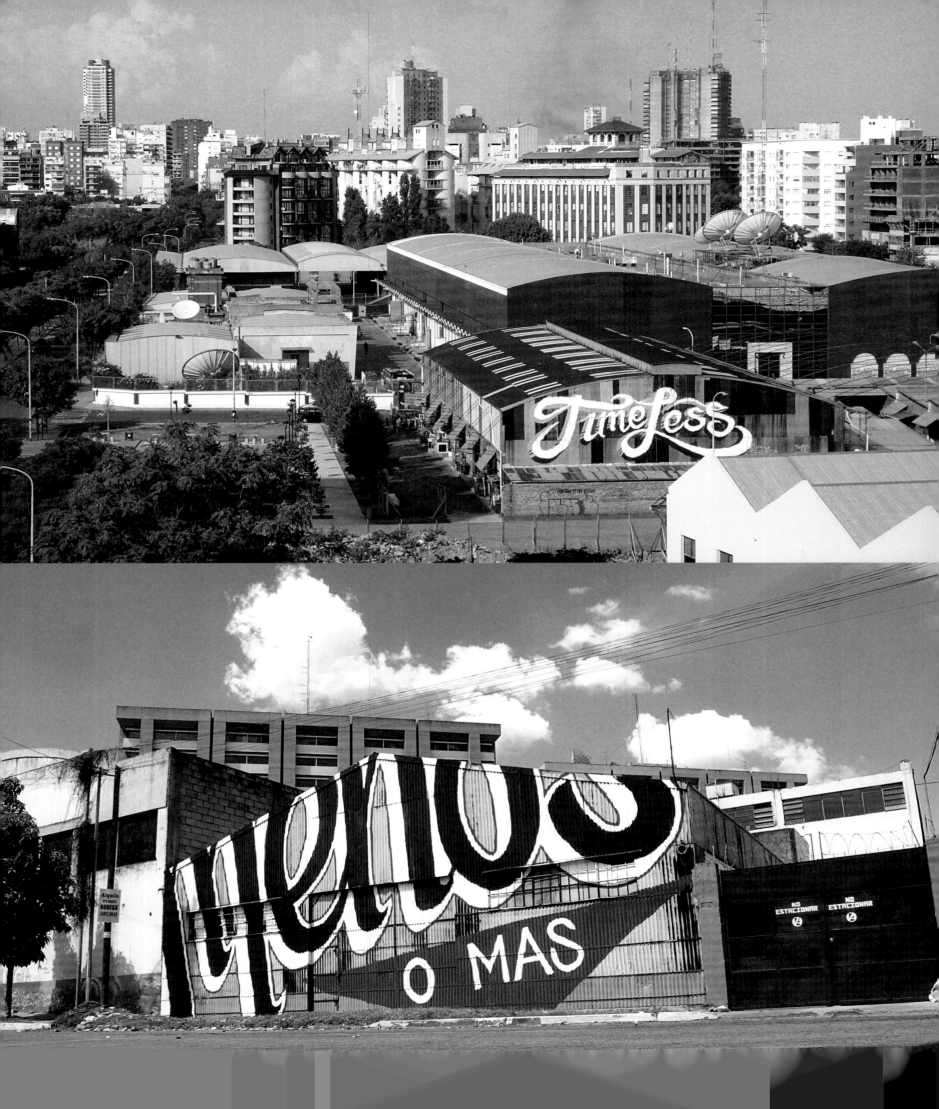

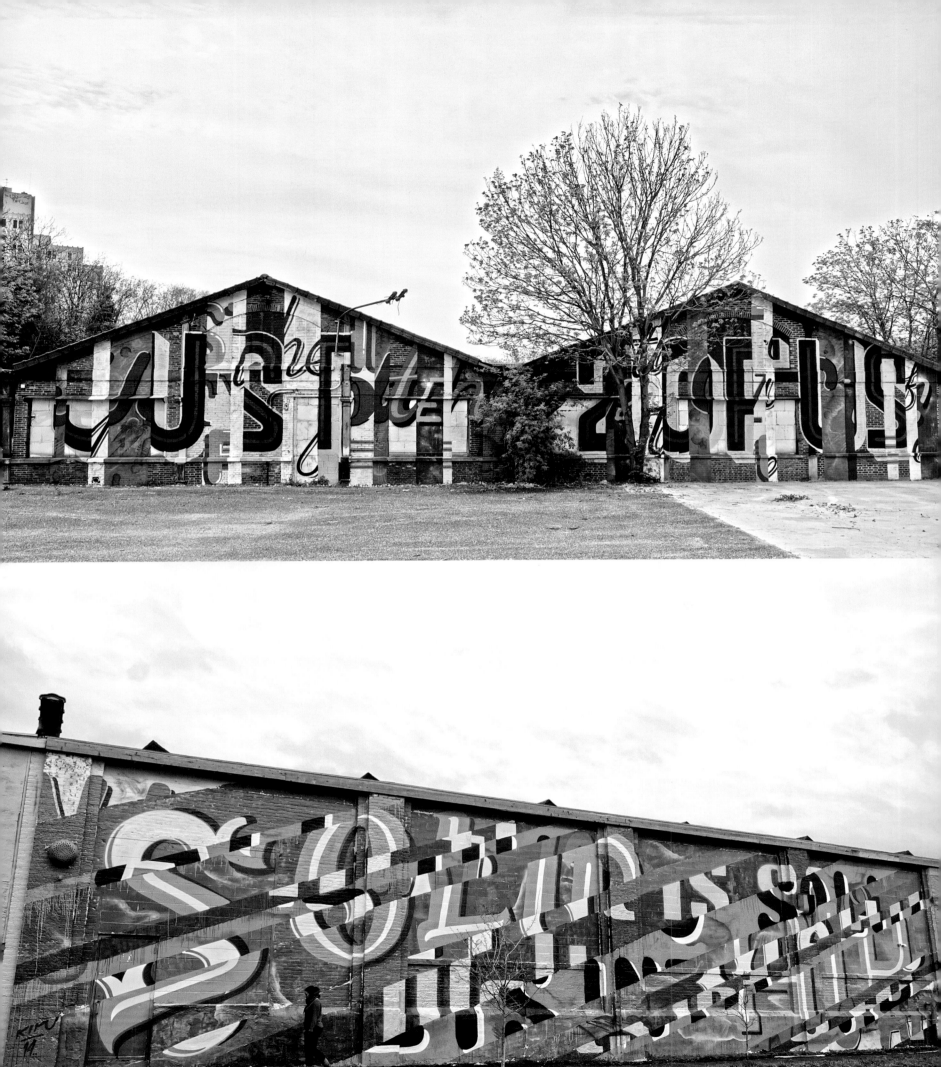

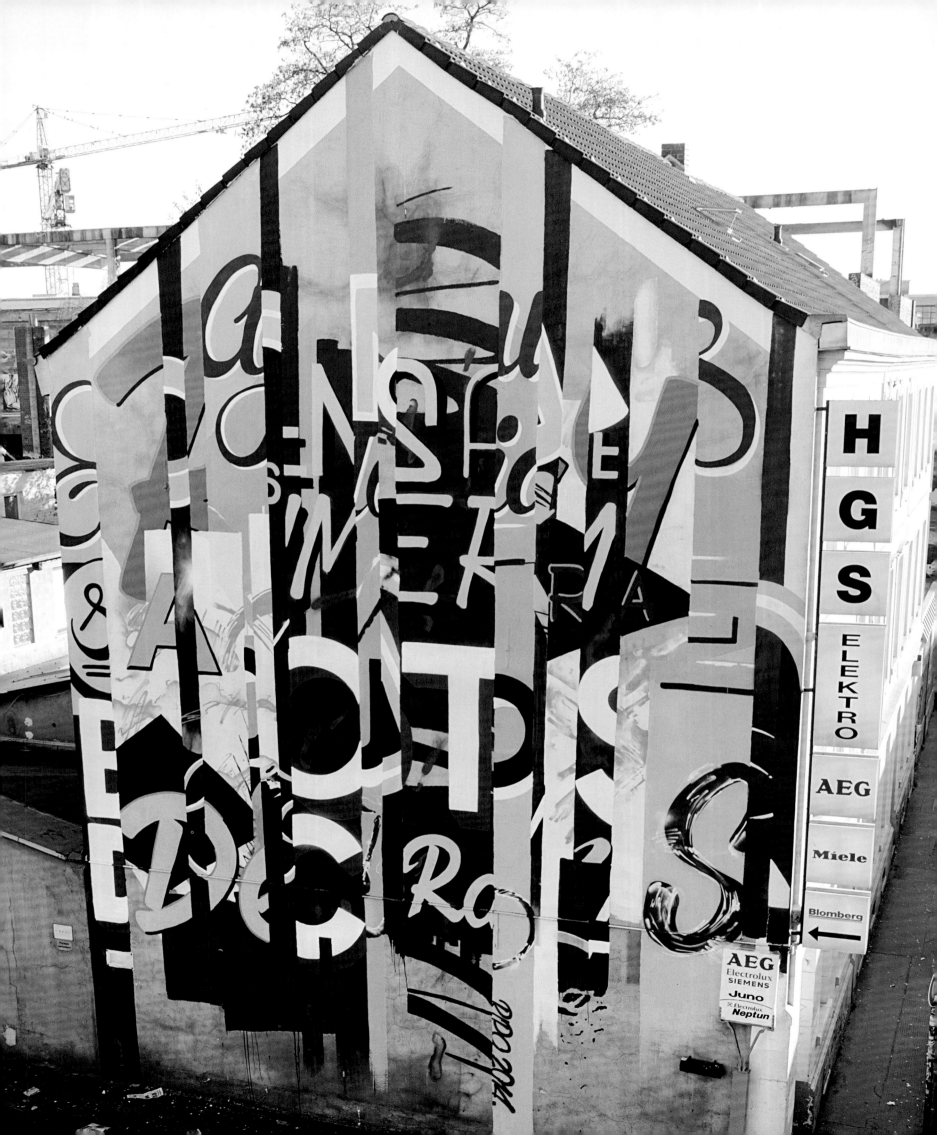

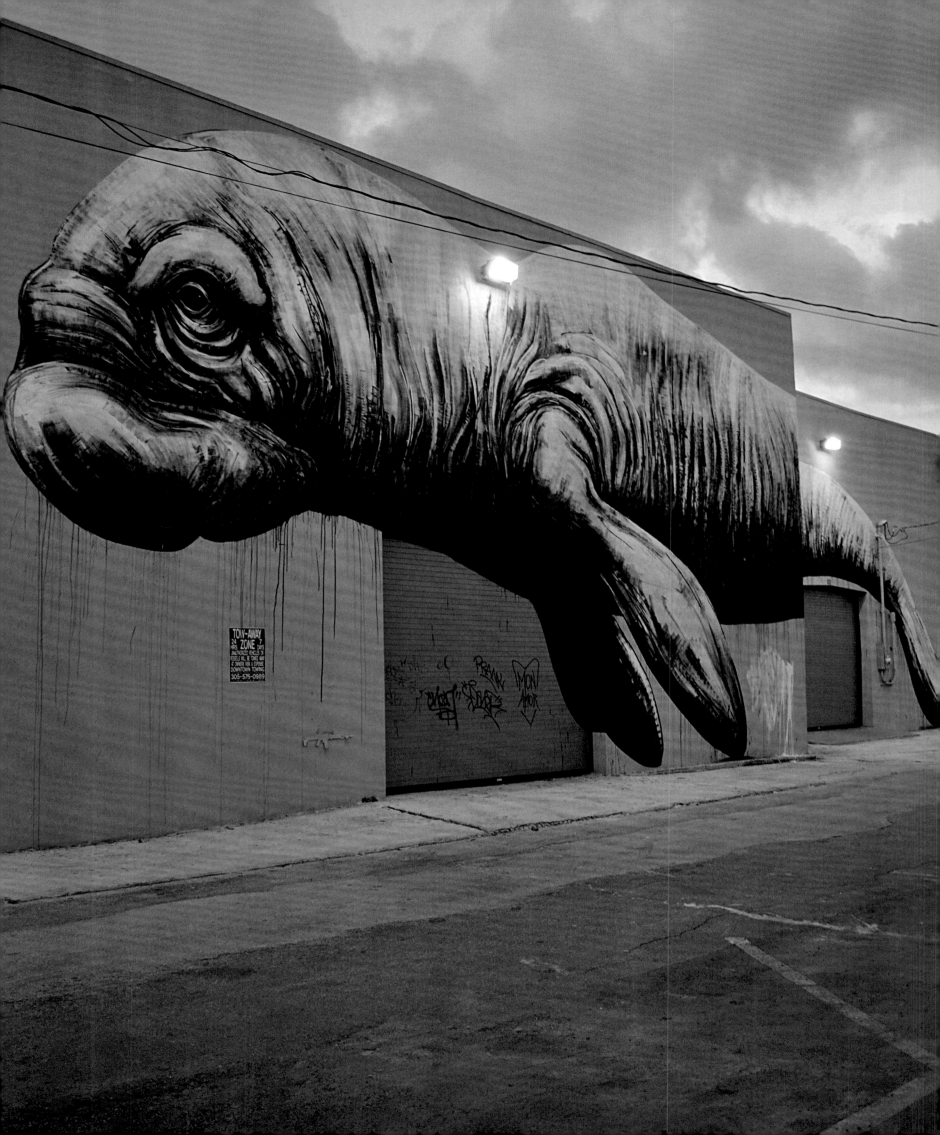

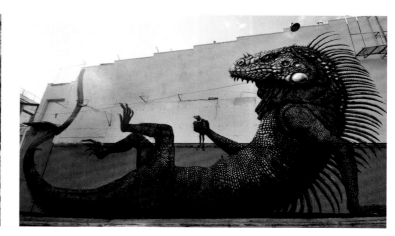

Belgian artist ROA has painted little of his hometown of Ghent for the past few years. Constantly on the move, travelling from mural to mural, he has spread his signature giant black-and-white animals across five continents. His first public art was in a classic graffiti style, inspired by the book *Subway Art*, but over time his focus shifted to animals and the theme of 'the circle of life'. For each mural, he selects an animal that not only fits the shape of the wall, but is also native or otherwise relevant to the location: rats, squirrels and hedgehogs in European cities, a giant snake in Australia, or a manatee in Miami. In some of his work he also draws attention to the threats many native species are facing from human activity, exotic invaders or environmental pollution.

ABOVE: Invasive iguana holding a native coquí frog, San Juan, Puerto Rico, 2012 (right); snake, Mexico City, 2012 (centre). **OPPOSITE AND ABOVE LEFT:** Manatee, Miami, 2013. **OVERLEAF:** Whale skeleton, Vardø, Norway, 2012. **SECOND OVERLEAF:** Badger, rats and squirrels, Malaga, Spain, 2011 (above left); African big game, Johannesburg, 2013 (below left); alligator, Atlanta, GA, USA, 2011 (right).

ROA

Viewed from an angle, the Miami manatee, for instance, reveals a bloody gash where it has been cut in half.

ROA painted his first large-scale solo mural in Warsaw, in the cold winter of 2009. 'It was a great experience. After that wall I painted mostly big walls.' He can't say for sure which piece has been his largest, but some have been at least eight or nine storeys high. He always keeps the original texture of the wall, incorporating his animals into the existing appearance of the building rather than covering every inch of it with paint. 'I paint the composition in relation to the structure and often I will integrate the pipes, the beams and the windows into my mural concept,' he explains. It usually takes him five or six days to finish these large pieces, which he always paints without assistants.

Before ROA starts a mural, he first takes a good look at the wall, its structure and its surroundings. Then, sitting in front of it, he makes a sketch to work out the composition. When he finally jumps into the basket of the cherry picker, he brings with him only wall paint, paint rollers, extension sticks and spray paint. He sketches freehand with the spray paint, using his sketches and sometimes also a scientific illustration of the animal as visual references. He then fills in the larger areas with white wall paint and adds shadows and depth with black paint, often building up innumerable black lines to create fine details such as fur or scales.

Despite the unrelenting travel and hard physical work, ROA says he will never tire of creating murals all over the world. 'Painting large is my passion and what I prefer to do most.'

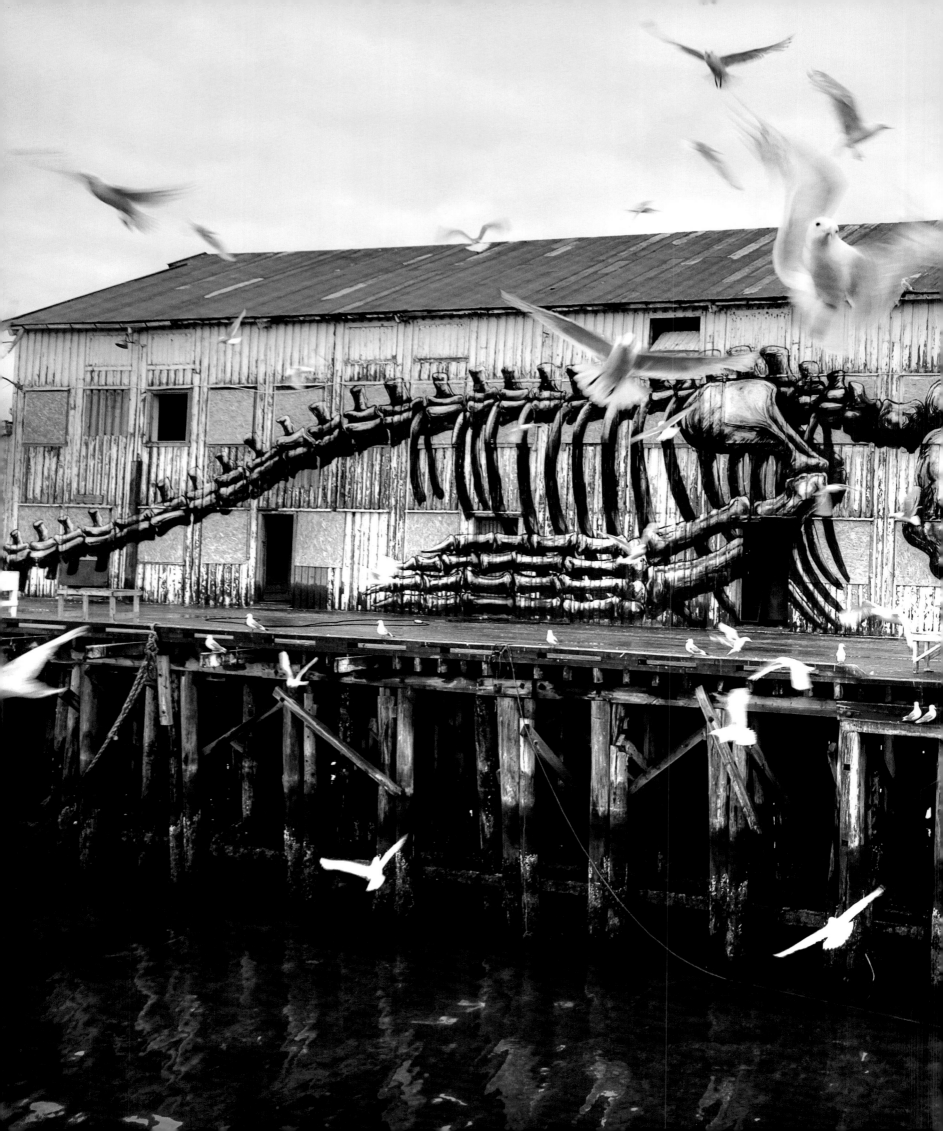

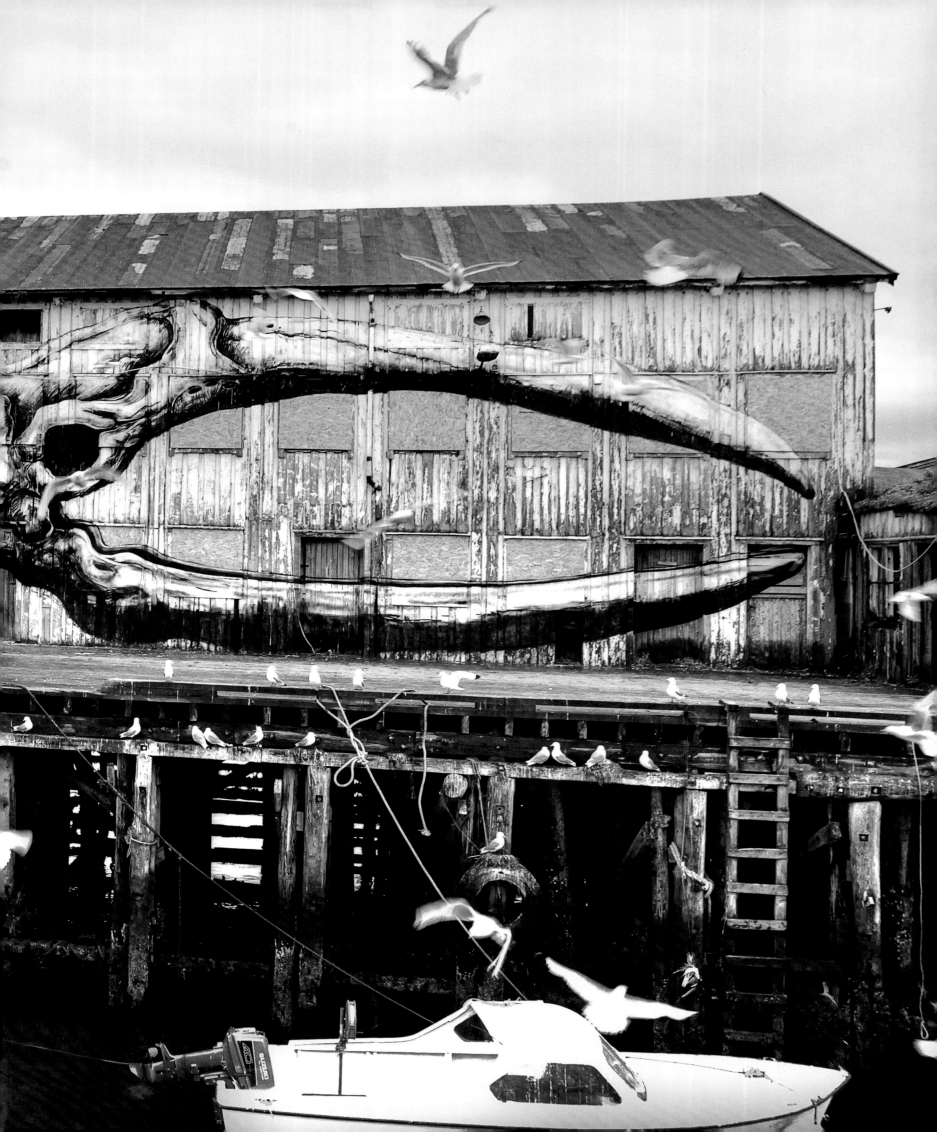

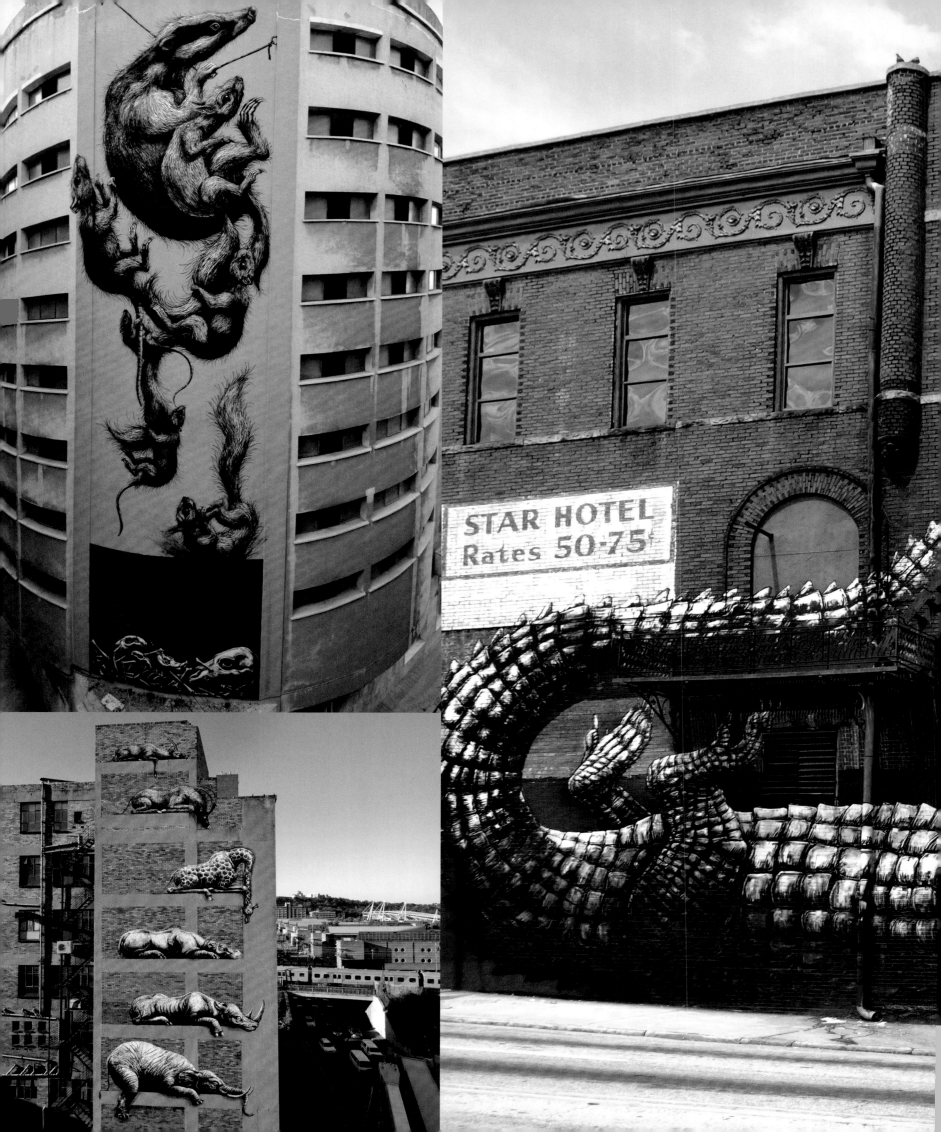

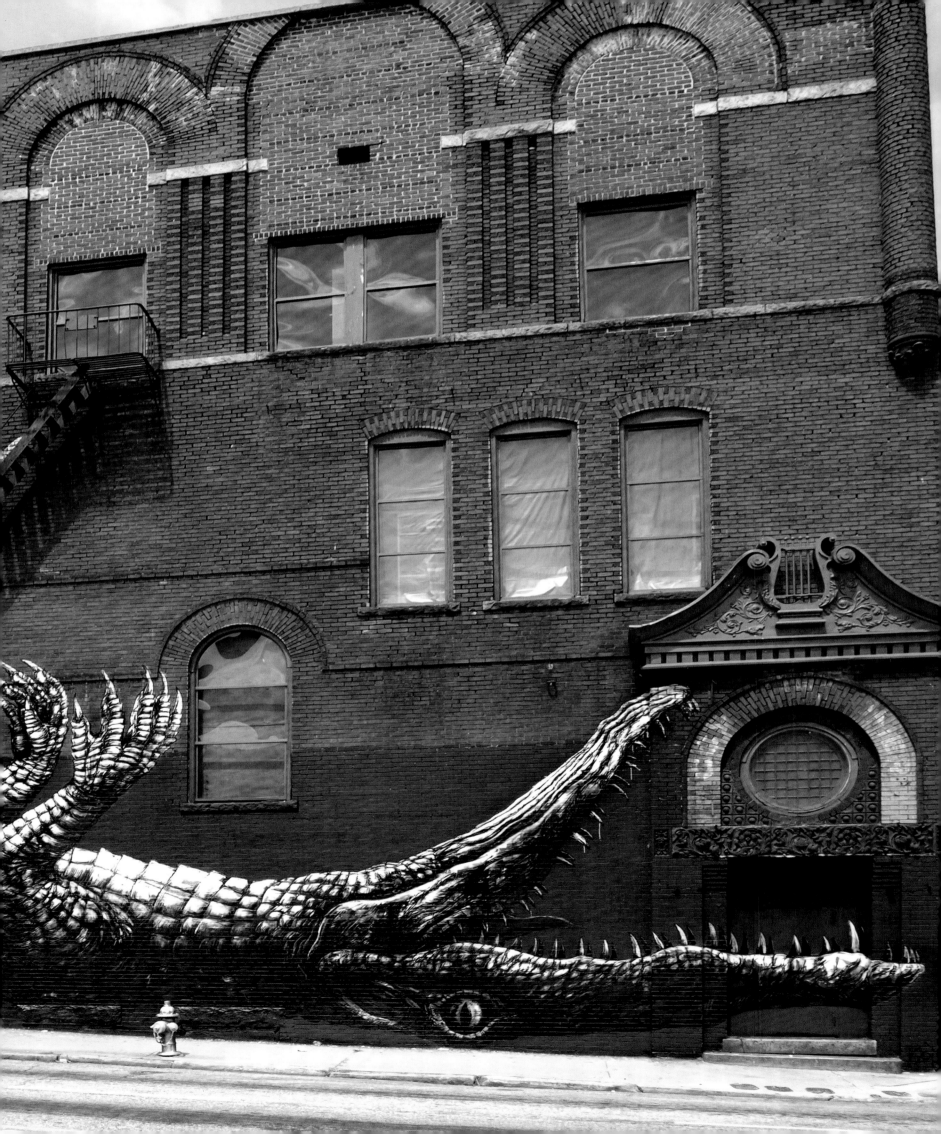

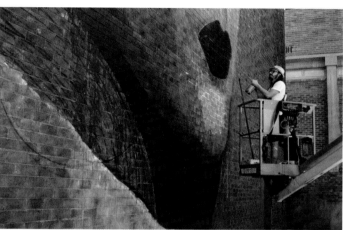

RONE

THIS PAGE: *Celestine*, Wollongong, Australia, 2012. OPPOSITE: 80 Collins Street, Melbourne, 2014. OVERLEAF: RONE x Kamea Hadar, Honolulu, HI, 2013. SECOND OVERLEAF: *ExhibiteBe*, New Orleans, 2014 (left); RONE x Wonder, Brunswick, Australia, 2013 (above right); Trendy Studio, Miami, 2013 (below right).

Australian artist RONE grew up in Geelong, Victoria, and later moved to Melbourne, where he still lives and works. He first developed an interest in graffiti through skateboarding and worked as a graphic designer. He currently works from Everfresh Studio, which he founded in 2003 with his fellow artists Meggs, Reka, Phibs Sync, and Wonder & Phibs, and is still actively involved with. Before he started painting large murals, he was known for the many stencils and paste-ups that he put up all over Melbourne, but since stencils and posters had natural limits to their size, he eventually moved on to painting large walls freehand. In 2013 and 2014 he finished his biggest walls to date. The first, featuring the face of fashion model Teresa Oman, covers the upper three storeys of the exterior of an apartment building in Berlin. It was followed by an even larger painting of Oman, nine storeys high, on Collins Street in his hometown of Melbourne (opposite).

RONE's favourite subjects for murals are cropped images of women's faces, painted in a monochromatic colour palette. He likes cropped compositions because they make his murals appear even larger. 'I'm not the first to use [this device], but by cropping the subject you can create an illusion of scale that is beyond the wall you are painting.' His limited colour palette is the result of trying to use the original colours of the surface in fitting the women's faces to a wall: 'I try to use the existing wall to work out my composition and use colours that are only tones darker or lighter than what is there.' The women he paints are typically young and beautiful with soft facial expressions. The artist calls them 'calming beauties' who bring a little peace to the buzzing streets.

To paint his large pieces, RONE found his own unique tool: 'I use a broom or mop. It's just like using a gigantic brush.' Instead of using a projector or grid, he marks certain spots and imperfections on the wall in his sketch to serve as guides when painting the mural. But he still feels that every piece painted large is a major mental and physical challenge: 'Other than the physical effort of working outside in burning sun or freezing cold, the mental pressure of getting it right is challenging. If you are in your studio and a painting isn't working out, you can just put it aside and never show anyone. But when you are painting half a city block, people are going to see if you fail. When it isn't working out on that scale, the pressure has made me feel physically ill.' Once a massive wall is completed successfully, however, he feels that he has made something monumental and beautiful for the city. 'It feels pretty good to be able to create a landmark.'

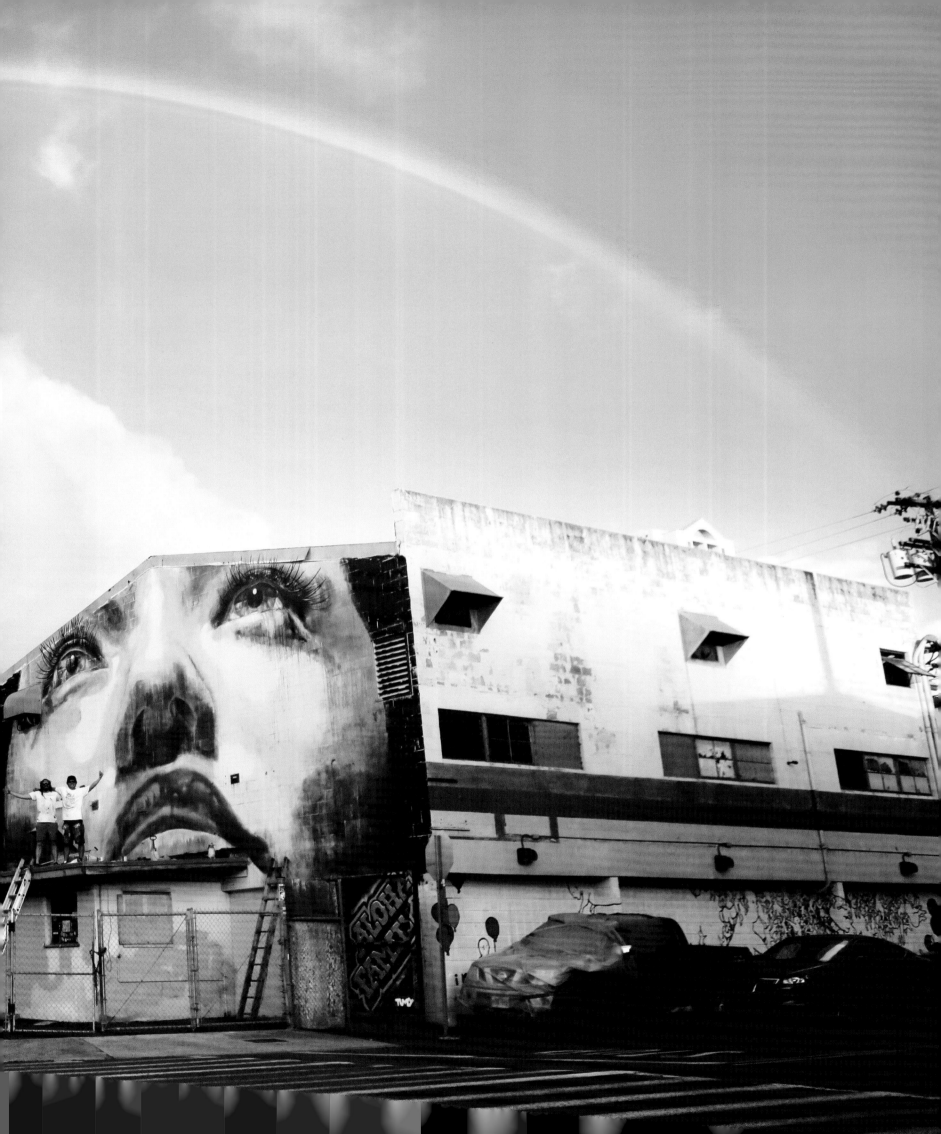

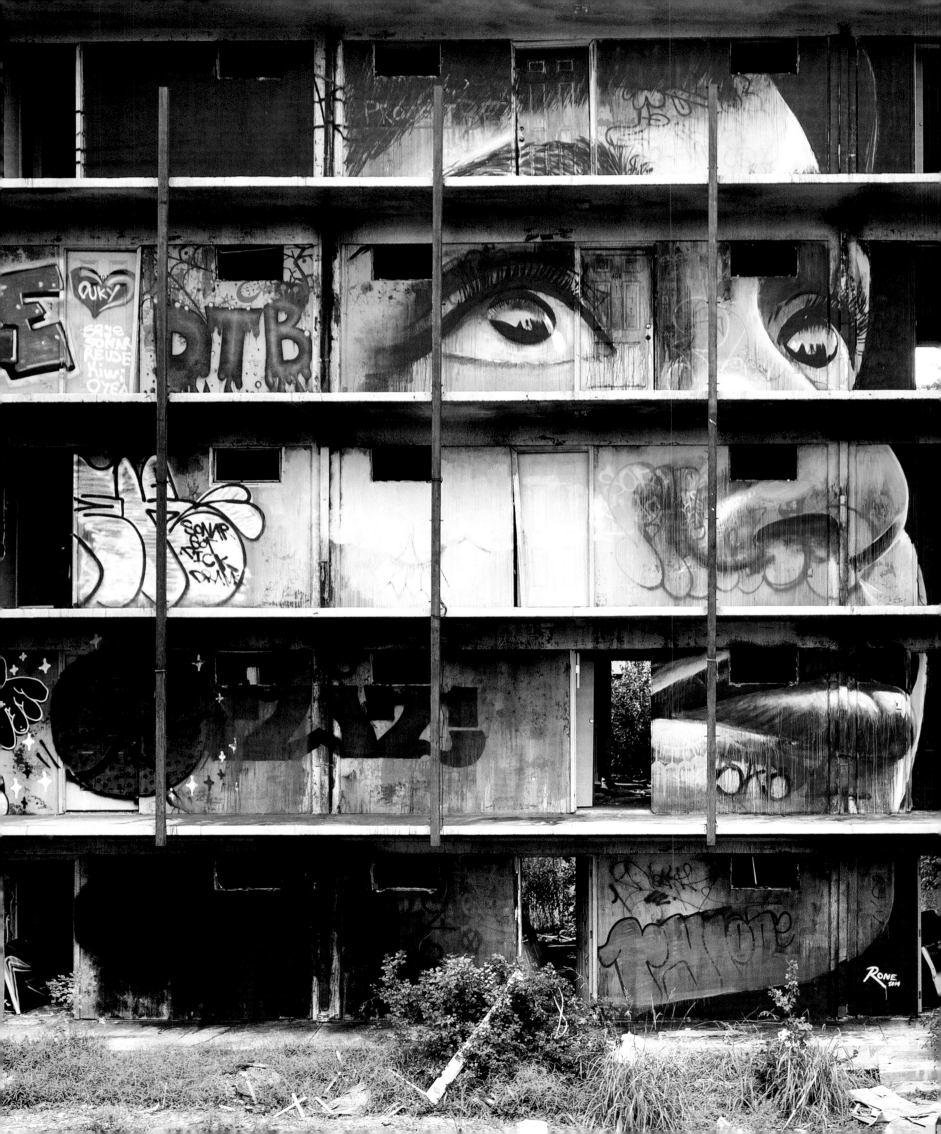

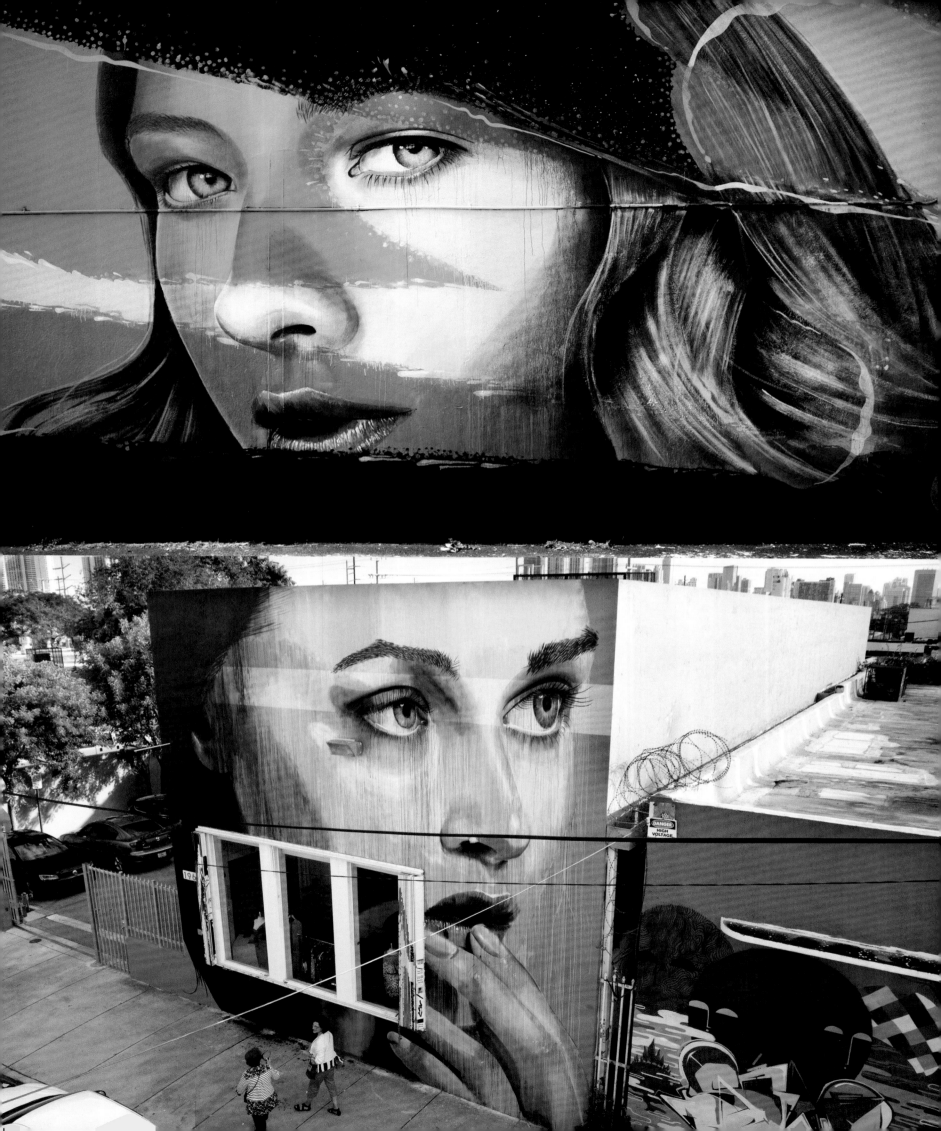

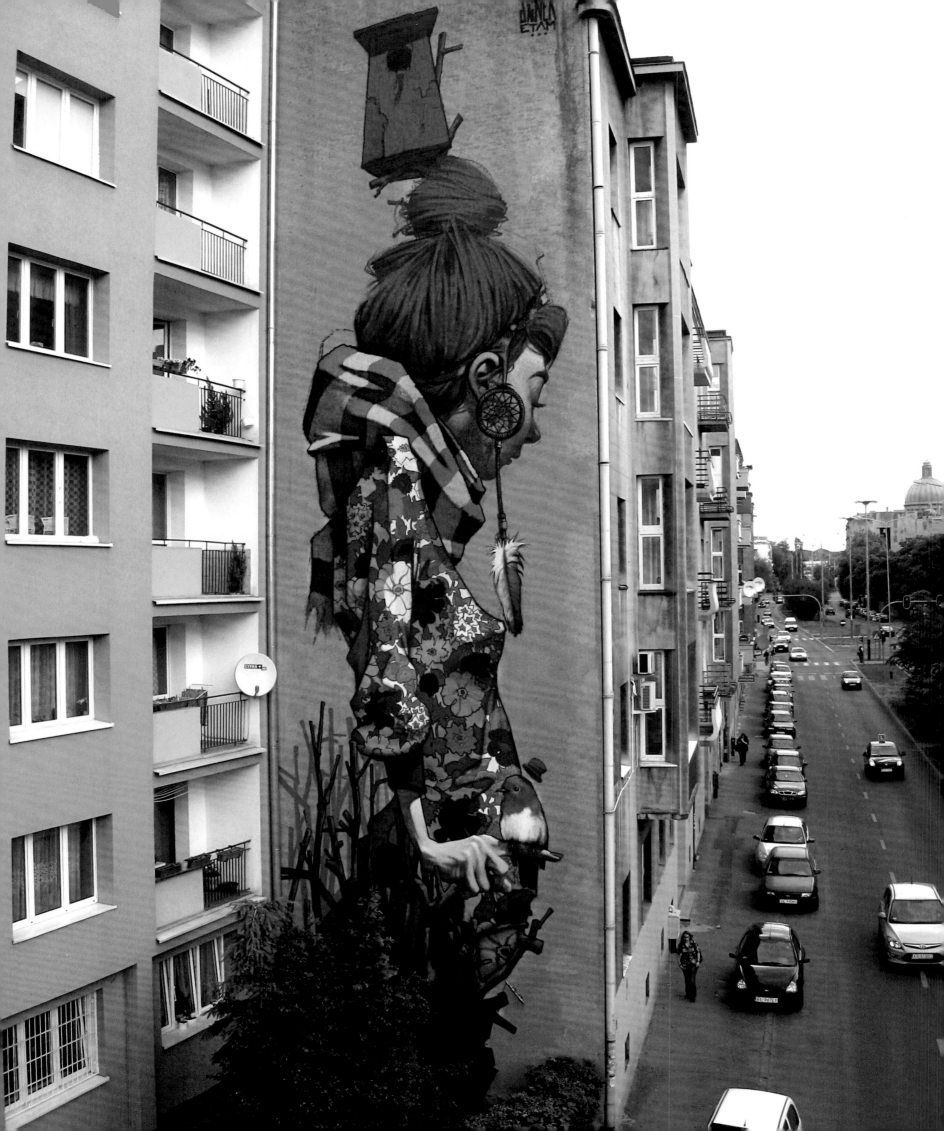

Sainer and Bezt

Polish artist Przemek Blejzyk, better known as Sainer, grew up in Łódz. His crewmate Bezt (Mateusz Gapski) was born and raised 100 km away in Turek. The two artists met while studying at the Władysław Strzeminski Academy of Fine Arts in Łódz, where they finished their degrees in 2012. Today Sainer and Bezt paint massive murals all over the world, either separately or together as ETAM Cru. In 2011, Sainer and Bezt painted their biggest wall to date in Łódz (not pictured), five storeys high, in collaboration with German artist SatOne. The three finished the mural in seven days, using exterior paint, rollers and spray paint.

Sainer and Bezt were initially interested in traditional graffiti but soon began to focus on characters, illustrations and large murals. Their massive, surrealistic illustrations feature large figures and portraits, and often show humans with animals, especially small birds. The people in their portraits rarely look in the viewer's direction, and seem preoccupied within their own worlds. Both artists use colourful palettes and often create additional visual interest and contrast by adding small details and objects, such as Sainer's signature skulls, surrounding their central characters.

Sainer's and Bezt's working method is always the same, regardless of whether they are painting a canvas with acrylics or a mural with exterior paint. First they make a sketch; then, once they begin working on the actual wall, they add the colours freehand. Finally they finish the mural by painting in the smaller details and additional surrounding objects.

Sainer enjoys the experience of creating a monumental work of art that beautifies the streets and engages the imagination of local residents. 'What's important to me in the first place is to create something good. It is really cool when it puts a smile on the faces of people passing by. After I finish a wall I am going back to my place, but the people who live there, they see this mural for years. So it is cool when my work boosts their imagination and when people create stories to my illustrations.'

THIS PAGE: Sainer's sketchbook. OPPOSITE: *Primavera*, by Sainer, Łódz, Poland, 2012. OVERLEAF: *The Healer*, by Bezt, Kosice, Slovakia, 2013 (left); *Hobo*, by Bezt, Montreal, 2014 (top centre); *Fish Huntress*, by Bezt, Vienna, 2013 (centre); *The Meaning of God*, by Bezt, Lagos, Portugal, 2013 (bottom centre); *The Change*, by Bezt, Miami, 2013 (right). SECOND OVERLEAF: *Monkey Business*, by ETAM Cru, Warsaw, 2013 (above left); *Moonshine*, by ETAM Cru, Richmond, VA, 2013 (below left); *Madamme Chicken*, by ETAM Cru, Łódz, Poland, 2013 (above centre); *Coffee Break*, by ETAM Cru, Rome, 2014 (below centre); *Good Morning*, by ETAM Cru, Boras, Sweden, 2014 (right).

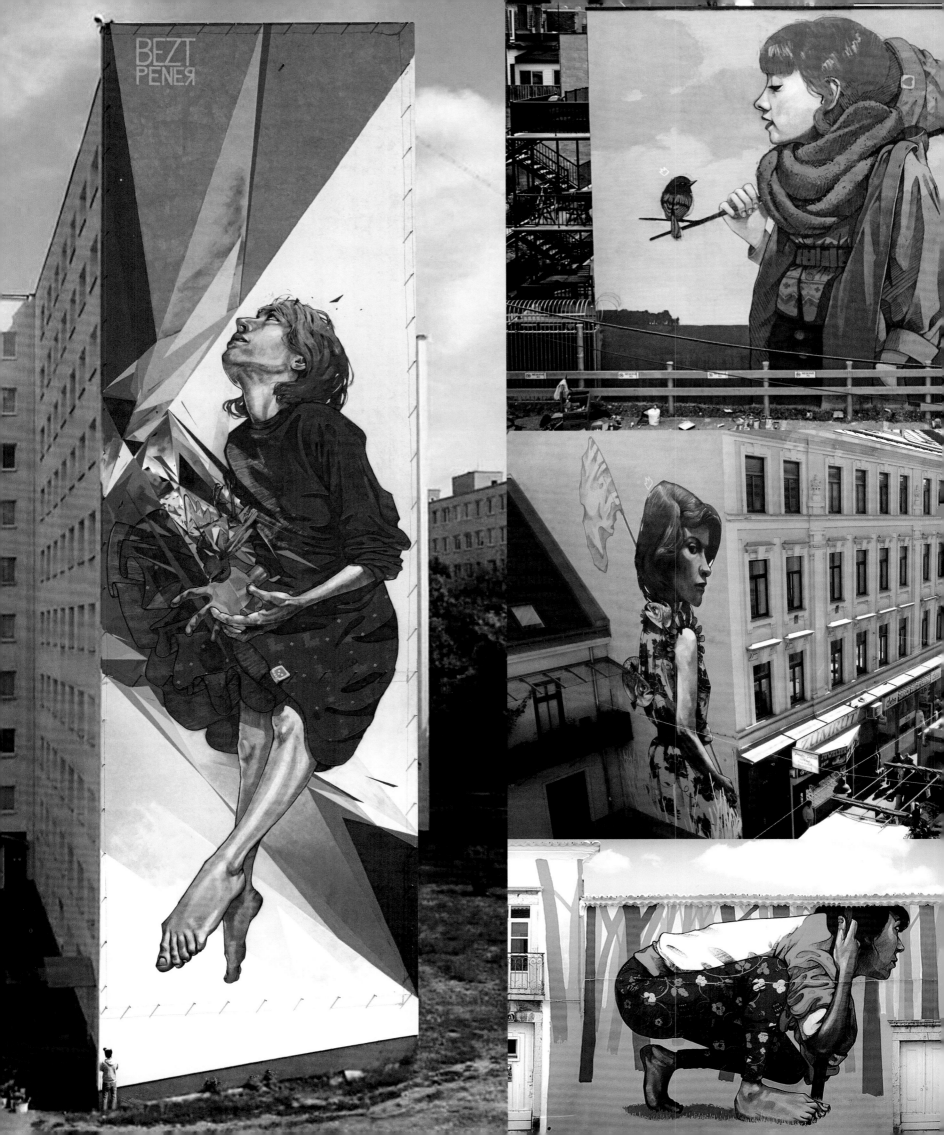

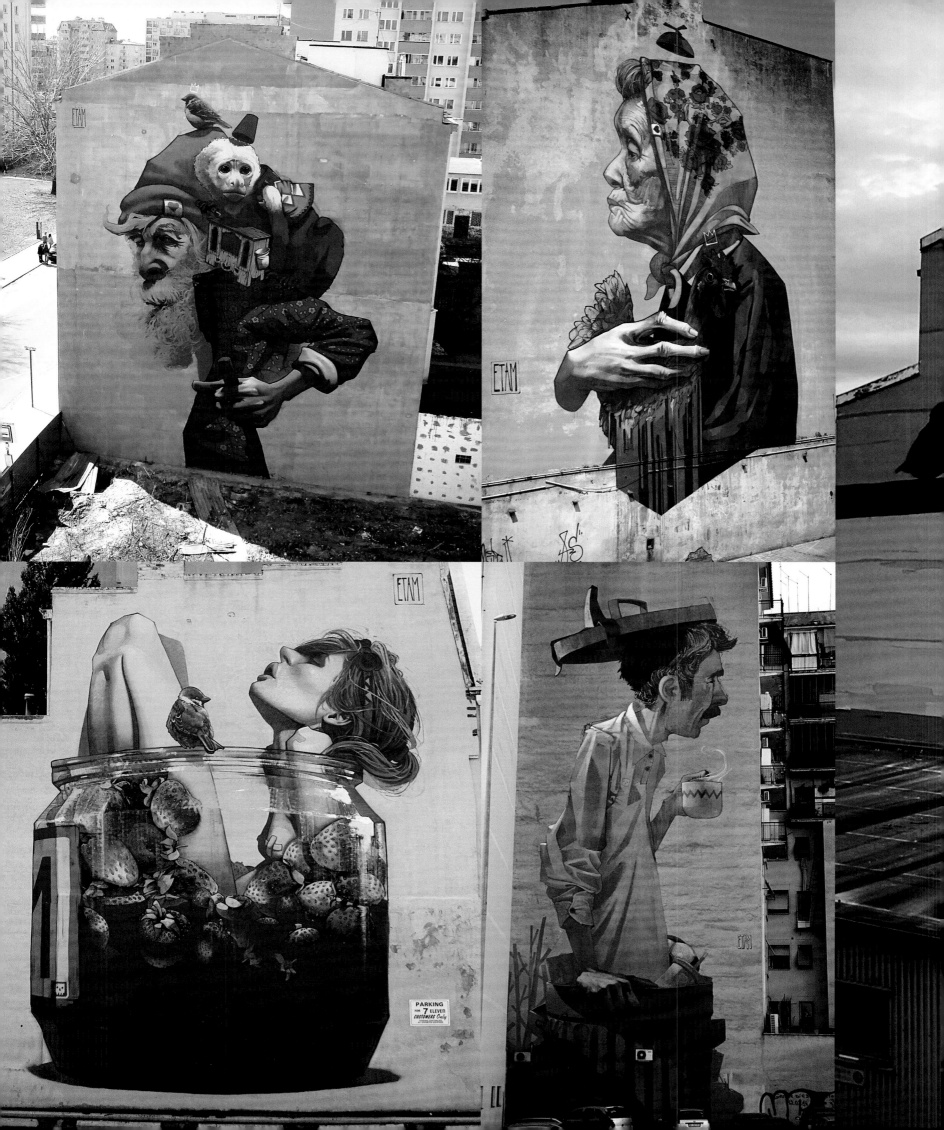

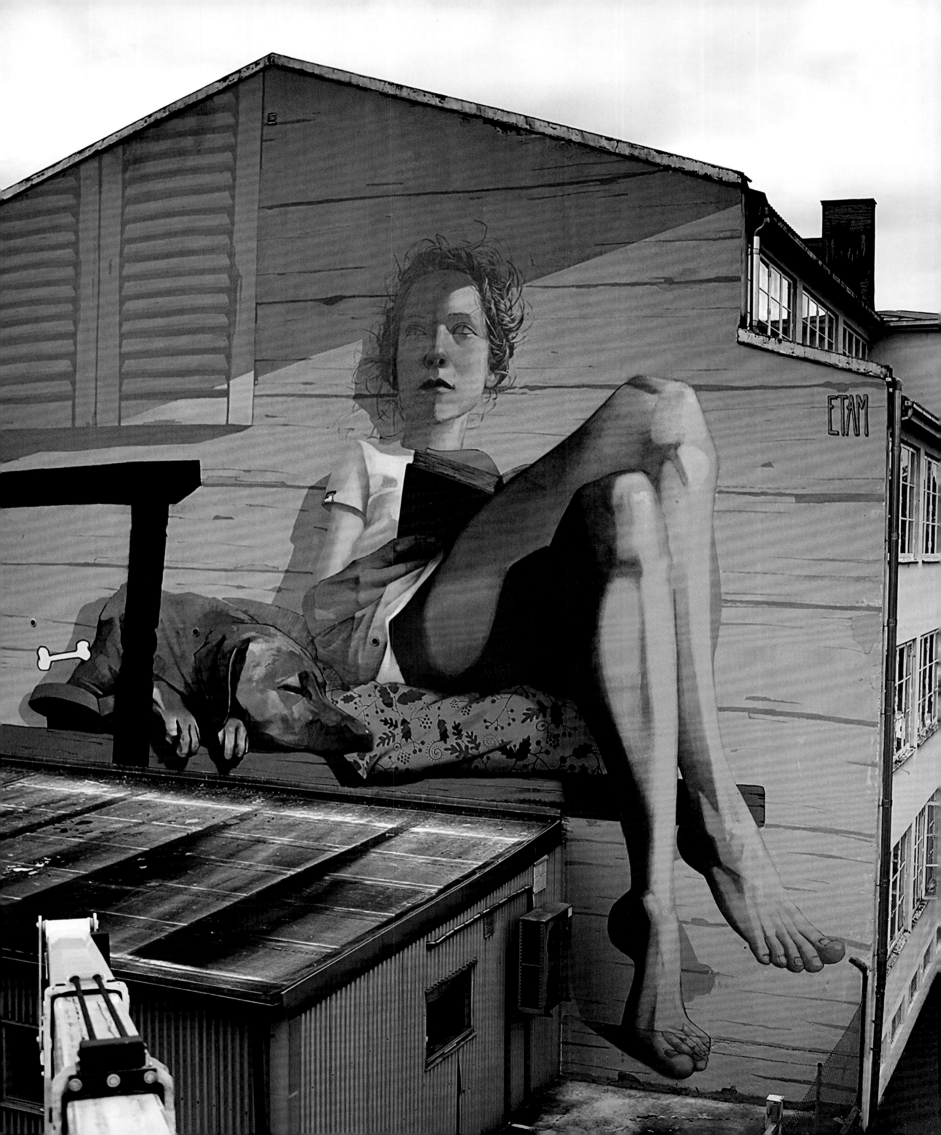

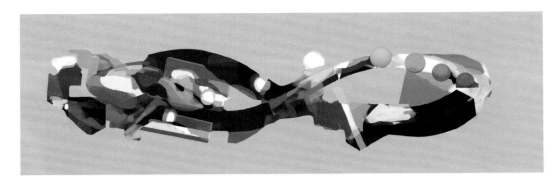

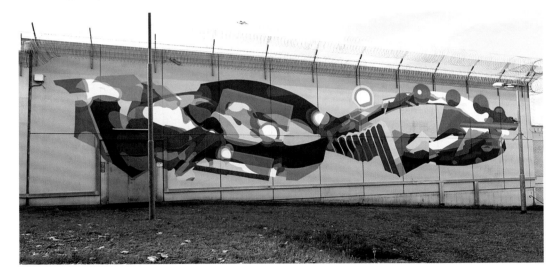

THIS PAGE: *TI:ME*, Frankfurt, Germany, 2013. OPPOSITE: *Diary*, Cologne, Germany, 2013. OVERLEAF: *Mural Competition*, Bristol, UK, 2012.

SatOne was born in Venezuela but grew up in Munich, where he is still based today. He started out writing classic graffiti letters in 1991 and painted his first large wall in 1998, in the outskirts of Munich. After studying graphic design and working for various graphics agencies, he moved on to painting murals and doing gallery exhibitions in the early 2000s. His past career as a graphic designer is clearly visible in his vector-like work, featuring abstract, colourful science fiction landscapes and characters. The elements are composed of organic shapes and recognizable faces in contrasting colours.

SatOne sees large murals as 'oversized pages of my diary' in which the story is key. One of those stories is told in the mural he painted in Bristol, UK, in 2012 (overleaf), which plays on the idea that some artists in the urban art movement feel like or are being treated like superheroes who constantly compete with each other. The Bristol mural is his largest piece to date and fills a space of 300 square metres (985 feet).

Even though SatOne also uses rollers and emulsion for larger spaces, his preferred tool is the spray can. He draws inspiration for his pieces directly from the buildings and their surroundings, prepares a preliminary drawing on paper and then moves on to painting the mural, starting with a spray-painted sketch on the wall. Like many of his fellow mural artists, he feels that the biggest challenge in completing a mural is not its size, but the ever-unpredictable weather. The power of large murals to reach a wide audience, however, compensates for the technical challenges of creating them: 'Painting on the street is a big attraction for us artists. Where else but on the street do we have such a large audience and such an unadorned form of dialogue?'

SatOne

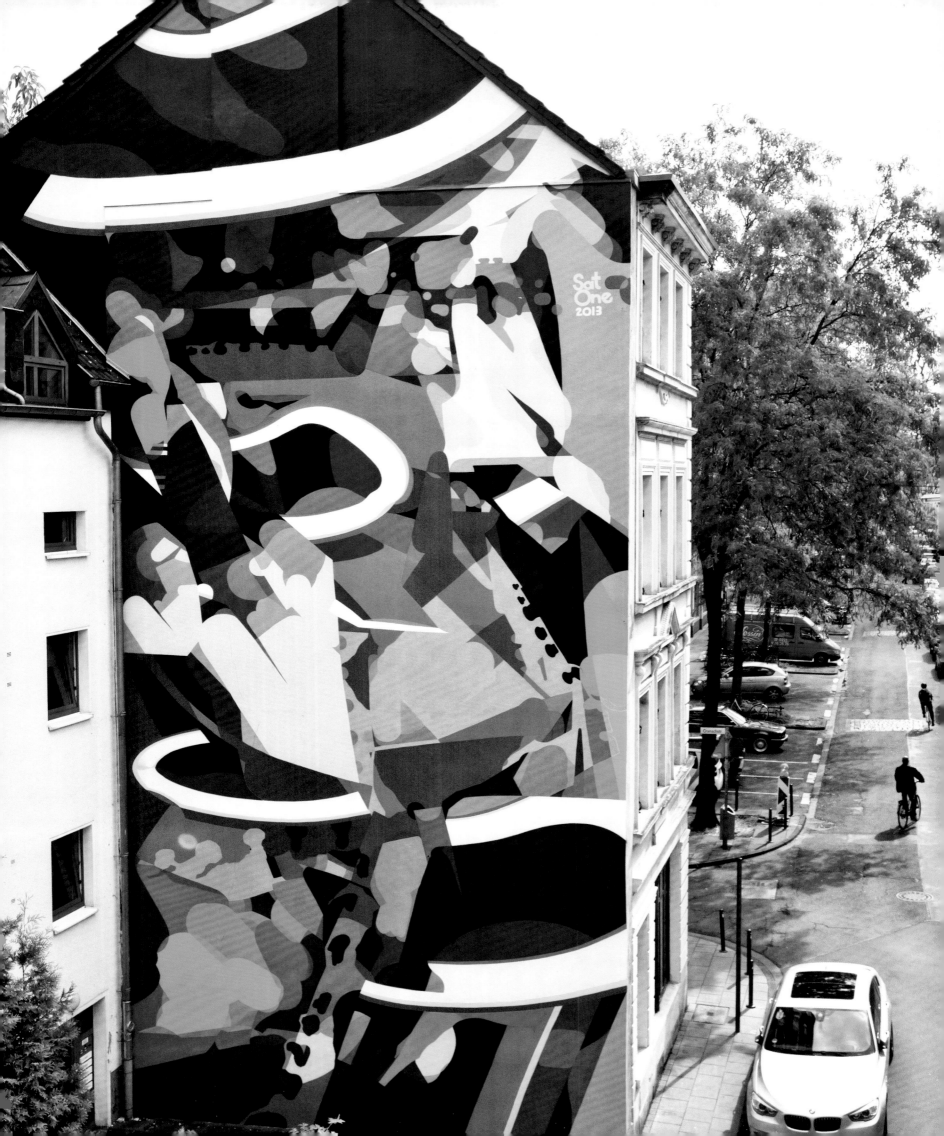

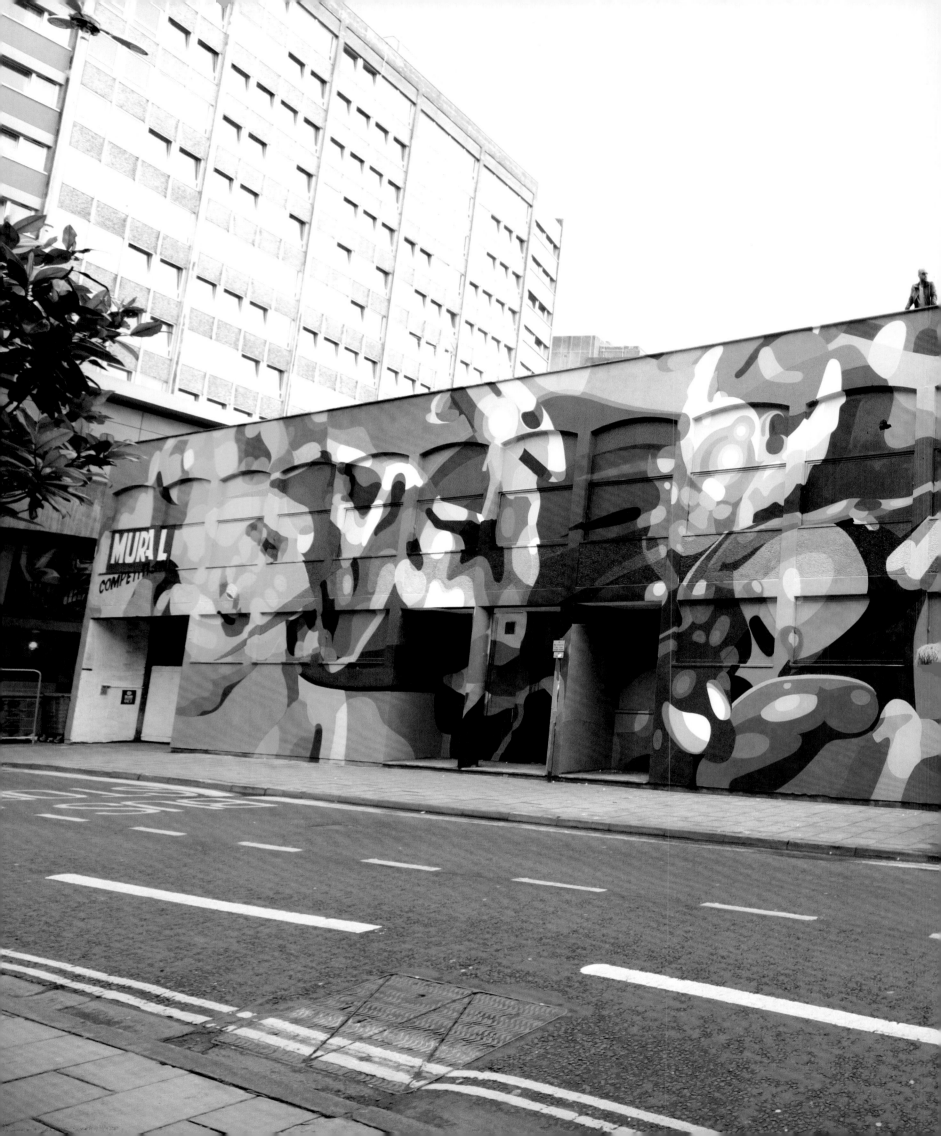

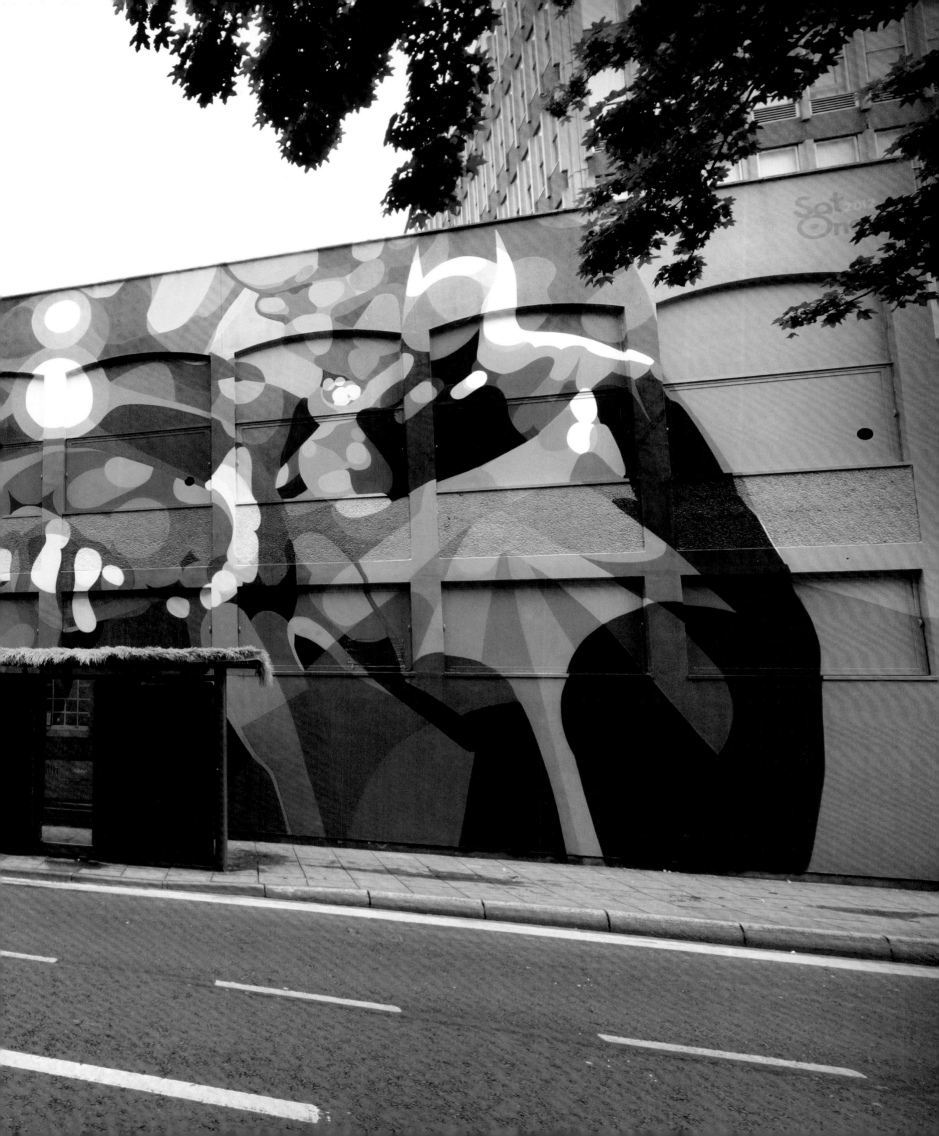

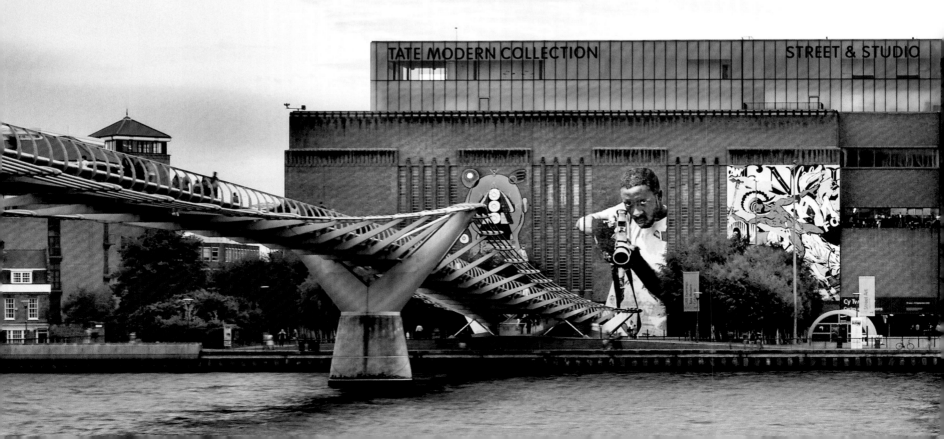

Collaborations

In the early days of graffiti, writers often collaborated on painting trains and walls. This could be purely for security – to have someone watching your back – or to spread your name wider and faster by being part of a crew. Even now, it is still uncommon for a graffiti writer to paint alone, and at graffiti jams writers often join forces to paint large surfaces.

Early street artists, on the other hand, often worked by themselves or with assistants who only helped to finish a piece, without introducing their own style. Large murals need substantial planning, so it took some years before collaborative murals showing a mix of two or more artists' styles emerged.

These collaborative pieces were often created during festivals or as parts of exhibitions or commissions. Tate Modern in London held a street art exhibition in 2008 for which various artists were invited to create a collaborative piece for the outside of the building. A similar event took place in Vienna in 2013 as part of the Cash, Cans & Candy festival hosted by Galerie Ernst Hilger.

These pages show a selection of some of the best XXL collaborative pieces. El Mac and Retna had been collaborating for a long time before it became common practice for other artists. Remi Rough has teamed up with various abstract mural artists to create pieces in which one painter's style seamlessly crosses over to the next. Even strongly different styles can work together perfectly, as in the collaborative pieces by Dabs & Myla with How and Nosm, Vhils with Pixel Pancho and Aryz with Os Gemeos.

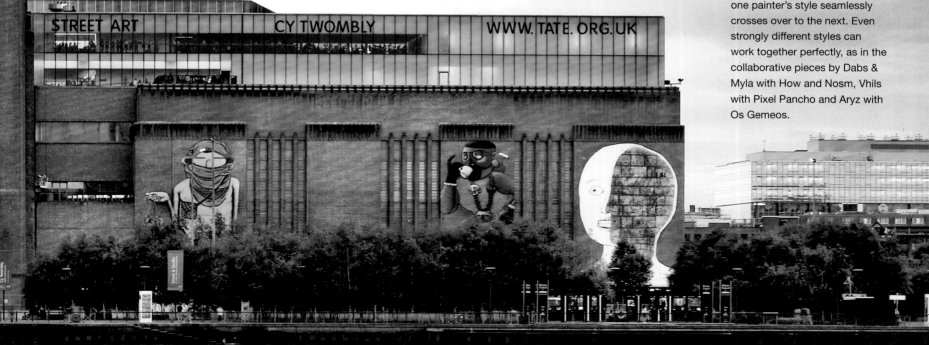

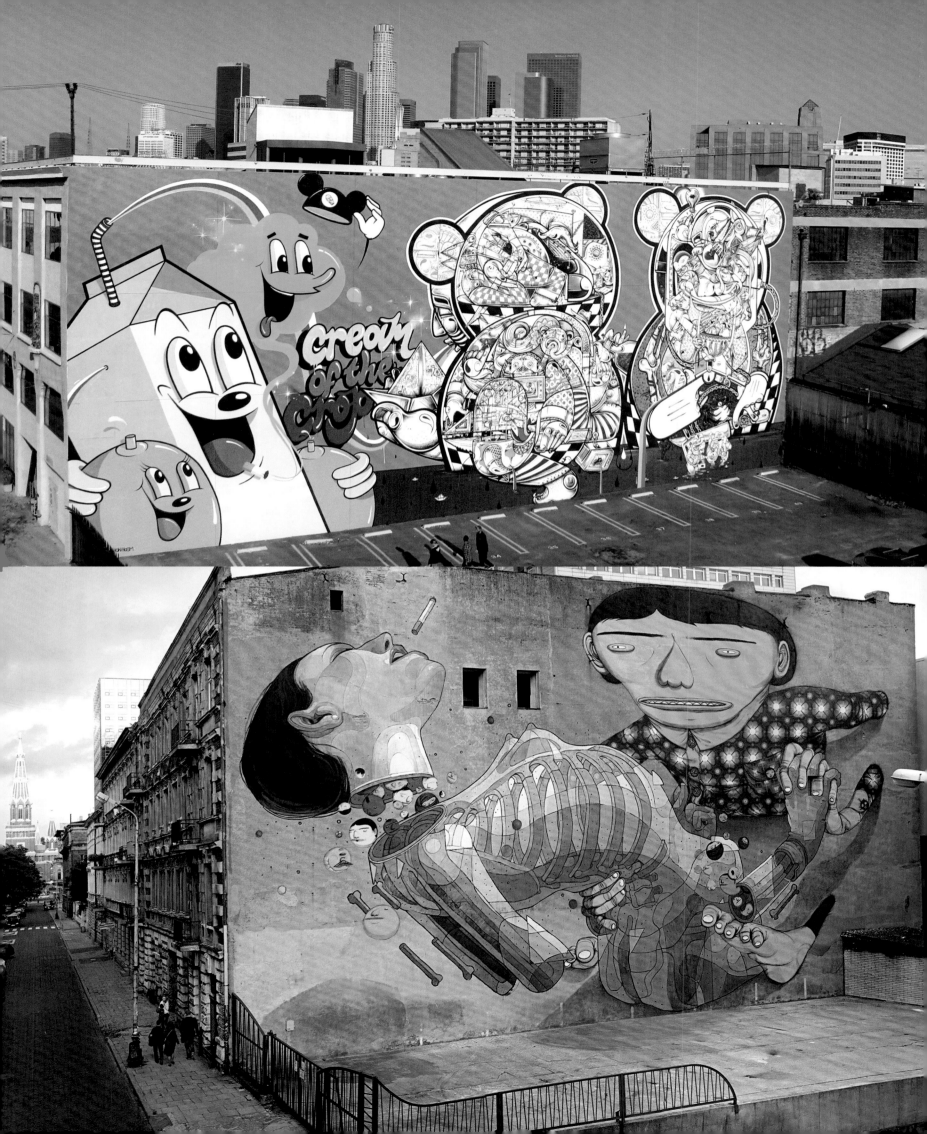

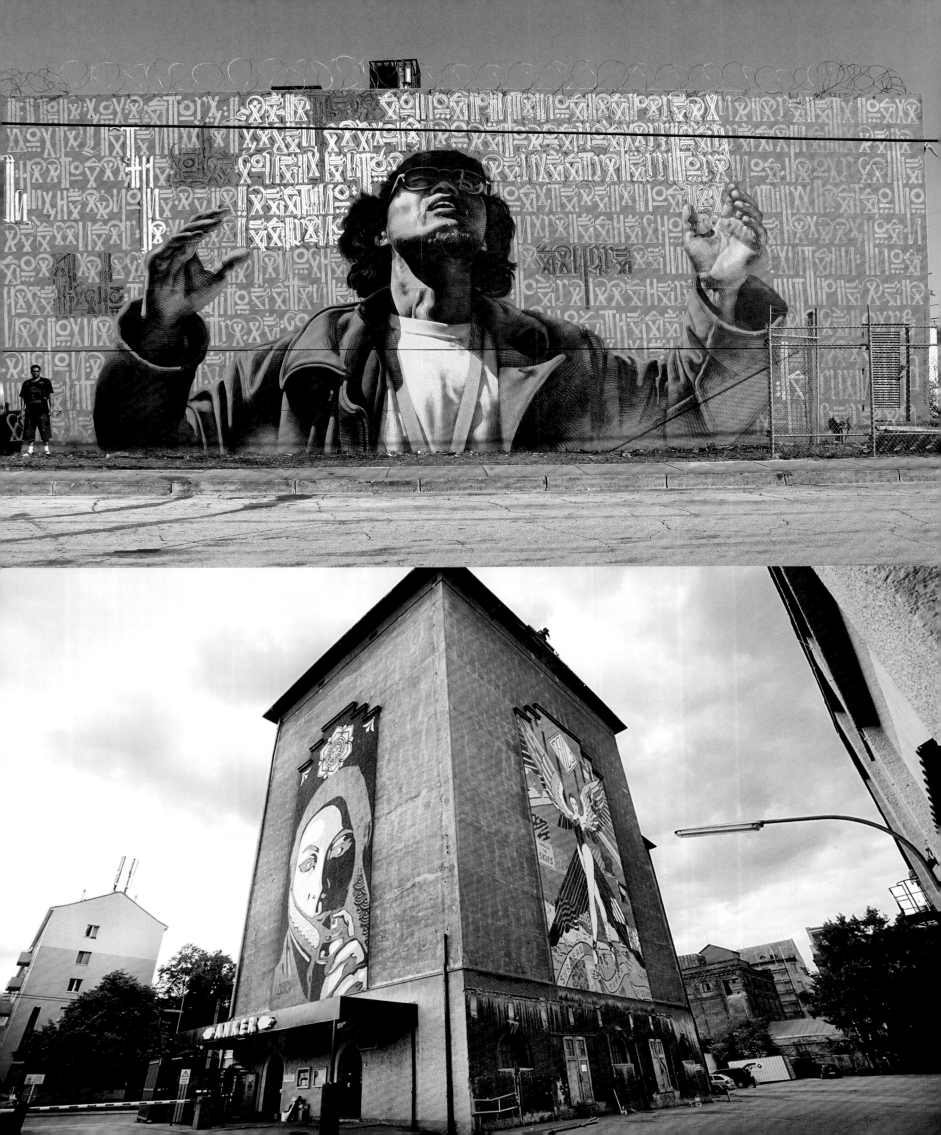

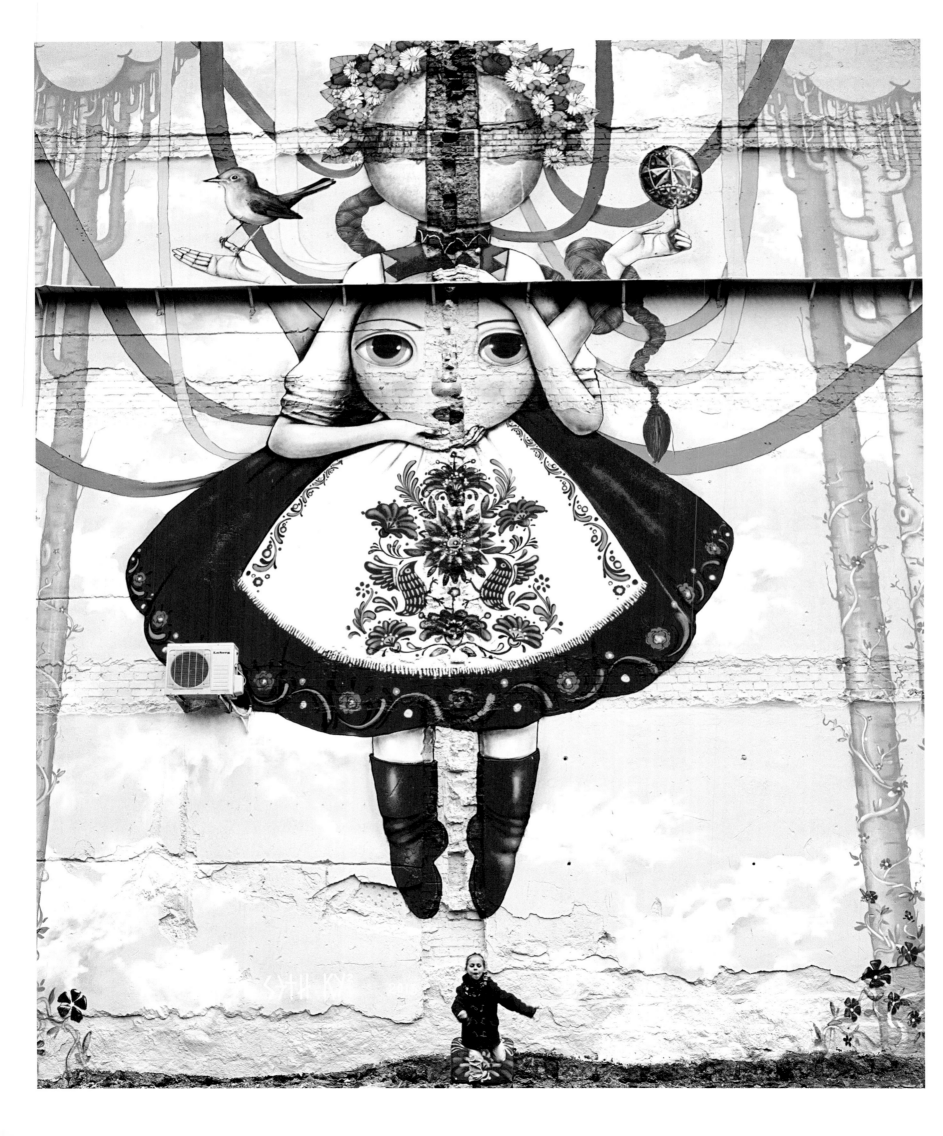

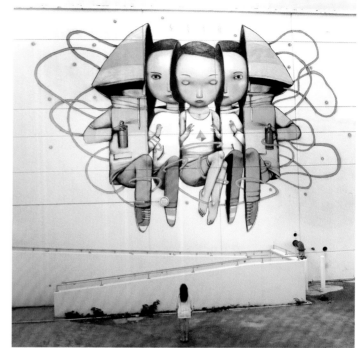

Seth

One of his especially important local projects was created in Kharkiv, Ukraine in collaboration with artists of the Ku2 group (opposite). 'This mural was a way to show the reality of the strong Ukrainian identity here in a city near the Russian border in a peaceful, almost innocent way. All of my paintings have a message that is not as innocent as it seems, but I do not want to impose it.'

When Seth first approaches a mural project, he likes to see an image of the wall he is going to paint, and tries to learn as much as possible about its location and community context. 'I make a sketch based on the cultural and social context of the place where I paint. Depending on the time I have and the complexity of the project, I paint directly on the wall, or I project the sketch. When it comes to choosing the colours, I am either inspired by the place and its local colours or I go for violent contrast with the wall.' He feels that the biggest challenge in painting large is to translate a small sketch on paper onto a massive scale. 'The large walls require a special technique and approach, and a very particular way of working. In my opinion they represent the most spectacular aspect of what I call "public art".'

THIS PAGE: Miami, 2013. OPPOSITE: Kharkiv, Ukraine, 2013. OVERLEAF: Paris, 2013 (above left); Rome, 2015 (above right); Fleur-y-les-Aubrais, France, 2012 (below); Seth x Kislow, Kiev, Ukraine, 2014 (right). SECOND OVERLEAF: San Juan, Puerto Rico, 2014 (above left); Honolulu, HI, USA, 2014 (below left) Montreal, 2014 (right).

Paris-based Seth has travelled the globe for more than a decade in order to paint his large public pieces. Like many of his fellow street artists, he started tagging in the late 1980s when hip-hop was first becoming popular in France. Over the course of his travels and his education at the École Nationale Supérieure des Beaux-Arts in Paris, he developed the characteristic figurative style that he brings to his colourful murals, which typically feature doll-like characters. He painted his first very large-scale mural in Santiago, Chile in March 2011, working in collaboration with Mono González, the father of Chilean muralism. Since then he has undertaken an increasing number of large murals every year. His largest mural to date measures 18 metres by 35 metres (59 x 115 feet). It was painted over twelve days in 2013 with the help of eight Chinese assistants in the city of Guanzhou, 'on the biggest, scariest scaffolding I've ever seen.'

Seth says that his murals are always intended for the local people, whom he often photographs in front of his finished work. 'It is my idea to create a wall that will fit the place it is situated in and that speaks to its inhabitants. The realization of such projects often takes time, which allows us to meet the locals, understand the context and share moments of life.'

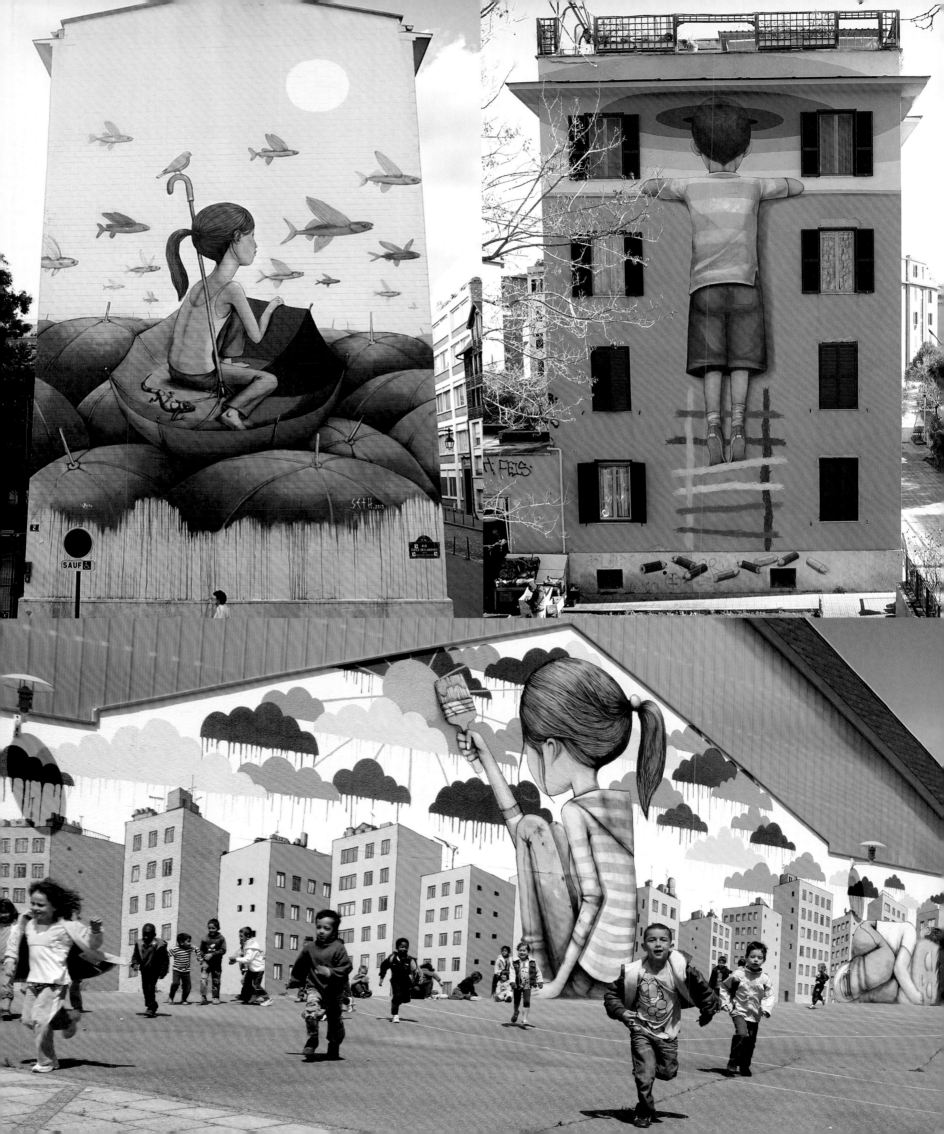

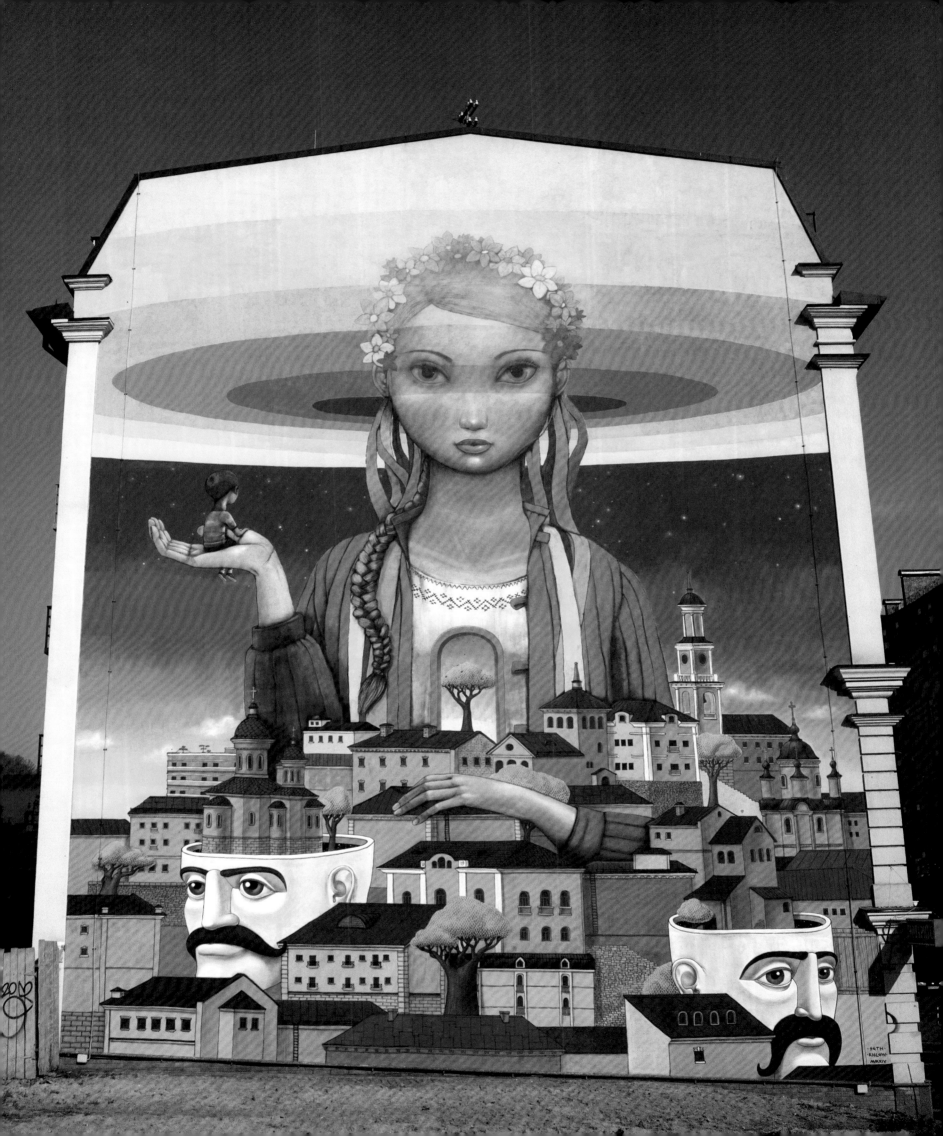

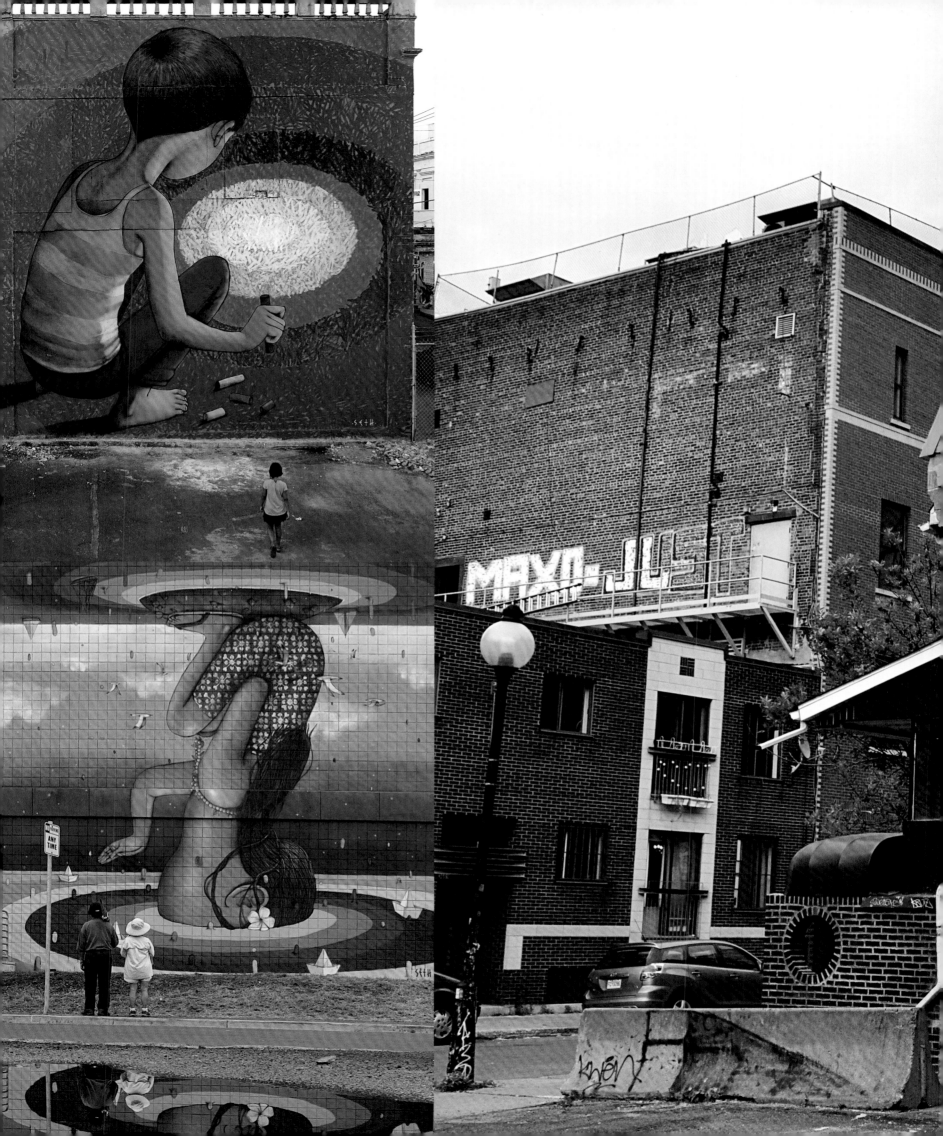

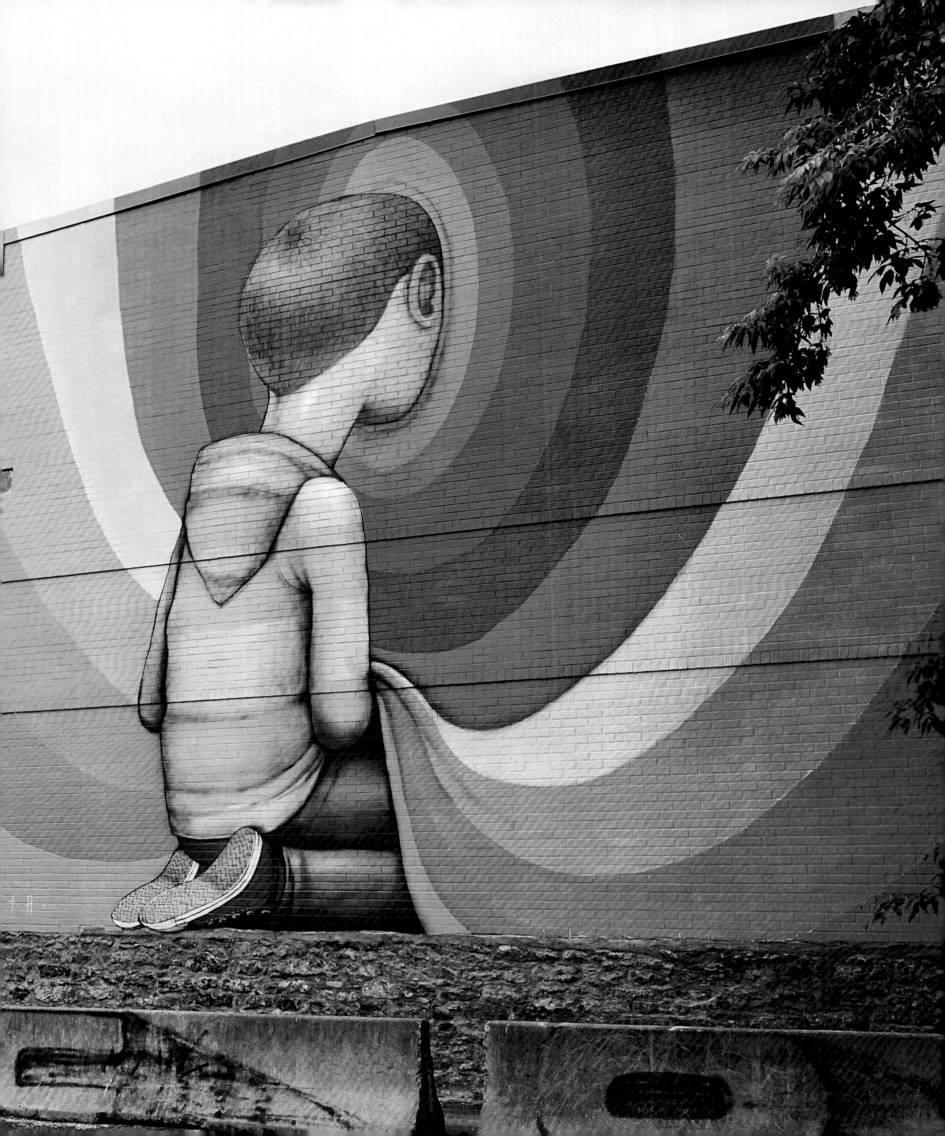

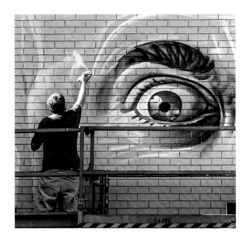
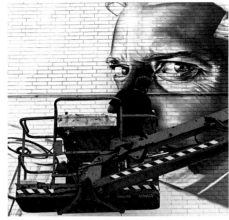
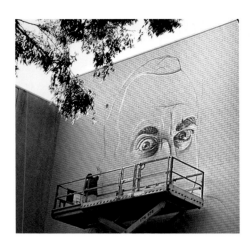

Smug, an Australian-born artist who now lives in Glasgow, first got into graffiti when he was a teenager listening to hip-hop music and hanging out at skate parks. He still paints classic graffiti letters, even though he has since gained international fame for his large, photorealistic portraits. Painting murals is his profession: he is able to earn a living from it, and over time his clients have given him more and more artistic freedom in his work. Between 2009 and 2010 he painted his first XXL mural. One of his largest pieces to date is a commissioned wall in Glasgow (opposite) that took him more than three months to complete.

Smug's large, colourful, unusually lit portraits convey enormous humour and wit. Often the portrayed individuals are his friends or fellow artists. 'Since I am primarily a photorealistic painter, the majority of my projects start with me trying to convince a friend to be a model

Smug

for me for five minutes. After I have the plan of what I will be doing, I select my colours and get straight into it.' This 'plan' is either a quick initial sketch or a photograph of the model.

Smug uses only aerosol cans to paint his murals, regardless of size, and never works with a projector or grid, despite the technical difficulties of applying outlines and colour accurately on such a large scale. 'I think the most challenging aspect to painting large-scale works is getting your first lines on the wall accurately. Another big challenge is getting the transition of tones

blending together seamlessly. You can spend an hour blending colours together, and they can look great when you're in front of it, but when you get off the lift and stand back to have a look the blending can look crude and messy. The larger the wall the harder this is for me.'

Smug nevertheless loves the challenges of working large. 'Painting photorealism on a very large scale is the biggest challenge for me. Maybe in a few years I'll start trying to paint as small as I can, although I doubt it, but for now I'm aiming for bigger and better!'

THIS PAGE: Wollongong, Australia, 2013 (above left and right); Eindhoven, the Netherlands, 2013 (above centre). OPPOSITE: Glasgow, 2011. OVERLEAF: Melbourne, 2013 (left); Limerick, Ireland, 2013 (right).

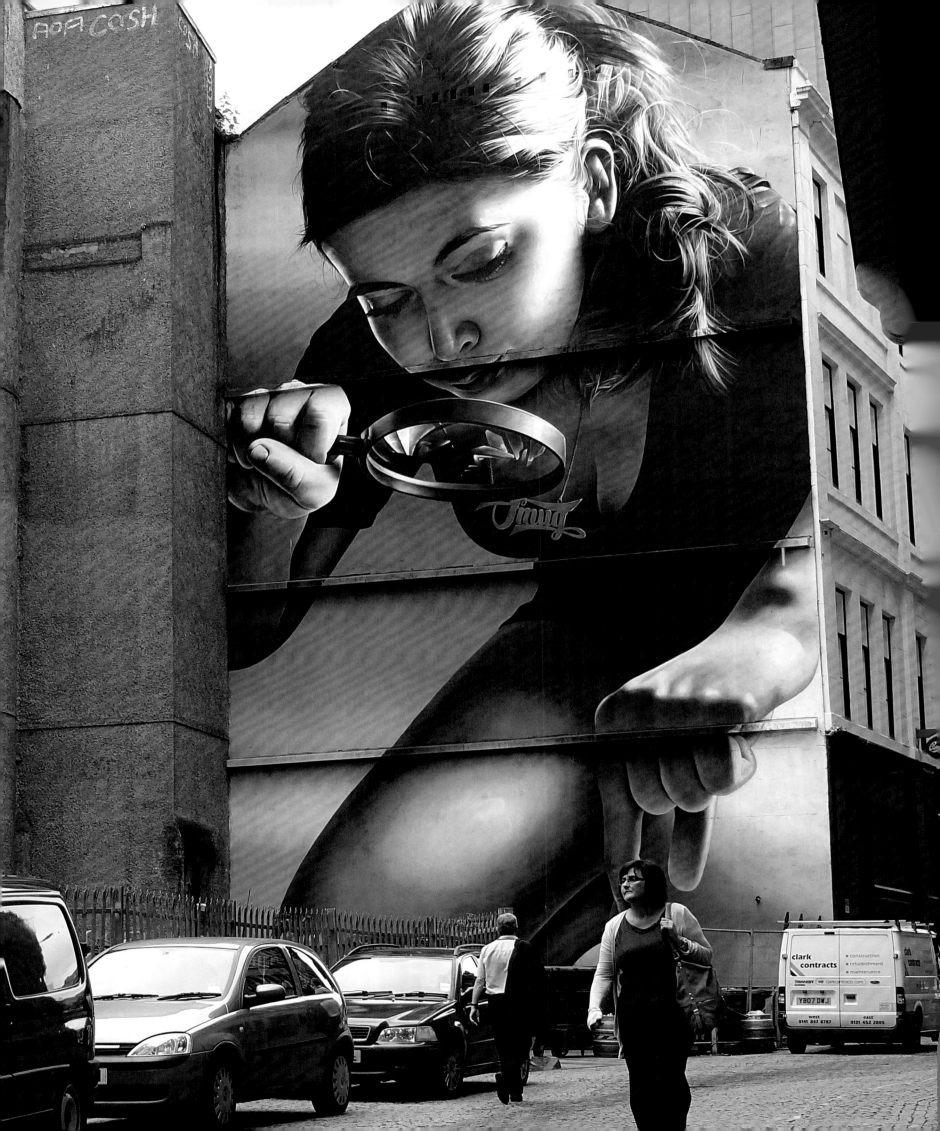

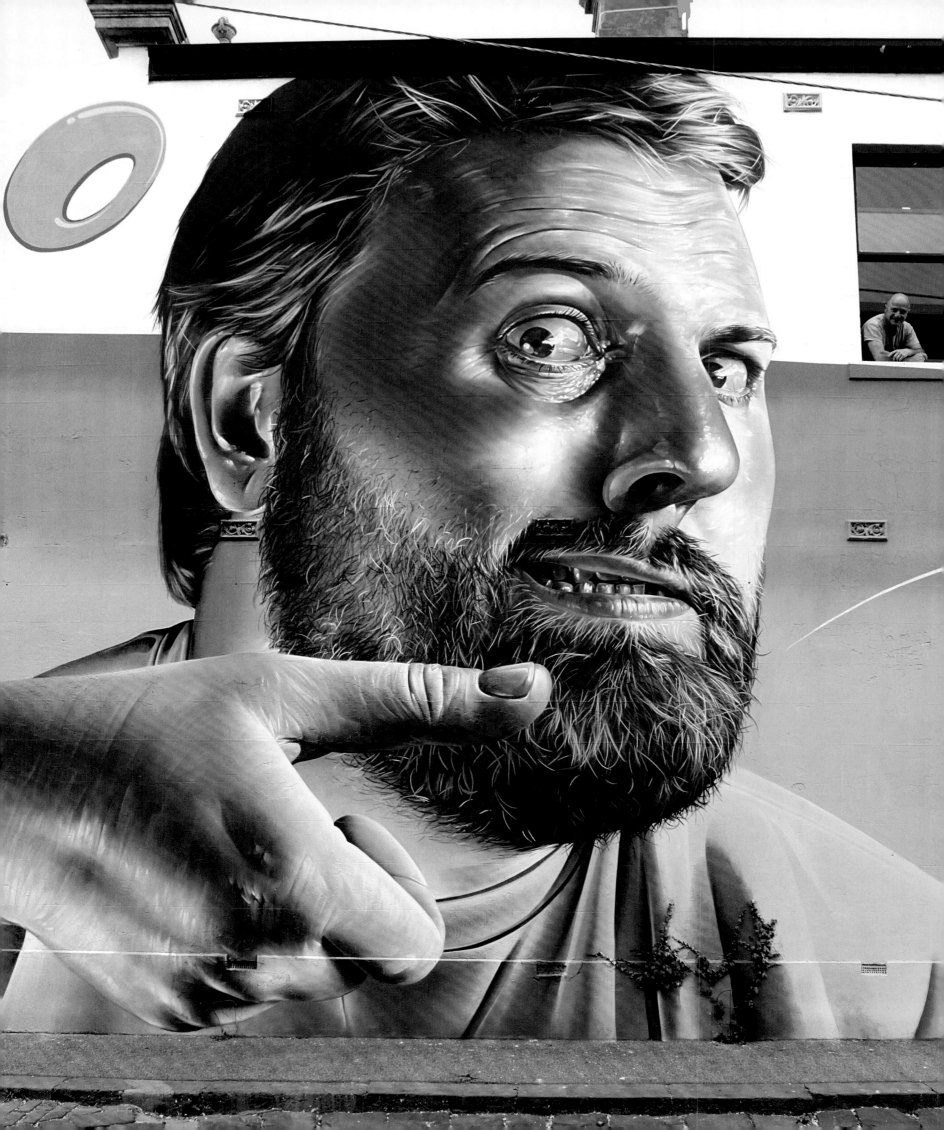

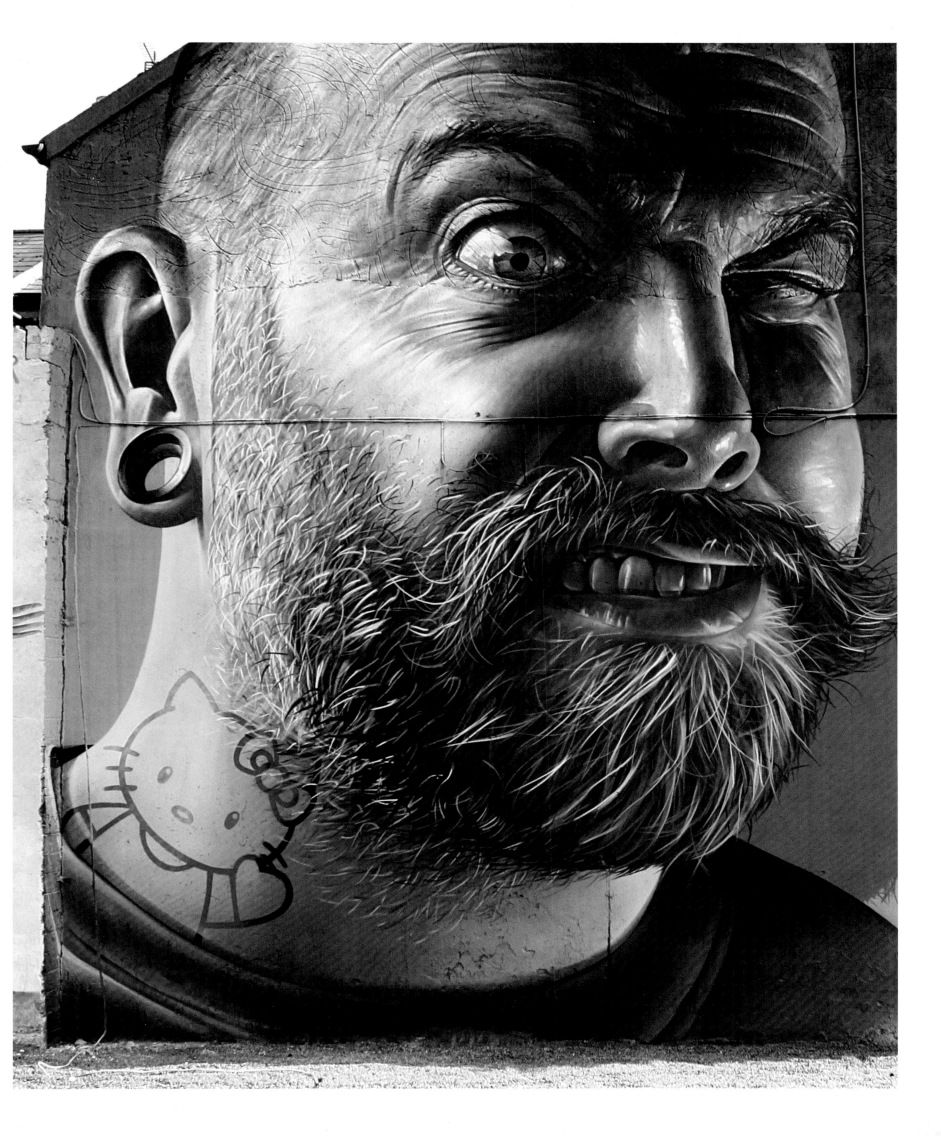

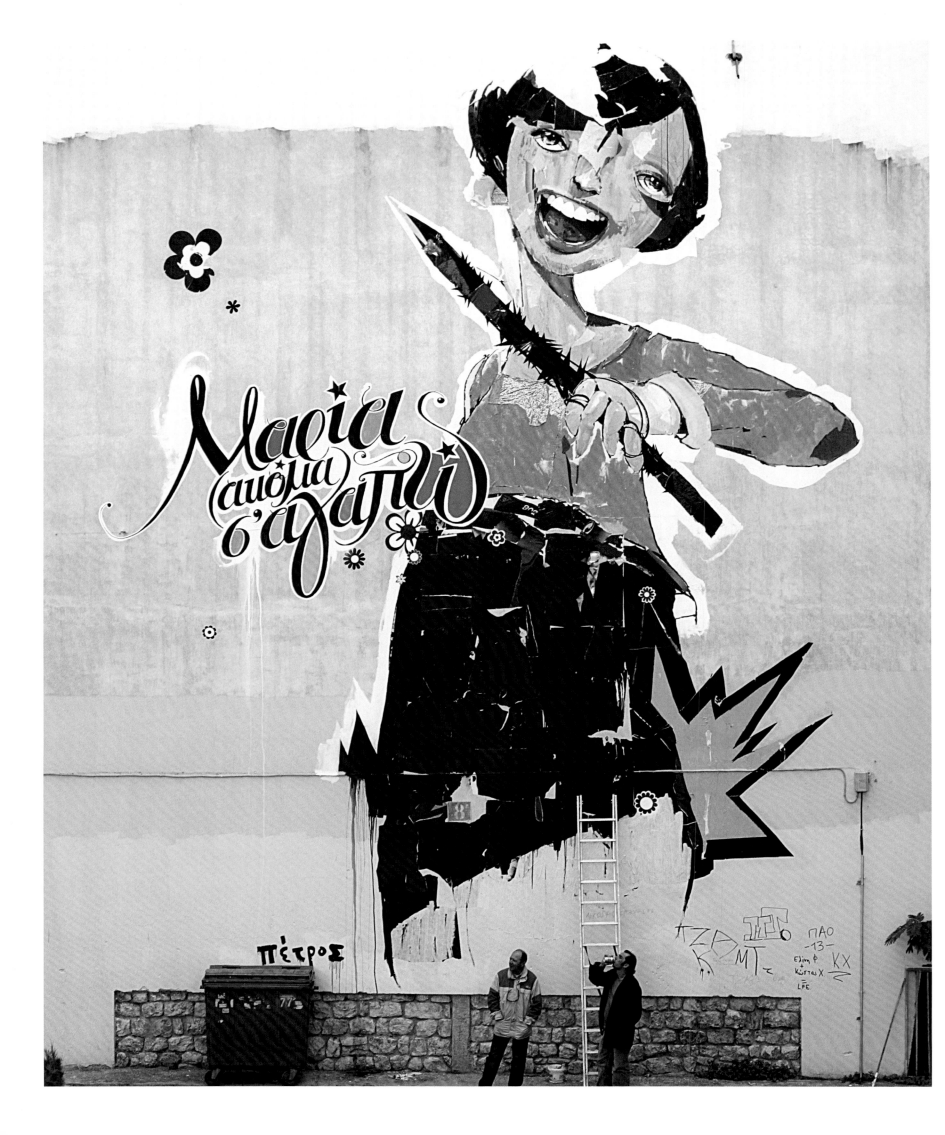

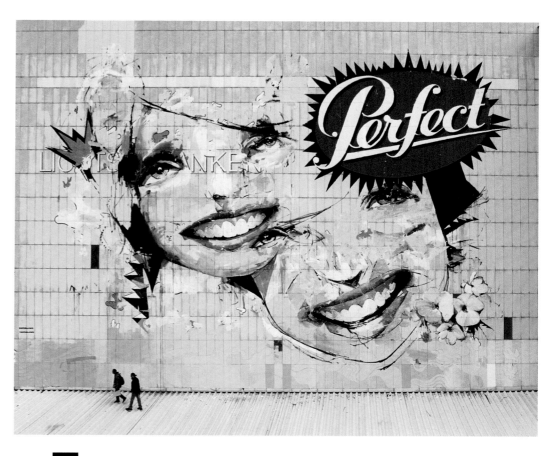

Alexandros Vasmoulakis and parisko

Alexandros Vasmoulakis is a Greek-born artist who has lived and worked in Athens, London and Berlin. He previously studied painting at the Athens School of Fine Arts and worked for a long time as an illustrator. Today he divides his time between three different artistic fields: large murals; installations made from found objects; and studio work, mostly figurative oil paintings and collages. Paris Koutsikos, better known as parisko, is a graphic artist who was born in Florence and is now based in Athens. He studied visual communications design at the AKTO Institute in Athens and Middlesex University in London.

Vasmoulakis and Koutsikos create most of their murals in collaboration. They don't do many murals throughout the year, but the few they do complete stand out due to their rough, collaged style and the emotion of their subjects' faces. The characters in the murals, mostly women, are creations of Alexandros Vasmoulakis, typically assembled from fragments of various different faces. He rips pages from magazines, taking a nose from one page, combining it with an eye from another page, a mouth from a third photo and so on, merging these collage fragments with his own drawings. The murals' typographic work is done by parisko.

The duo's technique is also unusual because they don't simply paint the wall surface, but also apply a wide range of materials, such as emulsion, paper, glue, tiles and sequins, in combination. 'Sequins make the mural look electrified,' says Vasmoulakis.

Together they created the series *Pseudo-Advertising* to start a dialogue about what does or doesn't make a mural distinctive. 'The series explores the connection of street art and outdoor advertising,' they explain.

When the two work on a mural, they prefer to take their time rather than rushing things. Depending on their mood, the weather and the size of the building they can spend up to three weeks completing a mural. Their largest piece to date,

ABOVE: *Perfect*, Alexandros Vasmoulakis x Paris Koutsikos, Berlin, 2010. OPPOSITE: *Maria, I Still Love You*, Alexandros Vasmoulakis x Paris Koutsikos, Athens, 2009. OVERLEAF: *Untitled (The Pseudo-Advertising Series)*, Shenzhen, China, 2011 (above and below left); *Brilliant!*, Alexandros Vasmoulakis x Paris Koutsikos, Tel Aviv, 2012 (right).

Perfect (above), in Berlin, is 23 metres high and 28 metres wide (75 x 92 feet) and was completed in eight days in 2010 with the help of four more people. However, Vasmoulakis and Koutsikos don't prioritize the size of a piece so much as its quality and strength.

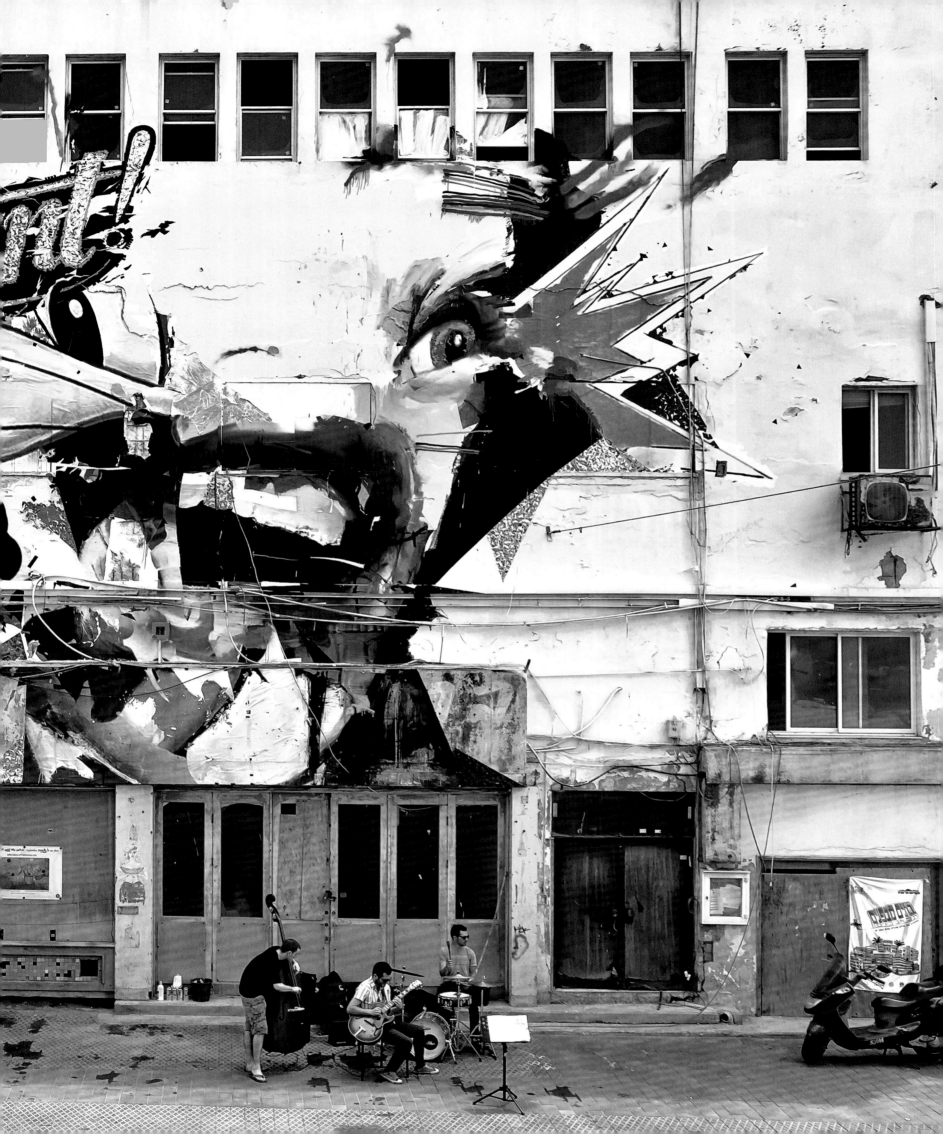

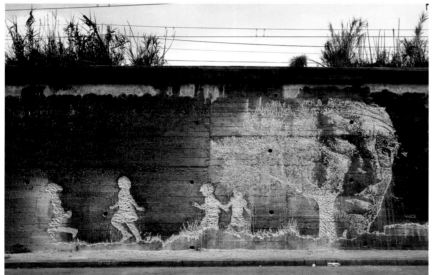

THIS PAGE: Rio de Janeiro, 2013 (above); Girona, Spain, 2012 (below). OPPOSITE: Le Mur billboard, Paris, 2012. OVERLEAF: Lisbon, 2014. SECOND OVERLEAF: Stavanger, Norway, 2010 (left); Paris, 2013 (above right); Lisnave, Portugal, 2014 (below right).

In the late 1990s, Portuguese street artist Vhils made his first appearance as a graffiti writer around Lisbon. (He chose his name because its letters were easy to write.) He was initially involved in the train-writing scene, through which he came to see the act of destruction as a creative process; later, he began using stencils and cutting into layers of posters on walls and billboards, then continued to experiment with the same techniques, using paper, wood, metal, styrofoam, cork, acid and even explosives. Today he is known for his massive portrait pieces, which are carved, cut, chiselled or blasted into walls and billboards, removing their exterior layers and revealing the different textures underneath. His pieces are not built up with layers of paint in the conventional way, but by cutting away layers of the work surface itself.

Vhils enjoys working with walls in this way because of the rich textures they offer. To create his murals, he first sketches the portrait, developing a composition that will fit the wall and its surface perfectly. As if making a reverse stencil, he then cuts out the negative areas – that is, the shadows – that shape the figure's face, using a cutter, drill, chisel or explosives, depending on the type of surface. The portraits take three to six days at minimum – or even a month when explosives are involved. He also makes video works, some of which capture in slow-motion the explosions he uses to 'paint' his murals.

Vhils

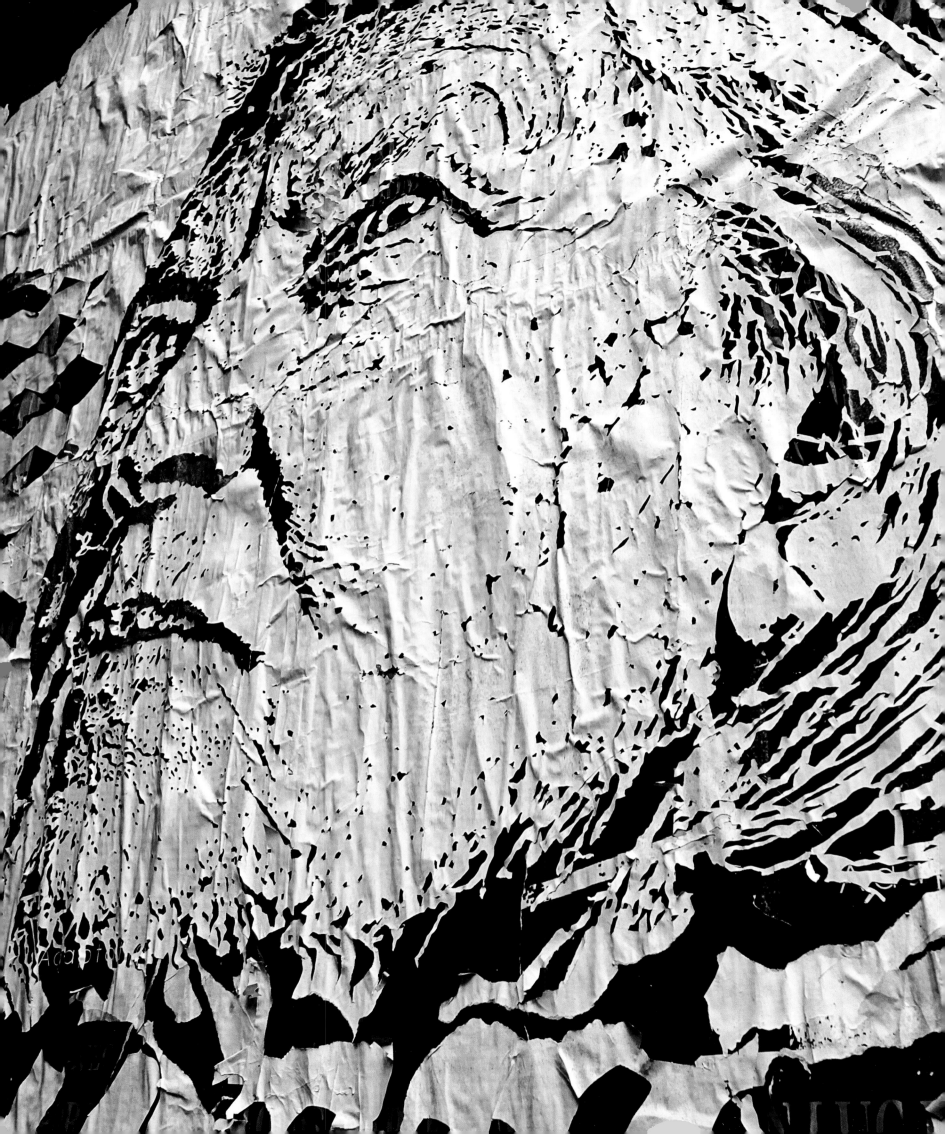

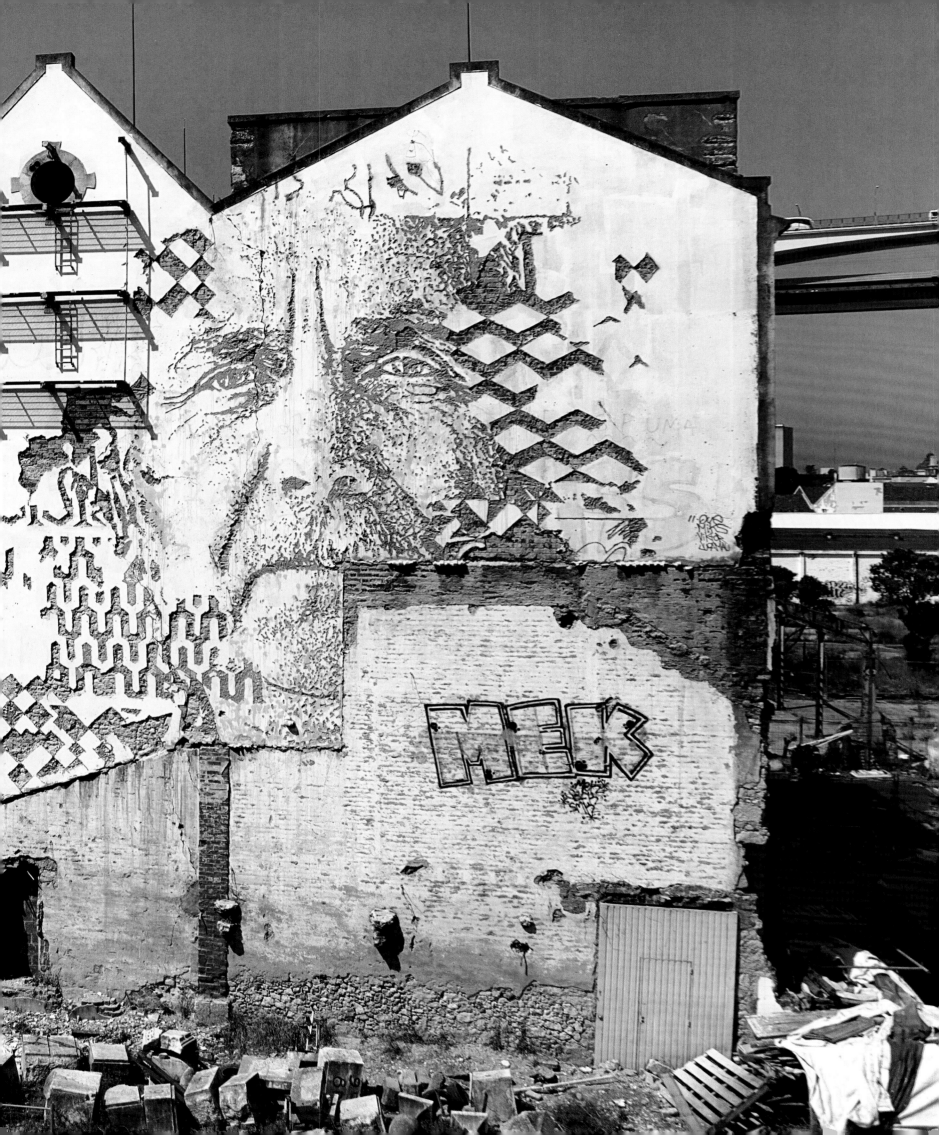

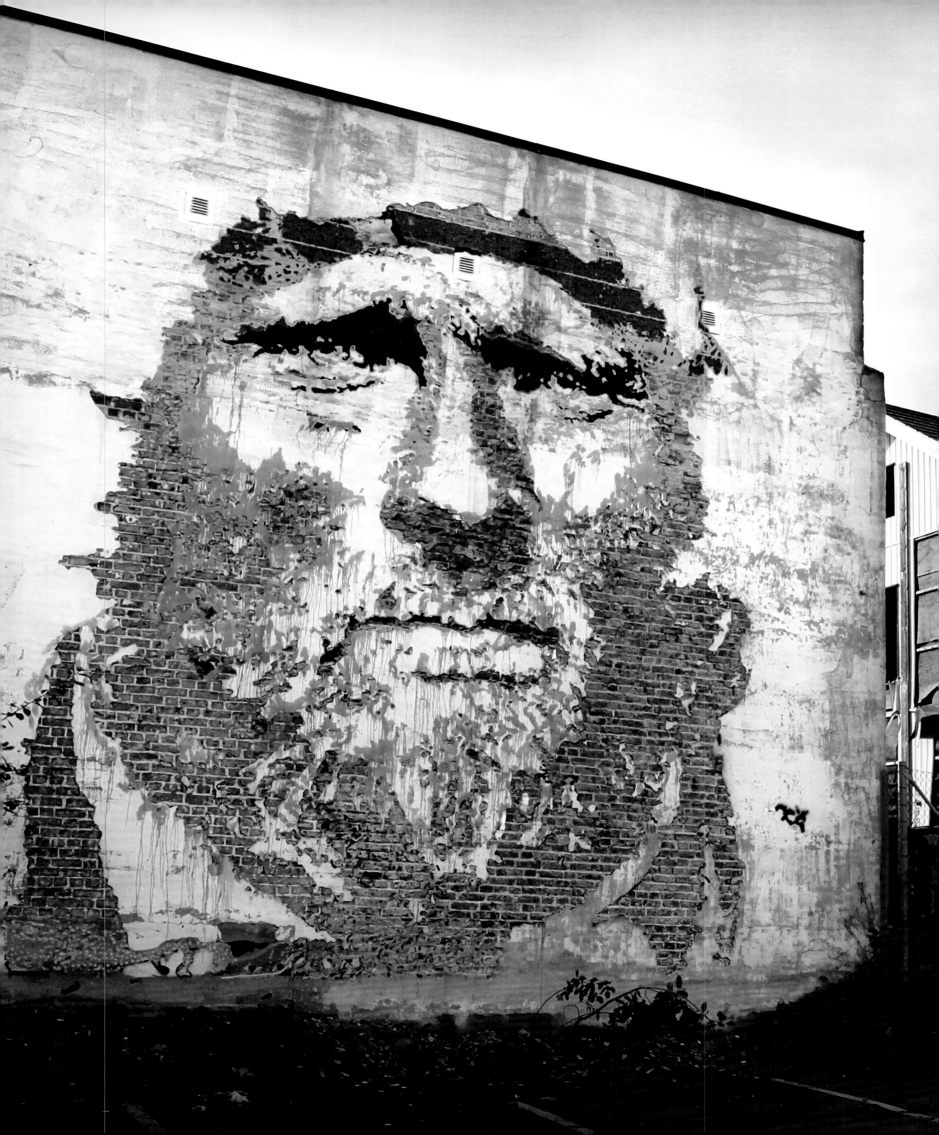

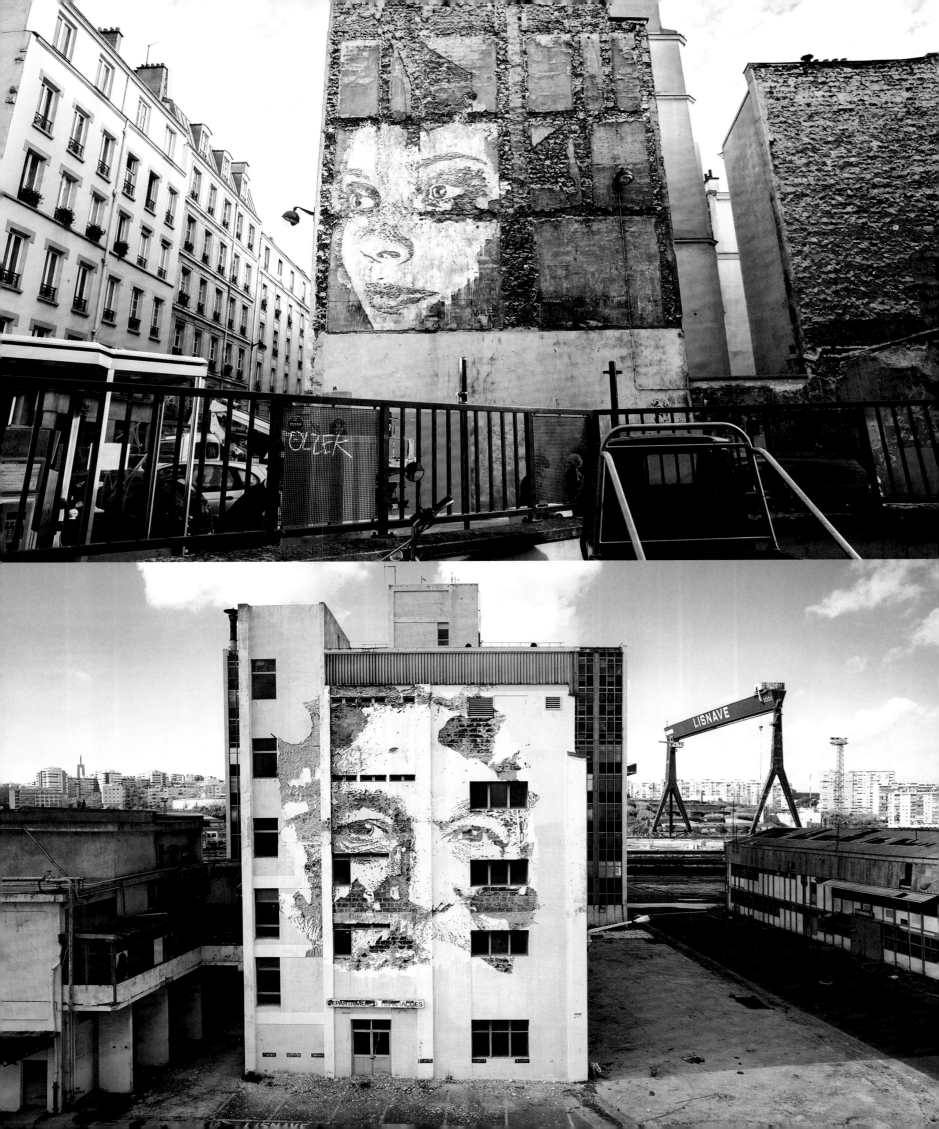

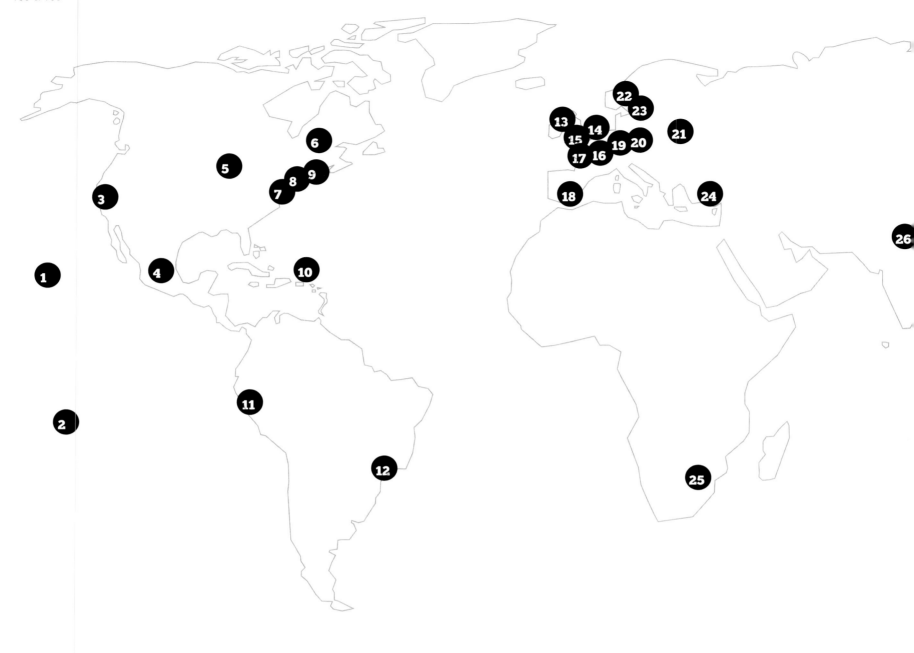

1

Kofie
Kamani and Halekauwila Street,
Honolulu, HI, USA

2

MadC
Avenue du Prince Hīnoi,
Papeete, Tahiti

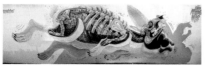

3

Nychos
1525 Webster Street, Oakland,
CA, USA

4

ROA
República de Paraguay 42, Colonia
Centro, Mexico City, Mexico

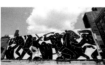

5

Cleon Peterson
634 S. Wabash Avenue,
Chicago, USA

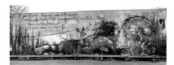

6

Herakut
PFK, 4310 Avenue Papineau,
Montreal, Canada

7

HENSE
700 Delaware Avenue,
Washington DC, USA

8

How and Nosm
13th and Sansom Street
Philadelphia, USA

Mural World

A selection of the best XXL murals worldwide

11 HENSE
Avenida Benavides 778,
Lima, Peru

12 Eduardo Kobra
Avenida Paulista,
São Paulo, Brazil

13 Askew
230 Cathedral Street,
Glasgow, UK

Smug
Mitchell Street near Argyle Street,
Glasgow, UK

14 Conor Harrington
Spurling Road, Dulwich,
London, UK

15 El Mac
Quay Street at Small Street,
Bristol, UK

16 C215
Boulevard Vincent Auriol,
Paris, France

16 Ripo
Fort d'Aubervilliers,
Paris, France

Vhils
Rue de la Fontaine au Roi,
Paris, France

17 Seth
Avenue de la Bataille Flandres-
Dunkerque, Rennes, France

18 D*Face
Calle Comandante Benitez 14,
Malaga, Spain

19 Herakut
Stiftstraße at Eschenheimer Turm,
Frankfurt, Germany

20 MadC
Perlickstraße, Leipzig,
Germany

21 Aryz / Os Gemeos
Roosevelta 5, Łódz, Poland

21 DALeast
Łakowa 10, Łódz, Poland

INTI
28 Pułku Strzelców Kaniowskich 48,
Łódz, Poland

22 Sainer
Feddersens gate,
Oslo, Norway

23 The London Police
Fabriksgatan, Borås, Sweden

24 Pixel Pancho
Nüzhet Efendi Sokak 56–66,
Istanbul, Turkey

25 ROA
63 Sivewright Avenue,
Johannesburg, South Africa

26 ecb
ITO Crossing, PWD Headquarters,
Indraprastha Marg, New Delhi, India

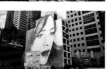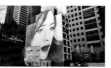

27 Millak Fisherman's Market,
60 Gwanganhaebyeon-ro,
Busan, South Korea

28 RONE
Little Collins Street,
Melbourne, Australia

Askew
Gloucester Street near
Cathedral Junction, Christchurch,
New Zealand

9 FAILE
Record Plant Recording Studios,
44th Street near 8th Avenue,
New York City, USA

Case
Colby Street and Park Avenue,
Rochester, NY, USA

Conor Harrington
595 Hollenbeck Street,
Rochester, NY, USA

10 ROA
Calle Lloveras, San Juan,
Puerto Rico

Picture Credits

All images are courtesy the artists, unless specified otherwise.

D*Face
7 (all images) Rob Walbers

Dabs & Myla
4–5 Carlos Gonzales

DALeast
34 (top) Anthony Taylor
34 (bottom) Jeff Coles Smith
35 (bottom) Brandon Shigeta
38 (all images) Marek Szyman ski

Faith47
58 (all images) Sandro Zanzinger

Conor Harrington
63 Ian Cox

Kofie
104–5 (all images) Paco Ambulante and A. Kofie
106–7 Riccardo Lanfranco

The London Police
110 (bottom) Soren Solkaer
111 (bottom) Samwell Ortiz

MadC
91–93 (gatefold overleaf, all images) Marco Prosch

Nychos
118 (top left) James Pawlish
118 (top right) Jyah Min
118 (bottom left) Upper Playground
118 (bottom right) Instagraffiti
119 Christian Fischer

Pixel Pancho
124 (top) Martha Cooper

Cleon Peterson
126 (all images) Furlong

ROA
138–39 Ian Cox

SatOne
155 Robert Winter
154 www.drawaline.de
156–57 Ian Cox

Seth
169 (left, sketch) Gilles Stuttgen
170 (bottom) Thomas Chretien

Alexandros Vasmoulakis
180 (top and bottom left) 吴其伟
Eric Wu

Vhils
182 (above) João Retorta
182 (below) Smart Bastard
183 Smart Bastard
184–85 Alexander Silva
186 Ian Cox

Acknowledgments

A massive thank-you to all artists around the world who contributed to the book, and special thanks to all those people who have helped and inspired me along the way. I would like to thank the following people in particular for their support:

My family

Marco Prosch

Emily

Stephan Walde

Reno Rössel

Annelies Maenhout

Jürgen Feuerstein

Pure Evil

Matthew Eaton

Anthony Curis

Thomas Stønjum

Julien Kolly

Karl-Hermann Schmiing

Ingrid Beazley

Jacob Kimvall

Julian Ziege

Thomas Deichsel

Jamie Camplin

Claudia Walde

Author Biography

Claudia Walde, better known as MadC, is an internationally renowned German artist who has produced public murals in more than thirty-five countries worldwide. Born in 1980 in Bautzen, in the former GDR, Walde began her artistic career as a graffiti writer while still a teenager, and has since extended her creative work into graphic design, writing and fine art. She studied at Burg Giebichenstein University of Art and Design, Halle, and Central Saint Martins College, London, and has a master's degree in graphic design. Walde is also the author and designer of two books on street and graffiti art: *Sticker City: Paper Graffiti Art* (Thames & Hudson, 2007) and *Street Fonts: Graffiti Alphabets from Around the World* (Thames & Hudson, 2011).

As MadC, she created her first graffiti piece in 1996 and gained international renown in 2010 with the production of a 700-square-metre mural, now known as the *700Wall*, along the train line between Berlin and Halle. This XXL work took four months to complete and is still believed to be the largest graffiti mural created by a single person. Since 2009 she has increasingly painted on canvas and her work has appeared in numerous solo gallery shows and group exhibitions.

MadC, *700Wall*, Germany, 2010

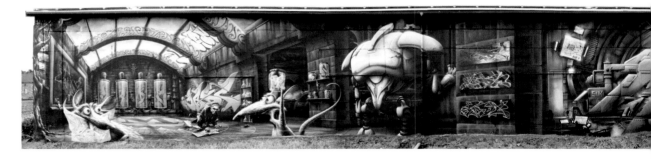

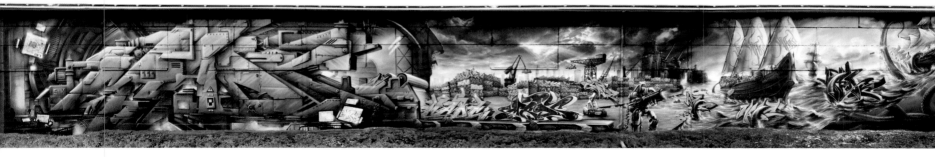

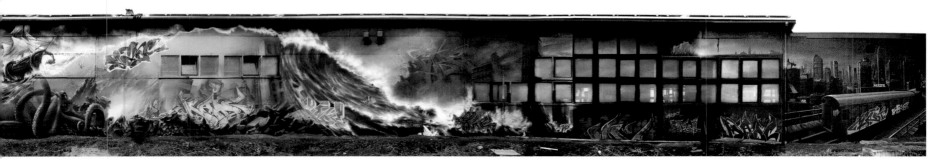